Richard Shone

# THE CENTURY OF CHANGE

British painting since 1900

Richard Shone

# THE CENTURY OF CHANGE

British painting since 1900

**PHAIDON**

*Phaidon Press Limited, Littlegate House, St Ebbe's Street, Oxford*

*Published in the United States of America by E. P. Dutton, New York*

*First published 1977*
*© 1977 Phaidon Press Limited*
*All rights reserved*

ISBN 0 7148 1782 1
*Library of Congress Catalog Card Number: 77-75 312*

*Printed in Italy by Amilcare Pizzi, S.p.A., Milan*

# Contents

*for Michael Craig-Martin*

# Acknowledgements

The author gratefully acknowledges the following people for help of various kinds during the writing of this book: Dr Wendy Baron, Mr Tony Carroll, Sir William Coldstream, Mr Giles Eyre, Mr Nigel Greenwood, Mr Eardley Knollys, Mr Richard Morphet, Mr Rodrigo Moynihan, Mr Ben Nicholson, Mr Andrew Patrick and Mr Peyton Skipwith.

# Introduction

Lecturing on British art in 1934, Roger Fry wrote the following:

> No, let us recognize straight away that ours is a minor school. But that does not mean that it is not intensely interesting, that it does not merit the most sympathetic and patient appreciation, that it has not its specific qualities, unlike those of all other schools, which it would be a great loss to miss or misunderstand.

Until recent years, only his first sentence has been generally heeded in regard to the painting of our own century. Individual artists have had their apologists; but as a whole, modern British painting has been treated as some unfortunate country cousin, charming and even attractive in some lights, but hopelessly out of date in borrowed finery, easily manipulated, irrevocably provincial. Ignorance of the period accounts for much misinformed comment; 'specific qualities' are not allowed to interrupt critical theory, an inflexible adherence to mainstream developments. I make no claims for a revision of the view that 'ours is a minor school'; we have no one to compare with Matisse or Kandinsky, Mondrian or Pollock. The whole concept of abstraction, which has motivated much of the dominant painting of the century, has been invariably misunderstood in Britain except by one or two individuals, largely because what Sickert called 'gross material facts' have been at the source of so much British art. The inspiration of landscape in particular has been a consistent factor in its development, paralleled by an intense social curiosity and narrational awareness; both can be traced back through the centuries to the splendid pre-Conquest style of illuminated manuscripts. Much art produced recently in Britain has reflected these qualities, separately or together. The discovery of landscape in its various aspects has occupied Ben Nicholson since the twenties, it has informed some of Richard Smith's recent work and is central to the preoccupations of David Tremlett and Richard Long among younger artists. An earthy realism and astringency have characterized our illustrators and genre painters, and it was in part a return to that tradition which motivated Sickert and Gilman and others of the Camden Town painters and appears intermittently through to the Pop Art of the sixties.

Although I have not felt impelled to deviate too far from an essentially modernist approach in the brief outline which follows, I hope there is a suggestion of the diversity and richness of British art. The three movements which emerge as the most original – Vorticism, the abstract and Constructivist art of the thirties and the earlier manifestation of Pop Art – inevitably dominate the illustrations. All three movements partake of qualities constant in British art while also reflecting aspects of foreign painting and culture; all three appeared at a time of pending or actual upheaval and change. The leading individuals such as Bomberg and Spencer, Paul Nash, Burra and Bacon are connected only superficially with these movements, and it is such individuality, an unfailingly personal, sometimes eccentric vision, which gives resonance to much of the work represented here. This peculiar silver spoon has been an undependable cultural inheritance; it has encouraged a narrow cultivation of gifts, an indulgence in whimsy and, when rejected, an often servile

aping of styles from abroad. Painters of obvious gifts and youthful achievement seem to roll over into the mud of imitation or fall into self-indulgent picture-making. Some may re-emerge with a fresh orientation – Mark Gertler comes to mind – and others like John or Wolmark fall by the wayside.

Many explanations have been put forward to account for the charming shambles of British painting in this century, the great gifts dissipated, the fluctuations within even the best of our painters: the narrow programmes of the art schools, blinkered criticism, amateur dealers, the whole misconception of the artist's social role which atrophied so much talent in the Victorian period. Further factors continually suggest themselves. The years 1910 to 1919 saw the premature deaths of Spencer Gore and Harold Gilman, of J. D. Innes and Derwent Lees and of that strangely impressive member of the Camden Town Group, M. G. Lightfoot, who killed himself in 1911; John Currie, well thought of by his contemporaries, committed suicide in 1913; two years later Gaudier-Brzeska was killed and in 1917 the critic and philosopher T. E. Hulme was another casualty of the war.

I briefly touch on the situation of British art after the war, on the relative quietness and pervasive sense of consolidation of that period. It saw the emergence of modest, sometimes engaging painters who in a more detailed survey would merit attention. Bernard Adeney and Bernard Meninsky, Frederick Porter and Adrian Allinson are among them. More original artists who might have been expected to enliven the post-war years followed other pursuits – Etchells turned to architecture, Atkinson and Cuthbert Hamilton to sculpture and Wyndham Lewis was mainly preoccupied with writing. The watery Post-Impressionism of much exhibited work hardly prepared the public for the Constructivist and Surrealist movements of the thirties. The public was generally slow in its appreciation – the Royal Academy summer exhibitions were still the norm for the vast majority, attracting visitors who would not otherwise look at a picture during the rest of the year. Periodic bouts of vandalism, censorship and abuse have continued to give fine copy for the press. With few outlets in America and France for showing their work and an indifferent public at home, British painters relied on a handful of galleries and private collectors for support. The same names recur – Edward Marsh, Michael Sadler, Wyndham Vint, J. L. Behrend, Samuel Courtauld, Hindley Smith and Tom Balston were among the few discerning collectors between the wars. Helen Sutherland gave great support to painters in the thirties, particularly Nicholson and David Jones, as well as buying work by Mondrian and Gabo. Kenneth Clark, Colin Anderson and Peter Watson helped many young artists of the late thirties and the forties. Some of these collectors were associated with the Contemporary Art Society (founded in 1910), which did invaluable work as purchaser and publicist. Private patronage in more recent years increased but hardly touched the immense scale it reached in America or Germany.

Such historical and social factors are only half the story and generalizations about national temperament and sensibility have only a partial usefulness in accounting for the strengths and weaknesses of British painting. A refined contemplation of often charged and potent 'incidents' characterizes its expressionist

tenor – we see this more particularly in Sickert and Bacon, in Paul Nash, Freud, Hodgkin and in the paintings illustrated here by Huxley and Lancaster. A combination of emphatic realism and personal lyricism has produced many of the most memorable images of our time.

Several considerations have determined the choice of plates for this book. Personal taste is overwhelmingly important but by no means alone in deciding the final selection; the availability of pictures for reproduction, publishing technicalities and copyright all make a contribution. The words 'private collection' in periodicals and exhibitions have put a stop to several pictures making an appearance and compromises have been inevitable. It will be found that certain painters well known here and abroad are scantily represented in comparison with less known artists. Several of them are well documented already and the subject of numerous books and catalogues. There are no books, for example, on Gore or Gilman, several on Sutherland, however. The number of plates allotted to a painter does not necessarily indicate a judgement. Some artists unfortunately lose more in reproduction than others – Riley, Hitchens, Hoyland are examples. In putting together a survey such as this, opportunity is given to bring attention to work by neglected figures or to paintings representative of a particular genre or episode. Mainly from considerations of space there are worthy painters not represented and some painters are shown at uncharacteristic moments in their development. To gain some structural cohesion those working now are often introduced by initial achievements which may be very different from their present work, whose direction is as yet transitional or oblique. But I have chosen pictures all of which I like or in which I find something to respond to with varying degrees of pleasure.

# 1 The Impressionist influence

In the first few years of this century, an intelligent and open-minded art student would have been presented with a number of alternatives when considering what course his work might follow. Presuming that he was neither a genius nor sufficiently developed in his taste and inclinations to know already what he wanted to do, then, generally, the alternatives would have been these: if cautious by nature, his goal would have been the Royal Academy Schools; if more progressive, either the Slade School or study abroad, preferably in Paris. If his inclination was towards portrait painting, then his aim would have been Sargent's classes at the Academy Schools; should he prefer fine draughtsmanship, then Professor Tonks at the Slade was the obvious choice, and Augustus John the young contemporary most worth emulating. If already aware of modern French painting, he would have visited the exhibitions of the New English Art Club, and looked carefully at the paintings of Steer and perhaps Sickert, at Tonks and Frederick Brown and the London Impressionists. In 1900, if exceptionally alert, he would have travelled up to Glasgow to see the progressive exhibition of Franco-British art; if lured to Paris, then the Exposition Universelle would have been a strong attraction, with gold medals awarded to George Clausen and William Nicholson and a silver one to the young William Rothenstein for his topical *The Doll's House*. In 1903 he would most likely have lamented the death of Whistler; the death of Watts in the following year might have drawn a respectful nod but no more.

Simplified as these alternatives are, they do suggest the diverse and unsettled situation in British art at that time, with, at one extreme, reflections of recent French art and, at the other, the rampant commercialism of the Royal Academy. Apart from Sickert, the prominent members of the New English Art Club (founded in 1886) failed to develop what they had learned from France. A tasteful picture-making ensued as they sank back into a comfortable middle age, a pattern we find repeated so often in modern British painting. Wilson Steer's gradual transformation from the brilliant 'Neo-Impressionism' of his Walberswick and Cowes period to the Elgarian landscapes of his later years is a familiar and disappointing tale. But it would be wrong to dismiss him from this survey and *Chepstow Castle* (PLATE 7) is a distinguished example of his conservatism at its best. Its breadth and intensity go well beyond the painting of some of his contemporaries working within the English landscape tradition. One aspect of that tradition continued under the influence of Whistler – the feathery greens and silver-greys of Paul Maitland (1863–1909), Sidney Starr (1857–1925) and Arthur Studd (1863–1919). The latter was adventurous enough to recognize the genius of Gauguin, whom he joined in Tahiti in 1898. A further group looked to Millet, Bastien-Lepage and the Barbizon painters, then avidly collected in England. George Clausen is the most forcible of these, when he manages to avoid the sentimentality of social comment (PLATE 2). In spite of the individual merits of other *plein-airistes* – Arnesby Brown, Arthur Melville and La Thangue, for example – their importance lies more in the refreshing coda they give to the last century rather than any new impetus to painting in this. Fresh thinking about the subject of a picture rarely accompanied advances in technique.

As the decade progressed, the public were able to see what the French Impressionists had achieved and to look at their work in far greater bulk than had been possible in the eighties and nineties. A taste of that achievement could be had at the exhibitions of the International Society, calamitously unselective though they were; but it was not until the French dealer Durand-Ruel organized a comprehensive show from Boudin to Cézanne in 1905 that a concerted impact was made. The closed book of European painting began steadily to open – Cézanne was again seen in London in 1906 and in the company of Matisse and Gauguin in 1908. But if we look for any reflection of these painters on their British contemporaries, let alone anything similarly original, we shall search in vain. There were, however, some notable independent artists such as Ethel Walker (PLATE 86), William Nicholson (PLATE 12) and William Rothenstein, and the young Slade-trained artists, all of whom were eventually caught in the English trap of professional portrait painting – Augustus John (PLATE 15), Ambrose McEvoy (PLATE 6) and William Orpen. John, the most hotly debated and revered painter of the decade, was indisputably the most talented of the three, a draughtsman of vigour and sensitivity. For a short period it seemed he would lead England back into the mainstream of European painting and a show of his landscape and figure studies in 1910 outraged most of the press because of his formal simplicity and racy handling of pure colour. Some of those pictures can now be seen as his most original contribution to the art of his time, though it would be churlish to deny the breadth and percipience of some of his later portraits, particularly those of *Lady Ottoline Morrell, Dylan Thomas* and *Matthew Smith*. While John's development was hampered by an imperfect understanding of his gifts, William Nicholson erred on the side of a too modest appraisal of his. Primarily a painter of small-scale still-lifes, he painted some fine early portraits and a lyrical series of Sussex landscapes (about 1908–14), which look increasingly substantial. Towards the end of his life his colour lightened in a series of Spanish landscapes and simple still-lifes (PLATE 90) – succinct and elegant works in which his characteristic perfection of tone is at its most eloquent. He is one of the most satisfying *petits-maîtres* in the history of British painting and was not without influence on his son, Ben Nicholson. McEvoy and Orpen squandered their talents, particularly the former, though they never reached the glittering degradation of de Laszlo and the later Lavery. Portrait painting was still a lucrative career, but the more memorable images, such as Steer's *Mrs Raynes* (Tate Gallery) or Nicholson's *Walter Greaves* (PLATE 12), were produced by the non-professionals.

One of the loveliest and quietest talents to emerge at this time was that of Gwen John, with her compelling studies of single female figures (PLATES 22 and 23). Self-knowledge and an absolute trust in her chosen medium make so much that was contemporary seem merely superficial. The portrait of her future sister-in-law, Dorelia John, is an outstanding early work. Later she became less dependent on Whistlerian tonalities, simplifying her design and colour with rigorous application. During her lifetime, her work was known only to a few painters and collectors and she rarely visited England from her reclusive home in Paris.

Most of the artists already mentioned studied at some time in Paris, usually at the Académie Julian. William Rothenstein and Charles Conder (PLATE 8) had been friends of Toulouse-Lautrec; Rothenstein was well acquainted with Monet and Degas. The example of Gauguin and others in Brittany caught the imagination of several younger painters. Eric Forbes-Robertson was there in the early nineties absorbing the decorative mysticism of the Pont-Aven school. R. A. Bevan stayed there during the same period, and the remarkable colourist Roderic O'Conor first painted there in 1892, the year of his *Still-life with bottles* (PLATE 27). Balancing the scales, Lucien Pissarro, the son of the Impressionist, was already living and working in England (PLATE 18). But the great link between Paris and London was Walter Sickert. Though by no means a supporter of the latest French movements, his knowledge and experience of painting abroad and his own highly professional practice were invaluable to the younger men who began to gather about him after 1905, the year in which he returned to London from Venice. It is with this date more than any other that we can usefully mark the beginnings of the modern movement in England. We soon find a considerable group under Sickert's leadership, instead of a handful of isolated explorers making raids across the Channel but returning exhausted to the cosy armchairs of the New English Art Club.

# 2 Camden Town

In 1905 Sickert was forty-five years old. As well as frequently exhibiting in Paris, he had established a school there and knew Degas as well as painters younger than himself, such as Bonnard, Vuillard and Signac. He was an energetic cosmopolitan with a wide, if capricious, knowledge of past European art; as a dedicated technician, he enjoyed imparting his knowledge through teaching. With his considerable social gifts and pungent literary style, it was natural that the livelier young painters in England should look to him for leadership. They were drawn together not only through their admiration for Sickert's art but by a common attitude of disgust with the Royal Academy and exasperation with the New English Art Club. Most of them were uninterested in imaginative composition and felt a need to depict the facts of daily life untainted by the picturesque or commercial bias which they deplored in the work of many contemporaries. Sickert's subjects were more to their taste – theatre and music-hall, interiors with figures, the urban landscape, women dressing, day to day occupations, pages 'torn from the book of life'.

Soon after Sickert's return to London, such painters as Spencer Gore (PLATES 10, 19 and 31) and Harold Gilman (PLATES 21 and 34) abandoned the subdued tonal painting which was a legacy of Whistler and the Slade School. Gore admired the pure colour and broken touch of Pissarro and Signac and adapted their methods in landscapes culminating in the lovely Hertfordshire series of 1908 and 1909. He became a close friend of Sickert after their first meeting in Dieppe in 1904, and the older painter acknowledged the influence of Gore on his own practice, as can be

seen in the lighter palette and drier application of paint in works of 1906 and after. Gilman developed more cautiously at first, though he was to go further than any of the others in his exploration of pure, bright colour. Other visitors who eventually came to Sickert's Fitzroy Street studio included Walter Bayes (PLATE 54), Malcolm Drummond (PLATE 29) and Robert Bevan. All were enthusiastic supporters of a new exhibiting society, the Allied Artists' Association, formed in 1908 at the suggestion of the critic Frank Rutter, which was run on similar lines to the Paris Salon des Indépendants. No picture was refused, the hanging committee was chosen alphabetically, and work by foreign artists was accepted. In 1910 Charles Ginner arrived in London from France with considerable knowledge of Van Gogh and Gauguin; with Gilman and Gore, he formed the nucleus of the Camden Town Group, founded in the following year and taking its name from that drab and dingy area of North London where many of the artists lived and worked. Augustus John and two younger painters, both trained in Paris, Henry Lamb (PLATE 14) and Duncan Grant (PLATE 36), joined in the group's exhibitions, though they contributed nothing to the Camden Town style. Further members included Wyndham Lewis, who was attracted by the whiff of revolt rather than by any common aesthetic, and James Dickson Innes, who painted brilliantly coloured landscapes in Wales and the South of France (PLATE 30) before tuberculosis cut short further achievement.

Just as these artists, some of whom were well into their thirties, were beginning to reap the benefits of closer European contact, they were pitched into further reappraisal by an exhibition 'Manet and the Post-Impressionists' held from 8 November 1910 to 15 January 1911. It is generally acknowledged as one of the most formative and galvanizing art exhibitions ever mounted in Britain. The organizer was Roger Fry, a noted connoisseur, writer on Italian art and exhibitor of rather timid work at the New English Art Club. His reputation was thrown to the winds when he gathered together twenty-one Cézannes, thirty-seven Gauguins, twenty Van Goghs and works by Picasso, Matisse, Derain and others. The exhibition was widely abused, from the Olympian heights of the Royal Academy to the gutter press. The old guard dismissed the pictures as the work of lunatics and charlatans; the public stamped and spluttered. For the future Camden Towners it was one of the most exciting events of their careers and a rapid transformation followed. Gilman soon burst into the thick primaries of Van Gogh; Gore took much from Cézanne and also something from Matisse (PLATE 31); for others Gauguin was the hero of the hour. Inevitably, the excitement produced shoddy, unassimilated imitations; but for painters like Gore, Gilman and Bevan, though cognizant of some Post-Impressionist work already, the magnitude of the exhibition acted as a spur towards some of their best work. For men like Lamb and his Slade contemporaries, the years immediately following the exhibition were their most fruitful.

When a second Post-Impressionist exhibition was organized in late 1912, with Matisse showing the greatest number of works, an English section was selected by the critic Clive Bell. Our response to such pictures now should in no way blind us to

the moving sincerity of these English painters attempting to come to grips with new ideas of expression in a country where the romantic, descriptive tradition was still prevalent, where adventurous patrons were scarce and where there were no such organizations as the Arts Council or museums with enlightened purchasing programmes. The diseased arm of British painting had been given a life-saving injection through the two Post-Impressionist exhibitions. They separated more sharply than before those who were prepared to forge ahead in a serious commitment to the *avant-garde* and those who refused to come to terms with it. Such an artist as Augustus John gradually took his place with the latter; young painters like Edward Wadsworth and William Roberts, both of whom had shown at the 1912 exhibition, were emphatically of the former. Sickert found himself in an ambiguous position. He held Cézanne in grudging respect and heartily disliked Matisse and Picasso. The espousal of the new movement by Gilman caused a cooling of their friendship, and, though he was greatly attached to Gore, it seems unlikely that Sickert would have approved of the direction of Gore's work in 1912 and 1913, with its violent oranges, glowing purples and emphatic geometry. Although held in high regard by many of the young converts, Sickert was left in an increasingly isolated position in terms of influence, until late in his life when the Euston Road School painters (see pp. 29 ff.) drew inspiration from his earlier work. In a period of upheaval, his painting survived through the seriousness of his purpose and the vitality of a personal vision nurtured in the European tradition. And some of his late paintings based on photographs, with their pale, scrubbed surfaces and sense of concentrated detachment (PLATE 82), have a real modernity about them when viewed in relation to certain developments in the art of the 1950s and 1960s.

While the brilliant colour often employed by the Camden Town painters was itself novel to most spectators, the subject-matter proved more so. Features of the urban scene figure prominently – underground stations, garden suburbs and aerodromes, public hoardings, factories (inside and out), shabby eating houses and coffee shops, music-halls, the fronts and backs of North London streets. And the rooms of some of those houses contained further surprises for a public used to the well-upholstered dames of Leighton and Alma-Tadema and the dreamy androgynes of Burne-Jones. Here were dusty bedrooms, on whose tousled beds lay nudes in shameless undisguise, grinning behind the bars of iron bedsteads. Sickert's Venetian and Dieppe nudes before 1905 were painted with uncommon frankness; when, in 1908–9, his Camden Town bedrooms often contained a man and a woman, disapprobation swiftly followed, even from such an old ally as Frederick Brown, who wrote to curtail their friendship. Although none of the Camden Town nucleus went as far as Sickert, they did extend the possibilities of subject-matter, through their attachment to life beyond the Edwardian drawing-room on the one hand and, on the other, away from the picturesque depiction of poverty common at the time. An adherence to obviously 'contemporary' subject-matter was not new in British art; and it was to become central to some members of the Euston Road School in the late 1930s and again to the Kitchen Sink artists in the 1950s. But the Camden Town style is distinguished by its unswerving objectivity; nothing is

faked, nothing outwardly contrived; an unhesitant application of paint and vigorous drawing in the service of truth contribute to that quality Sickert ascribed to Gore – of being able 'to take a flint and wring out attar of roses'.

# 3 The new generation and the First War

The creative ferment before the coming of war in 1914 produced work of unparalleled modernity in London. An insular culture was further scorched by European visitors and their activities. The Russian Ballet made annual appearances, performing *Le Sacre du Printemps* and *Jeux* in July 1913. The Italian Futurists regarded London as dynamic quarry, first exhibiting there in 1912. Marinetti and Severini made visits in the following year and Brancusi and Kandinsky exhibited works as radical as anything in Europe. Ezra Pound, T. S. Eliot and Jacob Epstein came from America and settled in London, as did Gaudier-Brzeska, from France. There was a show of Picasso in 1912 at the Stafford Gallery.

Though not unaffected by the activities around them, some young English painters, such as Paul Nash and Stanley Spencer, stuck resolutely to their own vision. Spencer Gore, before his untimely death in 1914, was re-examining the implications of Cézanne; but for reflections of a more extreme aesthetic we must turn to Wyndham Lewis, Duncan Grant and David Bomberg.

Lewis's intellectual restlessness (for he was writer and painter) provoked a curiosity about Europe which kept him abroad between 1902 and 1908 – in Madrid with Gore (a fellow Slade student), in Munich, Holland and in Paris, where he came to know the work of Matisse and Picasso. By 1909, Cubism had already determined aspects of his style and he was a fish out of water in the Camden Town Group of 1911. In the following year his increasingly hard, schematic drawings and ambitious restatement of certain continental concerns attracted the attention of the *avant-garde* critics such as T. E. Hulme and Roger Fry. In July that year his immense *Kermesse* (now lost) was a talking-point of the Allied Artists' Association. Clive Bell recommended its 'pure, formal expression' and asked Lewis to contribute to the 'Second Post-Impressionist Exhibition'. Whereas several of Lewis's contemporaries were engaged with the implications of Post-Impressionist and fauvist colour, Lewis's experience of Cubism demanded a total conceptual overhaul. Not primarily interesting as a colourist, his drawing became increasingly free of descriptive accidentals. The impact of this work, combined with his own anarchistic and exigent personality, naturally attracted rebellious juniors. Before a definite group emerged under his leadership, however, Lewis had become involved with Roger Fry (PLATE 17) and several other artists who represented a more lyrical and sensuous interpretation of recent foreign art.

After a relatively long apprenticeship, Duncan Grant had swiftly assimilated Gauguin and Cézanne and in 1911 seemed poised on the brink of several conventions, none of which quite suited a temperament divided between the flat

decorative possibilities of Matisse and the excavatory realism that had made him copy Chardin in 1906 and which characterizes such a work as *Portrait of James Strachey* (1909, Tate Gallery). His stylistic diversity over the following years, partly accounted for by that division, was also a result of a desire to focus his gifts more acutely. Out of much that was obviously derivative, a personal conception evolved, determined by a mercurial sense of design and an uninhibited use of colour and materials. Collage appeared in his work in 1912 and *papiers collés*, fabrics, pieces of wood, were frequently used until 1916. Collage also made an appearance in the work of Roger Fry and Vanessa Bell. With this stress on the formal properties of a painting and Grant's experience as a designer of non-representational textiles for the Omega Workshops, non-objective pictures were almost inevitable. His most surprising venture is his *Abstract kinetic collage painting with sound* (1914, Tate Gallery), which, with its combination of lights, music and progressively viewed collaged scroll (over 14 feet long), is a pioneering work in European abstraction.

The essentially lyrical impulse behind this work informed the rest of Grant's activities at this period and the best of his later, more representational work. The painting of Vanessa Bell, as radical as Grant in her *Abstract* (about 1914, Tate Gallery), is notable for its simplicity of design, a grave formal poetry and perfection of tone. In later decades, an unambitious realism intermittently infected the work of both artists.

Less spontaneous and calligraphic than Grant and Bell in temperament, Roger Fry produced a notable series of landscapes at this period, mainly French in subject and informed by that quality of classic resolution which he extolled in Corot and Cézanne. His later work, often uneven, shows an increasingly subtle appreciation of light while maintaining a firm conceptual impulse.

Although Matthew Smith was of the same generation as many of those painters coming to prominence in the pre-war years, his beginnings were more hesitant and it was not until the twenties that he evolved his mature style. After the angular construction and acid colour of his Fitzroy Street nudes (PLATE 42) and the ominous Cornish landscapes of 1920, Smith developed the lush, curvaceous handling of paint and hot, though often subdued colour, which characterized his work thereafter. Nudes, still-lifes and Provençal landscapes were his subjects, and though often regarded as one of the purest, most painterly of modern British artists, he did in fact inhabit a territory of considerable psychological potency, nearer to Ingres' *Bain Turc* than the Fauvists, among whom he is often counted. His seemingly fluid, indulgent handling orders a torrent of formal implications inseparable from atmosphere. In his most successful work they are in perfect accord. An approach which relied so much on chance and personal calligraphy left Smith a somewhat isolated figure in England (though there are affinities with Grant and the early Hitchens, for example); but the assured sweep of such a picture as *Couleur de rose* (PLATE 67) puts him among the best British painters.

In 1913, the ubiquitous Lewis was intensely interested in the possibilities of non-representational expression and was attracted to the work of two ex-Slade students, David Bomberg, from the poor Jewish East End of London, and William Roberts.

The former's *The Vision of Ezekiel* (1912, Tate Gallery) and the latter's *The Return of Ulysses* (1913, Nottingham Castle Museum) both rely on the paring down of Cubism, the banishment of details and on a surface dynamic not wholly attributable to the dramatic subjects typical of Slade School competitions. Both pictures show a refreshingly thoughtful approach to the structuring of a painting in contrast to much mindless Post-Impressionism carried out by far less youthful artists.

Most of the painters mentioned in this section either worked at or were in some way connected with the Omega Workshops, opened by Roger Fry in 1913 for the production of furniture, fabrics, pottery and murals executed under the liberating impetus of Fauvism and Cubism. Fry, Grant and Vanessa Bell were co-directors; from the start they were joined in the enterprise by their friend Frederick Etchells and by Wyndham Lewis, and further recruits included Edward Wadsworth and Cuthbert Hamilton (1884–1959). The initial months of this collaborative venture produced work of a surprising homogeneity in a bold non-figurative idiom. In the autumn of 1913, however, Lewis quarrelled with Fry and left the Omega taking with him Etchells, Hamilton and Wadsworth and together they rapidly established the Rebel Art Centre. The details of this schism and the personalities involved are too complicated to discuss in a survey of this kind, but what had looked, for a short time, to be an agreement amongst the *avant-garde* became a sharp division. And partially from that division emerged Vorticism, the most vital contribution to modernism made by the English.

As a forecast of the movement we can turn to the words of T. E. Hulme, who in January, 1914, declared that the move towards abstraction would 'culminate, not so much in the simple geometrical forms found in archaic art, but in the more complicated ones associated in our minds with the idea of machinery'.

Vorticism had an essentially humanist impetus; it was anti-theoretical, individualist and empirical. Lewis deplored the 'tasteful passivity' of Cubism and was drawn more to the Italian Futurists' conception of a vital, contemporary art with its emphasis on speed and mechanization. But Lewis and his fellow artists rejected the romantic-descriptive elements in Futurism and moved towards a pictorial programme that included clear forms and colours, independent of representation and reflective of the energy that characterized modern life. And, unlike the Futurists, they did not scorn the past but were deeply conscious of the spiritual impulses behind primitive art, the angular schematized forms of certain pre-Renaissance movements. To quote T.E. Hulme again: 'Pure geometrical regularity gives a certain pleasure to men troubled by the obscurity of outside appearance. The geometrical line is something absolutely distinct from the messiness, the confusion, and the accidental details of existing things.'

In June 1914 the Futurist Marinetti collaborated with C. R. W. Nevinson on a manifesto published in the *Observer* entitled 'Vital English Art. Futurist Manifesto'. They called on the English public to support the Futurist artists and their associates – Atkinson, Bomberg, Jacob Epstein, Etchells, Hamilton, Nevinson, Roberts, Wadsworth, Lewis. And below his signature Nevinson gave the address of the Rebel Art Centre. There was an immediate uproar; Lewis and the others dis-

claimed any allegiance to Marinetti, and Bomberg, with characteristic independence, claimed no association with the Centre. A month later the first number of *Blast* was issued (July 2), masterminded by Lewis, in which the Vorticists first publicly proclaimed themselves as a united group. The large, boldly printed magazine, with its harsh typography, black and white illustrations and explosive contents, was something unique in British artistic life, the complacency and timidity of which is castigated from page to page. Many of the drawings and paintings reproduced in *Blast* are only now known from its pages, for so much Vorticist work has been subsequently lost or destroyed.

The degree of abstraction attained by the Vorticists differs from artist to artist. William Roberts, for example, retains representational features and a general figurative impulse much more overtly than does Lewis in his *Red duet* (PLATE 55), or Lawrence Atkinson in his *Abstract composition* (PLATE 47). The degrees of concentrated energy vary. Some of the small woodcuts reproduced in *Blast* – notably those of Roberts, Wadsworth, Helen Saunders (1885–1963) and Ezra Pound's wife Dorothy Shakespear (1886–1973) – are economical, thrusting examples of the Vorticist aesthetic. Lewis himself was erratic, sometimes combining severe abstract 'architecture' with representational elements, as in *The crowd* (PLATE 49). Its disturbing force arises from a taut contrast between the over-all, heavy geometry and 'the remnants of humanity' which it frames. A more programmatic development of non-figurative painting can be found in David Bomberg's work just before the war, in his *The mud bath* and *In the hold* (PLATES 46 and 59). His single-minded and rigorous examination of pictorial structure and rejection of 'everything in painting that is not Pure Form' constitute a high watermark in modern British art.

The outbreak of war a few weeks after the first issue of *Blast* diminished the impact of the Vorticist movement as well as interrupting most aspects of the *avant-garde*. A second *Blast* appeared in June 1915, when the first and only Vorticist exhibition was held in London. That second issue contained a statement on primitive art by the young sculptor Henri Gaudier-Brzeska as well as his obituary. T. E. Hulme was also killed. Most of the artists were called up and, in the second half of the war, most of them were executing drawings and paintings of the fighting and of military life. The exigencies of commissioned work (through the Ministry of Information and the Canadian War Memorial scheme) forced stylistic compromises on the Vorticists and their associates. Though sometimes uneasy and wooden, their often large compositions, dense with figures, gain in power from the artists' earlier concern with surface dynamics. Nevinson proved himself his father's son (see biography) with his brilliant reportage, becoming widely known after his war paintings were shown in 1916 at the Leicester Galleries (PLATE 51). Wadsworth's work in ship-camouflage suggested his memorable *Dazzle-ships in drydock at Liverpool* (PLATE 56), and Roberts attained that mastery of exaggerated and haunting gesture in *The first German gas attack at Ypres* which became his hallmark.

The outstanding war artist was Paul Nash, whose pre-war landscapes give little intimation of the power to come. The war toughened his concerns, sharpened his vocabulary and introduced a willingness to manipulate the components of a land-

scape, which, after some stumbling years in the twenties, made him one of the most resourceful landscape artists of the century. The horrors of the front are all there in Nevinson's work, but they are 'flung at you in cheapening haste', only headlines against Nash's deeply felt depictions of a ravaged land (PLATE 53).

One of the few places where painters could show their work during the war was at the large exhibitions of the London Group, held twice a year at the Goupil Gallery (and, after 1917, at Heal's Mansard Gallery). The London Group was originally formed at the end of 1913 and mainly consisted of the Camden Town painters and those artists associated with Wyndham Lewis; early members also include the Nash brothers, Jacob Kramer (1892–1962) and Mark Gertler. Gertler, from the Jewish East End of London, had been a star pupil at the Slade School. His early paintings are intensely observed, often sombre studies of Jewish life – *Jews arguing, Rabbi and grandchild* (PLATE 24) and *The Jewish family* (Tate Gallery) – in which the drawing often has an acutely northern expressiveness, as one finds it in Rogier van der Weyden and Hugo van der Goes. In 1916 Gertler painted *The merry-go-round* (PLATE 50), a civilian war painting, as it were, an image of senselessness carried out with immense formal vitality. His work after the war leans more heavily on Cézanne and Renoir in a distinguished series of still-lifes and portraits of women and girls. Tightly-knit surface organization is often allied to hot, almost fluorescent colour, as in *Supper* (PLATE 84).

The particular intensity of Gertler's studies of the isolated Jewish community finds a parallel in the vision of his Slade contemporary Stanley Spencer – though from an entirely different world. For most of his life Spencer lived and worked in the village of Cookham-on-Thames, the reality and childhood memories of which were a fundamental source for his art. Sometimes he depicted its geography and inhabitants with an aggressive accuracy; at others he used it as the natural dwelling place of Biblical events and visions (PLATE 61). So intense was his feeling for these surroundings that in his best work the juxtaposition of some miraculous occurrence with the cottages' red brick and village green of the twentieth century brings about a penetrating transformation.

It no longer matters that his visions are often claustrophobically private, even neurotic; a radiancy, pure and naïve, goes beyond illustrational concerns, particularly in his earliest works such as *Zacharias and Elizabeth* (PLATE 25), *The Nativity* and *Joachim among the shepherds*. Into his newly constituted scenes from the Old Testament and from the life of Christ, he frequently introduces local villagers, his family and himself, the best-known instance of the latter being his nude self-portrait in the Cookham *Resurrection* (Tate Gallery). This high degree of spiritual self-involvement is paralleled by Spencer's exploration of 'the joys of change and sexual experience'. He was 'convinced of their ultimate union', as he wrote, and much of his work in the thirties was concentrated on such a fusion. It led him towards the creation of some of the most sexually frank paintings of our time (e.g., *Double nude portrait*, 1936, Tate Gallery).

Spencer's style changed comparatively little during his working life. His early work owes much to his Slade School training in its emphasis on drawing and

definition of form by chiaroscuro. His 1911 *John Donne arriving in Heaven* has marked similarities with near-contemporary works by Gertler, Bomberg and Roberts, particularly the latter's *The return of Ulysses* with its raised viewpoint and simplified figures. The influence of early Italians like Giotto and Fra Angelico must be placed beside his interest in Gauguin and Cézanne. Certainly the decorative grouping and hieratic gestures of *The apple gatherers* (1912–13) are inconceivable without Gauguin. Spencer remained faithful to these early influences though they became less pronounced after the First War, his experiences in which found expression in his murals for the Oratory of All Souls, Burghclere. This astonishing series achieves its strength through Spencer's ability to invest the mundane activities of military life with a spiritual significance and without ever compromising his peculiar personal vision. As the work of a sophisticated artist designing on a large scale, the chapel is a comparatively rare achievement in England.

# 4 Traditionalism and abstraction

It has often been stated that the First World War effectively wrung the neck of the modern movement in England. Lewis's attempt to recapture and continue pre-war excitements resulted in Group X, which managed only one exhibition (in 1920). Thereafter he was an essentially solo performer. The critical and intellectual atmosphere was impoverished: Hulme was dead; Fry was increasingly occupied with his own painting, though his collection of essays *Vision and Design* (1920) is a classic of British art criticism; writers like P. G. Konody and Frank Rutter gradually took up a reactionary position; Clive Bell, who had played a not unimportant part as critic and apologist in the 1910 to 1914 period, denigrated most British painters (save his own small circle) in favour of exclusively Parisian developments. In some senses he was right, for the twenties was a quiet decade of consolidation by the older generation and the new talents to emerge in its earlier years were less weighty. But the pictures which filled the annual London Group shows, while often anaemic translations of Cézanne – Provençal hills and olive groves stretching out to the crack of doom – did maintain certain painterly standards and a decent professionalism. It was against such a background that the names of the thirties emerged – Ivon Hitchens, Ben Nicholson, John Piper and Graham Sutherland.

Few painters of the earlier generation seemed to have that strength of intellectual purpose which would have sustained them through the passing of their youthful spontaneity and lyricism. Changes in style seem to be more the results of a desperate search for a solution rather than an affirmative progression. Paul Nash, one of the few British painters who remained intellectually alive in the inter-war years, was in danger of losing his essential inspiration – that mystical apprehension of 'the spirit of place'. The massive construction of Gertler's still-lifes hardly compensates for the loss of the intensity of his pre-war Jewish subjects. Grant aimed for solidity of form at the expense of his lyrical sense of colour.

The British were not alone in this often sober return to order, and such French painters as Derain, Marchand and Segonzac, all greatly admired in England, were part of a general movement away from the obvious audacities and pictorial questionings of pre-war years. The neo-classical phase of Picasso was congenial to some British painters because it suited their inclination towards retrospection and the 're-ordering of old resources'. Very few, however, remained long in this essentially Mediterranean style and soon found their way to a more indigenous inspiration. (A similar parallel line of development can be traced in contempory British music, though the time-lag between native production and continental example was even more glaring than in painting.) Christopher Wood, with a brilliant superficiality, skimmed the Parisian scene until his fruitful meeting with Ben Nicholson and their discovery of the Cornish primitive Alfred Wallis; whereupon Wood's last works became more personally poetic and sophisticated (PLATE 97).

Wood and Nicholson were both associated with the Seven and Five Society, the major association of progressive painters in the later years of the decade and early thirties. Originally a group of seven painters and five sculptors, founded in 1919 and holding its first exhibition a year later, the society had twenty members by 1926. Ivon Hitchens was a founder member (the only one to remain an exhibitor up to the society's demise in 1935). In 1924, Ben Nicholson was elected and became chairman in 1926. Other early members included Jessica Dismorr (PLATE 95), Winifred Nicholson (PLATE 91), and two artists influenced by Futurism and working along decorative semi-abstract principles: Claude Flight and Sidney Hunt. Christopher Wood became a member in 1926, David Jones in 1928, Frances Hodgkins in the following year, when two paintings by Alfred Wallis (PLATE 151) were included in the society's exhibition. Some of the original members – fauvist-inclined landscape painters and figurative sculptors found also at the Royal Academy – were swiftly excluded. The sculptors Barbara Hepworth and Henry Moore were elected in 1932, and in 1934 John Piper and Cecil Stephenson were added to the society, both already working in a non-figurative idiom (i.e., Piper's *Construction*, 1934, PLATE 117). The society's development falls into three phases, which, roughly characterized, begin with the initial four years of a generally tepid commitment to modernism, the ascendancy of Ben Nicholson with the 1928 and 1929 exhibitions representing 'a high level in English figurative painting', and the period of about 1930–5, in which the society became a platform for British abstraction of a character unusually austere and assured.

The middle phase can be seen most profitably as representative of a Seven and Five style. Still-life and landscape were the predominant motifs; handling and structural patterning were close to the fauvist work of Matisse of 1905 and 1906, but with less intensity of colour (save in Hitchens). A direct, spontaneous application of paint, free spatial interpretation and an emphatic use of the physical properties of a painting's support are characteristics found individually and together. They are to be seen in varying degrees in Dismorr and Jones, employed for more psychological and spiritual ends (e.g., in their portraits, PLATES 72 and 95). Frances Hodgkins combined landscape and still-life objects (PLATE 96) in an overtly

romantic, dashing way, eventually finding landscape the ideal vehicle for her investigation of colour as light and for calligraphic composition. Her last works in the 1940s include some of the most poetic inventions of the English landscape tradition. Other painters associated with rather than integral to the society were Percy Jowett, Cedric Morris (born 1889) and the South African Edward Wolfe, who early on had been stimulated by his fellow artists at the Omega Workshops (PLATE 80).

The most substantial, innovatory and intellectually alert painter to emerge from the Seven and Five was Ben Nicholson, one of the handful of twentieth-century British artists to achieve an international reputation. The non-figurative work of the Vorticist and Bloomsbury painters remained virtually unknown and invisible after the war; there was no recent tradition of such work in England as there was abroad; any dialogue with Paris was still carried on with the 'old masters' of the modern movement; in 1921 the Tate Gallery had refused a gift of a Cézanne; in the same year two large pictures by Mondrian went unnoticed at a show of modern Dutch art at the Whitechapel Gallery. Throughout Nicholson's career from the mid-twenties, he has worked in figurative and non-figurative styles, his starting-point being still-life and landscape, the two conventions in which his father, William Nicholson, worked most successfully. The Italian primitives (for their architectural settings and landscape backgrounds) and Cubist Picasso made a strong impression in his formative years. With Wood he met Alfred Wallis in St Ives, Cornwall, in 1928; Wallis's work confirmed Nicholson's tendency towards simplification, non-perspectival space and a very physical exploration of the shape and texture of the support on which he was painting. This led him towards his first painted reliefs (1933–4), in which shapes are carved into or out of the surface, marks akin to the geometry of early magic. On more than one occasion Nicholson has emphasized the similarity of painting and the 'religious experience'. His tough and refined examination of surface in the reliefs which he has continued to make can be compared to the textural command of Barbara Hepworth, to whom Nicholson was married. The tonal subtleties achieved by the fall of light on these white reliefs (essential to their being) enabled Nicholson to develop the rectilinear paintings prominent in his work from the mid-thirties. They are characterized by a restricted number of elements and colour range, by less immediate 'atmosphere' than the reliefs (so often close to the experience of landscape) and by harmonious formal structures. Since that time Nicholson has refined these discoveries, introducing non-figurative passages into landscape and developing his ever-present, sensuous apprehension of light, particularly of a Mediterranean-architectural inspiration.

Though Nicholson's work in the thirties never found much of a public, he was not alone; several British painters and sculptors, critics and architects were in close sympathy with him. Groups were formed, articles written and magazines published. At first English artists naturally turned to Paris: Hepworth, Nicholson and Moore were frequent visitors, coming to know Mondrian, Gabo, Hélion, Arp and other artists in the Association Abstraction-Création founded in 1931. Edward

Wadsworth was a member in 1932, Nicholson and Moore from 1933; annual *cahiers* were issued and multi-national exhibitions held in Paris by those artists specifically committed to non-figurative and constructivist art. Contacts and friendships formed through Abstraction-Création led to several European artists coming to England in the thirties – Naum Gabo in 1935, and refugees from Hitler such as Mondrian, Moholy-Nagy and Kokoschka. As Gabo testified, the meetings, discussions and exhibitions which then occurred were of resounding importance and for the first time London was a truly international creative centre, until the outbreak of war in 1939 and the dispersal of the artists to the country and America. For a more comprehensive view of this situation, we must look at the concurrent influence of Surrealism, and a way of seeing which was perhaps more conducive than was constructivism to the English temperament.

# 5 English Surrealism

A nation which has produced two such superrealists as William Blake and Lewis Carroll is to the manner born. Because our art and literature is the most romantic in the world, it is likely to become the most superrealistic (Herbert Read in his catalogue introduction to the International Surrealist Exhibition, London, 1936).

Much of the painting discussed so far has taken its initial lead from France. Although Surrealism, too, was an international, Paris-based movement, painters in previous centuries in England had revealed certain surrealist tendencies. That detailed observation of visual facts, a characteristic strain in English painting, produced works of an hallucinatory realism. The death's-head moth in the hand of Holman Hunt's *Hireling shepherd* and the compelling silence of Dyce's *Pegwell Bay* come to mind. Artists as various as Blake, Fuseli, Martin and Dadd evoke a whole world of visions and dreams, of the subconscious and the grotesque. These two broad characteristics of English art emerged, sometimes together, sometimes separately, in the whole group of Surrealists which flourished in the late twenties and throughout the thirties. None of the group, however, were full-time, committed Surrealists as were men abroad like André Breton, Max Ernst or Salvador Dali. English Surrealism was generally concerned with the unavoidable strangeness of the *objet trouvé*, with the juxtaposition of disparate elements to create poetic, disturbing or humorous images and the introduction of unusual or unlikely objects into realistic settings, creating ambiguity in both. The forging of new forms in the manner of Miró or Arp was less congenial to the English sensibility though they feature in work by Wadsworth, Julian Trevelyan and Conroy Maddox.

Paul Nash made the most personal and substantial contribution to the movement and some of his pre-1914 painting already established his feeling for the

opposition of order and disturbance, the interpenetration of dream and reality, of images in 'spiritual' association. In 1934 Nash wrote:

> Last summer, I walked in a field near Avebury where two rough monoliths stand up, sixteen feet high, miraculously patterned with black and orange lichen, remnants of the avenue of stones which led to the Great Circle. A mile away, a green pyramid casts a gigantic shadow. In the hedge, at hand, the white trumpet of a convolvulus turns from its spiral stem, following the sun. In my art I would solve such an equation (*Unit One*, 1934).

For Nash the plastic conception of such an association was of equal importance to the spiritual and poetic content. But whereas Nash's formal sensibility was exceptionally mature, the power of much that was potent and valid in the content of his fellow Surrealists was restricted by formal conventionality. As had happened after the impact of Post-Impressionism, the surrealist invasion was followed by pale imitations and second-hand, ill-digested ideas. But there were some individual voices – the sinister gracefulness of John Banting (PLATE 111); the deathly quiet pervading the landscapes of Tristram Hillier (PLATE 106); the ingratiating and macabre poetry of Ithell Colquhoun (born 1906), and the hypnotic dreamworld of John Armstrong (PLATE 115), with his fresh interpretation of classical imagery – statues, busts and broken columns – his use of ancient myths and the *commedia dell'arte*. The grotesque and fantastic tradition in northern Europe flowered magnificently in the work of Edward Burra. 'Everything looks menacing;' he once said, 'I'm always expecting something calamitous to happen.' Burra's jaunty and ominous collages of the late twenties (PLATE 112) find a parallel in their inventive imagery and contemporaneity with those of Paolozzi in the forties. With Roberts and Spencer, he is a master of expressive gesture, whether depicting the sailors and tarts of Marseilles bars or the bizarre gaieties of Harlem; he can be as vicious as Grosz, as erotic as Beardsley. From his visits to the Continent, his intense observations were translated into works prophetic of the tragedy of the Spanish Civil War and the Second World War, works becoming grander in design and more gravely compassionate. His prodigious technical command of his chosen medium of watercolour and gouache can be seen in *Soldiers at Rye* (PLATE 109).

The only group to which Burra belonged was Unit One, organized by his friend Paul Nash, who announced its formation in June 1933 in *The Times* as standing for 'the expression of a truly contemporary spirit, for that which is recognized as peculiarly of today.' The artists of Unit One worked in surrealist and non-figurative styles and included Wadsworth and Nicholson, Nash himself, Hillier, Burra, Armstrong and John Selby Bigge (born 1892); two architects and the sculptors Hepworth and Moore were also members. Herbert Read, their spokesman along with Nash, edited *Unit One*, a symposium published in 1934. The group was short-lived (there was an exhibition at the progressive Mayor Gallery in April 1934 followed by a provincial tour), but the two tendencies in painting which it represented culminated in two major London exhibitions. The first, organized by Nicolete Gray and called 'Abstract and Concrete' was held at the Lefevre Gallery in

1936. It included work by Calder, Gabo, Miró, Mondrian and Kandinsky as well as the English artists. It was respectfully received; five works were sold. The second exhibition was held at the New Burlington Galleries from 11 June to 4 July 1936. This was the 'International Surrealist Exhibition' with fourteen countries represented, catalogue introductions by Read and Breton and over 400 exhibits. The show was a spectacular success as regards the number of visitors owing to the publicity it received – most of it bad. Ernst, Dali, Breton and Paul Eluard were among the visitors from abroad, Dali making an appearance to give a lecture 'in a diving suit, complete with helmet, leading two enormous borzois'. The intense summer sun coming through the gallery's glass roof nearly led to his suffocation. This first taste in England of surrealist activities brought about the formation of a surrealist group headed by such artists as Julian Trevelyan (PLATE 107), Roland Penrose (PLATE 103) and Merlyn Evans (PLATE 127). Exhibitions, readings, 'happenings' and political demonstrations were organized, but, with the outbreak of war, group activities dwindled. As Trevelyan has written: 'It became absurd to compose Surrealist confections when high explosives could do it so much better, and when German soldiers with Tommy-guns descended from the clouds dressed as nuns. Life had caught up with Surrealism' (*Indigo Days*, 1957). Although the large showing by the English contingent was varied and in some cases amateur, substantial work was shown by Burra, Nash, Eileen Agar (born 1904), Cecil Collins and Graham Sutherland. Artists associated with the movement generally include John Tunnard (PLATE 147) and Ceri Richards; the latter's poetic constructions (PLATE 116) making use of discarded objects and painted wood reliefs, metaphysically conceived are among the most inventive of the works of their kind produced in the thirties.

# 6 Other directions

The previous two sections dealt exclusively with those movements which can loosely be termed progressive, with painters intent on forging individual languages that show an awareness of European developments. The constant dialogue between such developments and native preoccupations produced much of the most vital painting between the wars. There were of course several painters almost wholly unaffected by the continental concerns of the period who produced outstanding work in their chosen genres. There was, for example, a revival in tempera painting headed by the Birmingham artist Joseph Southall (1861–1944). He founded the Tempera Society in 1901. Maxwell Armfield (PLATE 9) was his chief disciple and apologist for the movement, which attracted painters as diverse as Robert Anning Bell (1863–1933) and Charles Gere (1869–1957), Edward Wadsworth and John Armstrong (PLATE 115). In the 1940s Eliot Hodgkin (born 1905) used the medium for his rather tautly conceived and disturbing studies of vegetation and forest undergrowth.

Portrait painting continued to be lucrative and ubiquitous and during the slump of the early thirties several painters hitherto working on different lines benefited from portrait commissions, an example being William Roberts's large *Maynard and Lydia Keynes* (1935). Highly successful Royal Academicians noted for their portraits include Gerald Kelly (PLATE 76), James Gunn (1893–1964), Philip Connard (1875–1958) and Harold Knight (1874–1961). After an early and not uninteresting *plein-airiste* phase, Alfred Munnings (1878–1959) became the leading sporting artist of his time and president of the Royal Academy from 1944 to 1949. Less formal in approach and by no means restricted to portraiture, painters such as Thomas Lowinsky (1892–1947), Glyn Philpot (PLATE 37), Wyndham Lewis (PLATE 125) and the artists of the Euston Road School (see pp. 29 ff.) produced individual and often striking images.

Mural painting and the applied arts, though outside the compass of this introduction, apart from a brief mention of certain projects, attracted several painters who were not primarily decorative artists or designers. Notable schemes include the Borough Polytechnic murals of 1911 (by Fry, Etchells, Grant, Albert Rutherston and others; the panels now in the Tate Gallery); Stanley Spencer's Burghclere Chapel (see p. 22); Rex Whistler's *The pursuit of rare meats* (1926–7, Tate Gallery Restaurant); the panels for St Stephen's Hall, Westminster (1928, by Clausen, Arthur Sims, Monnington, and others); the Morley College murals, London, by Edward Bawden, Eric Ravilious and Charles Mahoney (1929, destroyed 1941); panels by John Armstrong, 1933, for Shell-Mex (a company distinguished by its patronage of painters and designers) and Edward Wadsworth's 1936 mural for the de la Warr Pavilion, Bexhill. The most prolific muralist of the time, however, was Sir Frank Brangwyn (PLATE 11), whose smouldering colour and imperial breadth of design won him an international reputation. His murals include ones for Skinners Hall, London (1904–9) and the Rockefeller Center, New York (1932). Like many other painters, Brangwyn was employed to design fabrics and pottery; his colleagues in this included Laura Knight, Ben Nicholson, Edward Bawden, Vanessa Bell, Duncan Grant and Graham Sutherland. Decoration was naturally not limited to public ventures (which were in any case deplorably unforthcoming). In private houses successful schemes were carried out by Paul Nash and John Armstrong; by Allan Walton (who commissioned several prominent artists to design for his textile firm); by John Banting and several by Grant and Bell in collaboration, one of their few public commissions being the decoration of Berwick Church, Sussex (1940–2). Other artists working for the Church included David Jones (Ditchling), Sutherland and Cecil Collins (Chichester), Moore (Northampton), Grant (Lincoln), and Piper, Sutherland and Sir Jacob Epstein at Coventry Cathedral. Mural decorations also featured in the work of E. McKnight Kauffer (PLATE 73), the most successful and original designer between the wars of posters, advertising, carpets and furniture. The leading painter to emerge in the later forties, Francis Bacon, had been a distinguished interior designer in the previous decade.

The political and social upheavals of the thirties – the Slump, strikes, the rise of Fascism and mass unemployment – deeply affected the poets who began to publish at the beginning of the decade. 'For anyone of human feeling', wrote a former member of the Euston Road School, 'it was impossible, in the Chamberlain era, to be an artist without being also some sort of a radical' (Colin MacInnes, catalogue preface to Thelma Hulbert retrospective, Whitechapel Art Gallery, 1962). A reflection of social life and change and an awareness of ominous events in Europe can be seen in the work of painters of several persuasions: London at work and play in William Roberts; Lowry's industrial landscapes (PLATE 105); Trevelyan's Potteries, Medley's London tenements; Sutherland's anxious premonitions of disaster, and the increasing menace of Burra's Spanish and Mexican subjects. In 1931, two exhibitions by the East London Group were sympathetically received, particularly by left-wing artists and writers. Harold Steggles was the best of this group of 'non-professional' painters who lived and worked in London's East End. Painters, too, were a valuable ingredient of Tom Harrisson's 'Mass Observation', a movement dedicated to observing and recording in anthropological detail the customs, habits, speech and surroundings of working-class communities. William Coldstream, Graham Bell, Julian Trevelyan and Humphrey Spender were among the artists involved, with Bolton, Lancashire, as a base. Northumberland miners comprised the Ashington Group, whose paintings of pit-life and colliery villages were widely exhibited by the Workers' Educational Association.

In the year before William Coldstream painted Bolton (1938), he was a co-founder of the Euston Road School with Claude Rogers and Victor Pasmore. This 'School of Drawing and Painting' had interesting origins. The aesthetic which it represented was in several ways contrary to the earlier development of some of the artists associated with it. This change in direction was brought about by socio-political considerations as much as by personal aesthetic needs, though of course the emphasis alters from artist to artist. In the early thirties Pasmore, Coldstream and Rogers were members of the London Artists' Association (founded in 1926), in which painters were guaranteed an income and exhibitions were held under the auspices of the association, which in effect acted as agents for the elected members. Initially the group was of a general Post-Impressionist tendency, with Duncan Grant, Vanessa Bell and Keith Baynes (1887–1977) at its core. Its success and flexibility are reflected in the diversity of artists elected in the first few years – Paul Nash, Ivon Hitchens, William Roberts, Edward Wolfe, Robert Medley and the three young painters who were to form the teaching nucleus of the Euston Road School. Sickert and Grant were the painters they particularly admired in England; Cézanne, Degas and Bonnard were among their continental masters.

In 1934 at the Zwemmer Gallery, London, several artists describing themselves as 'Objective Abstractionists' showed non-figurative paintings which relied not on formal constructivist principles but on paint and gesture in an exploration of

'sequences of colour'. Victor Pasmore was one of the exhibitors along with Geoffrey Tibble, Rodrigo Moynihan and Graham Bell. The painter William Townsend (1909–73) wrote in his journal in 1935: 'Both Tibble's and Moynihan's paintings had at this time a superficial resemblance to late storm-pieces by Turner. Their surfaces had become elaborate, melting, without definite centres of focus; the paint was thick, the tone uniformly very high in key.' This interesting and in some ways prophetic movement was short-lived and few pictures survive but its implications acted as a spur to the founding of the Euston Road School. William Coldstream, though not in fact an exhibitor at Zwemmer's, was sensitive to the movement's aims as well as its limitations: 'I became convinced that art ought to be directed to a wider public; whereas all ideas which I had learned to regard as *artistically* revolutionary ran in the opposite direction. It seemed to me important that the broken communications between the artist and the public should be built up again and that this most probably implied a movement towards realism.' Coldstream and Graham Bell temporarily abandoned painting. Left-wing activities, film making for the G.P.O. Film Unit (*Coal Face* was an Auden-Coldstream collaboration), journalism (Graham Bell wrote art criticism for the *New Statesman*) and 'Mass Observation' intervened but contributed to the 'social realist' accent of the Euston Road School programme. The school opened in Fitzroy Street (the venue of the Camden Town Group), later moving to two first floor studios at 316 Euston Road. Visiting teachers included Vanessa Bell and Duncan Grant, but the instruction mainly fell to Pasmore, Coldstream and Rogers aided by Graham Bell. Moynihan, Tibble, Townsend, Lawrence Gowing, Thelma Hulbert, the writer and painter Adrian Stokes, the poet Stephen Spender and Peter Lanyon were associated with the school in student and teaching activities. Certain attitudes towards art and methods of painting emerged as common to the Euston Road painters. They can be characterized as a fundamental belief in realism, an unrhetorical, objective appraisal of the subject, the emergence of poetic and sensuous qualities through sustained observation, an essential modesty of gesture in paint. The subjects were traditional (though they excluded 'imaginative' compositions) – portraits, still-lifes, urban and rural landscapes and figures in interiors. The marks made during the slow evolution of a painting were often frankly exposed in the texture of the final statement (as one sees, for example, in Sickert and Degas). This is particularly true of Coldstream, who over the years has developed a confident, highly elaborate method of representing the visual world without recourse to description. The work of Graham Bell (PLATE 119) was nearest to Coldstream in his portraits, with their largeness of design and unemphatic poetry. Rogers and Pasmore were initially more *intimiste*, but developed an objective ordering of their sensations which led Pasmore towards abstraction in the late forties.

The Euston Road 'programme' of restraint, in which technical procedure and subject are more than usually inextricable, has been mistaken in the past for an escapist solution, a retreat from the aesthetic revolutions of the century. A juster estimate would point to its origins in late Cézanne and Seurat and a development of procedural methods which those painters' work implied. The arrestingly tra-

ditional look of Euston Road paintings – met by many at the time and usually for the wrong reasons with sighs of relief – 'masked', in Lawrence Gowring's words, 'a subtle and original demolition of all the conclusions about style that had lately been drawn from past and present'. On the other hand the social realist content, then made much of, has dwindled rapidly now that its contextual immediacy has passed.

# 8 The Second War and the 1940s

With the outbreak of war in September 1939, there began a period in British painting which is perhaps more diverse and complex than any we have looked at so far. It witnessed extremes of insular nationalism and fecund receptivity to foreign concerns, bursts of romanticism and earthy realism, geometric abstraction and an uninhibited relish for the media and objects of daily life. The war put an end to the activities of the English Surrealists; Nicholson was a virtually isolated devotee of non-figurative art; the internationalism of London in the thirties seemed like a puff of smoke on the horizon of an increasingly British landscape. The refugee artists, save Gabo, had gone to America. In London, artistic life was initially makeshift and dispersed; painters came and went as the services absorbed them or commissions from the War Artists' Committee took them to other parts of the country. Later in the war several painters, some of whom had been rejected for or invalided out of military service, formed a lively group alongside such poets as Dylan Thomas and George Barker. The painters included Robert MacBryde and Robert Colquhoun, both from Scotland, John Craxton, Lucian Freud, John Minton, Michael Ayrton (1921–75) and later Francis Bacon and Keith Vaughan. Some of these painters were working in styles variously derived from Cubism, from early nineteenth-century landscape painting and influential older artists such as Wyndham Lewis, Graham Sutherland and the Polish refugee Jankel Adler (1895–1949).

Certain national characteristics, emerging in the closed atmosphere of a country at war, and an inevitable desire to celebrate aspects of the British tradition, came together to be heralded as a vital new school of painting, often called 'Neo-Romanticism'. It was given much publicity through central London galleries and the newly-constituted Arts Council; the work of the painters was reproduced in magazines such as *Studio*, *Penguin New Writing* and *Horizon*; it was discussed in books and articles by Wyndham Lewis, Geoffrey Grigson, Robin Ironside and Michael Ayrton, himself a representative painter of the movement.

It is worth briefly examining some of the origins of this romantic revival with its nocturnal landscapes, ruined décors, its charged, taut lines, which could transform a portrait of a friend into an icon for an anxious age or a dead hare on a table into something accusatory and unbalancing. Several inherent characteristics of British art are discernible in the work of these painters, chief among them being an essentially linear mode of expression, a predilection for realistic and earthy characteri-

zation, an intricate decorative presentation and a temperamental aversion to the formal classicism of much Renaissance and post-Renaissance art. Such means have often been employed in the service of poetic and romantic ends. Some of these qualities we find in abundance in Anglo-Saxon and Celtic decoration, in medieval illumination, the miniature painters of the sixteenth century and the cold, jewelled frontality of Elizabethan portraits. The satiric, earthy observations of life found in Hogarth and the great caricaturists can be traced back to manuscripts and church carvings and forward to the black and white illustrators of the Victorian period, to Beardsley, Sickert and Burra. The most exalted exemplar of that linear tradition was William Blake and the clarity with which he expressed his teeming, visionary world made the greatest impact on the Neo-Romantics. But their work has little to parallel the force of inner conflict and moral complexity of Blake's later visions. More modestly, it was the poetic impetus given by Blake to Palmer and his Shoreham circle, through such works as the early *Songs of Innocence* and the woodcuts to Virgil's *Pastorals*, which inspired Sutherland and the work of Craxton, Minton and Vaughan. But, instead of the romantic idealism of the 'Valley of Vision', we have often harsh, angular landscapes replacing such serenity, carried out with a nervous sensibility of line, a moonlight concealing less than it illuminates. This is particularly true of Minton and Ayrton with their ragged figures and lost, contemplative nudes, spectral foreshores, estuaries, entrances to tangled woods barred by fallen branches.

In a similar mode but more directly illustrational, mention should be made of the drawings of Mervyn Peake (1911–68) and the apparitions of Leslie Hurry (born 1901), now better known for his stage designs of a gothic exuberance. Keith Vaughan (PLATE 166) was much influenced by Moore and Sutherland but soon asserted his interest in single and grouped figures, tenderly evoking gestures and relationships with a significance outside time and place. A more anxious sense of personal communication can be found in the painting of Robert Colquhoun (PLATE 133), who brought to his personal, schematized figuration a sombre northern apprehension of drama and human compassion, Celtic echoes of an inscrutable ritual. Less expressionist was Robert MacBryde (PLATE 126), always associated with Colquhoun; owing more to Braque and Gris, he developed a predisposition for brilliant, emblematic colour in some notable still-lifes. The work of Wyndham Lewis and Jankel Adler made an impact on both these artists, especially Adler, who came to London as a refugee via Glasgow, where Colquhoun and MacBryde had been students. Further currency was given to this emotive adaptation of a geometrical, linear style when an exhibition of Picasso's recent work was held in London at the end of 1945. The Matisses shown simultaneously had considerably less observable influence and their implications were to be followed through in America.

Neo-Romanticism was a brief phase and those artists associated with it moved in other directions – particularly Keith Vaughan and John Craxton. Both have maintained a figurative impulse, Craxton finding in the landscape of Greece a setting for dramatic human incident (PLATE 131), and Vaughan, increasingly

conscious of the European tradition of Piero della Francesca, Poussin, Cézanne, creating figures of often melancholy and austere grandeur (PLATE 166). An exact contemporary of Craxton is Lucian Freud, whose early works contain surrealist and fantastic elements delineated with crisp definition (e.g., *Self-portrait with a thistle*, 1947, Tate Gallery). In recent years an expressive fluency in the handling of paint has enriched the obsessional clarity of his vision (PLATE 156).

Graham Sutherland has already been mentioned in an almost Elder Statesman-like capacity and certainly his works of the late thirties and his War Artist commissions were widely influential. (Keith Vaughan, for example, records in his journal an important conversation with Sutherland in 1944.) When representing Britain at the 1952 Venice Biennale he was singled out in the catalogue as 'the outstanding English painter of his generation'. The intensity of his Pembrokeshire paintings, with their investigations of dramatic light, hills, boulders and vegetation positively ambushed by colour, have lost none of their force and presentiment. Through the transformation of arresting natural images, by a banishment of scenic details and perspective and the use of highly personal colour schemes, Sutherland made an individual contribution to the English landscape tradition. From this position of disciplined romanticism, he gradually moved to a more symbolic interpretation of nature, in which animal and human references considerably enlarged his emotional appeal beyond the English landscape. Such metamorphoses were accompanied by a greater inventiveness in colour, a more fluent use of paint and a presentation of the image in an often iconic isolation. The frontal emphasis given to such images – frequently ominous and sometimes repellent as they are – results in a certain monotony of surface organization, with backgrounds remaining unanimated or spatially ambiguous. Sutherland's portraits, which began with *Somerset Maugham* (1949, Tate Gallery), and his religious compositions share obvious characteristics with his other work, though they draw more on the expressionist tradition of northern Europe as we find it in Grünewald, Max Beckmann and the early Kokoschka.

At first associated with Sutherland was Francis Bacon, the most considerable painter to emerge in post-war Britain and one of the few internationally recognized British artists of the century. Although Bacon painted and exhibited intermittently in the thirties and was included in Read's *Art Now* (1933), it was not until 1945, when he showed a group of paintings at the Lefevre Gallery, London, that his characteristic concerns became evident, the seam he has since continued to work with varying degrees of emphasis. One of those paintings was *Figure study II* (PLATE 138), which, though instantly recognizable as a Bacon, contains elements of his earlier surrealist interest and the work of Sutherland – particularly in the colour scheme, the spiky plant and sense of pending metamorphosis. Bacon at once established his predilection for the human figure, usually seen in isolation, and the often violent and erotic nature of his subject-matter, revealed as much in the actual physical manipulation of the paint (which can make 'a direct assault on the nervous system' as he once said) as in the images themselves. His sources are manifold – reproductions of European paintings (Cimabue, Velasquez, Rubens, Van

Gogh), film stills, news photographs, picture postcards, Muybridge's *The Human Figure in Motion*, facial close-ups and medical textbooks. Several commonplace objects have frequently appeared in his work and include umbrellas, bicycles, light bulbs, couches, shutters and curtains, wire-netting and richly textured rugs. Animals have provided subjects – monkeys and dogs – and there are several series of multiple portraits such as the Isabel Rawsthorne triptych (1965, London, Private Collection).

Bacon is an extremely sophisticated artist in the European figurative tradition, using all the resources of oil paint from careful *belle-peinture* to throwing it at the canvas or applying it with rags and scrubbing-brushes. He establishes a dialogue of high tension between a deliberate transcription of his intentions and the results of chance and accident. 'Half my painting activity', he has said, 'is disrupting what I can do with ease.' The violence of his coupling figures, heads and crucifixions has inevitably been overstressed at the expense of his almost orthodox aesthetic. The violence really comes when we turn away from his work into life again. It is never narrative but a presentation of situations at their maximum pitch of inherent violence, as though one came into the middle of a Greek tragedy knowing nothing of its story or outcome, yet sensing, in their purest state, the forces of destruction. Nothing is cushioned and no one escapes, least of all Bacon himself. This combination of courageous narcissism and an uncompromising view of life enables him to give to personal and idiosyncratic images a grandeur that positively subdues. In less successful work, Bacon sometimes overplays his hand in the direction of melodrama and loses that necessary balance between formal invention and the exigencies of the subject. Figures isolated against unmodelled areas of colour, while giving them further clarity, remove certain layers of feeling from the work as a whole. By his very nature, Bacon is without imitators and in some senses has been isolated in the context of twentieth-century painting. But an illuminating attention has been drawn to his affinities with Sickert and Warhol and certainly there are points of contact with Sutherland, Freud, Colquhoun and even the early Hodgkin.

A contemporary of Bacon, who was also associated as we have seen with the Surrealists, is Cecil Collins (PLATES 134 and 135). With rare independence he has developed a world of imagery consistent with a particularly poetic critique of modern life. Central to his thought is the Fool, a creature embodying those qualities of spontaneity, purity and light which Collins sees as the antitheses of modern commercialism and exploitation, in which everything is reduced to its lowest common denominator. In such a society the Fool is jeered at in much the same way as Dostoevsky's Prince Mishkin. The Holy Fools were joined by Angels, and Collins's themes of dance, celebration, night-time with its promise of rebirth, of death and transfiguration are frequently situated in heavenly landscapes, an invented cosmos brimming with energy. Such a highly-developed personal vision might imply an esoteric formal expression. But Collins presents his world with clarity and simplicity, for he has an innocent acceptance of an imagery which in others might appear mannered and artificial. An appreciation of that imagery has sometimes caused his considerable technical accomplishments to be overlooked. Technique

and imagery are of course mutually dependent in an artist whose every mark goes beyond an aesthetic commitment.

# 9 St Ives and the 1950s

Towards the end of the forties and in the early fifties, a less insular note can be detected in British painting. Foreign travel on an extensive scale was once more possible and new painting from France and Italy again made a decisive impact. A new generation of sculptors were sympathetically received in Europe, culminating in the Venice Biennale of 1952, where Herbert Read described the work of Paolozzi, Lynn Chadwick (born 1914), Reg Butler (born 1913), Kenneth Armitage (born 1916) and others as belonging to 'the iconography of despair'. Such artists did much to enliven a confused situation, in which the reception of abstract painting was still chilly, Neo-Romanticism a spent force and Euston Road realism no longer attractive to the young. In the late forties, sculptors such as Paolozzi and William Turnbull (PLATE 164) moved to Paris, and two painters, also from Scotland, William Gear (PLATE 146) and Alan Davie (PLATE 160), both preferred continental stimuli (and a measure of acclaim) to the seemingly directionless and insipid atmosphere of London. But London no longer held the monopoly; the fishing town of St Ives, Cornwall, was rapidly attracting a group of artists centering on Ben Nicholson and Barbara Hepworth, who had moved there in 1939, and two local painters, Peter Lanyon (PLATE 159) and John Wells (born 1907). That area of Cornwall had long attracted painters: Frank Bramley and Stanhope Forbes had led the Newlyn School in the 1880s; early this century Laura and Harold Knight, Alfred Munnings, Ernest and Dod Procter had painted there; Nicholson and Wood had met Alfred Wallis in St Ives, as we have seen, but it was still very much the world of amateur *plein-airistes* evoked by Virginia Woolf in *To the Lighthouse*, until the Nicholsons settled there and were joined by Naum Gabo. In 1949 the Penwith Society of Arts was founded by these artists with Herbert Read as president. Schools emerged such as the St Peter's Loft School, where Lanyon and Terry Frost were teachers; Frost (born 1915) had been taught by John Tunnard at the Penzance School of Art. Other painters gravitating to the area included Bryan Wynter (born 1915), moving there in 1945, and Roger Hilton. Local communities were swelled in the summer months by visiting painters as well as tourists; mixed exhibitions and the activities of craftsmen (their doyen being the potter Bernard Leach) reflected in their various ways the light, topography and texture of the surrounding landscape and coast.

Terry Frost has evoked the starting-point for one of his own paintings; in several ways it can be taken as representative of the impulse of much painting in the fifties, in Cornwall and elsewhere:

I had spent a number of evenings looking out over the harbour at St Ives in Cornwall. Although I had been observing a multiplicity of movement during these evenings they all evolved a common emotion or mood – a state of delight in front of nature. On one particular evening, I was watching what I can only describe as a synthesis of movement and counter-movement. That is to say the rise and fall of the boats, the space drawing of the mastheads, the opposing movements of the incoming sea and the outblowing off-shore wind – all this plus the predominant feel of blue in the evening and the static brown of the foreshore, generated an emotional state which was to find expression in the painting 'Blue Movement'.

The freely calligraphic and emotive painting resulting from such experiences was practised most precisely and powerfully by Peter Lanyon. In the hands of others, the convention became tepid, over-tasteful, too much concerned with the refinements of registering a narrational response to the landscape. It was a way of painting that became widely influential and reactions against it came swiftly.

Before looking at some of those reactions, some account must be given of the reception in Britain of the new American painting in the fifties. The showing in London of artists such as Pollock, Rothko and Kline was at first sporadic and often unrepresentative; little was seen in reproduction until the middle of the decade. 'Modern Art in the United States', an exhibition sponsored by the New York Museum of Modern Art, was held at the Tate Gallery in January 1956 and contained one room devoted to Abstract Expressionism. A few painters and critics were warmly responsive, particularly Patrick Heron, William Scott and Roger Hilton. Only Pollock's work was known in the late forties; Alan Davie had appreciated his work in the collection of Peggy Guggenheim in Venice in 1948 (as had Lanyon in the same year). Perhaps the most significant point of contact was a visit paid by William Scott to New York in 1953. Although Pollock's work was just known to him, he was introduced for the first time to the work of several Americans who made their names in the mid-fifties. Though deeply impressed, his general reservation was perhaps shared by his English contemporaries, that the painting came out of a new, different tradition and was basically untransplantable. It did however confirm certain prevailing preoccupations among English painters – an increase in the scale of their work, an elimination of detail and finesse, a simplification of the picture surface and minimal spatial definition. What seemed to elude the English was the non-referential and unmetaphorical impulse of the Americans, particularly in an artist like Barnett Newman. Domestic and natural references haunt much of their work. An exception should be made for Patrick Heron's stripe paintings of 1956–7 (PLATE 161) and some of Hilton's work of 1953–4 (PLATE 163). But part of Hilton and Scott's reaction to American work was an intensification of their interest in subject. Whereas Scott had denied the subjective importance of the common still-life objects of his work (precisely because they held little interest for him, he could use them more freely), he later explored erotic, primitive and even humorous nuances of his 'subjects'. At his best, Scott imbues his simple yet

resourcefully varied forms with an instinctive sensuousness, a characteristic of his handling of paint and texture (PLATES 144 and 158). Sensuality is a hallmark of Hilton's later, more figurative work in which his variations on the nude are distinguished by an immediacy of image and assured calligraphy. Patrick Heron's later work is rigorously simplified in design, enabling him to concentrate on an exploration of brilliant, unmodulated colour as the instrument of pictorial space. As a journalist and lecturer, he has consistently upheld the belief that the great figures of Abstract Expressionism in America owed something to the example of their British contemporaries who were exhibited in the early fifties in New York. Such painters as Lanyon and Scott were certainly received there sympathetically. Affinities can be advanced between Scott and Motherwell, between Heron himself and Adolph Gottlieb, for example. Their appreciation of the new American art must be applauded, especially when seen beside the relative indifference to it shown by certain French abstractionists. But in the face of visual evidence, their understanding of it seems questionable. In perspective, their allegiances to Braque, Matisse and Bonnard become increasingly apparent. Such affiliations interfered with the possibilities of their developing an art as radical and unconstrained as the Americans.

Reaction against many of the painters associated with British fifties abstraction was strong both from the new generation of artists and a little later from the public. Much of their work was 'shelved' in public collections in the mid-sixties (particularly such painters as Sandra Blow, Hamilton Fraser, Adrian Heath, Peter Kinley and Kit Barker). The modest accomplishments of some of them (Frost and Wynter, Heath and Hamilton Fraser more especially) have only recently begun to be seen again in relation to their later work and the possibility of a more objective appraisal of post-war painting.

Of those painters who first worked before the war but only achieved maturity after it, Robert Medley has shown a consistently intelligent awareness of new American painting while remaining true to his experience of the European figurative tradition. Before the war, surrealist fantasy characterized work which often reflected the social unrest of the period. His early involvement with the Group Theatre naturally influenced his large-scale, figurative compositions of the early fifties, such as *Summer Eclogue No 2* (Arts Council Collection), and those with a mythological inspiration. He gradually freed himself from representation in an attempt to realize his perceptions and experience with increased force, employing richer colour and a more gestural application of paint. The humane, philosophic impulse seen in all periods of his work saved him from the painterly effusion of some of his contemporaries and deepened the impact of an imagery which remains rooted in the human figure and its surroundings.

The free abstract style developed by so many painters in the fifties frequently reflected the British landscape. Some of the most distinguished landscape paintings of the time came from David Bomberg in a manner considerably different from his early work. Through emphatic brushmarks and thick pigment, the landscape emerges, recreated not so much by formal imposition but by a willingness to explore a

variety of sensations before nature in a synthesis of acute observation within a passionately subjective situation. His emphasis on the re-creational possibilities of paint – where paint is both a vehicle for description and a reality in itself, was developed by several of his students who form a distinct group in post-war painting, notable for its involvement in the urban scene rather than landscape and for highly-charged portraits and figures in interiors. Frank Auerbach (PLATE 153) and Leon Kossoff (PLATE 154) maintain a dense gestural freedom directed by the suggestiveness of particular, observable facts. Both painters offered a welcome alternative to the sometimes starved presentation of reality given by the heirs of Euston Road. Both share affinities with Sickert and Bacon.

# 10 Pop Art and the 1960s

One small group of painters in the mid-fifties scored a popular success in Britain under the name of the Kitchen Sink School. They belong to the period of Kingsley Amis and John Osborne, to the quiet domestic tone of much English poetry, to the era of *Woman in a dressing gown* and that group of young novelists which included Allan Sillitoe and Keith Waterhouse. They never consciously formed an alliance and never issued a manifesto. They were, however, roughly contemporary in age, studied at the Royal College of Art, showed at the Beaux Arts Gallery, were championed by the Marxist critic John Berger and, in 1956, John Bratby, Jack Smith, Edward Middleditch and Derrick Greaves represented Britain at the 28th Venice Biennale. Their supposed social realism originated more from the circumstances of their lives than from any idealistic political or social programme. Bratby was the most colourful and essentially expressionist of the four, using autobiographical and urban imagery with a vengeance. Emphatic drawing was allied to an emotive impasto in which the influence of Van Gogh was paramount (PLATE 167). He favoured high viewpoints, often working on a panoramic scale. His associates generally used a more restrained colour range, Jack Smith often restricting himself to greys, ochre and soiled whites. An initial interest in the effects of light has carried him through to an exploration of non-objective optical imagery (PLATE 169).

As an alternative to the austere world of the British Constructivists – Pasmore, Kenneth Martin and Anthony Hill (born 1930) – the Kitchen Sink painters had a considerable following. Bratby, in *Studio* magazine for example, was grouped with Rembrandt and Courbet. In their identification with their surroundings, whether in the streets of Sheffield or the debris of the kitchen table, these painters exhibit connections with Pop Art, a movement then gathering momentum and which swiftly displaced them in popular esteem. Elvis Presley and Marilyn Monroe, fast cars and the Something Sisters celebrated dreams, fitted the mood – helped create it in fact – of those years in which people were told that they'd never had it so good. Popular imagery re-presented with wit and formal ingenuity, laced with frank personal allusions and tied up in the ribbons of youthful success, made for an

unprecedented movement in modern British painting; it was popular, it was anti-Establishment and relied little on foreign stylistic developments, though heavily on American admass culture. Some of its qualities are detailed in Richard Hamilton's often quoted list of 1957:

> Popular (designed for mass audience)
> Transient (short term solution)
> Expendable (easily forgotten)
> Low Cost
> Mass Produced
> Youth (aimed at Youth)
> Witty
> Sexy
> Gimmicky
> Glamorous
> Big Business

Such a programme was intimately connected with the researches into communication and advertising carried out by Hamilton and a group of friends in the early fifties. Frustrated with the policy of the Institute of Contemporary Arts in London and the generally apathetic attitudes of the art world to manifestations of contemporary life, they formed the Independent Group for their own lectures and discussions. The first such meeting (late 1952) included a screen projection by Eduardo Paolozzi of his *Bunk* collages (PLATE 148), which displayed a wide variety of images culled from advertising, comics, dime novels and illustrated magazines, relying on the associative responses of the spectator for their effect. Similar, predominantly American imagery was to be used by the younger generation of British Pop artists in various ways, though as a unifying factor it has been overstressed at the expense of the considerable conceptual inventiveness which evolved from a contemplation of such imagery.

The exhibitions mounted by members of the Independent Group (which, besides Hamilton and Paolozzi, included the photographer Nigel Henderson, the sculptor and painter William Turnbull, the critic Lawrence Alloway, the architects Peter and Alison Smithson, the artist John McHale and the writer and architectural historian Reyner Banham) were all concerned with aspects of the environment presented through photographs, installations and music. They culminated in the famous 'This is Tomorrow' exhibition at the Whitechapel Gallery (August to September 1956), for which Hamilton made the poster *Just What Is It that makes Today's Homes So Different, So Appealing* (PLATE 149) on the familiar motif of figures in an interior – but what figures and what an interior! Gone are the drab inhabitants of North London rooms, *Ennui's* tired publican and his wife, gone the lazy armchairs and antimacassars of British *intimisme*. From 'True Love Romance' to television, gift-wrapped pin-up to consumer goods, we see here an inclusive display of so much source material for his own later work and that of a younger generation, as well as several of those qualities quoted above. The term

Pop Art rapidly came to designate the fine art evolved from such images and attitudes as against the products of the media themselves. Through his statements and teaching as much as through his own work, Hamilton brought about a new awareness of the possibilities inherent in contemporary popular culture. Alongside artists like Lewis and Ben Nicholson, he has been one of the most active intelligences at work in modern British art. While presenting his investigations among aspects of commercial design (e.g., *Fashion-plate series*, 1969), pop culture (e.g., *I'm dreaming of a white Christmas*, PLATE 179) and technology (e.g., *Hommage à Chrysler Corp*, 1957) – all overlapping – Hamilton shows a consistent visual virtuosity and technical resourcefulness. In the breaking down and reassembling of this iconography, he has pushed his work further than most of his contemporaries – sometimes to the point of excessive refinement. Such processing has been enriched in presentation by a study of Cézanne and in concept by his admiration for Marcel Duchamp, whose *Large glass* he reconstructed for exhibition in 1966. Hamilton's range and influence, the latter extending to artists little indebted to the actual look of his work, only became generally apparent at his large retrospective at the Tate Gallery in 1970.

A painter developing away from the Independent Group but with some similar interests was Peter Blake, Hamilton's junior by ten years and an artist whose work in the late fifties and early sixties employed pop imagery in a very different way. Less concerned with presentation and the advertiser's dreamworld, he concentrated, with autobiographical obsession, on folk heroes (all-in wrestlers as much as the Everley Brothers), on the hero worship of fan magazines and lapel badges, on the folk art of shop signs, caravans, circus costumes and matchbox designs. His work at that time was the most direct and spontaneous celebration of pop imagery, achieved through a variety of finely attuned stylistic devices. His earlier work, such as *Children reading comics* (1954), reflects his interest in Ben Shahn and Honoré Sharrer; the latter's panoramic *Workers and pictures*, included in the 1956 Tate Gallery exhibition of American painting, provided a possible source for Blake's early masterpiece *On the balcony* (PLATE 171). Blake later developed a more declamatory presentation using heraldic motifs – stripes, hearts, targets – to offset pin-ups, fan pictures and simulated collage (e.g., *Elvis Presley wall*, 1962, and *Got a girl*, PLATE 178). Blake is an exuberant, highly-skilled magpie, gathering images from a wide spectrum – Alice in Wonderland to soft porn – and matching them to, in his own words, 'the technical forms that will best recapture the authentic feel of folk art'.

In the late fifties and early sixties several influential exhibitions took place in London. At the Tate Gallery 'The New American Painting' (February to March 1959) followed hard on the Whitechapel retrospective accorded to Jackson Pollock. The Tate show demonstrated the superiority of the new American school over contemporary European modernism, but did not discourage those British abstractionists already pursuing different ends – as could be seen from a collaborative venture 'Place' organized the same year at the Institute of Contemporary Arts by Robyn Denny, Richard Smith and Ralph Rumney, in which aspects of the artist-

spectator, artist-in-society questions were examined through an environmental impact. Pop Art was simultaneously exploring the other side of the coin. It was the latter's side which turned up heads for the public, particularly after the revealing 1961 exhibition of 'Young Contemporaries' (at the R.B.A. Suffolk Street Galleries), in which David Hockney, Allen Jones, Derek Boshier, Peter Phillips and Patrick Caulfield were introduced to a wider audience. The year before, a group of painters showing under the name 'Situation' held their first show. Most of them were thirty or under, were painting large-scale predominantly abstract works and, unlike the St Ives group, were re-establishing the painting as an object existing for itself without moody landscape or figurative connotations. Some emphasized the paint's evocative, physical properties (Gillian Ayres, born 1930, Henry Mundy, born 1919); others the eventful, improvisatory handling of more formal concepts (Marc Vaux, born 1932). The majority were concerned with the perceptual possibilities of a narrow range of simple, formal propositions as in the work of Robyn Denny, William Turnbull, Bernard Cohen or John Hoyland. It must, of course, be stressed that these artists in no way formed a school and each has developed as individually as any of the Pop artists with whom, in choice of initial imagery, they sometimes overlapped.

English Pop Art is invariably seen to have developed in three stages: the first being the Independent Group artists and collaborators, who opened up the whole territory; the second, consisting of Richard Smith, Robyn Denny, Bernard Cohen and others, whose titles and motifs have popular overtones (for instance, Denny's *Baby is three*, PLATE 187, and Cohen's *art deco* picture palace imagery in *Empire*, 1961); and the third stage being represented by the Young Contemporaries listed above and certain independent figures such as Joe Tilson, Anthony Donaldson and Gerald Laing. A fellow student at the Royal College with Jones, Hockney and the others was R. B. Kitaj, an American some years their senior, who played an important catalystic role through his greater knowledge of contemporary developments and highly professional approach. Popular imagery is virtually absent from his work; European literature and history were and continue to be the sources of his enigmatic, reference-filled and often sombre paintings and graphic work. His manipulation of formal devices influenced Hockney as much as his elision of imagery influenced early Jones and Boshier. The political air of much of his work finds no echo in that of the English artists, although the biting comments of Boshier's Identi-Kit series (PLATE 175) lead in that direction.

Richard Smith, a year older than Kitaj, is one of the most substantial British artists to emerge in the post-war period. Old enough to have come under the influence of the Independent Group, he left the Royal College of Art in 1957 and two years later went to live in New York. In 1961 he held a show at the Green Gallery there and it had considerable success; shows by young British artists were comparatively rare in New York (extended visits to America, however, were increasing – Peter Phillips, Allen Jones, Mark Lancaster and Paul Huxley, for example, spent time there between 1964 and 1966). In the next few years Smith was much in America, painting and teaching; in London he established an influence on

the Royal College and 'New Generation' artists of the mid-sixties. His early work was said to have grown 'out of Abstract Expressionism in terms of its large scale, directness and impact while at the same time rejecting the autobiographical and "heroic" stance of action painting in favour of a cooler, more detached attitude and a greater openness to the sights, sounds and sensations of the contemporary environment' (Barbara Rose, Introduction to *Richard Smith*, '*Seven Exhibitions*', Tate Gallery, 1975). Smith's characteristics include a refined painterly handling, a colour sense partly generated by his iconographic sources (from the evocative, mentholated pastels of the New York work to the lush greens and purples of *Martin's plum* (1975) and *The pod* (PLATE 174), an acute feeling for formal priorities, stemming nevertheless from a contemplation of the chosen image and its levels of association, and a technical resourcefulness – shaping, cutting, exposing or concealing construction, which is both tough and elegant. Free-standing works such as *Gazebo* (1966), an extension of his projecting, three-dimensional works (e.g., *Piano*, 1963), were an inevitable step in 'bringing more of the spectator to art', in Smith's words, while emphasizing an essentially painterly, rather than sculptural, redefinition of his iconography.

The density of content achieved by a reduction of the components of a painting and the undisguised disclosure of working methods have been a leading feature of painting and sculpture since the early sixties in Europe and America. Minimal and conceptual art partake of these qualities in varying degrees. Such an approach has naturally led to the use of new materials in the reprocessing of relatively familiar imagery. Painting has been stretched to its limits, though there are artists working who continue with traditional methods – John Hoyland, John Golding and John Walker (PLATE 192) are among them. This reductive position can be seen in Howard Hodgkin's *Dancing* (PLATE 173), though a re-complication of the picture surface (without recourse to narrative) has gradually deepened the sensuous, tightly-wrought impact of his work, which is among the most compelling to have been produced in England in the last twenty years. David Hockney, who shares with Hodgkin a similarly exuberant sense of colour, if more descriptively employed, has achieved a position of edgy traditionalism while retaining that personal combination of the ironic and the matter of fact which marked his early work. Its effervescent juxtaposition of styles and references – written words and lines of poetry, witty stylistic canards, Pop motifs (less evident than is commonly supposed) and a very direct observation of the world about him – added a new note to that English commitment to the lyrico-narrative impulse. The pungent personality emanating from all his work and his adherence to representational idioms have already made him an isolated figure among the younger painters working today. Some of his earlier concerns were common to Patrick Procktor, a participant in the 1964 'New Generation' exhibition at the Whitechapel Art Gallery, with his disturbing clusters of gothic figures, changes of scale and semi-realistic ambience. Patrick Caulfield, a further exhibitor in 1964, is a deceptively simple artist, presenting commonplace, easily assimilable imagery (PLATE 185) in a manner that is highly complex in its formal and iconographic propositions. Irony is directed with

ruthless self-discipline towards familiar styles and motifs, from which he extracts some of their original compulsion. In the work of Mark Lancaster, a student of Hamilton's in the early sixties, a subdued lyricism and potent choice of imagery (from commercial, architectural and landscape sources) are presented through a deliberately restricted number of formal elements involving grids, repetitions, reversals and a highly personal use of colour also systematically varied and distributed (PLATE 184). Unexpectedly complex emotions are revealed through a seemingly simple structure achieved, nevertheless, by a rigorous interaction of chosen procedures, an ability to command a large scale with fluency and an avoidance of sententiousness too rare in much contemporary British painting.

An intellectual laziness and fundamental lack of commitment to visual ideas has blighted British art in this century as before. Even among some of the better painters working now a certain fussy empiricism endangers their development. But in the sixties, that wide-ranging interrogation of the inextricable properties of form and content, the number and variety of serious painters at work and a prevailing climate, which, if sometimes cliquish, sometimes starved, was at least more inclusive and generative than for many years, enabled British painting to regain much lost ground. The work of artists as different as Richard Hamilton and Francis Bacon, Richard Smith and Bridget Riley, Tom Phillips (PLATE 188) and Keith Milow (PLATE 194), Patrick Caulfield and Stephen Buckley (PLATE 195) provides an impressive frame of reference and a body of achievement which all of them are capable of sustaining. In the context of painting today, the proverbial over-deprecatory response of the British towards their art has not looked so out of place for a long time. A change in focus (already occurring), though charged with the dangers of an easy chauvinism, would provide not only a reconsideration of earlier painting but a more rooted confidence and sense of vitality for the artists of future years.

# Chronology of selected exhibitions

Unless otherwise stated, all exhibitions were in London.

1889   Twenty 'Impressions' by Claude Monet, Goupil Gallery
       'London Impressionists', first exhibition, Goupil Gallery
1898   Toulouse-Lautree exhibition, Goupil Gallery
       First exhibition of the International Society
1905   French Impressionist pictures at Durand-Ruel
1906   Rodin and Cézanne in the International Society exhibition
1908   Renoir and Pissarro included in fourth Friday Club exhibition, Baillee Gallery
       Matisse, Cézanne and Gauguin at the New Gallery
       First exhibition of Allied Artists' Association, Albert Hall
1910   'Exhibition of the Works of Modern French Artists', Public Art Galleries, Brighton
       'Manet and the Post-Impressionists', Grafton Galleries
1911   First exhibition of the Camden Town Group, Carfax Gallery (June)
       Second exhibition of the Camden Town Group, Carfax Gallery (December)
1912   'Exposition de Quelques Indépendants Anglais', Galerie Barbazanges, Paris
       Works by the Italian Futurist Painters, Sackville Gallery (March)
       Third exhibition of the Camden Town Group, Carfax Gallery (December)
       'Second Post-Impressionist Exhibition. British, French and Russian Artists'. Grafton Gal-
       leries, October to January, 1913
1913   Grafton Group exhibition, Alpine Club Gallery
       Post-Impressionist and Futurist exhibition, Doré Galleries (October)
       'Exhibition by the Camden Town Group and Others', Public Art Galleries, Brighton,
       (December 1913 to January 1914)
1914   First exhibition of the London Group, Goupil Gallery
       Second Grafton Group exhibition, Alpine Club Gallery
       'Twentieth Century Art. A Review of Modern Movements', Whitechapel Art Gallery
1915   Vorticist exhibition, Doré Galleries
1917   Vorticist exhibition, Penguin Club, New York
       'The New Movement in Art', Birmingham Society of Artists and Mansard Gallery,
       Heal's
1918   Last general exhibition of Omega artists and others, Omega Workshops (October)
1920   Group X exhibition at Mansard Gallery, Heal's
1923   First London exhibition of Van Gogh, Leicester Galleries
1924   First London exhibition of Gauguin, Leicester Galleries
1925   First London exhibition of Cézanne, Leicester Galleries
1926   Advanced French Art, Mayor Gallery
       First exhibition of the London Artists' Association, Leicester Galleries
1929–34 Annual Seven and Five Society exhibitions, Leicester Galleries
1933   'A Survey of Contemporary Art', Mayor Gallery, arranged in connection with Herbert
       Read's 'Art Now'
1934   Unit One exhibition, Mayor Gallery (and provincial tour)
       'Objective Abstractionists', Zwemmer Gallery
1935   Last exhibition of Seven and Five Society, Zwemmer Gallery – first all abstract exhibition
       in London
1936   'Abstract and Concrete' exhibition in London, Liverpool, Oxford and Cambridge
       'International Surrealist Exhibition', New Burlington Galleries
1937   'Constructive Art', London Gallery

1939 'Living Art in England', London Gallery
1940 'Surrealism Today', Zwemmer Gallery
1945 Picasso and Matisse exhibition, Victoria and Albert Museum
1949 First exhibition of Penwith Society, St Ives, Cornwall
1953 'Parallel of Life and Art', Institute of Contemporary Arts
1954 Hepworth, Bacon and Scott exhibition, Martha Jackson Gallery, New York
1955 'Man, Machine and Motion', Newcastle upon Tyne and I.C.A.
1956 'Modern Art in the United States', Tate Gallery
     'This is Tomorrow', Whitechapel Art Gallery
1957 'Metavisual, Tachiste, Abstract', Redfern Gallery
1958 Jackson Pollock exhibition, Whitechapel Art Gallery
     'Abstract Impressionism' (French, British and American artists), Nottingham University
     and Arts Council Gallery, London (and tour)
1959 'The New American Painting', Tate Gallery
1960 'Situation' exhibition, R.B.A. Galleries
     'Young Contemporaries', R.B.A. Galleries
1961 Mark Rothko exhibition, Whitechapel Art Gallery
1962 'Image in Progress', Grabowski Gallery
1964 Jasper Johns exhibition, Whitechapel Art Gallery
     'The New Generation', Whitechapel Art Gallery
1965 'The English Eye', Marlborough-Gerson Gallery, New York
1966 'The New Generation', Whitechapel Art Gallery
1969 'The Art of the Real', Tate Gallery
1972 'The New Art', Hayward Gallery
1974 'British Painting '74', Hayward Gallery

# Select bibliography

BAKER, Denys Val  *Britain's Art Colony by the Sea*, 1959

BARBER, Noel  *Conversations with Painters*, 1964

BARON, Wendy  *Sickert*, 1973

BELL, Clive  *Since Cézanne*, 1922

BERTRAM, Anthony  *A Century of British Painting 1851–1951*, 1951
*Paul Nash, The Portrait of an Artist*, 1955

BOWNESS, Alan  *Alan Davie*, 1967

BROWN, Oliver  *Exhibition, The Memoirs of Oliver Brown*, 1968

BROWSE, Lillian  *Sickert*, 1943
*William Nicholson*, 1966

COLLIS, Maurice  *Intimate Biography of Stanley Spencer*, 1962

COOPER, Douglas  *Graham Sutherland*, 1961

CORK, Richard  *Vorticism and Abstract Art in the Machine Age*, 2 vols, 1976–7

EATES, Margot  *Paul Nash, Master of the Image*, 1973

FINCH, Christopher  *Image as Language*, 1969

FRY, Roger  *Transformations*, 1926
*Reflections on British Painting*, 1934
*Letters*, ed. Denys Sutton, 2 vols, 1971

GARLAND, Madge  *The Indecisive Decade*, 1968

GAUNT, William  *Concise History of English Painting*, 1964
*The Restless Century, Painting in Britain 1800–1900*, 1972

HAMNETT, Nina  *Laughing Torso*, 1932

HASKELL, Arnold (and others)  *Since 1939*, 1948

HEATH, Adrian  *Abstract Painting*, 1953

HOCKNEY, David  *David Hockney*, ed. Nicos Stangos, 1976

HOLMAN-HUNT, Diana  *Latin Among Lions, Alvaro Guevara*, 1974

HOLROYD, Michael  *Augustus John*, 2 vols, 1974

LAMBERT, R. S. (ed.)  *Art in England*, 1938

LILLY, Marjorie  *Sickert: The Painter and his Circle*, 1971

LUCIE-SMITH, Edward  *Movements in Art since 1945*, 1969

NEWTON, Eric  *In my View*, 1950

PIPER, John  *British Romantic Artists*, 1944

READ, Herbert  *Art Now*, 1933; revised ed. 1948
*Contemporary British Art*, 1951; revised ed. 1964

ROTHENSTEIN, Elizabeth  *Stanley Spencer*, 1945

ROTHENSTEIN, John  *Modern English Painters*, 3 vols, 1952–74
*British Art since 1900*, 1962
*Matthew Smith*, 1962

ROTHENSTEIN, William  *Men and Memoirs 1872–1900*, 1931
*Men and Memoirs 1900–1922*, 1932
*Since Fifty*, 1939

RUSSELL, John  *From Sickert to 1948*, 1948

RUSSELL, John and GABLIK, Suzi  *Pop Art Redefined*, 1969

RUTTER, Frank  *Evolution in Modern Art*, 1926
*Art in my Time*, 1933

SAUSMAREZ, Maurice de (ed.)  *Ben Nicholson, Studio*, 1969

SHIPP, Horace  *The New Art*, 1922

SHONE, Richard  *Bloomsbury Portraits*, 1976

SYLVESTER, David  *Interviews with Francis Bacon*, 1975

THORNTON, Alfred  *Fifty Years of the New English Art Club*, 1935

TOWNSEND, William  *The Townsend Journals*, ed. Andrew Forge, 1976

TREVELYAN, Julian  *Indigo Days*, 1957

VAUGHAN, Keith  *Journals and Drawings*, 1966

WALKER, John A.  *Art Since Pop*, 1975

WILENSKI, R. H.  *The Modern Movement in Art*, 1927; revised ed. 1945

WILSON, Simon  *Pop*, 1974

Two series of individual monographs have been invaluable in the writing of this book:

*Penguin Modern Painters*, begun in 1944 under the editorship of Kenneth Clark, contain an essay on the artist and thirty-two reproductions. Titles include: *Edward Bawden, Duncan Grant, Ivon Hitchens, Frances Hodgkins, David Jones, Henry Moore, Paul Nash, Ben Nicholson, William Nicholson, Victor Pasmore, John Piper, Matthew Smith* and *Stanley Spencer*.

*Art in Progress*, Methuen, 1961–4, essay, plates and comprehensive bibliographies. Titles include: *Alan Davie, Ben Nicholson, Victor Pasmore, Ceri Richards, Eduardo Paolozzi, William Scott*.

Until more comprehensive accounts of individual painters appear, the only sources of information are gallery catalogues and periodical literature. Most of the retrospective and memorial exhibitions listed in the artists' biographies section carry catalogues. Particularly useful are those issued by the Tate and Hayward Galleries, the Arts Council, the Leicester and Lefevre Galleries, the Fine Art Society, the Anthony d'Offay Gallery and the Whitechapel Gallery. Periodicals consulted include *Apollo, Ark, Art and Artists, Arts Review*, the *Burlington Magazine*, the *Connoisseur, Motif, Studio* and *Studio International*; and the arts pages of the *Athenaeum*, the *Spectator, New Society* and the *New Statesman*.

The plates

1 John Singer Sargent (1856–1925): *The Acheson sisters*. 1902. Canvas, 108 × 78 in. Chatsworth, Devonshire Collection

'It is a pitiful thing, and one of the best proofs of the nullity of art criticism in this country', wrote Walter Sickert in 1910, 'that Sargent's painting is accepted, as it is, as the standard of art, the *ne plus ultra* and high-water mark of modernity.'

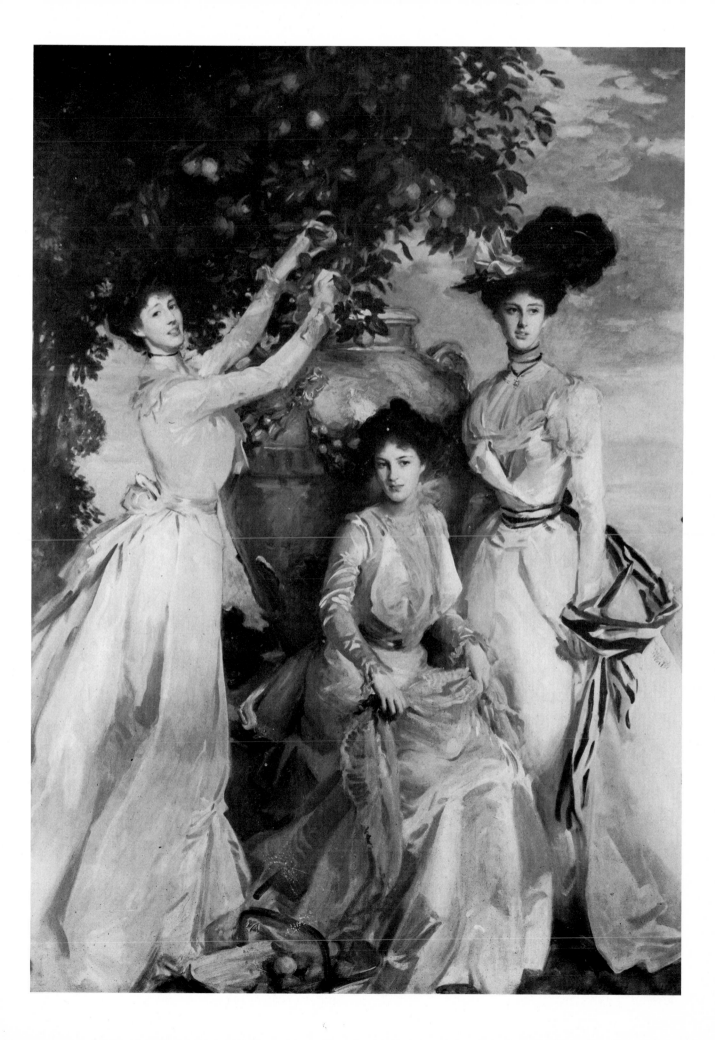

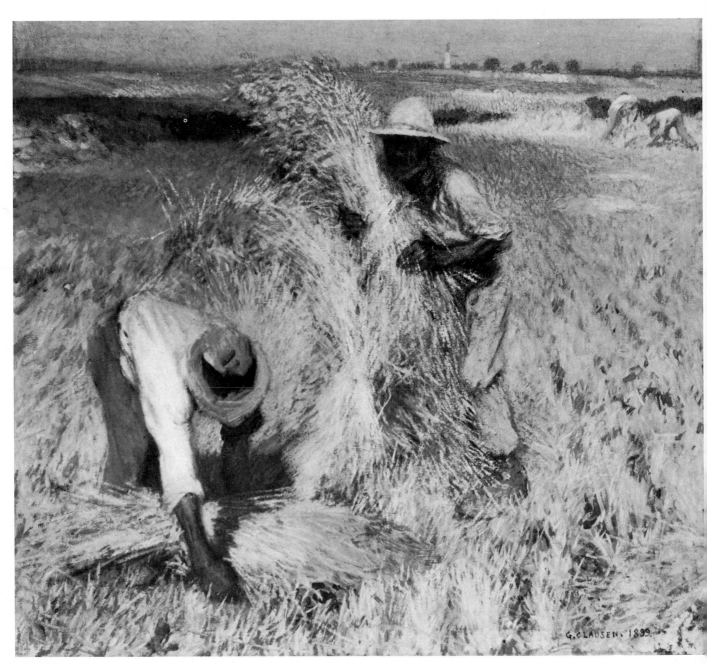

2 Sir George Clausen (1852–1944): *Harvesters cutting up sheaves.* 1899. Canvas, 21 ×
23 in. Courtesy of Sotheby & Co.

In his best work Clausen presents an unpretentious and sturdy vision of country
life, which relates him both to Millet and the *plein-airistes* and to the English
tradition of rural genre painting as seen for example in Fred Walker.

3 Dame Laura Knight (1877–1970): *On the cliff.* 1916. Canvas, 24 × 30½ in. London, The Fine Art Society Ltd

With direct, freshly painted scenes such as this, Laura Knight achieved her initial success, showing a sensitivity not much in evidence in her later treatment of circus and ballet subjects.

4 Henry Scott Tuke (1858–1933): *Lying on the beach.* 1885. Canvas, 21 × 37 in. Courtesy of Sotheby & Co.

Though active in the New English Art Club and the Royal Academy, Tuke spent most of his life in Cornwall, where he celebrated the charms of its coastline and the looks of its youthful population.

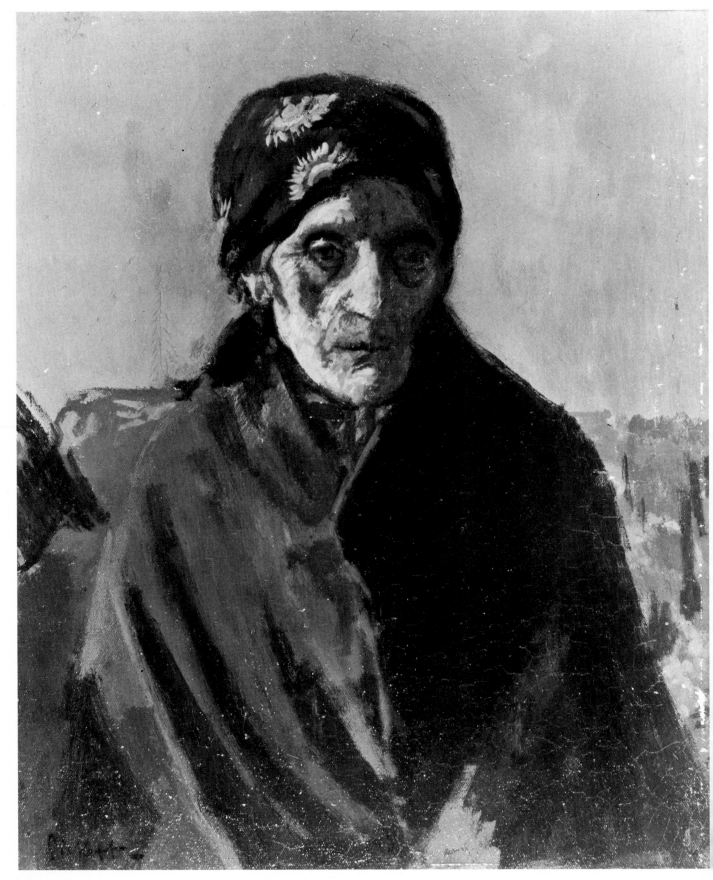

5 Walter Richard Sickert (1860–1942): *Mamma Mia Poveretta*. 1903. Canvas, 16$\frac{1}{8}$ × 22$\frac{3}{8}$ in. Manchester, City Art Gallery

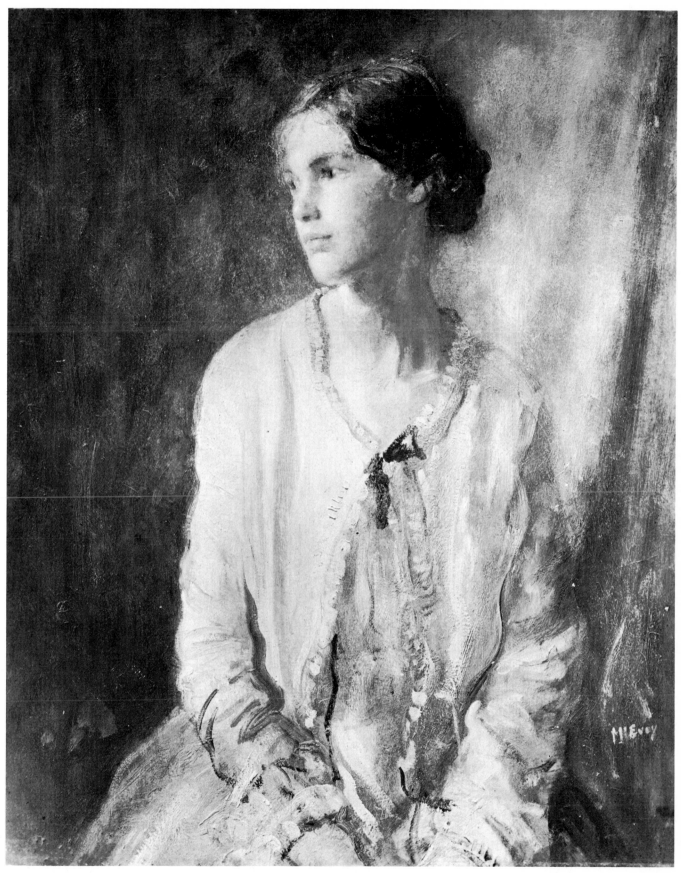

6 Ambrose McEvoy (1878–1927): *Silver and grey (Mrs McEvoy)*. 1915. Canvas, 33 ×
28 in. Manchester, City Art Gallery

McEvoy's gifts, seen in this study, were eroded by such a demand for society
portraits that one critic, in the First World War, commented that in a time of sugar
shortage McEvoy was 'a positive asset to the nation'.

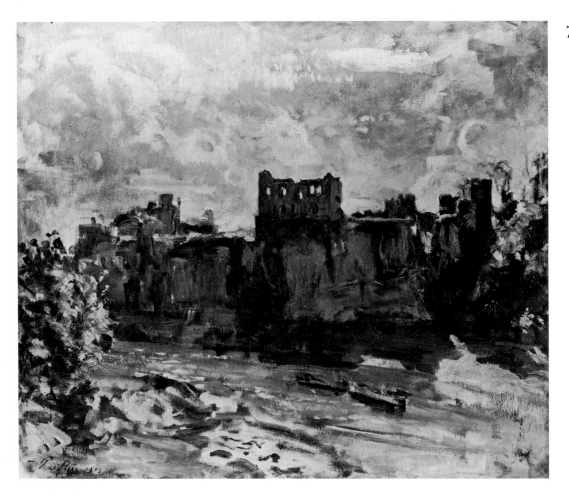

7 Philip Wilson
Steer (1860–
1942): *Chepstow
Castle*. 1905.
Canvas, 30⅛ ×
36⅛ in. London,
Tate Gallery

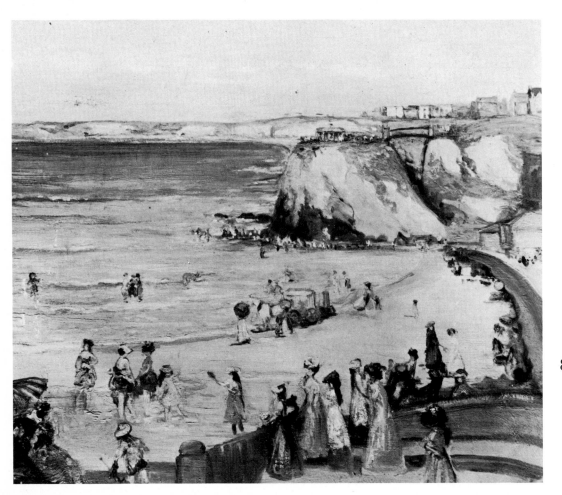

8 Charles Conder
(1868 – 1909):
*Newquay*. 1906.
Canvas, 25¼ ×
30⅜ in. Liverpool,
Walker Art Gal-
lery

9 Maxwell Armfield (1881–1972): *The tunnel*. 1905. Canvas, $10\frac{1}{2} \times 13\frac{1}{2}$ in. London, Private Collection

Armfield's elaborate tempera portraits owe much to his study of early Flemish art. *The tunnel*—a study of the underground at Oxford Circus—is a less formal work, more in keeping with his output as an illustrator.

10 Spencer Gore (1878–1914): *The Mad Pierrot Ballet, the Alhambra*. About 1905. Canvas, $17 \times 12\frac{1}{4}$ in. Private Collection

Gore's natural appreciation of the theatre—he himself acted—was stimulated by Sickert, whom he met at about the time this picture was painted.

11 Sir Frank Brangwyn (1867–1956): *Fisherwomen*. 1911. Canvas, 46½ × 57½ in. Bradford, Cartwright Hall

Brangwyn achieved an astonishing world-wide reputation as a muralist who, with muscular rhetoric and opulent colour, specialized in scenes of trading, shipping and industry and in lavish re-creations of history for patrons who enjoyed such high meat. Here he can be appreciated on a less gargantuan scale.

12 Sir William Nicholson (1872–1949): *Portrait of Walter Greaves*. 1917. Canvas, 75 × 56½ in. Manchester, City Art Gallery

Brangwyn can be accounted in every way the opposite of Nicholson, one of the most delicate painters of the period. At his best in landscape and still-life (*Plate 90*), some of his portraits achieve an individual elegance and feeling for character—as in this of the painter Greaves, one-time assistant to Whistler.

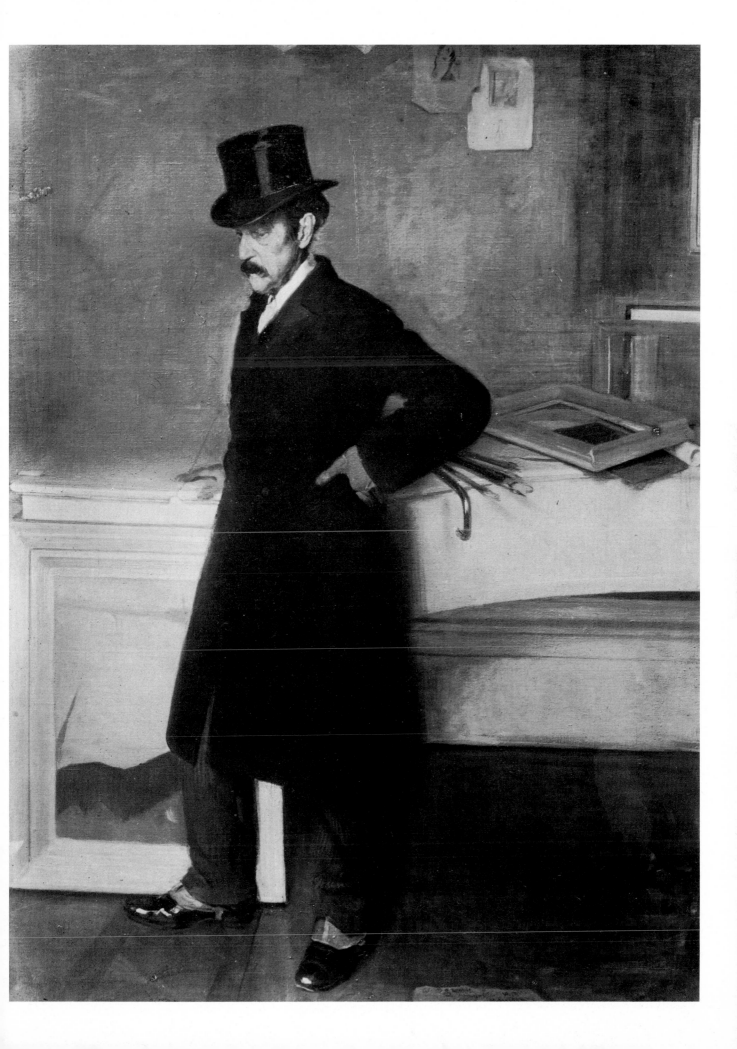

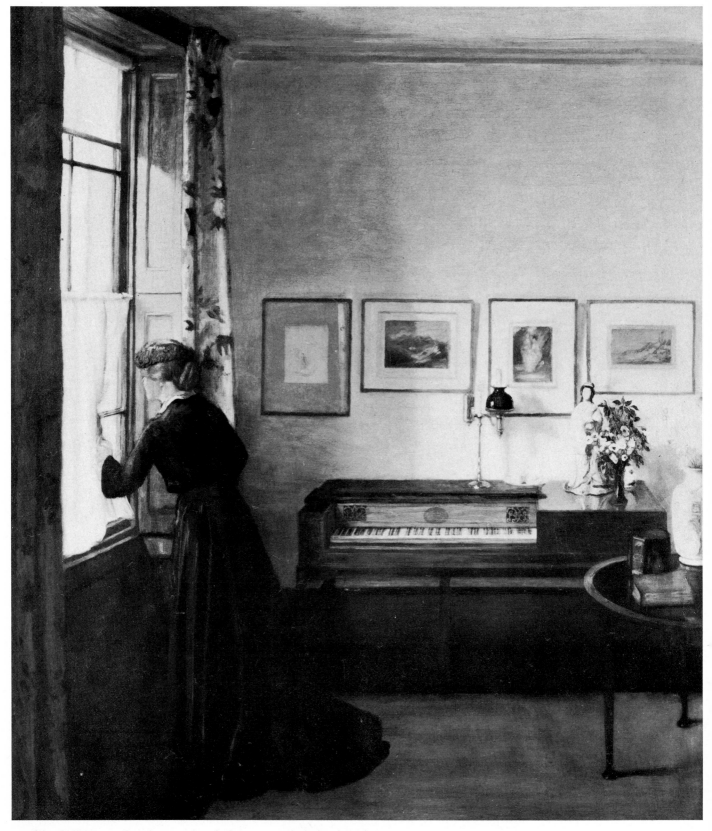

13 Sir William Rothenstein (1872–1945): *An interior*. 1901. Canvas, 39 × 35 in.
Peyton Skipwith, Esq.

14 Henry Lamb (1883–1960): *Purple and gold: A portrait of Edie McNeill*. 1911. Canvas,
24 × 19¼ in. Collection of A. R. B. Burrows, Esq.

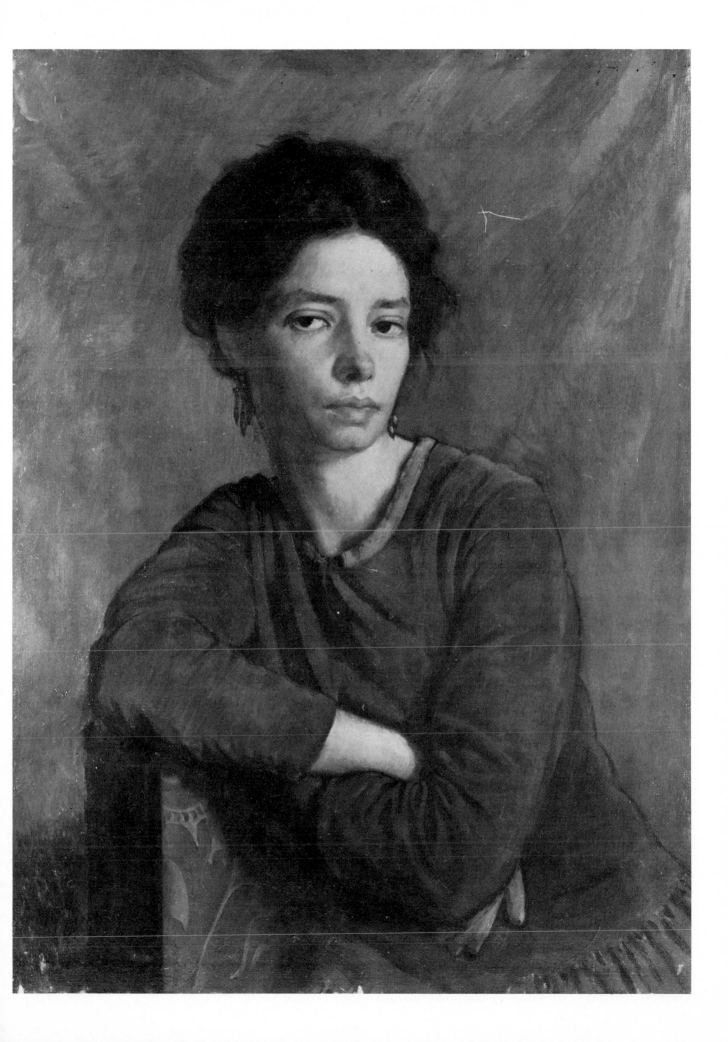

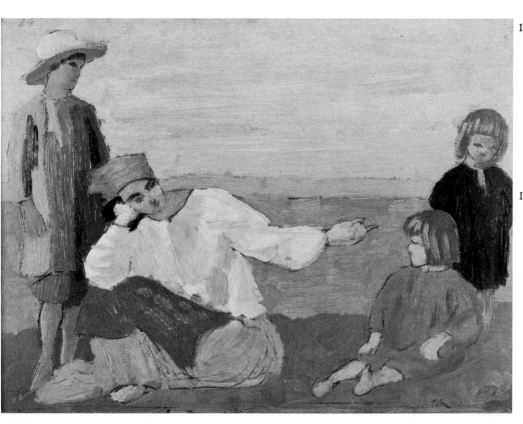

15 Augustus John (1878–1961): *Dorelia with three children at Martigues*. 1910. Canvas, 9¼ × 12¾ in. Cambridge, Fitzwilliam Museum

16 Vanessa Bell (1879–1961): *Studland Beach*. 1911. Canvas, 30 × 40 in. London, Tate Gallery

The haunting reticence of feeling and bold simplification of *Studland Beach* characterize much of Vanessa Bell's contribution to English modernism.

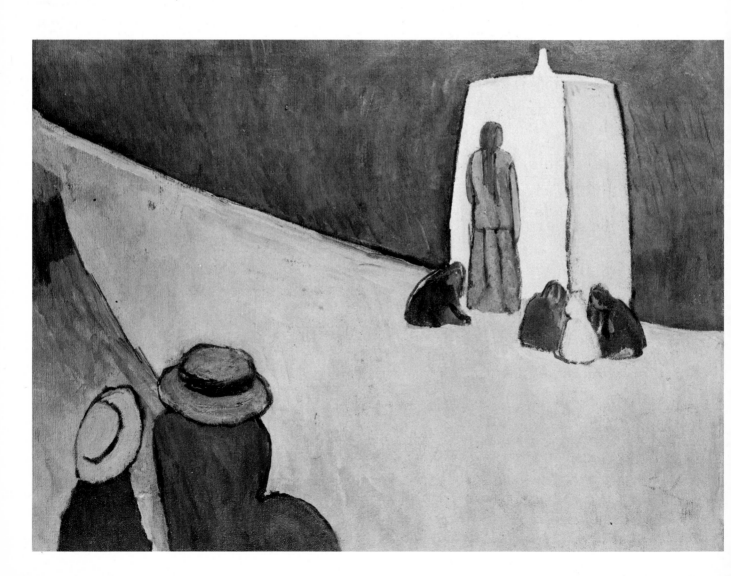

17 Roger Fry (1886–1934): *Farm buildings in France*. About 1912. Canvas, 26 × 32 in. University of Hull, The Art Collection

Some of Fry's most attractive landscapes belong to this period during which his admiration for Cézanne is registered with confident excitement.

18 Lucien Pissarro (1863–1944): *Well Farm railway bridge, Acton*. 1907. Canvas, 18 × 21½ in. Leeds, Collection of the Leeds City Art Galleries

Clearly echoing his father Camille Pissarro's London landscapes (1870–1), Lucien's choice of subject was still regarded as 'unpromising' when the picture was shown at the Camden Town Group exhibition of June 1911.

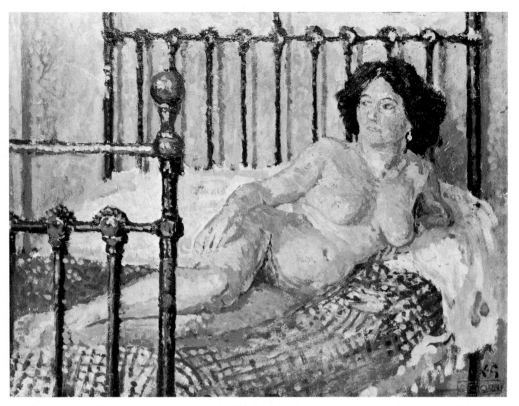

19 Spencer Gore (1878–1914): *Nude female figure on a bed*. 1910. Canvas, 12 × 16 in. Bristol, City Art Gallery

20 Walter Richard Sickert (1860–1942): *Le lit de cuivre*. 1905–7. Canvas, 16⅛ × 20 in. Exeter, Royal Albert Memorial Museum

It is with such pictures as these that the Camden Town painters extended the possibilities of subject-matter by their frank adherence to contemporary life. Gore's temperate vision strongly contrasts with Sickert's brooding reclamation of light.

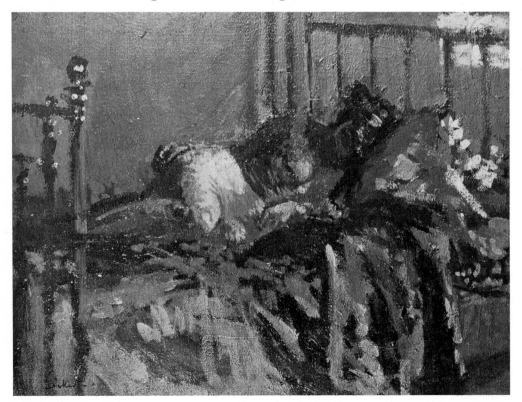

Five o'clock and the cup is empty. The girl sits on in a moment of forlorn indecision. Gilman suggests all this without a trace of sentimentality; his uncompromising view of reality is seen here in all its strength.

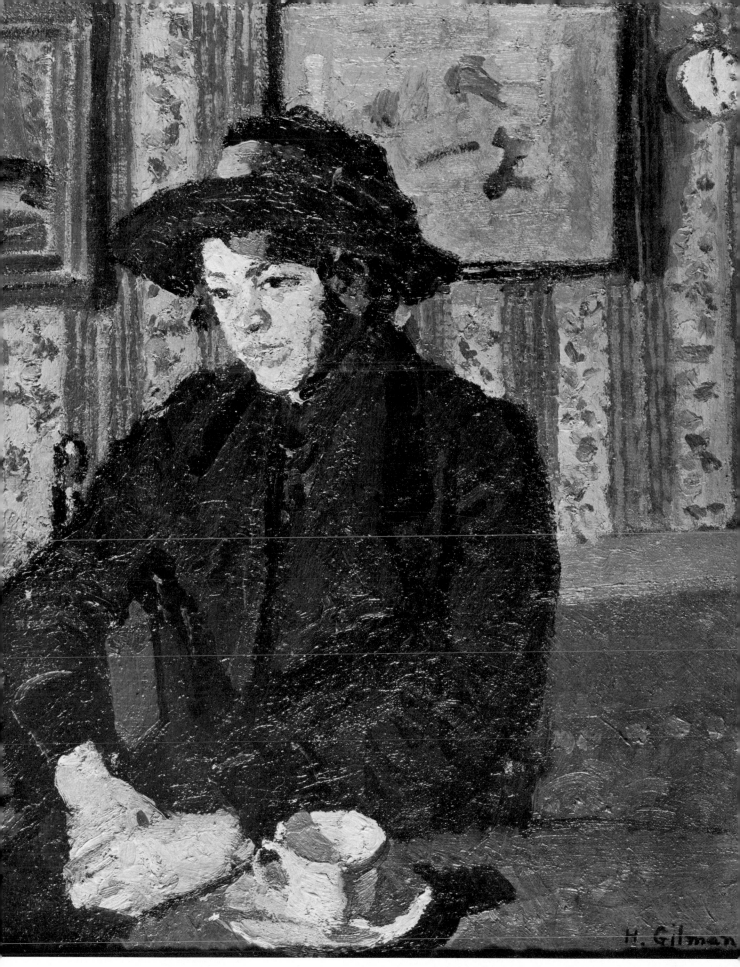

21 Harold Gilman (1876–1919): *Girl with teacup*. About 1914. Canvas, 24 × 20 in.
London, Thos. Agnew & Sons Ltd.

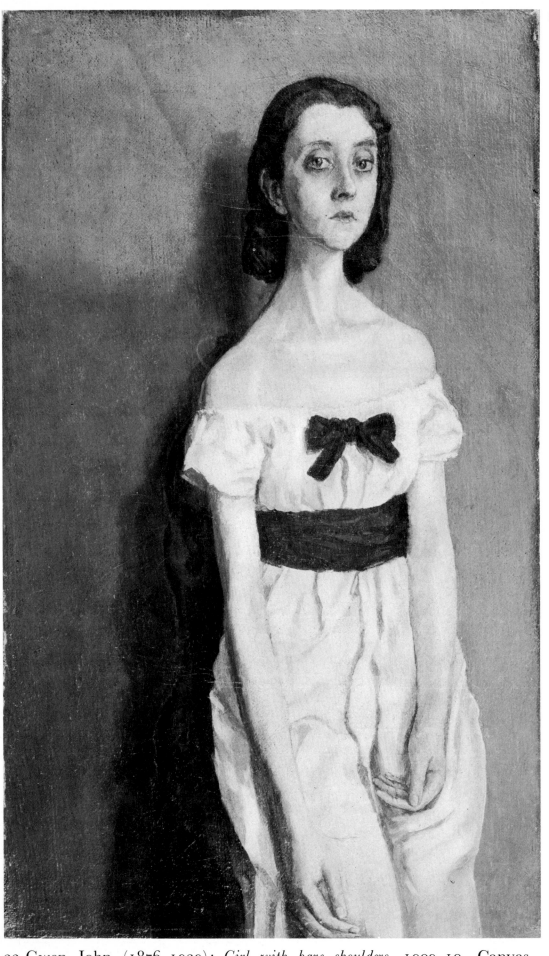

23 Gwen John (1876–
1939): *Dorelia by
lamplight, Toul-
ouse.* 1903–4. Can-
vas, $21\frac{1}{2} \times 12\frac{1}{2}$ in.
Private Collec-
tion

In the earlier pic-
ture (*right*) Gwen
John has painted
her future sister-
in-law Dorelia
with all that sub-
tle appreciation of
vulnerable youth
and tonal sensi-
tivity which are
the hallmarks of
her work. In the
later painting
(*left*) her unswerv-
ing honesty and
trust in her
medium implant
a touch of cruelty
in this compelling
delineation of
character.

22 Gwen John (1876–1939): *Girl with bare shoulders.* 1909–10. Canvas,
$17\frac{1}{8} \times 10\frac{1}{4}$ in. New York, Museum of Modern Art

24 Mark Gertler (1891–1939): *The Rabbi and his grandchild.* 1913. Canvas, 19 × 18 in. Southampton Art Gallery

Gertler's early years were spent almost entirely in the closed world of the Jewish quarter of London's East End. It was a world which offered subjects of a timeless stability during the upheaval of his education at the Slade School and the possible directions following on from his discovery of Post-Impressionism.

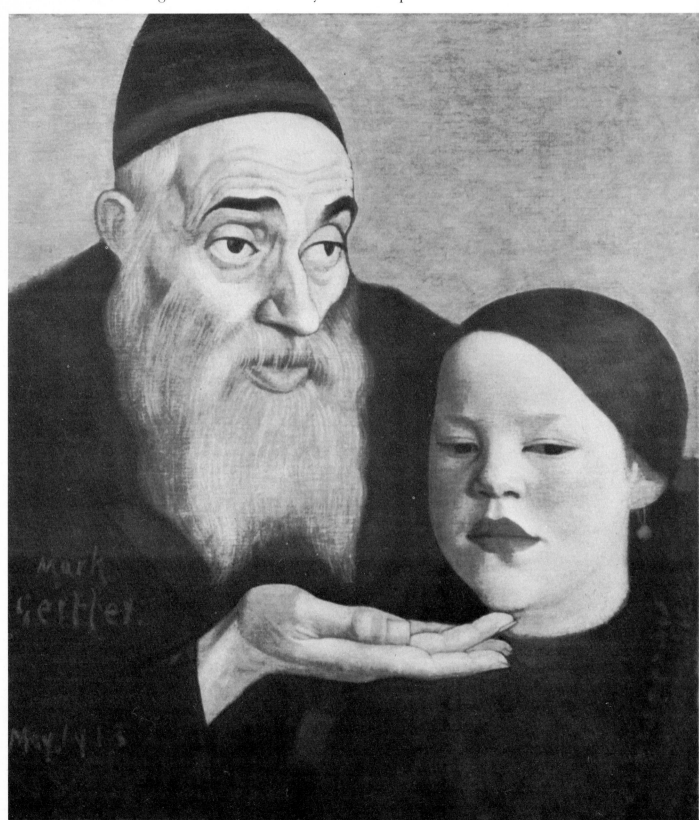

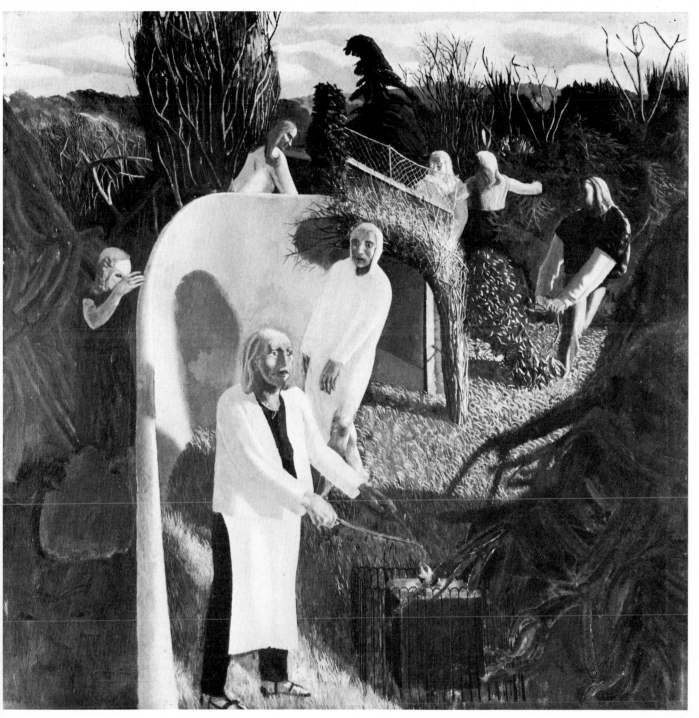

25 Sir Stanley Spencer (1891–1959): *Zacharias and Elizabeth*. 1912–13. Canvas, 60 × 60 in. Private Collection

This painting belongs to that early group of pictures carried out by Spencer before the First World War in which, with exalted fervour of vision, he depicted various Biblical events taking place among the houses of his native village of Cookham and the surrounding fields of Berkshire. It shows the visitation of an angel to the elderly priest Zacharias, who is making a sacrifice, to tell him that his wife Elizabeth (in the centre) 'shall bear thee a son, and thou shalt call his name John'. At the time of these works—*Joachim among the shepherds* (1912) is another—Spencer was immersed in the early Italian masters especially Giotto and Fra Angelico—known to him mainly from black and white reproductions. Rossetti and Gauguin were also influential on the formation of his style.

26 John Singer Sargent (1856–1925): *Mosquito nets*. 1908. Canvas, $22\frac{1}{4} \times 28\frac{1}{4}$ in. Ormond family collection

Painted in the summer of 1908 in Majorca where Sargent took a holiday with his sister Emily (on the left) and Elizabeth Wedgwood, a great granddaughter of Josiah Wedgwood. It is in such 'shirt-sleeve order' sketches that Sargent showed his small but exuberant natural talent. When he began to exhibit such studies it was almost the first time that the public at large gathered some notion of what 'that beastly thing' Impressionism was.

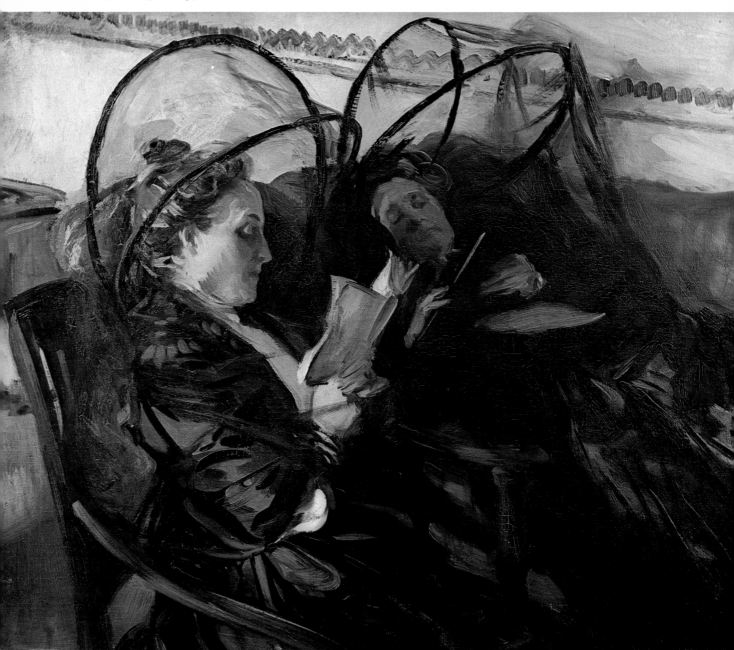

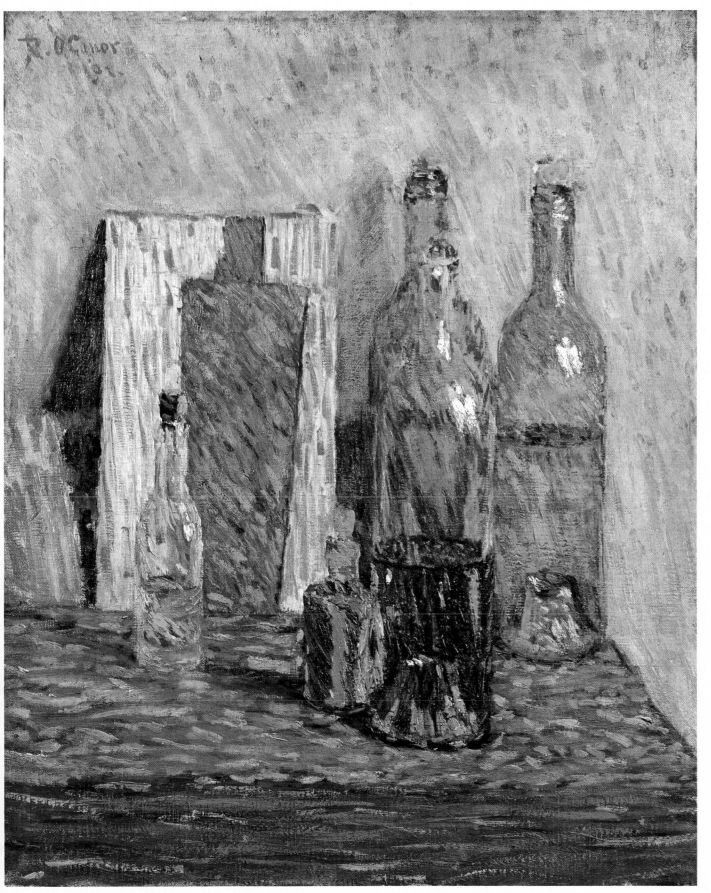

27 Roderic O'Conor (1860–1940): *Still-life with bottles*. 1892. Canvas, $21\frac{3}{4} \times 18\frac{1}{4}$ in.
London, Tate Gallery

28 Charles Ginner (1878–1952): *The circus*. 1912. Canvas, 30 × 24 in. Leeds City Art
Galleries

29 Malcolm Drummond (1880–1945): *Hammersmith Palais de Dance*. About 1920.
Canvas, 28 × 19¾ in. Plymouth, City Museum and Art Gallery

30 James Dickson Innes (1887–1914): *Welsh mountain landscape*. About 1912. Canvas, $12\frac{1}{2} \times 15\frac{1}{2}$ in. Manchester, City Art Gallery

Two events in Innes's short career are of outstanding importance. The first was his visit to Collioure in south-west France, the scene a few years earlier of Matisse and Derain's crucial stay. The second was his meeting with Augustus John and their close accord on painting trips to the Arenig Mountain area in Wales in 1911 and 1912. Innes's glowing colour is given added force by an essentially Celtic apprehension of the landscape.

31 Spencer Gore (1878–1914): *Harold Gilman's House, Letchworth*. About 1912. Canvas, 25 × 30 in. Leicester Museum and Art Gallery

Spencer Gore rented Gilman's raw, new house in Letchworth, Hertfordshire in the hot, late summer of 1912. He produced there a series of landscapes of startling colour and emphatic geometry which were a culmination of his interest in the constructive implications of Cézanne and the potency of Fauve colour. With his London houses and interiors, they constitute one of the most distinguished groups of English paintings of the time.

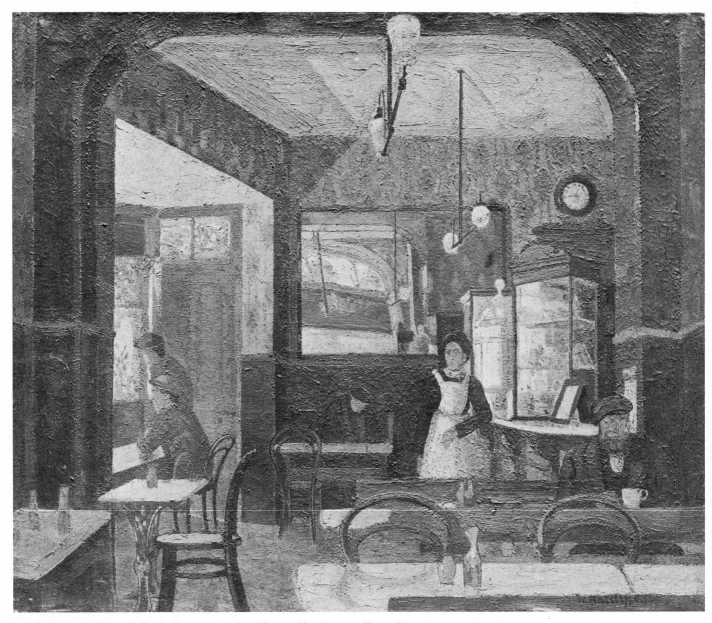

32 William Ratcliffe (1870–1955): *The coffee-house, East Finchley*. 1914. Canvas, 20 × 24 in. Southampton Art Gallery

Around the figures of Sickert, Gore, Gilman, Bevan and Ginner, there were some delightful lesser talents. Drummond (*Plate 29*) is the most interesting, and Ratcliffe, in a handful of inspired pictures, proved worthy of the others. Painted from drawings made in a North London coffee-house, where, as one critic has written, 'to all eternity the sunlight plays listlessly upon stale buns and shiny tables.'

33 Harold Gilman (1876–1919): *Tea in the bed-sitter*. About 1912. Canvas, $27\frac{3}{4} \times 35\frac{3}{4}$ in. Huddersfield Art Gallery

Ratcliffe's debt to Gilman is evident at a glance at these two interiors. Dusty sunlight filters through on to the relentless wallpaper and cheap crockery. The two girls waiting, without much anticipation, for two guests recall Eliot's London typists home for their tea on winter afternoons.

34 Harold Gilman (1876–1919): *The eating house*. About 1914. Canvas, $22\frac{1}{2} \times 29\frac{1}{2}$ in.
Sheffield, City Art Gallery

35 Walter Richard Sickert (1860–1942): *Ennui*. About 1914. Canvas, $60 \times 44\frac{1}{4}$ in.
London, Tate Gallery

Pubs, theatres, coffee shops and eating houses were subjects common to most of the
Camden Town painters. Sickert's *Ennui*, of which there are several versions, is one
of the best known of all modern English pictures. To Virginia Woolf it suggested
'an old publican, with his glass on the table before him and a cigar gone cold at his
lips, looking out of his shrewd little pigs' eyes at the intolerable wastes of desolation
in front of him[?]. A fat woman lounges, her arm on a cheap yellow chest of
drawers, behind him. It is all over with them, one feels. The accumulated
weariness of innumerable days has discharged its burden on them. They are buried
under an avalanche of rubbish.'

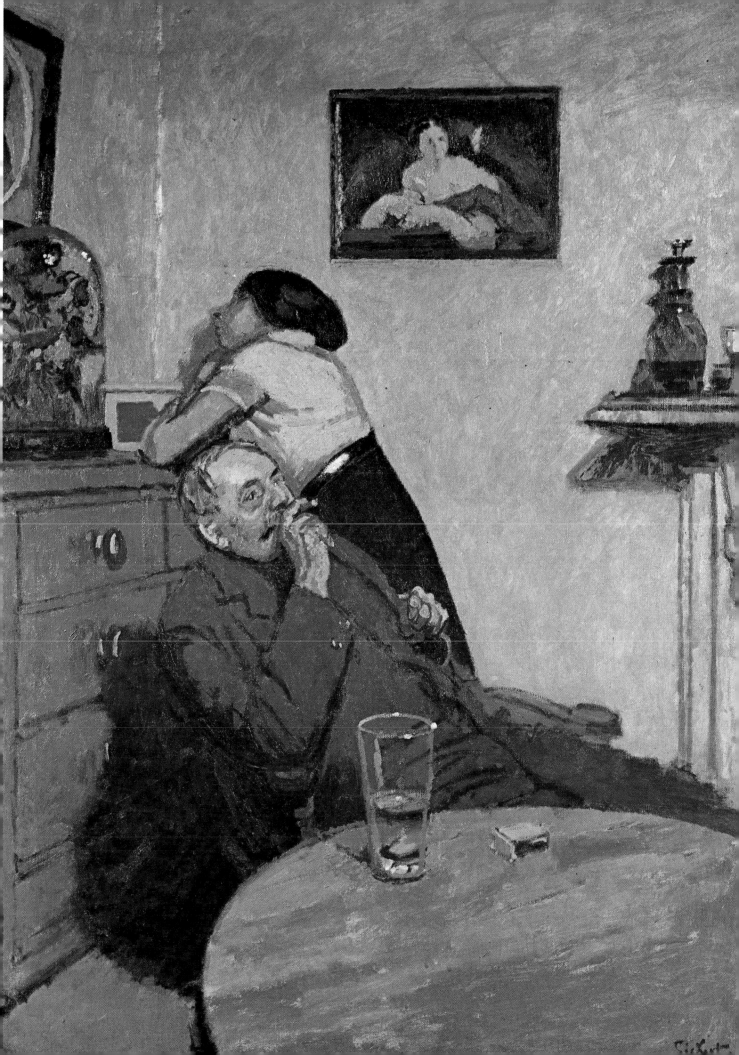

36 Duncan Grant (born 1885): *The Queen of Sheba*. 1912. Panel, $47\frac{1}{4} \times 47\frac{1}{4}$ in. London, Tate Gallery

The visits to London of Diaghilev's Russian Ballet before the First World War attracted several painters, not least Duncan Grant, to whom such works as *Schéhérazade* and *L'Oiseau de Feu* were revelations of colour and movement; Spencer Gore was another devotee. Something of the ballets' exotic effect can be seen in this picture, originally conceived as a mural decoration and one of the successes of the English section of the Second Post-Impressionist Exhibition. Eclectic as it is, it shows that lyrical, imaginative side of Grant's gifts which is evident in some of his decorative work and in the *Nymph and satyr (Plate 85)*.

37 Glyn Philpot (1884–1937): *L'après-midi Tunisien*. About 1921. Canvas, 50 × 52 in.
Private Collection

The camels in Grant's *Queen of Sheba* were inspired by a visit to Tunis, the setting for
this sultry and accomplished work by Glyn Philpot, the wry suggestiveness of
which seemed to escape most visitors to the Royal Academy where it was exhibited
in 1922. Philpot's later work debatedly benefited from a study of contemporary
French painting made on a stay in Paris in 1932.

38 Vanessa Bell (1879–1961): *Portrait of Mrs Hutchinson*. 1915. Oil on board, 29 × 22¾ in. London, Tate Gallery

The uncommissioned portrait produced some notable images at this period, not least from Vanessa Bell, whose brimming colour, sure design and somewhat mordant psychological approach are all here exemplified. 'It's a frightfully difficult arrangement,' she wrote, 'for I'm bang in front of her and everything is very straight and simple and delicate in colour.'

39 Sylvia Gosse (1881–1968): *The printer*. 1915–16. Canvas, 30 × 40⅜ in. Private Collection

Sylvia Gosse's meeting with Sickert in 1908 was, as for many another painter, momentous. She was perhaps his most talented pupil and he made her a partner in his school at Rowlandson House. Influenced by his touch and sense of composition, she also learnt etching from him and it is probably her own prints that are pinned above the press in this painting.

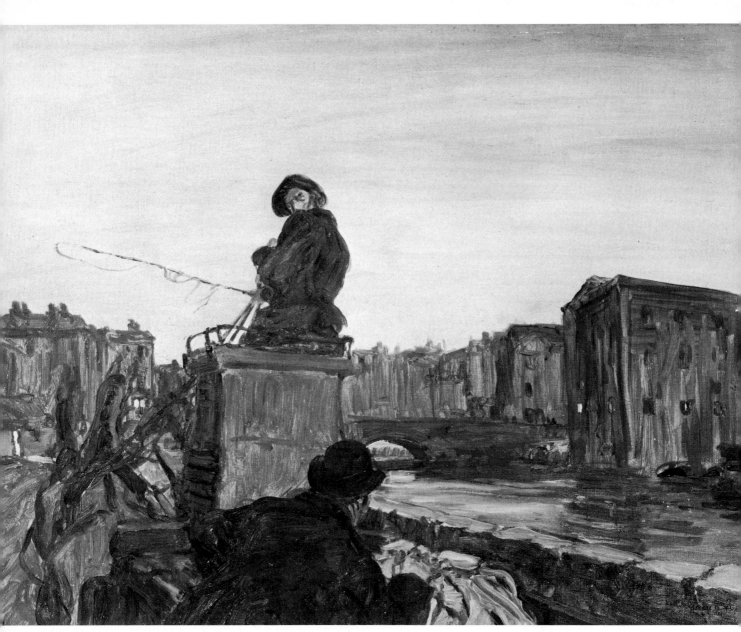

40 Jack B. Yeats (1871–1957): *A lift on the long car*. 1914. Canvas, 18 × 24 in. Leeds, Collection of the Leeds City Art Galleries

While the Scottish contribution to British painting this century has been notably strong—from the Colourists through Colquhoun to Davie and Gear—Ireland produced relatively few painters and of them Yeats achieved a considerable international following, dubbed by Kokoschka 'The Last of the Great Masters of the World'. *A lift on the long car* is typical of his early genre scenes of Dublin with their often expressionist intention and illustrative detail.

41 Alvaro Guevara (1894–1951): *Fast swim*. About 1915–16. Board, $26\frac{5}{8}$ × $17\frac{1}{4}$ in. Private Collection

Recently arrived from Chile, Guevara had been impressed by the Matisse room of the Second Post-Impressionist Exhibition and had further been encouraged by Sickert's everyday subject-matter. An exuberant chemistry ensued in paintings of cafés, dance-halls, theatres and swimming-pools. The structural freedom and gaiety of colour were superseded in Guevara's later portraits and surrealist-inspired work. Of the former his *The Editor of Wheels*, a portrait of Edith Sitwell (National Portrait Gallery, London) is the best known.

42 Sir Matthew Smith (1879—1959): *Nude: Fitzroy Street, No. 1.* 1916. Canvas, 34 × 30 in. London, Tate Gallery

After a long apprenticeship of much hesitancy and self-doubt, Smith emerged in his mid-thirties as a powerful draughtsman with a violent sense of colour (the body here is emerald, cobalt blue and ochre, the floor and wall vermilion). Though the psychological attitude to his subject is not yet attuned (*see Plate 67*), Smith already shows a mastery of formal implications.

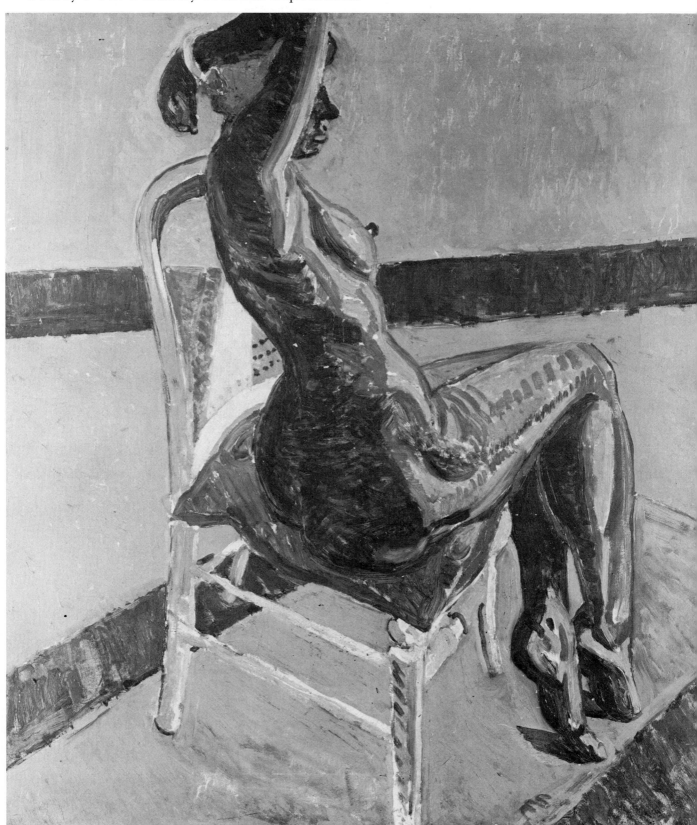

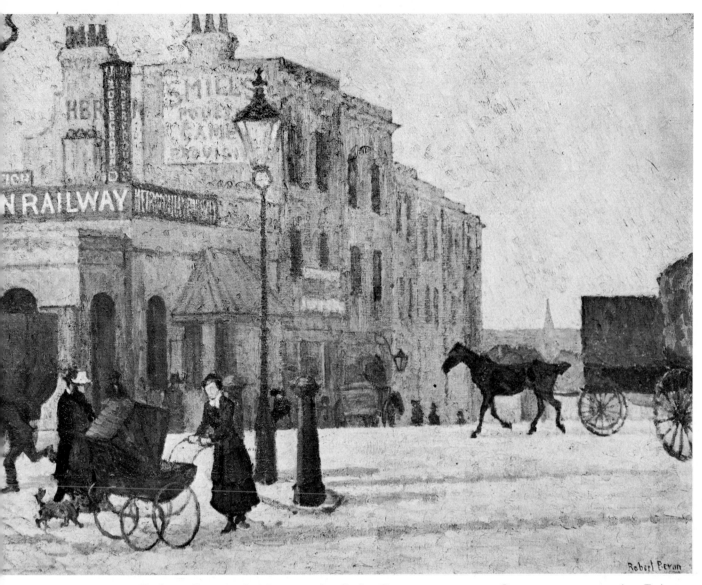

43 Robert Bevan (1865–1925): *Swiss Cottage*. 1912–13. Canvas, 24 × 32 in. Private Collection

Among English painters alert to developments abroad, Robert Bevan occupies a conspicuous place through his youthful study of Impressionism and his enthusiastic response to the work of Gauguin whom he met in Pont-Aven in 1893. It was not until his association with the Fitzroy Street Group of painters that his work became at all known, particularly those evocative and beautifully painted cabhorse scenes of 1910–12. The Swiss Cottage underground station was close to his home in North London.

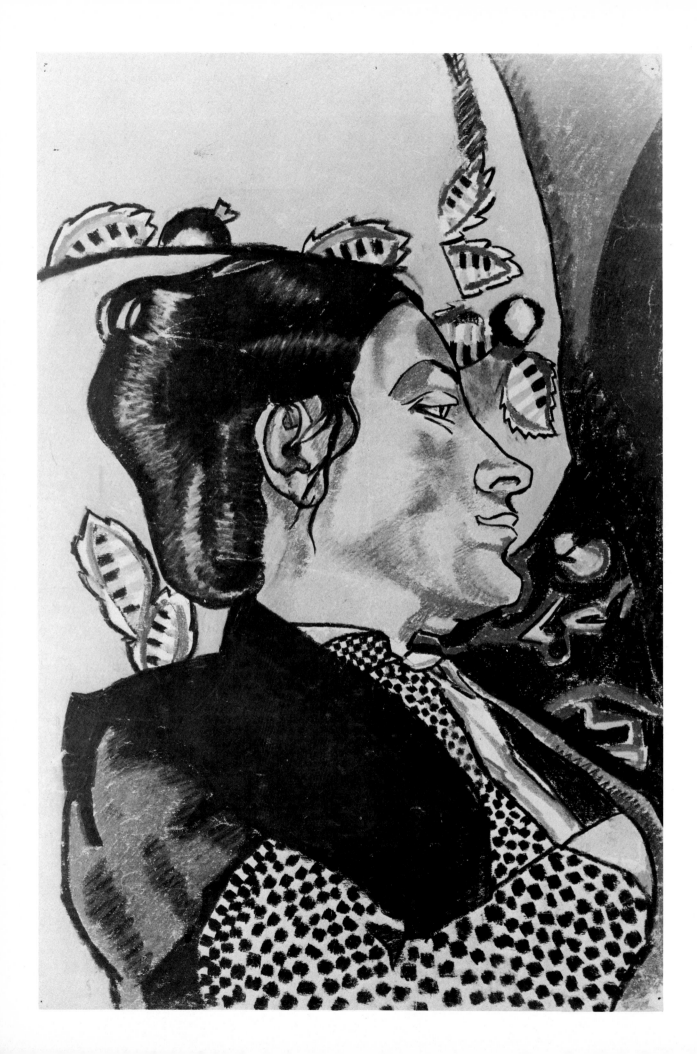

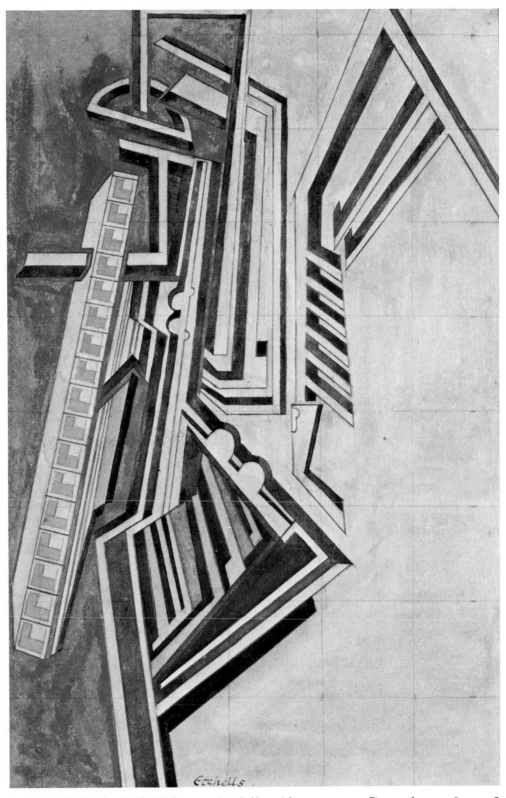

45 Frederick Etchells (1886–1973): *Stilts*. About 1914. Gouache, $12\frac{5}{8} \times 7\frac{7}{8}$ in. British Council Collection

44 Henri Gaudier-Brzeska (1891–1915): *Sophie Brzeska*. 1913. Pastel, 22 × $15\frac{1}{8}$ in. London, Tate Gallery

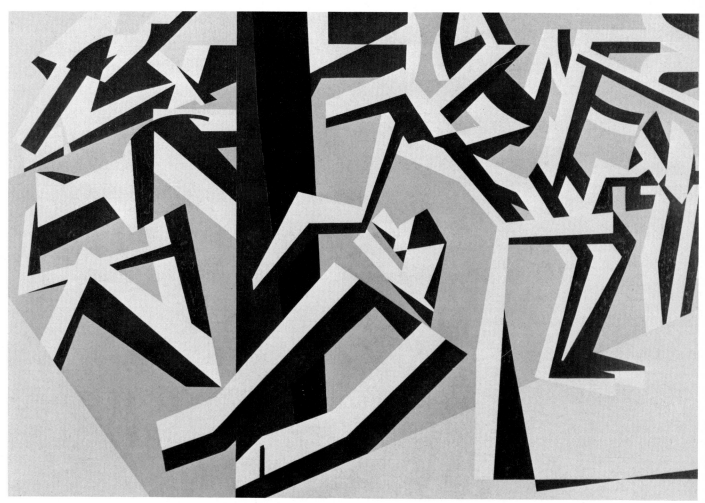

46 David Bomberg (1890–1957): *The mud bath*. 1914. Canvas, 60 × 88¼ in. London, Tate Gallery

Until recent years Bomberg suffered scandalous neglect, the more astonishing when one considers the critical attention he received in his early twenties. In Rothenstein's thirty-three essays on modern English painters (see bibliography) he is only mentioned in a few lists of names. In 1964 such pictures as *The mud bath* and *In the hold (Plate 59)* were heralded by one writer as standing out 'a mile' from everything else done in England under the first impact of the Cubist revolution and the Futurist firework display.' Although high claims have been made for the landscapes of his later years, Bomberg's early achievement remained unsurpassed in formal originality and the expression of a vital urban environment.

47 Lawrence Atkinson (1873–1931): *Abstract composition*. About 1914–15. Pencil and coloured crayons, 31½ × 21½ in. Private Collection

As with the Camden Town Group, certain lesser figures among the Vorticists were galvanized into their most creatively fertile work by contact with the leaders of the movement. Ratcliffe's *The coffee-house (Plate 32)* is quintessential Camden Town much in the way that this energetic composition contains several features of Vorticist painting. Little work by Atkinson is known from this period (he turned later to sculpture), but his personally distinguished colour sense is evident through it all.

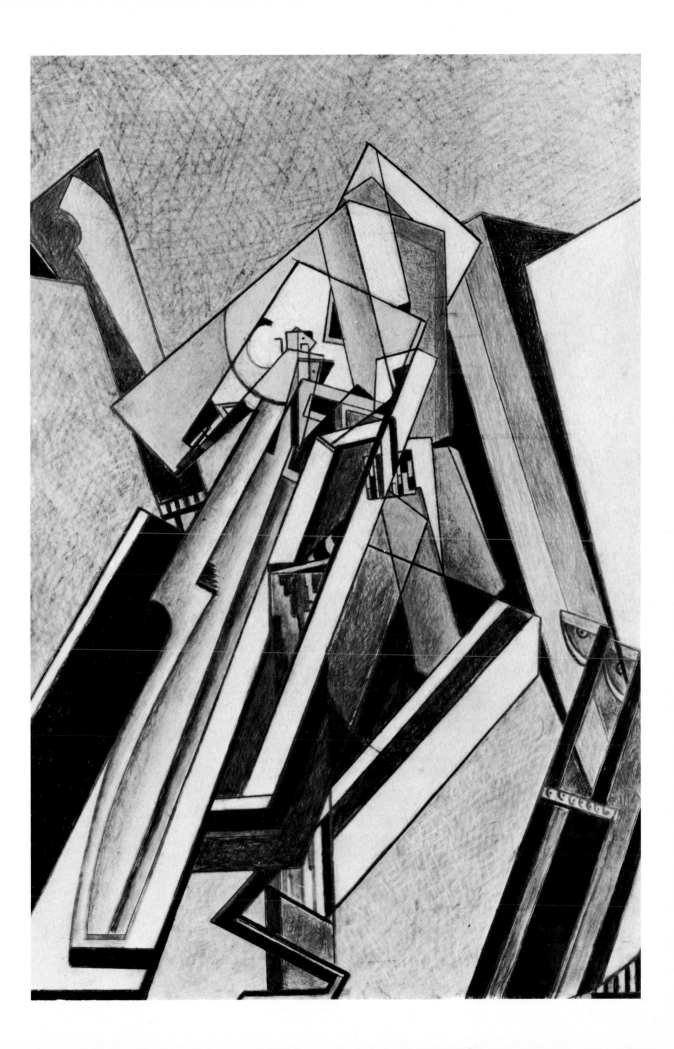

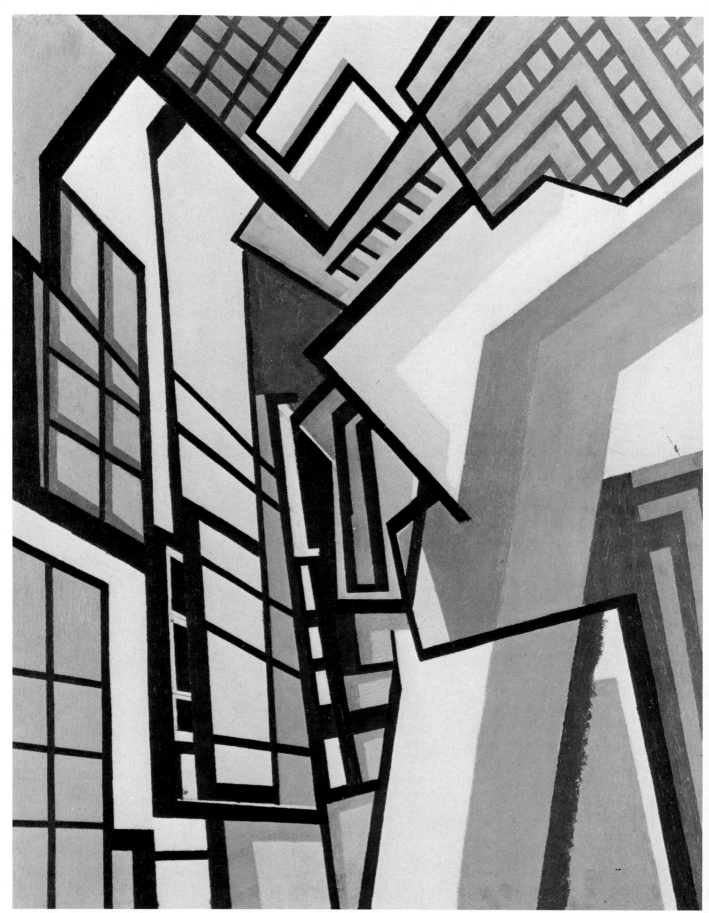

48 Wyndham Lewis (1882–1957): *Workshop*. About 1914–15. Canvas, 30⅛ × 24 in. London, Tate Gallery

49 Wyndham Lewis (1882–1957): *The crowd*. 1914–15. Oil and drawing on canvas, 79 × 60½ in. London, Tate Gallery

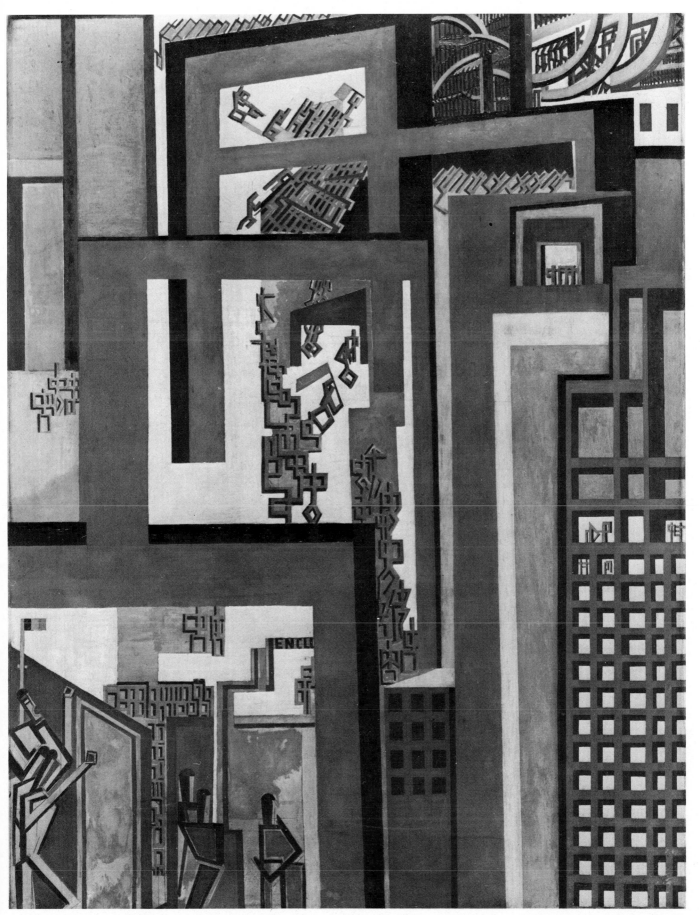

These two paintings must be accounted among the definitive expressions of Vorticist theory, combining a harsh, geometrical surface, bristling with points of stress and tense diagonals and a celebration (equivocal in *The crowd*) of communal activity and industry.

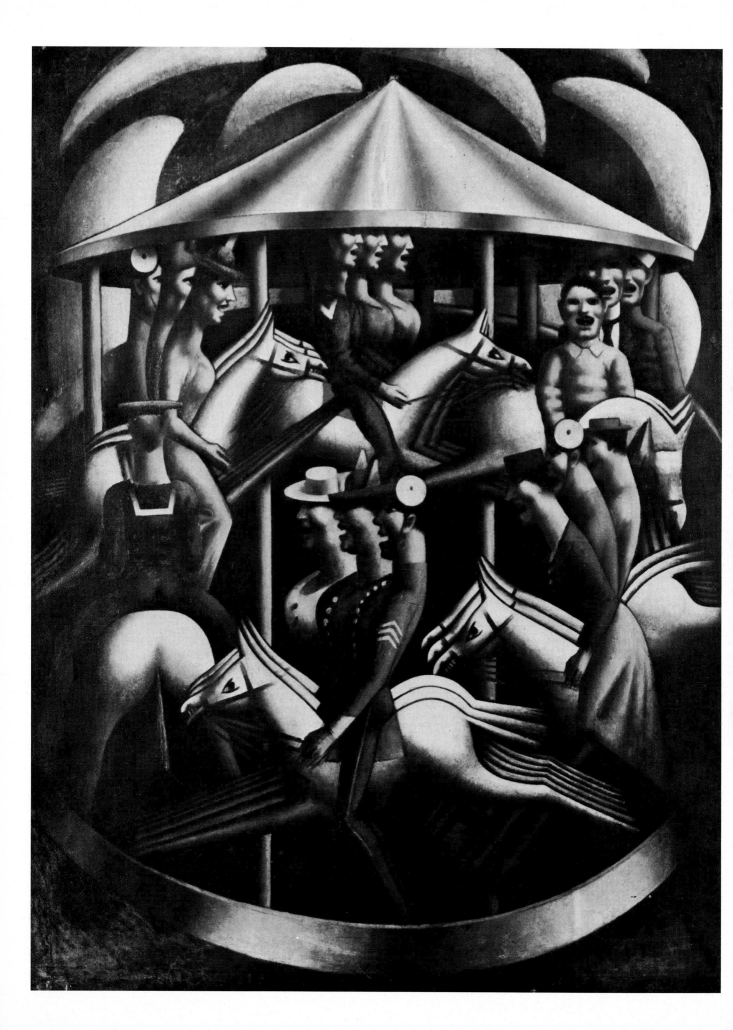

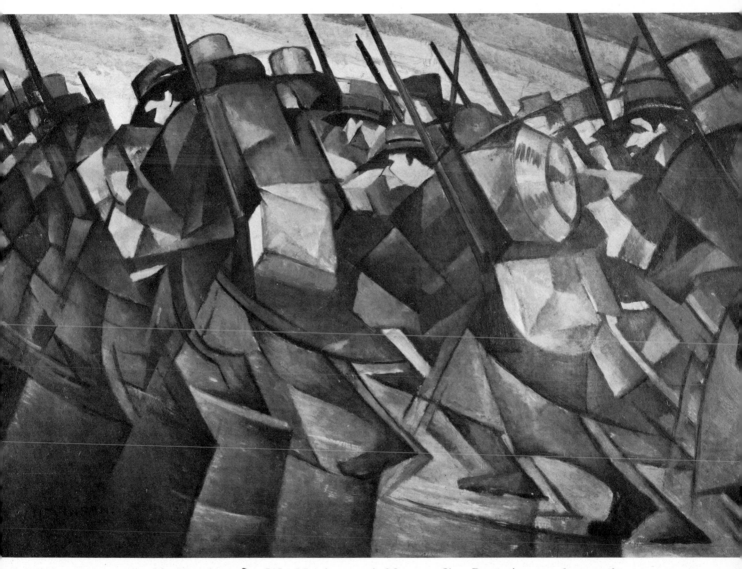

51 Christopher R. W. Nevinson (1889–1946): *Returning to the trenches*. 1914–15.
Canvas, 20 × 30 in. Ottawa, National Gallery of Canada

50 Mark Gertler (1891–1939): *The merry-go-round*. 1916. Canvas, 76 × 56 in. London,
Ben Uri Art Gallery

D. H. Lawrence wrote to Gertler about *The merry-go-round* that with its 'violent
mechanised rotation and complex involution, and ghastly, utterly mindless human
intensity of sensational extremity, you have made a real and ultimate revelation. I
think this picture is your arrival—it marks a great arrival.' (9 October 1916)

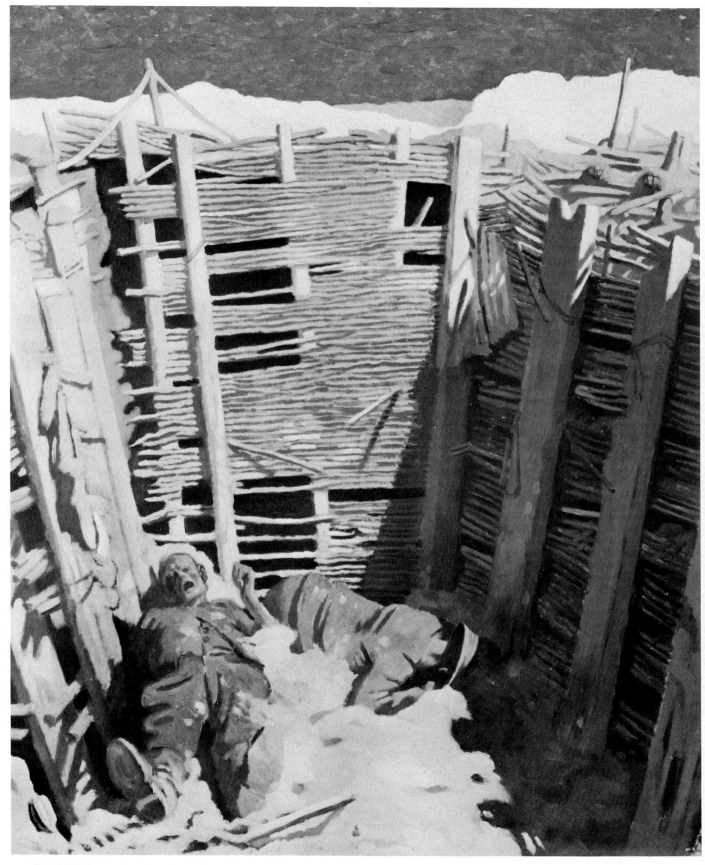

52 Sir William Orpen (1878–1931): *Dead Germans in a trench*. 1918. Canvas, 36 × 30 in. London, Imperial War Museum

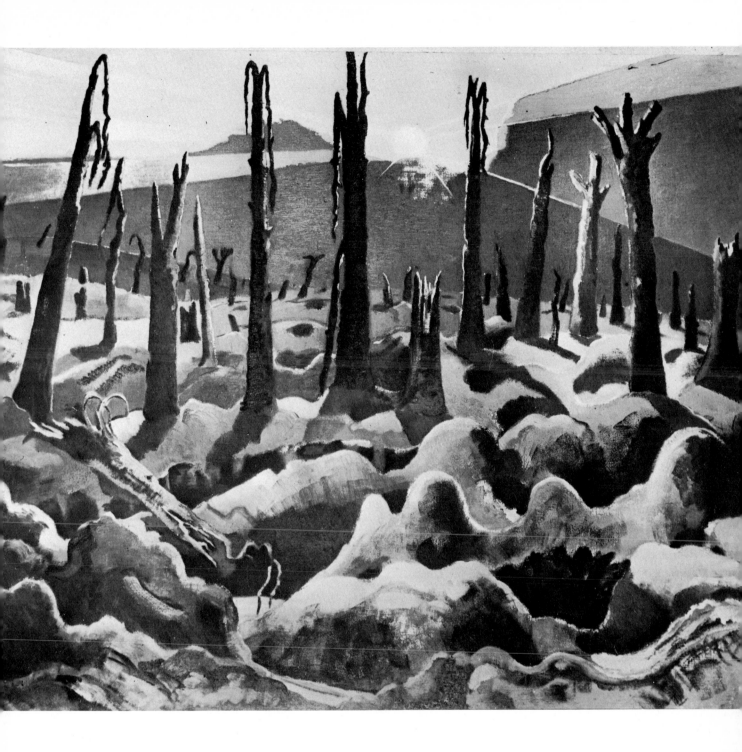

53 Paul Nash (1889–1946): *We are making a new world.* 1918. Canvas, 28 × 36 in. London, Imperial War Museum

Unlike the frank reportage of Orpen (*left*) or the brilliant journalism of Nevinson (*Plate 51*), Nash's war paintings jump from the world of the particular into an evocation of the senselessness of all war. With its bloody sky, unlimited desolation and bitter title it is one of the most haunting images of war made by an Englishman. The poet and critic Herbert Read had also been to the Front: 'All was black and upriven. In the valley the shell-holes were full of water and reflected the harsh cold sky. Devil's Wood was a naked congregation of shattered trunks, like an old broken comb against the skyline. This was his earth. . . . Now riven and violated . . . a black diseased scab, erupted and pustulous.'

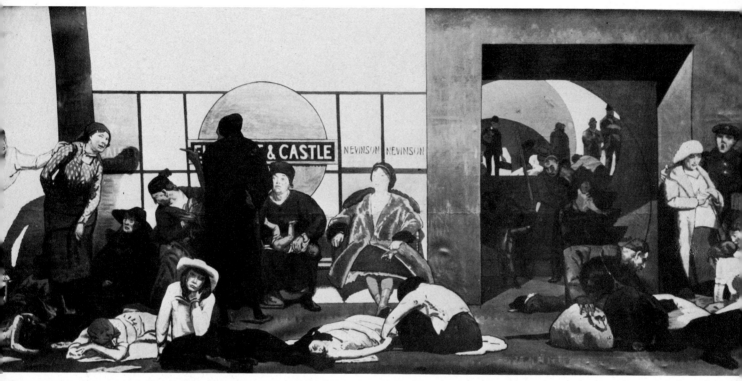

54 Walter Bayes (1869–1956): *The Underworld*. 1914. Canvas, 100 × 216 in. London, Imperial War Museum

55 Wyndham Lewis (1882–1957): *Red duet*. 1914. Pastel and gouache, $15\frac{1}{8} \times 22$ in. Private Collection

Writing in 1914, Lewis evoked the inevitability of certain formal arrangements, their almost sinister domination over the physical facts of external reality: 'In a painting certain forms MUST be so; in the same meticulous, profound manner that your pen or a book must lie on the table at a certain angle, your clothes at night be arranged in a set personal symmetry, certain birds be avoided, a set of railings tapped with your hand as you pass, without missing one.'

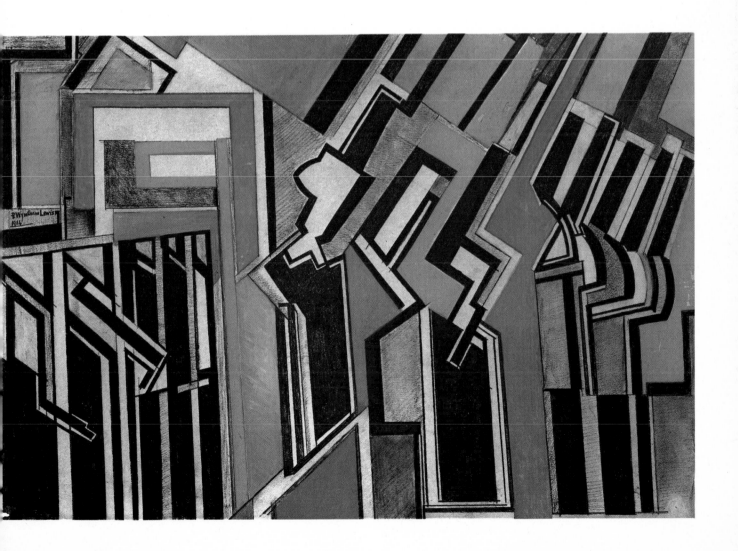

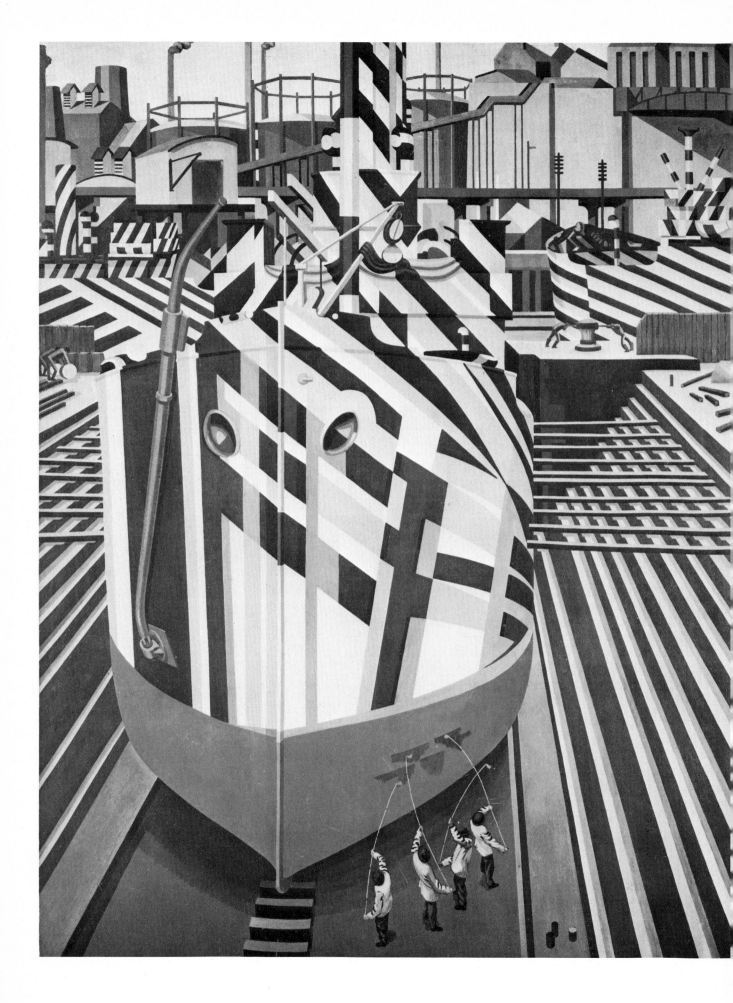

57 John Duncan Fergusson (1874–1961): *Damaged Destroyers*. 1918. Canvas, 29 × 30 in. London, Imperial War Museum

56 Edward Wadsworth (1889–1949): *Dazzle ships in dry dock at Liverpool*. 1919. Canvas, 119½ × 96 in. Ottawa, National Gallery of Canada

58 Edward Wadsworth (1889–1949): *Abstract composition*. 1915. Ink and gouache, 16½ × 13½ in. London, Tate Gallery

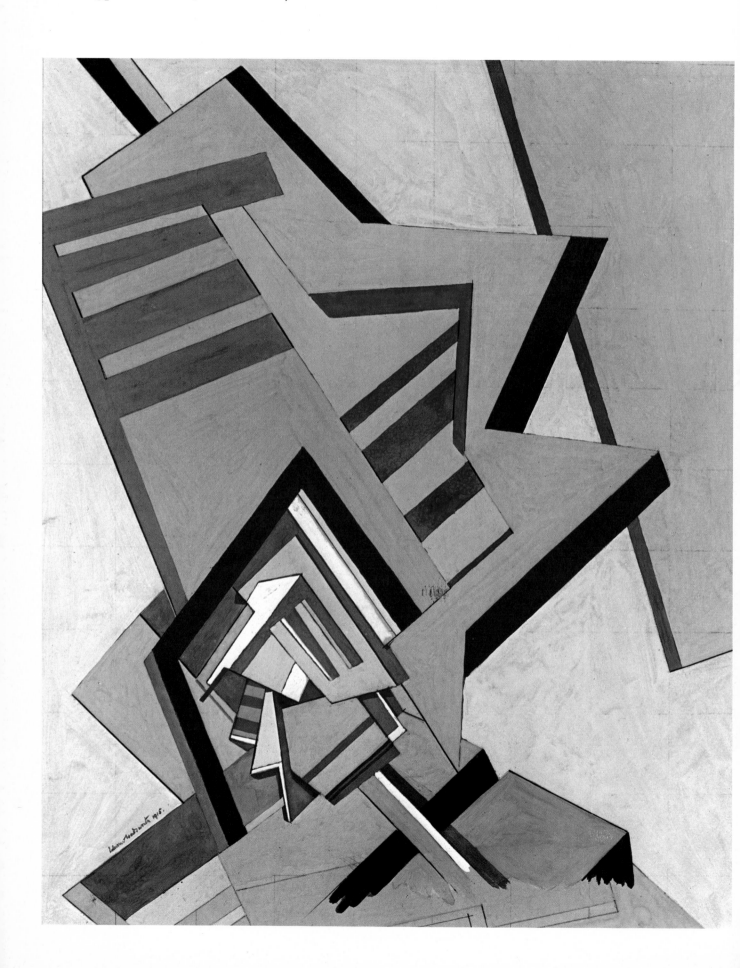

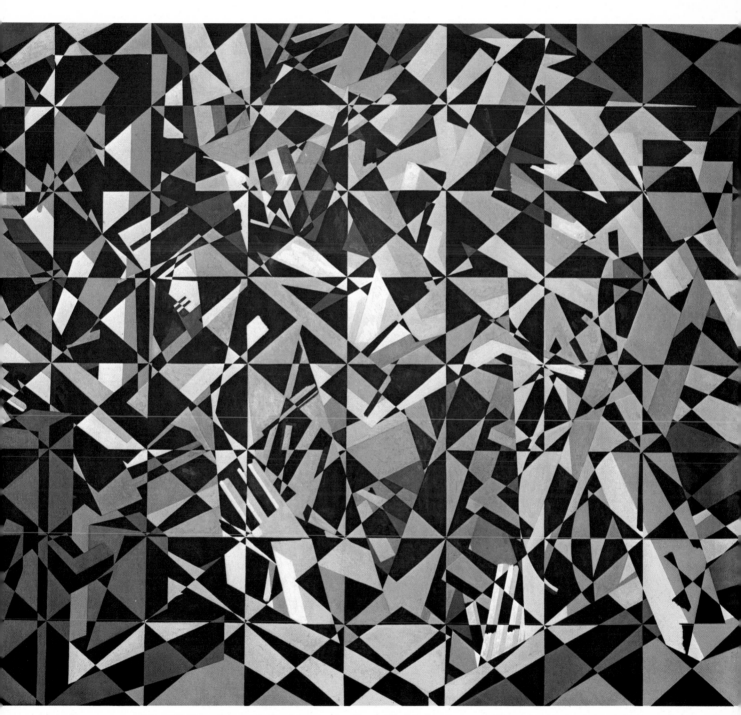

59 David Bomberg (1890–1957): *In the hold*. 1913–14. Canvas, $77\frac{1}{4} \times 91$ in. London, Tate Gallery

Attracting much respect and attention when first exhibited, Bomberg's huge canvas, suggested by men loading goods in the hold of a ship, can be seen as one of the few internationally substantial paintings of its period in England.

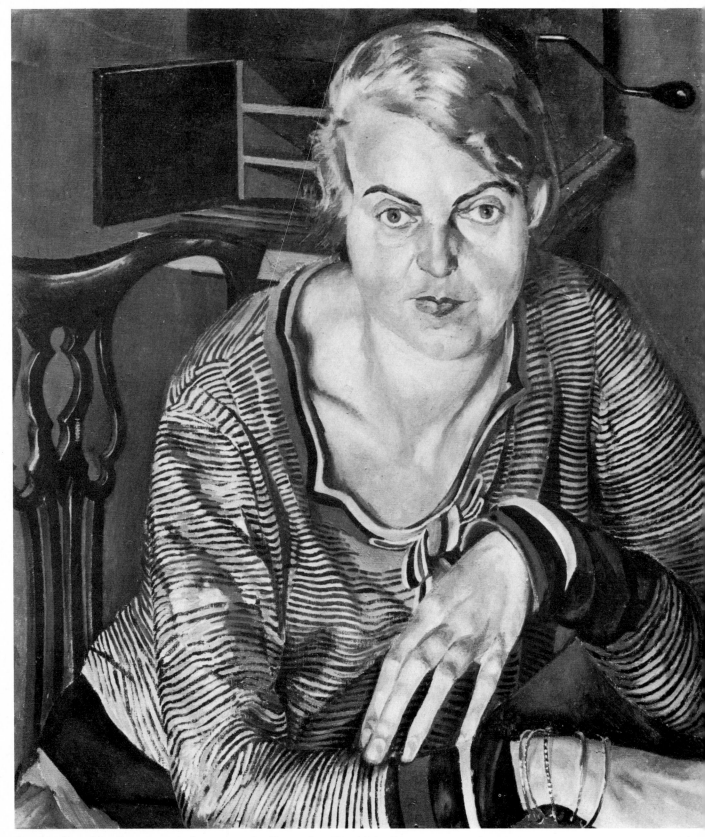

60 Sir Stanley Spencer (1891–1959): *Portrait of Patricia Preece*. 1933. Canvas, 33 × 29 in. Southampton Art Gallery

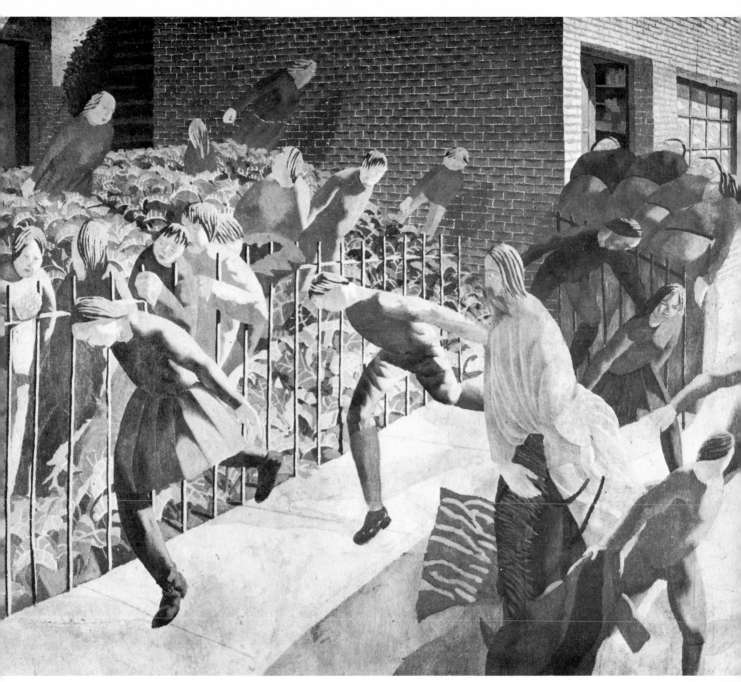

61 Sir Stanley Spencer (1891–1959): *Christ's entry into Jerusalem*. About 1920. Canvas, 45 × 57 in. Leeds, Collection of the Leeds City Art Galleries

Alongside Spencer's imaginative works (*Plates 25 and 61*) there are many perfectly straight landscapes and portraits which rely almost entirely on acute observation and immaculate Slade School technique. Some Cookham landscapes were done deliberately as pot-boilers. Other pictures, such as this portrait of his second wife, occupy a mid-way position of relaxed autobiography.

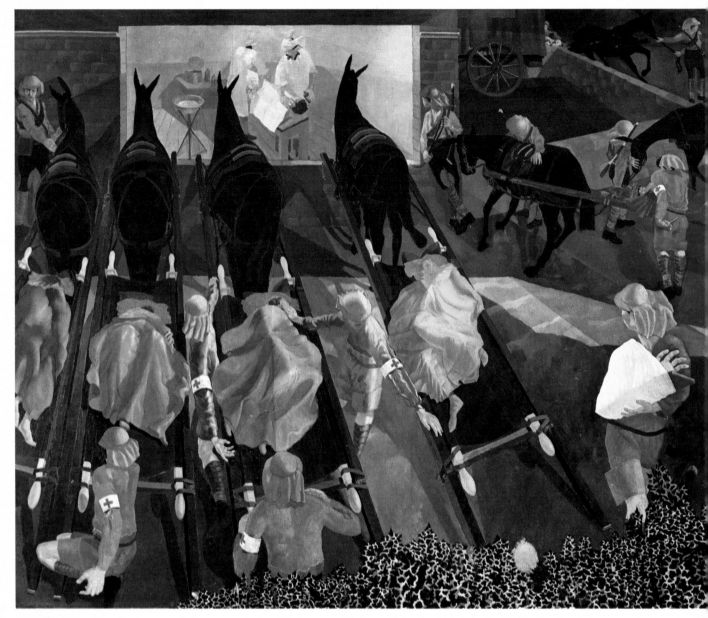

62 Sir Stanley Spencer (1891–1959): *Travoys arriving with wounded—Smol, Macedonia.*
1919. Canvas, 72 × 86 in. London, Imperial War Museum

Unlike Paul Nash (*Plate 53*), Spencer's war experiences as a Red Cross orderly
and soldier in Macedonia continued to provide subjects in later years, culminating
in the Burghclere Memorial Chapel finished in 1933. The present picture,
commissioned by the Ministry of Information, shows wounded men on stretchers
arriving by mule at a small Greek church near Smol used one night as a temporary
dressing-station.

63 William Roberts (born 1895): *The cinema.* 1920. Canvas, 36 × 30 in. London, Tate
Gallery

Right from the beginning of his career, Roberts, like Spencer, favoured complex
figurative compositions taken from the urban milieu—sports and street games,
dancing, boxing, diners in a restaurant and, as here, a performance at the movies.
The resemblance of audience and actors does not escape Roberts's sly and satirical
observation. It has been estimated that in 1919, the year before this picture was
painted, half the population of Britain went to the cinema twice a week or more.

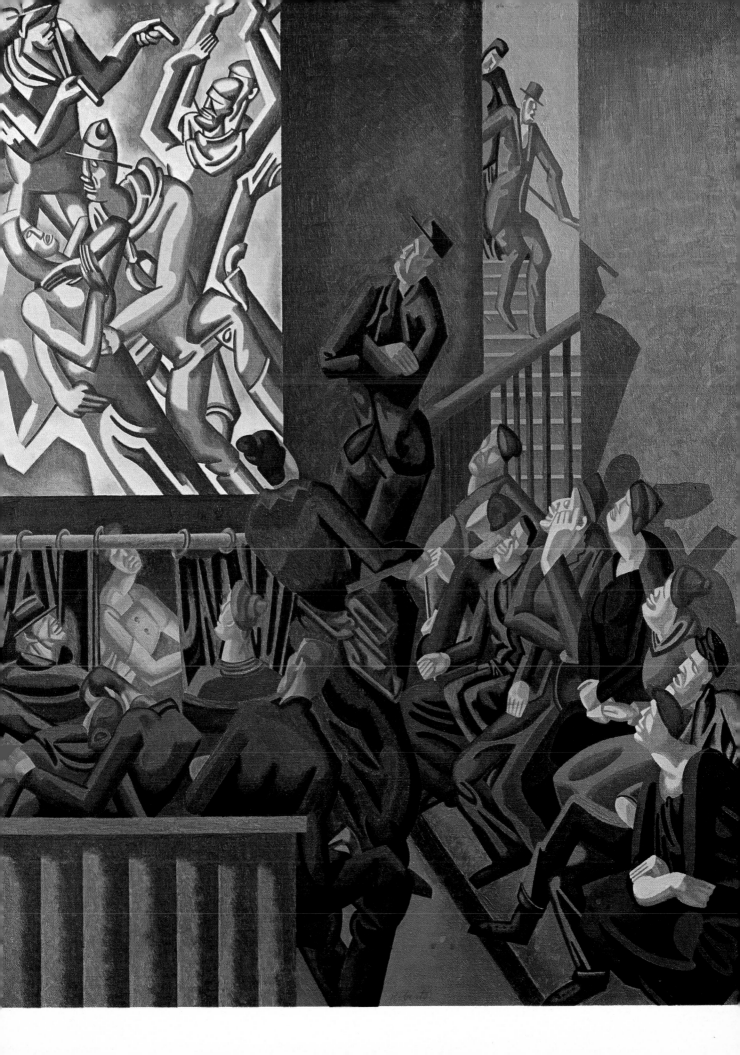

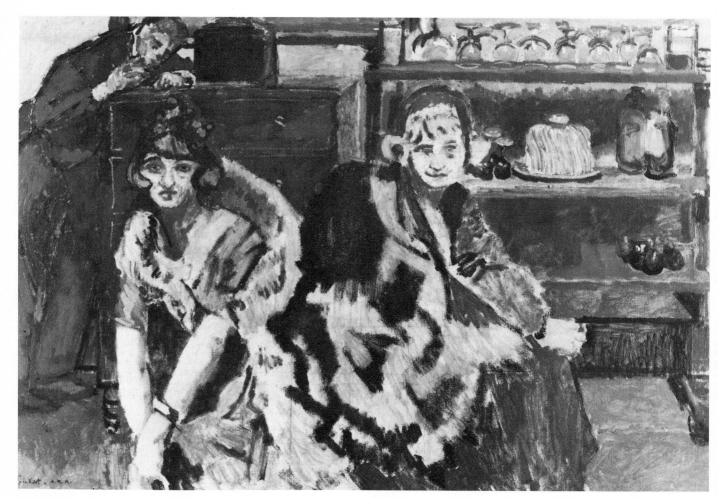

64 Walter Richard Sickert (1860–1942): *The bar parlour*. 1922. Canvas, 39 × 61 in.
Cambridge, King's College, Keynes Collection

Sickert continually advocated, through his painting, teaching and writing, a
figurative art that drew on the artist's surroundings, an art immersed in
contemporary life which preferably by-passed the drawing room, the 'wriggle and
chiffon' of society portraiture (*see opposite plate*), good taste and gentility. Here we
see two women 'of doubtful reputation' dressed up for a kill in the parlour of a city
hotel, an elderly waiter busy in the background.

65  Philip de Laszlo (1869–1937): *The Countess of Mansfield*. 1927. Canvas, 50 × 40 in.
Private Collection

66 Duncan Grant (born 1885): *The white jug*. 1914–18. Panel, 42 × 17½ in. London, Private Collection

The possibilities of a non-representational painting gained ground in London in the years before the First War. Fry and Bell were enthusiastic over Kandinsky's pictures shown in 1913, Wadsworth translated passages from Kandinsky for the first issue of *Blast*, T. E. Hulme's thought was orientated in that direction. Much work by the Vorticists, though retaining figurative references, was essentially non-representational. The Bloomsbury painters Grant and Vanessa Bell were also intensely interested in a pure formal expression, characteristically relying more on sensuous colour and clear geometrical configurations than did their Vorticist contemporaries. Some years after painting this work, Grant counteracted its geometrical severity with the addition of the jug, lemon and decorative passage at the bottom.

67 Sir Matthew Smith (1879–1959): *Couleur de rose*. 1924. Canvas, 21¼ × 28¾ in. British Council Collection

In the early twenties Smith began to transcend the somewhat untypical accomplishment of his *Nude: Fitzroy Street, No. 1 (Plate 42)*. The reins were loosened; a voluptuous handling of the medium became a perfect vehicle for his controlled yet ecstatic realization of form. Francis Bacon later wrote of him as 'one of the very few English painters since Constable and Turner to be concerned with painting—that is, with attempting to make idea and technique inseparable.'

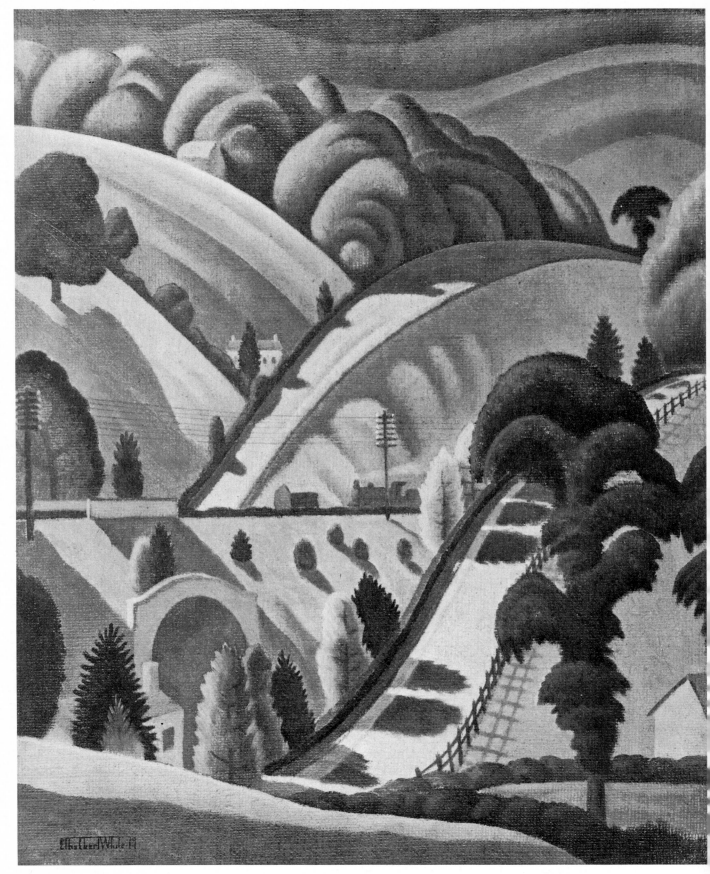

68 Ethelbert White (1891–1972): *The tunnel*. 1919. Canvas, 24 × 20 in. Private
Collection

69 John Nash (born 1893): *The cornfield*. 1918. Canvas, 27 × 30 in. London, Tate Gallery

All three painters reproduced here developed their own interpretation of the English countryside taking something from the French Post-Impressionists—particularly Seabrooke whose pointillism strikes an individual note—while retaining the linear sensibility which characterizes an earlier phase of the English landscape tradition.

70 Elliott Seabrooke (1886–1950): *Harbour scene*. 1947. Canvas, 20 × 24 in. Private Collection

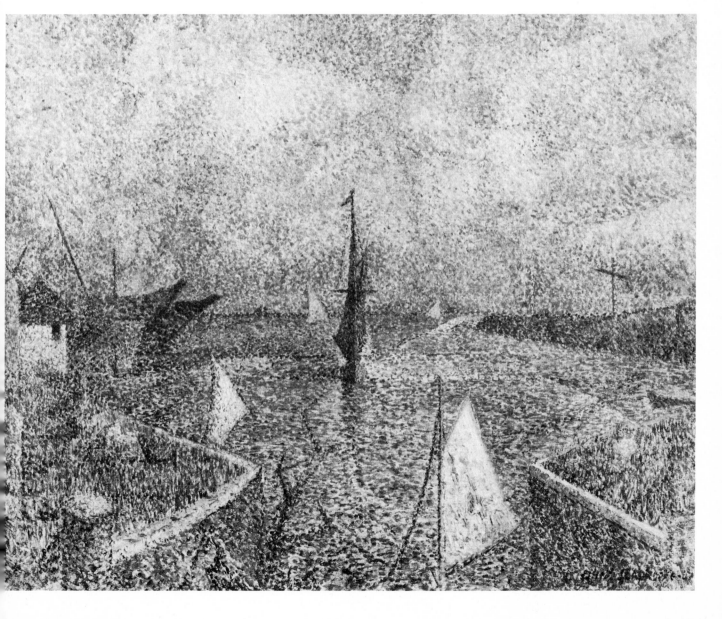

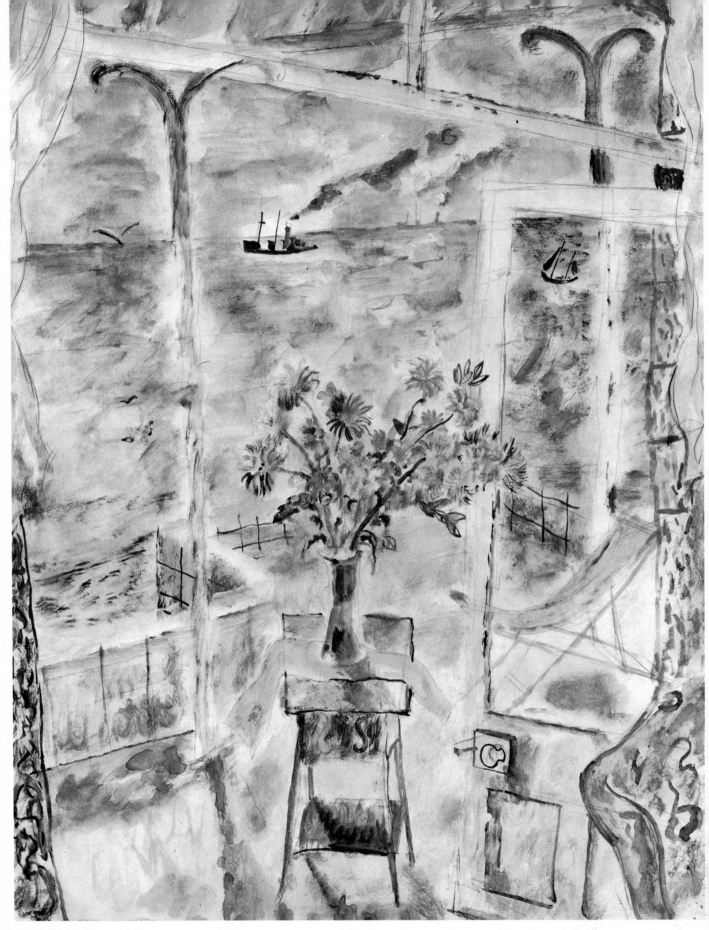

71 David Jones (1895–1974): *The terrace*. 1929. Watercolour, $25\frac{1}{2} \times 19\frac{3}{4}$ in. London, Tate Gallery

72 David Jones (1895–1974): *Human being*. 1931. Canvas, $29\frac{1}{2} \times 23\frac{5}{8}$ in. Private Collection

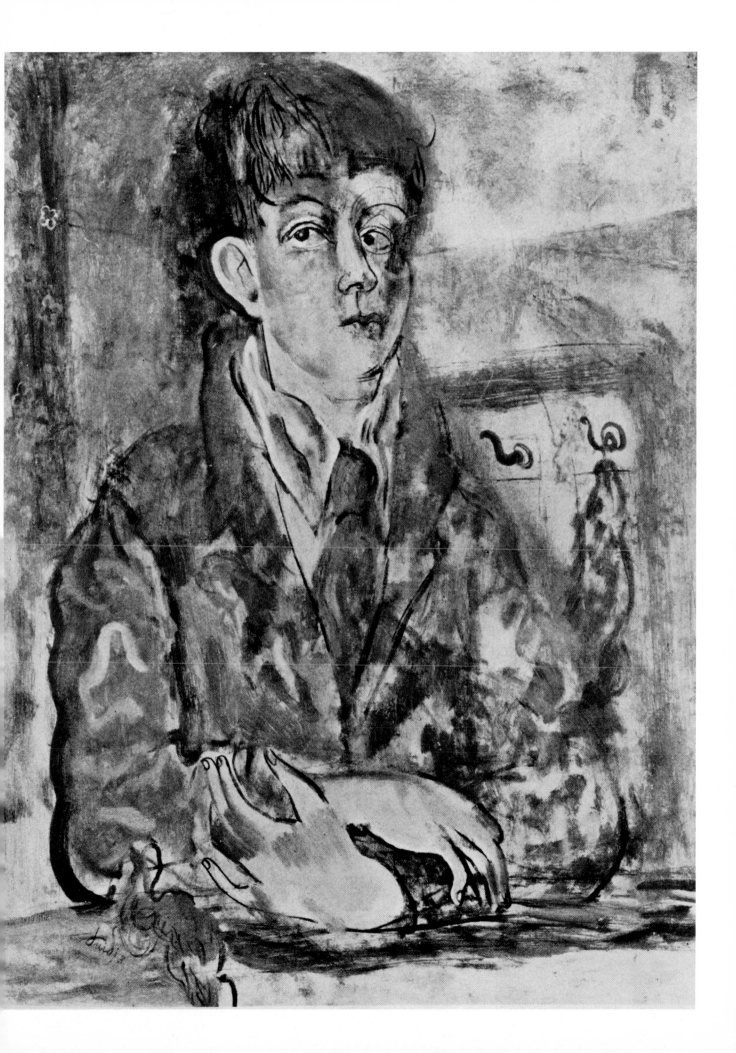

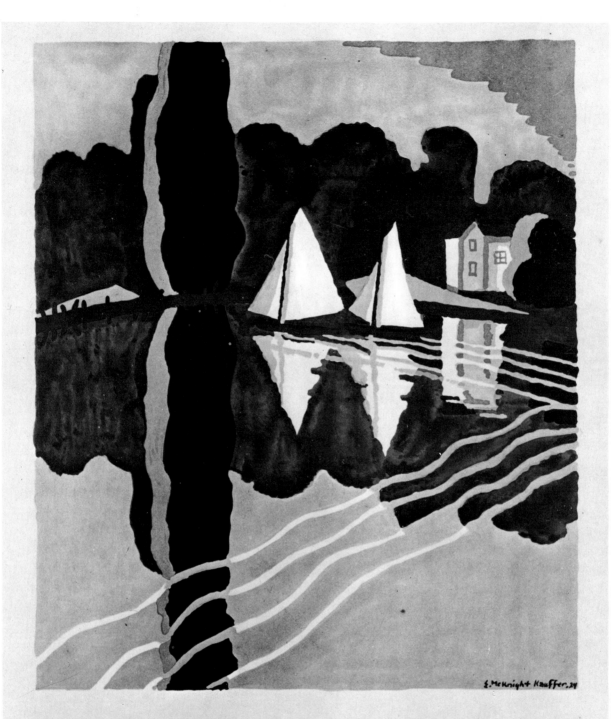

E. McKnight Kauffer. 34

# TWICKENHAM

# BY TRAM

Sanders Phillips and Co., Ltd, THE BAYNARD PRESS, Chryssell Road, S.W.9

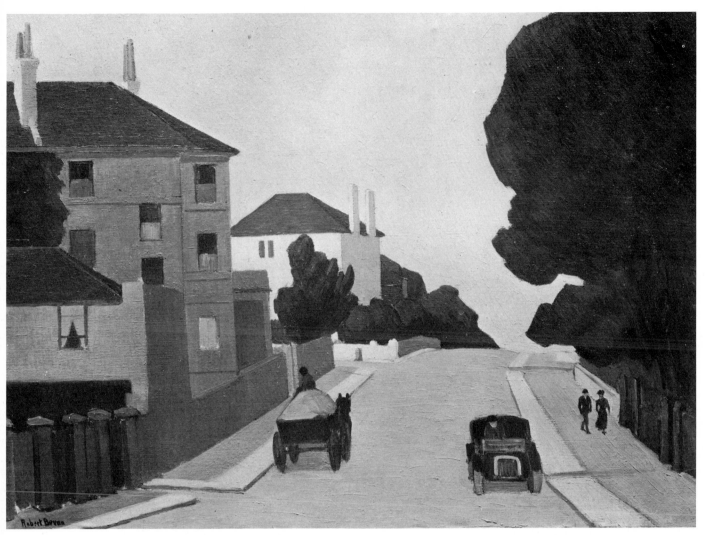

74 Robert Bevan (1865–1925): *Adelaide Road, 1922.* Canvas, $20\frac{1}{4} \times 28\frac{1}{4}$ in. Boston, Museum of Fine Arts

In the last years of his life Bevan's style became increasingly simplified and schematic with an emphasis on contour and relatively unmodelled areas of colour. The sometimes violent colours of his earlier work were replaced by a more muted range of ochres, mauves and greens. London horse-sales and suburban scenes continued to attract him; in the best of them he extracted a vein of individual poetry—an indefinable melancholy of half-deserted streets and dusty sunlight.

73 Edward McKnight Kauffer (1890–1954): *Twickenham.* 1924. 30 × 20 in. Poster for London Transport

An American by birth, McKnight Kauffer entered the world of English art through the London Group and the Omega Workshops and was briefly affiliated to the Cumberland Market Group showing alongside Bevan and Ginner. In the early twenties he gave up painting for full-time commercial design, in which field he became a revolutionary figure and a master of succinct, arresting images. Seen here at a transitional stage, his poster offers leisure by tube for the tired Londoner.

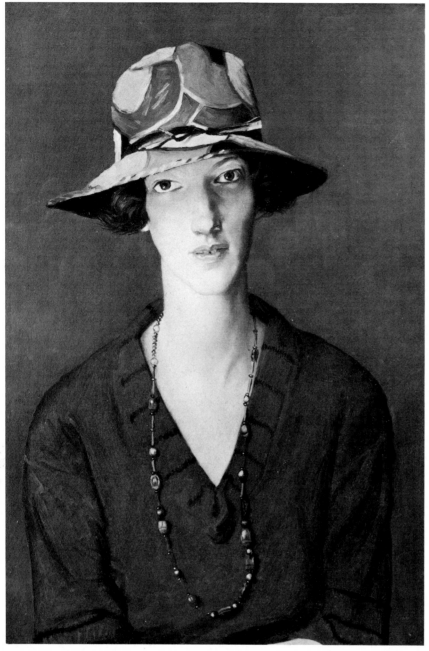

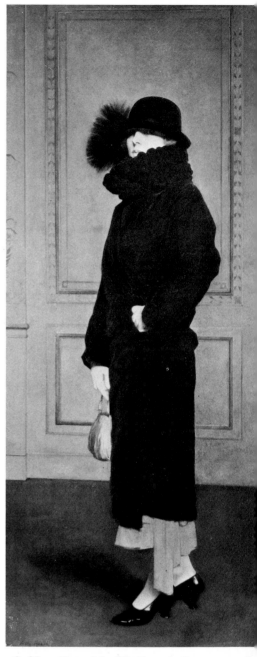

75 William Strang (1859–1921): *The harlequin hat.* 1920.
Canvas, 27 × 18 in. Private Collection

76 Sir Gerald Kelly (1879–1972)
*Jane (XXV).* 1924–6. Canvas
76½ × 36¼ in. Private Collection

77 Gilbert Spencer (born 1892): *A Reading boy.* About 1920–5. Canvas, 26 × 20 in
Reading, Museum and Art Gallery

With this portrait of a local boy in Sunday best, Gilbert Spencer has added to tha
line of English portraits, beginning perhaps with *Hogarth's Servants,* which
informally conceived and carried out with an honesty of vision and psychologica
sympathy, are touchstones of the English character.

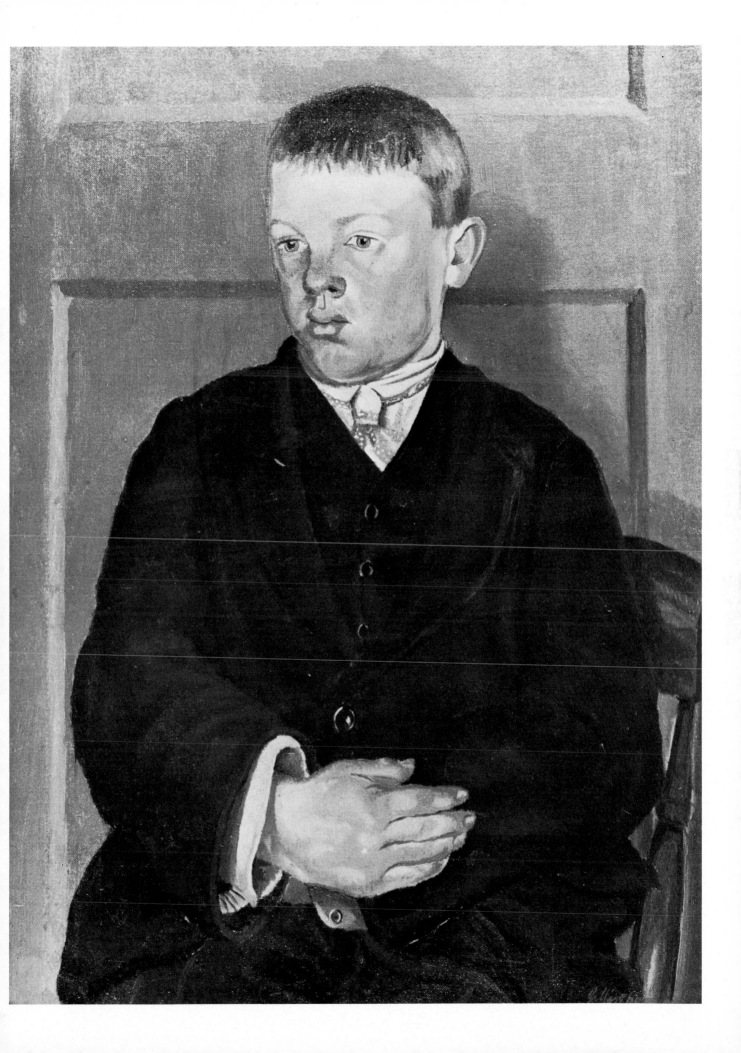

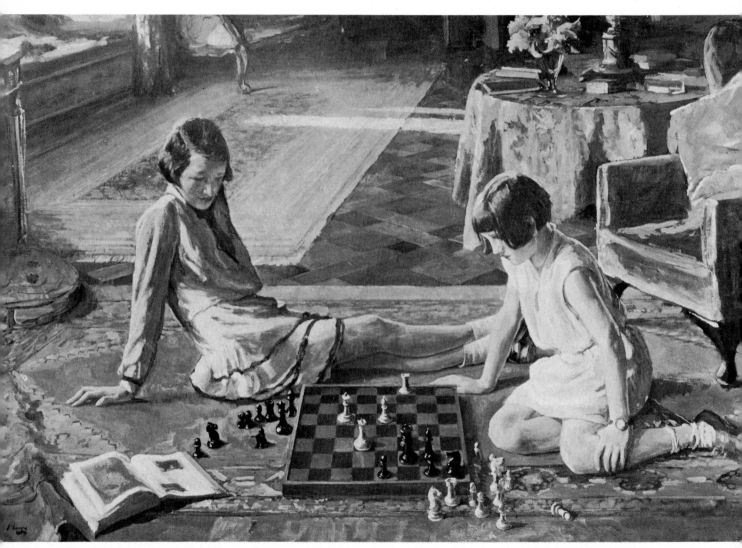

78 Sir John Lavery: *The chess players*. 1929. Canvas, $48\frac{1}{2} \times 75\frac{1}{2}$ in. London, Tate Gallery

Lavery very much enjoyed an enormous reputation as a portrait painter. As a critic in the *Studio* wrote in 1914: 'With the exception of Mr Sargent no living painter has been so canvassed, catalogued and criticised as Mr John Lavery. His name and work are known wherever Western art has penetrated.'

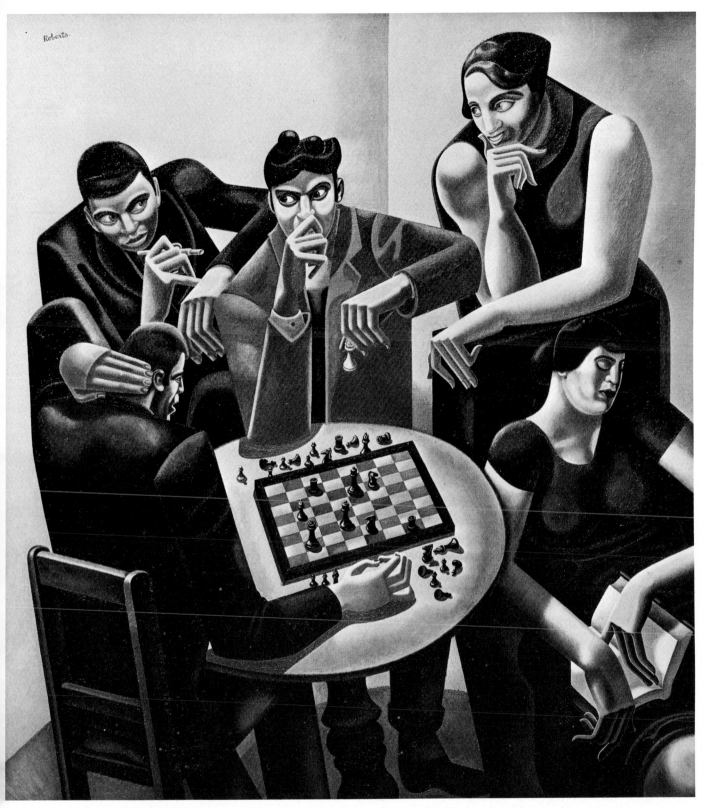

79 William Roberts (born 1895): *Chess players*. 1929–30. Canvas, 40 × 36 in. New Jersey, Newark Museum

To a seemingly ordinary scene of two chess players and friends—as ordinary as Lavery's 'radiant supergeese' opposite—Roberts brings, through a claustrophobic filling of the picture space with expressive gesture, an air of menace and conspiracy. 'And we shall play a game of chess,' wrote Eliot, 'Pressing lidless eyes and waiting for a knock upon the door.'

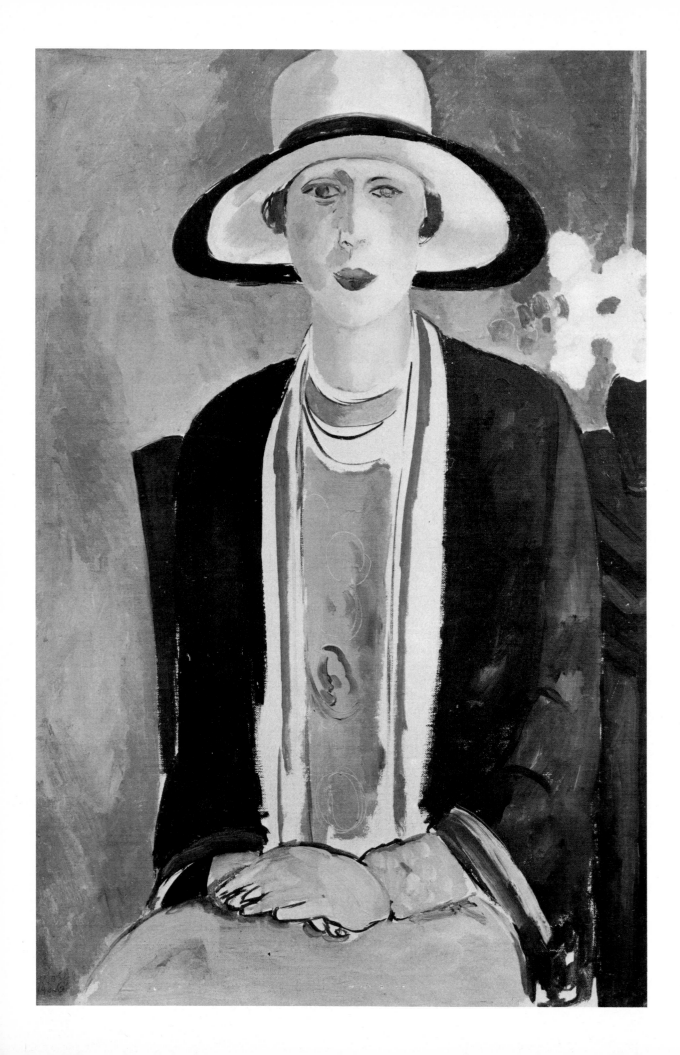

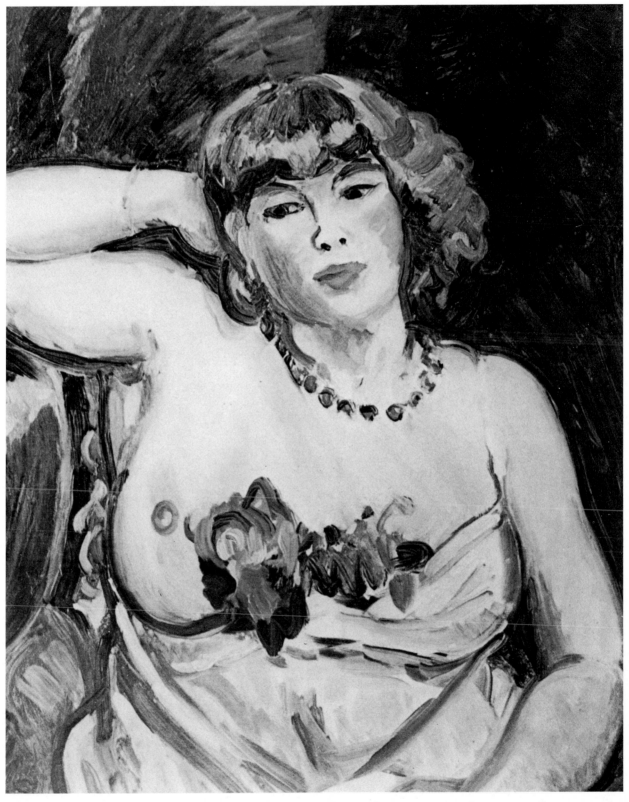

81 Sir Matthew Smith (1879–1959): *Jeune femme*. 1930. Canvas, 28 × 23 in.
Capetown, South African National Gallery, Natale Labia Collection

80 Edward Wolfe (born 1897): *Portrait of Madge Garland*. 1926. Canvas, 32 × 32 in.
London, Geffrye Museum

The sitter for this fluent and attractive portrait was the fashion editor of *Vogue*
magazine, which did much to publicize contemporary British painting.

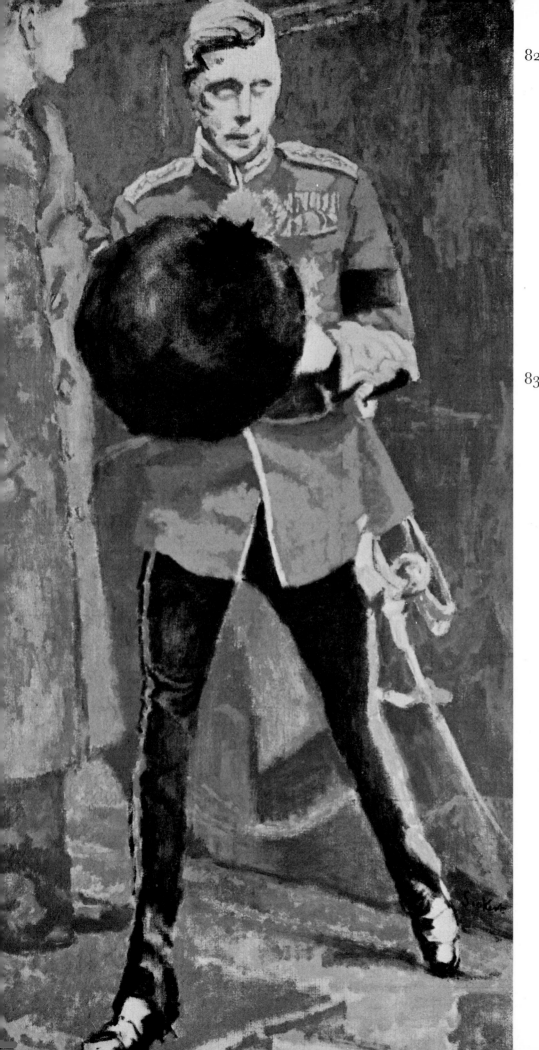

82 Walter Richard Sickert (1860–1942): *Edward VIII.* 1936. Canvas, 72 × 36 in. Fredericton, New Brunswick, Beaverbrook Art Gallery

83 Walter Richard Sickert (1860–1942): *Sir Alec Martin.* 1935. Canvas, 55 × 42½ in. London, Tate Gallery

Two characteristic works of Sickert's late phase, for both of which he relied on photographs. For King Edward a daily paper was the source; it belongs to a whole series of topical works drawn from public life, the cinema and theatre —from George V to Edward G. Robinson. The connoisseur and collector Sir Alec Martin commissioned portraits of himself, his wife and schoolboy son (all in the Tate Gallery), for which Sickert had photographs especially taken. The portraits assert several of Sickert's past preoccupations (*compare Plate 64 with 83*), while extending his range to connect him with later figurative art—with Bacon, Kitaj and Hockney for example. They are simultaneously bland and mysteriously potent, personal and gravely detached.

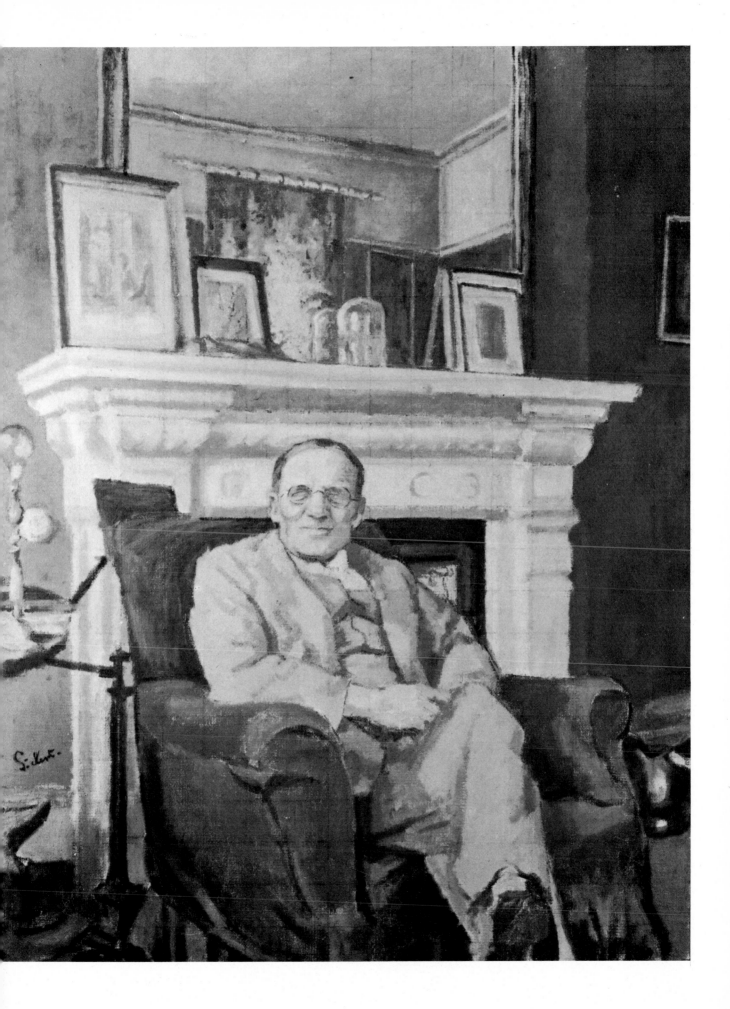

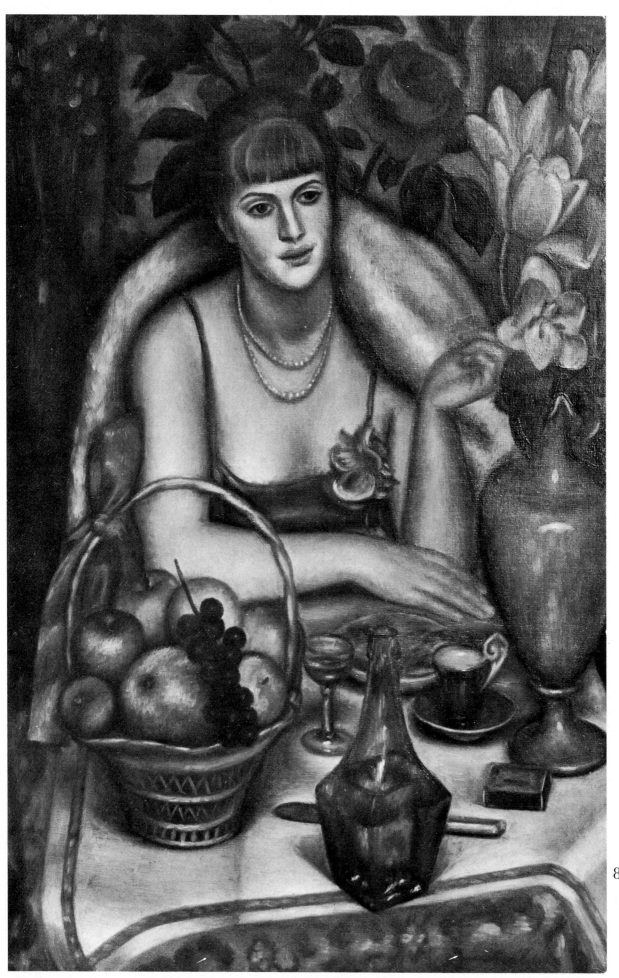

84 Mark Ge
(1891–19
*Supper*. 1
Canvas,
28 in. Pri
Collectio

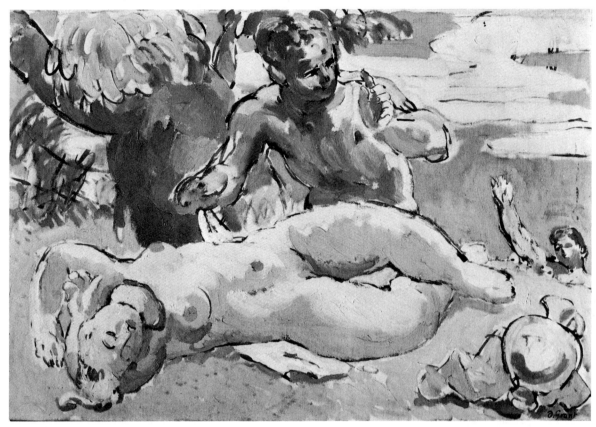

85 Duncan Grant (born 1885): *Nymph and satyr*. About 1926. Canvas, 20 × 31 in.
Private Collection

86 Dame Ethel Walker (1861–1951): *The waterfall*. About 1930. Canvas, 22 × 30 in.
Private Collection

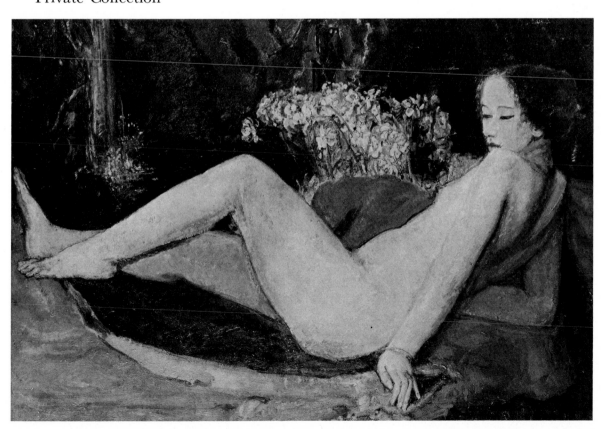

87 Duncan Grant (born 1885): *The Sharaku scarf*. 1972. Canvas, 36 × 26 in. Private Collection

Parallel with Grant's imaginative compositions there has been a long series of more realistic works in the best of which he achieves a classic formal harmony while retaining characteristics discernible in his decorative work—a delight in pattern and texture and the suggestive juxtapositioning of objects. This recent painting contains a scarf reproducing a work by the eighteenth-century Japanese artist Toshusai Sharaku.

88 S. J. Peploe (1871–1935): *Still-life with Japanese background*. About 1918. Canvas, 16 × 18 in. Kirkcaldy Art Gallery

Peploe and his friend and contemporary J. D. Fergusson (*Plate 57*) were swiftly alive to Post-Impressionism and Fauvism and had been nurtured in the strong tradition of Franco-Scottish sympathies. Both lived and worked in France before the First War. Peploe employed brilliant colour (and an individual use of glowing blacks and pinks) in his still-lifes with a particularly sensitive appreciation of two-dimensional design.

89 Sir Matthew Smith (1879–1959): *Still-life with clay figure*. About 1939. Canvas, $51\frac{3}{4}$ × $38\frac{1}{4}$ in. Southampton Art Gallery

90 Sir William Nicholson (1872–1949): *Pears*. 1938. Canvas, 11 × 16 in.
Leeds, Collection of the Leeds City Art Galleries

91 Winifred Nicholson (born 1893): *Flowers*. About 1921–3. Canvas, $19\frac{3}{8} \times 21\frac{1}{2}$
in. University of Cambridge, Kettle's Yard

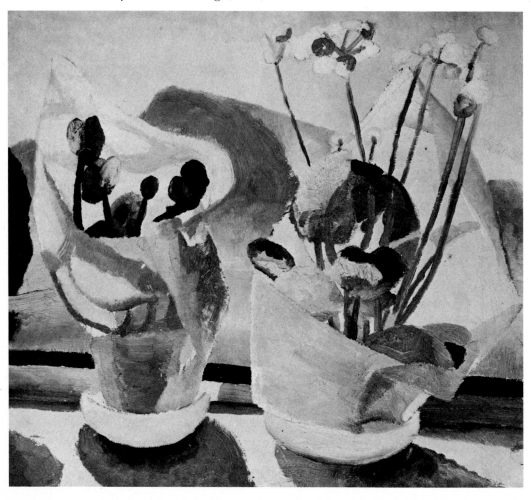

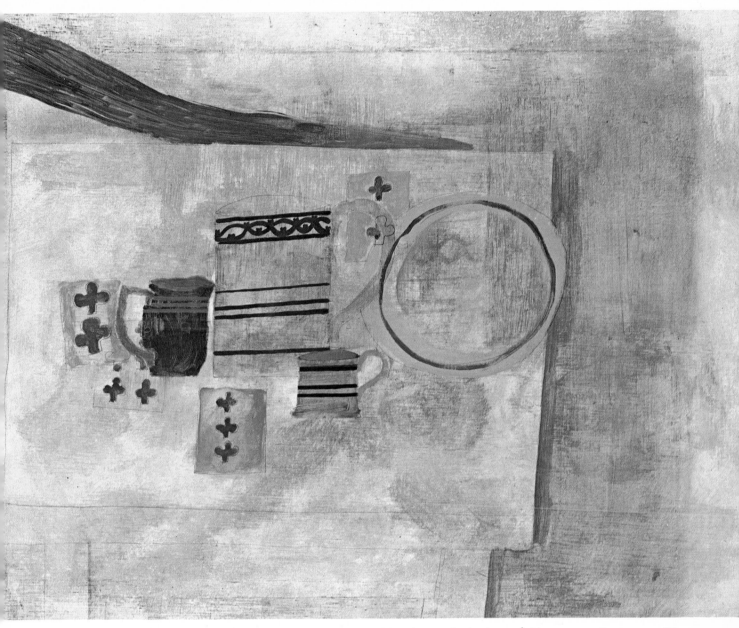

92 Ben Nicholson (born 1894): *Still-life (jug and playing cards)*. 1929. Canvas, $26\frac{1}{4} \times 34\frac{1}{2}$ in. Private Collection

The painter and critic Maurice de Sausmarez has written illuminatingly of the similarities between Ben Nicholson's work and his father William's: 'First, the marvellous sense of tone and the ability to control unusually closely related sequences of tone and colour is an attribute that is clearly demonstrated in William Nicholson's still-lifes and smaller paintings as it is from first to last in Ben Nicholson's work. . . . Secondly, a careful study of William Nicholson's paintings will reveal an unusually developed sensitivity to rare intervallic relationships and the use of simple uninterrupted shapes, a sensitivity that is crucial to the success of Ben Nicholson's reliefs.' Such sensitivity is apparent in this still-life and the *White relief (Plate 100)*.

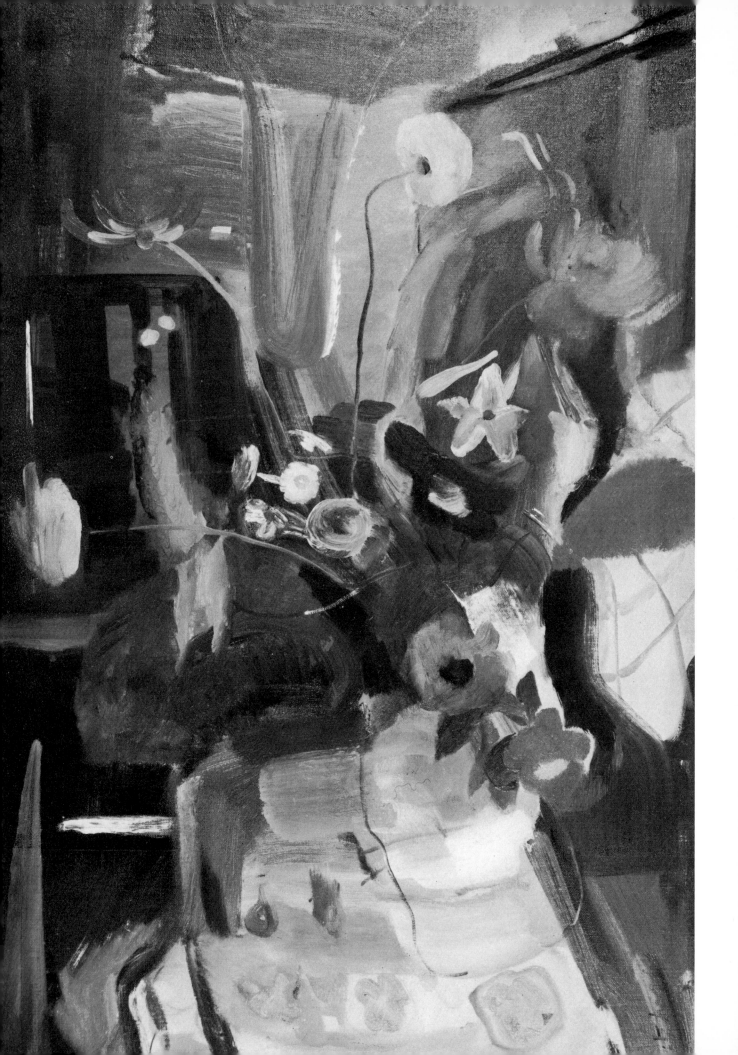

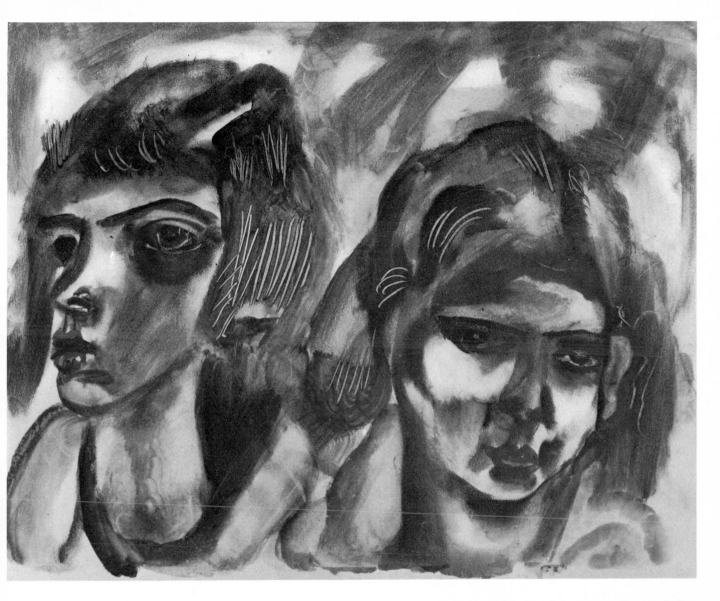

94 Frances Hodgkins (1869–1947): *Two heads*. About 1935.
Canvas, 14¼ × 18½ in. Alan Rowe, Esq.

95 Jessica Dismorr (1885–1939): *Head of a young girl*.
1931. Board, 24 × 18½ in. Private Collection

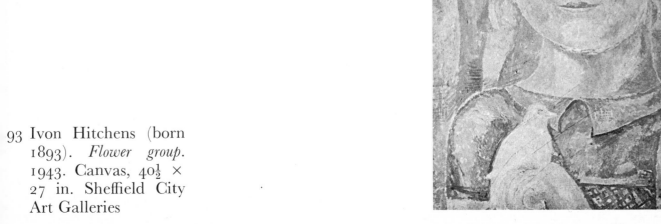

93 Ivon Hitchens (born
1893). *Flower group*.
1943. Canvas, 40½ ×
27 in. Sheffield City
Art Galleries

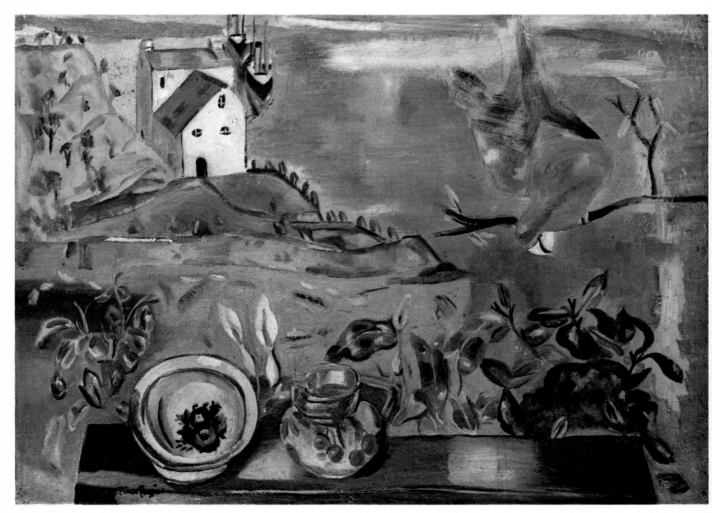

96 Frances Hodgkins (1869–1947): *Wings over water*. 1935. Canvas, 26 × 36 in. Leeds, Temple Newsam House

The continuing influence of Cézanne on English painters in the twenties produced much unassimilated and fly-blown painting, particularly in the London Group. Members of the Seven and Five Society as various as Ivon Hitchens, Cedric Morris and Frances Hodgkins offered an alternative which relied on gayer colour, a lyrical handling of paint and a less formalist, more decorative surface organization. Frances Hodgkins, a New Zealander by birth, had been particularly impressed by Matisse's work of the twenties, an impact which released a relish for purer colour and a more flexible approach to the picture's imagery, often combining, as here, still-life and landscape. Later still she developed a subtle appreciation of English light and weather in some of the loveliest landscapes of the century.

97 Christopher Wood (1901–30): *Zebra and parachute*. Canvas, 18 × 21¾ in. London, Whitney Straight, Esq.

In this, one of Christopher Wood's last paintings, we see him moving towards a lyrical association of images—Le Corbusier's Villa Savoie at Poissy, then under construction, a zebra and a parachutist. While retaining some of the sophisticated naivety of his Breton and Cornish scenes, the feelings aroused are more complex and suggestive and the composition more succinct. Paul Nash wrote admiringly of Wood's 'ability to keep his canvas alive from corner to corner, yet leaving restful spaces for the eye.'

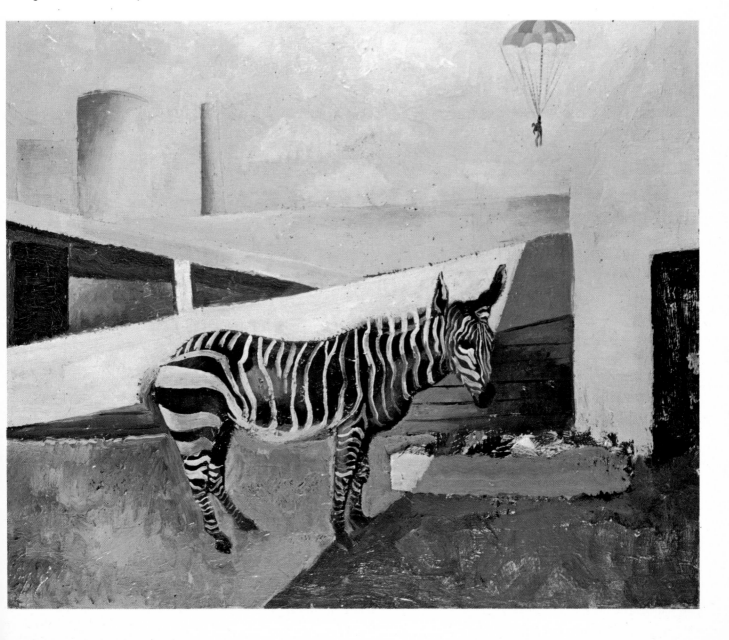

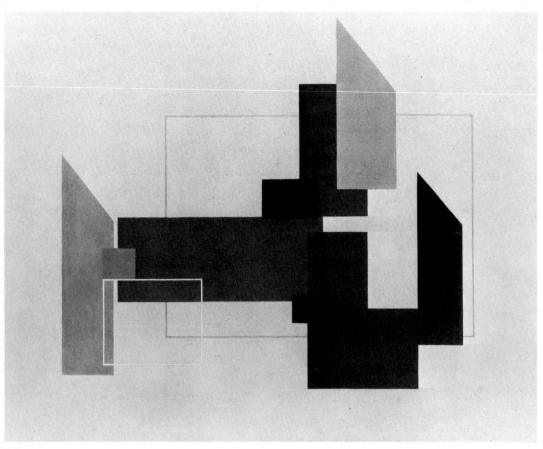

An art of geometrical purity, much indebted to European constructivist art was practised by such painters as Alastair Morton and Cecil Stephenson. Both were closely involved in aspects of design and technology.

98 Cecil Stephenson (1889–1965): *Painting*. 1937. Tempera on canvas, 28 × 36 in. London, Tate Gallery

99 Paul Nash (1889–1946): *Encounter in the afternoon*. 1936. Canvas, 20 × 30 in. The Edward James Foundation

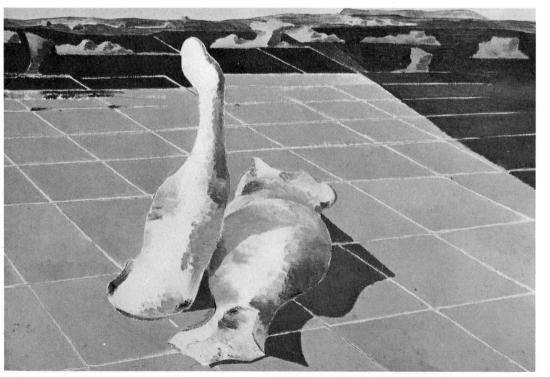

Nash wrote of this picture: 'Sometimes one may find a pair of stone birds almost side by side. Inseparable complements, in true relation. Yet, lying there in the grass never finding each other . . . but so soon as my stones came into my hands their equation was solved.'

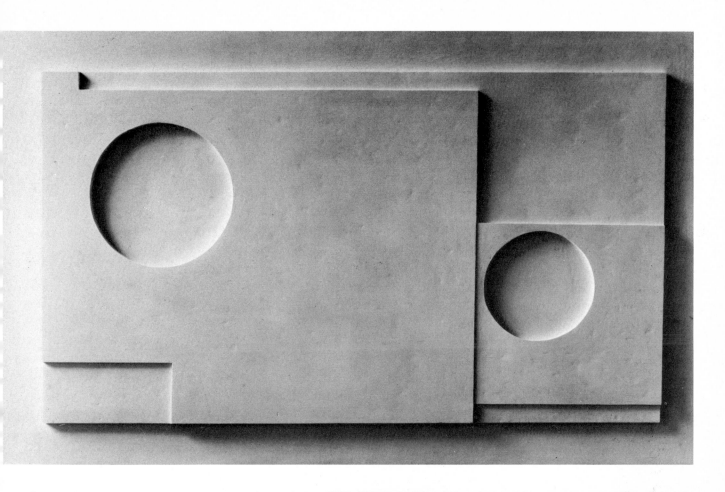

100 Ben Nicholson (born 1894): *White relief*. 1935. Oil, relief, wood, 40 × 65½ in. London, Tate Gallery

Nicholson's painted reliefs are among the most outstanding works of British modernism and established a dialogue (peculiar to much of his work) between a tender imprisoning and emanation of light of subtle gradations and an exploration of a restricted number of formal elements manipulated with an acute awareness of their physical properties.

101 Rodrigo Moynihan (born 1910): *Painting: objective abstraction*. About 1935. Canvas, 18 × 14 in. London, Tate Gallery

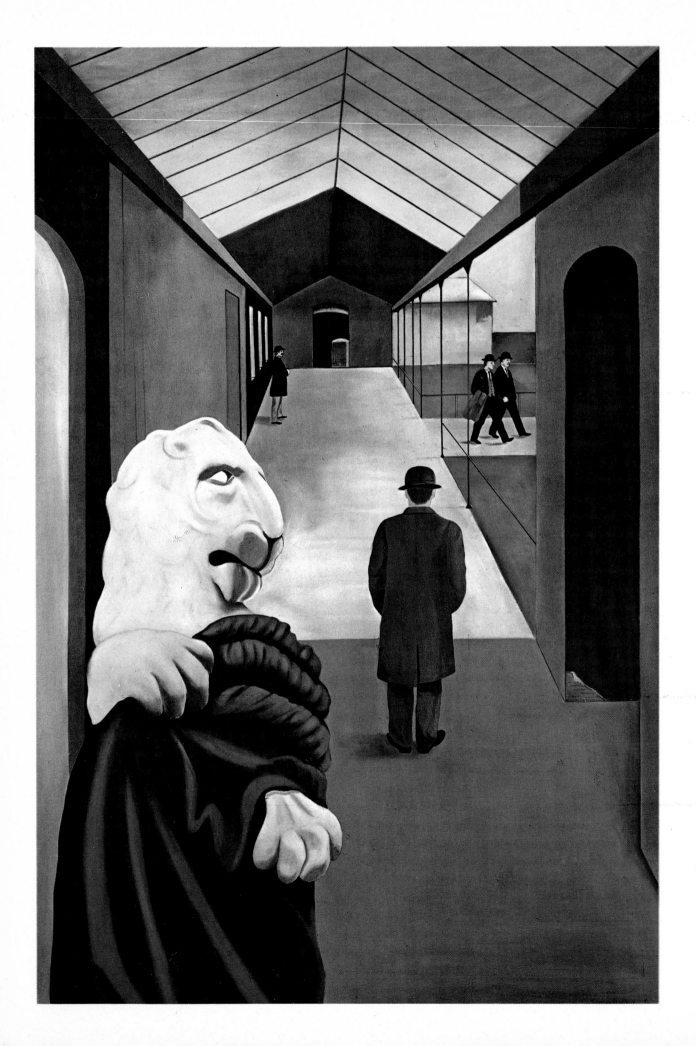

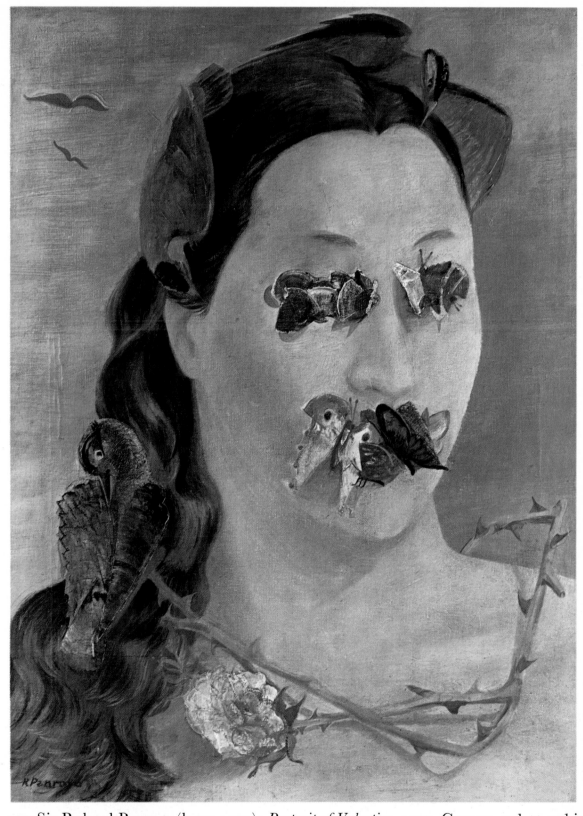

103 Sir Roland Penrose (born 1900): *Portrait of Valentine*. 1937. Canvas, $23\frac{1}{2} \times 17\frac{1}{4}$ in. London, Private Collection

102 Conroy Maddox (born 1912): *Passage de l'Opéra*. About 1932. Canvas, $53\frac{3}{4} \times 37$ in. London, Hamet Fine Art Ltd.

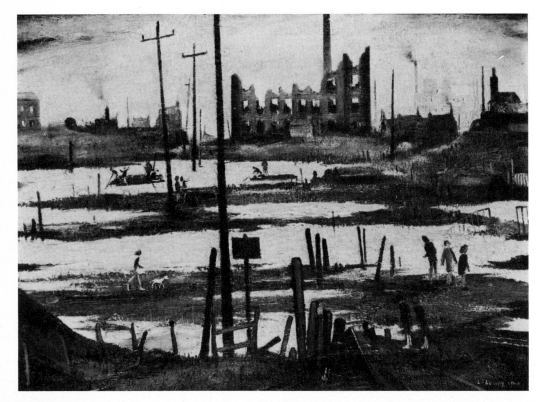

104 Algernon Newton (1880–1968): *The Surrey Canal, Camberwell.* 1935. Canvas, $28\frac{1}{4} \times 36$ in. London, Tate Gallery

105 Laurence Stephen Lowry (1887–1976): *Deserted mill.* 1945. Canvas, $15\frac{1}{2} \times 21\frac{1}{2}$ in. Courtesy of Sotheby & Co.

106 Tristram Hillier (born 1905): *La route des Alpes*. 1937. Tempera on canvas, 23½ × 31¾ in. London, Tate Gallery

107 Julian Trevelyan (born 1910): *Coalmine*. 1937. Collage, 14½ × 20½ in. Artist's Collection

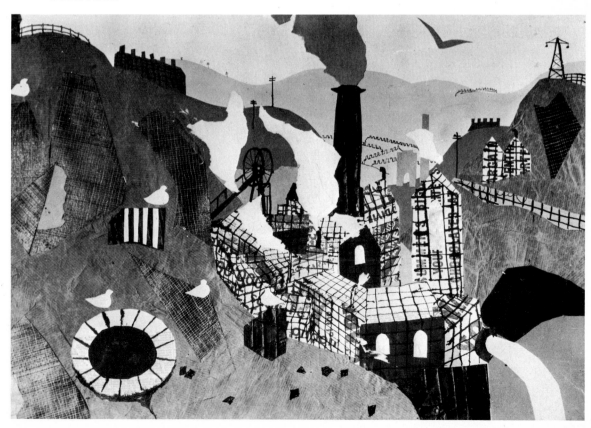

108 Paul Nash (1889–1946): *Equivalents for the megaliths*. 1935. Canvas, 18 × 26 in. London, Tate Gallery

Of all those painters influenced by Surrealism, Paul Nash, with his highly personal fusion of landscape and object, is outstanding and still deserves wider recognition for his unique contribution. Nash's feeling for the weight and texture of objects was variously expressed in painting (*Plate 99*), *objets trouvés* and photographs. From before the First War, landscape had been his central concern. This painting was inspired by the group of large, prehistoric stones, some standing, some horizontal in the fields near Avebury, Wiltshire. Their timeless, super-real qualities immediately appealed to Nash and the intention behind this work was to unite those qualities with the dramatic impact of their physical presence.

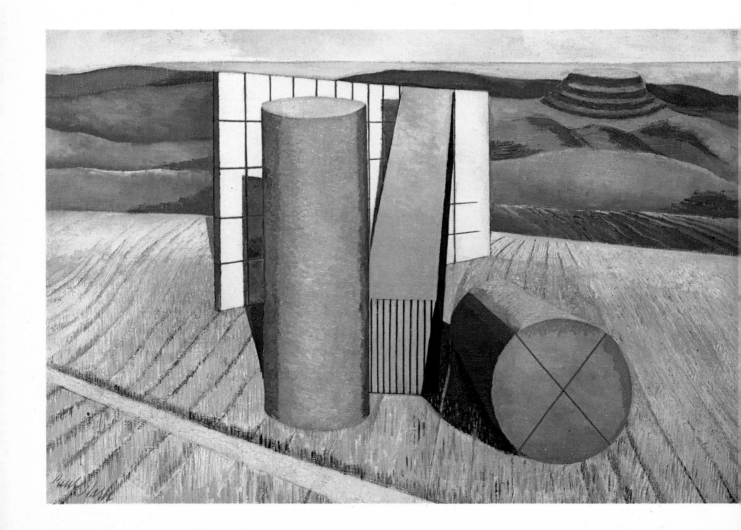

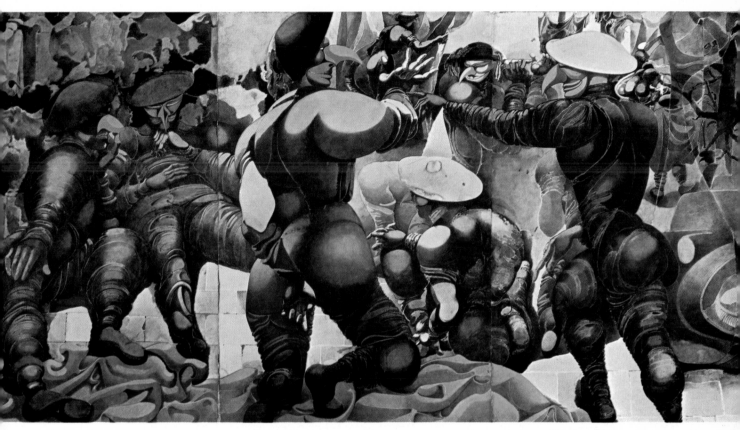

109 Edward Burra (1905–76): *Soldiers at Rye*. 1941. Gouache and watercolour, 40¼ × 81½ in. London, Tate Gallery

The events leading up to the outbreak of war in 1939 had gradually turned Burra away from the sinister levity of his earlier work to a more gravely compassionate, if no less satirical vision of life. In this *tour de force* (carried out on three sheets of paper joined together after completion) Burra was inspired by troop activities near his home at Rye on the south coast. With its figurative complexity and rabid invention it is disturbing even among Burra's work. The echoes of various European styles— of painting as much as of costume—extend its implications beyond the local.

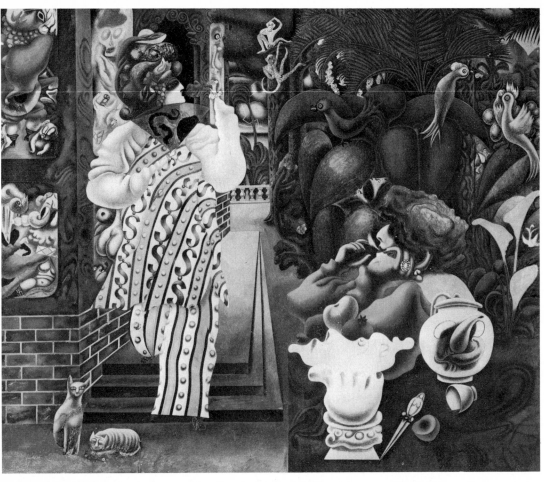

Prior to the impact of political events in the thirties on his painting, Burra's sources were drawn from the street life of Harlem, sleazy Marseilles bars and a satirical view of society akin to some of Evelyn Waugh's contemporaneous novels.

110 Edward Burra (1905–76): *Storm in the jungle*. About 1931. Gouache, 22$\frac{1}{2}$ × 27$\frac{1}{4}$ in. Nottingham, The Castle Museum

111 John Banting (1902–72): *Dead gossip*. 1931. Gouache, 18$\frac{1}{4}$ × 24$\frac{1}{2}$ in. Private Collection

A painter and muralist of modish invention and wit, Banting's awareness of social nuance, sometimes flippant, sometimes biting, was often combined with a sense of the curious qualities of objects as in this still highly articulate fossil.

112 Edward Burra (1905–76): *Venez avec moi*. About 1930. Pencil and collage, 24 × 19 in. Leeds City Art Galleries

113 Graham Sutherland (born 1903): *Sun setting between hills*. 1938. Watercolour, $9\frac{7}{8} \times 14$ in. Lord Clark Collection

In the so-called Neo-Romantic movement of the forties, Sutherland's earlier work spurred the imagination of a younger generation. His long apprenticeship had familiarized him with the world of Samuel Palmer through his work as an etcher and engraver; the dramatic impact of some British Romantic painting—Ward for example—further nourished a growing disposition towards those symbolic and literary aspects of nature which are hallmarks of the Neo-Romantic painters. Some of the anguish of Picasso's *Guernica*, which impressed Sutherland when exhibited in London, increased the menace and anxiety of his painting. In small works such as this, fluent yet highly concentrated, Sutherland made his most individual contribution to the English landscape tradition.

114 Paul Nash (1889–1946): *Landscape of the vernal equinox.* 1944. Canvas, 25 × 30 in. Edinburgh, Scottish National Gallery of Modern Art

In his last years, Nash became less involved with those objects which characterize his painting of the thirties—rocks, stones, stumps of trees—and more concerned with images of flight and the cosmic suggestiveness of the cycle of night and day, the growth and decay of flowers, death and the passing of time. This picture—a version of one painted in the previous year—combines Nash's natural feeling for particularized locality—Boars Hill near Oxford—with a subtle appreciation of the tonal complexities and dreamlike state of the rising moon and setting sun.

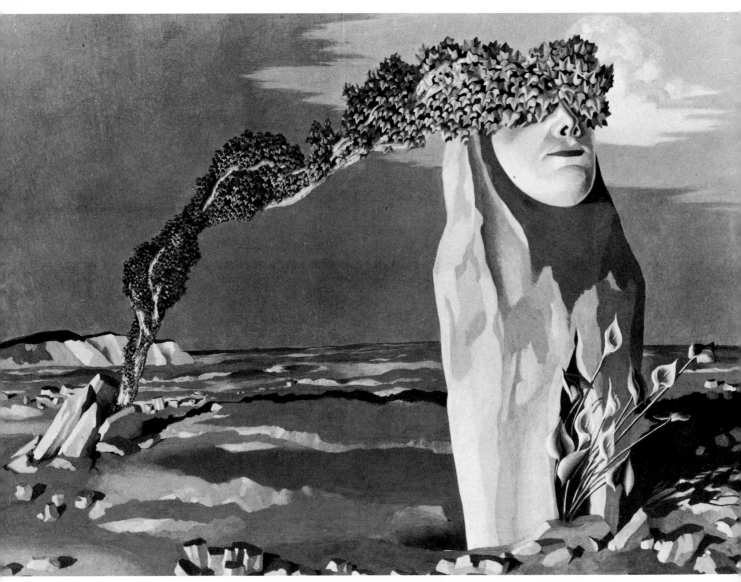

115 John Armstrong (1893–1973): *Heaviness of sleep*. 1938. Tempera, $21\frac{1}{4} \times 29\frac{1}{8}$ in.
London, Private Collection

In his work of the twenties and early thirties, Armstrong had made use of puppets,
dolls and acrobats in a sweet-sad fusion of dream and reality. In the later thirties,
his interest intensified in the irrational and darker elements of the unconscious,
producing some of the most haunting images of the time—particularly in such
works as this and *Dreaming head* (Tate Gallery). They contain a melancholy
undercurrent of despair with their tumbling architecture, eyeless classical heads
and images of Icarus above deserted seas.

116 Ceri Richards (1903–71): *The variable costerwoman*. 1938. Relief construction, 33 × 32 in. Manchester, City Art Gallery.

Fusing some of the techniques of constructivist art with a richly allusive vocabulary drawing on natural, sexual and heraldic imagery, Richards produced more metaphysically conceived works than his contemporaries, who were following social and decorative impulses—see Piper's elegant *Construction* (*below*).

117 John Piper (born 1903): *Construction*. 1934/1967. Oil and relief on panel, 39½ × 45½ in. London, Tate Gallery

118 Victor Pasmore (born 1908): *The Jewish model*. 1945–5. Canvas, 20 × 16 in. London, Tate Gallery

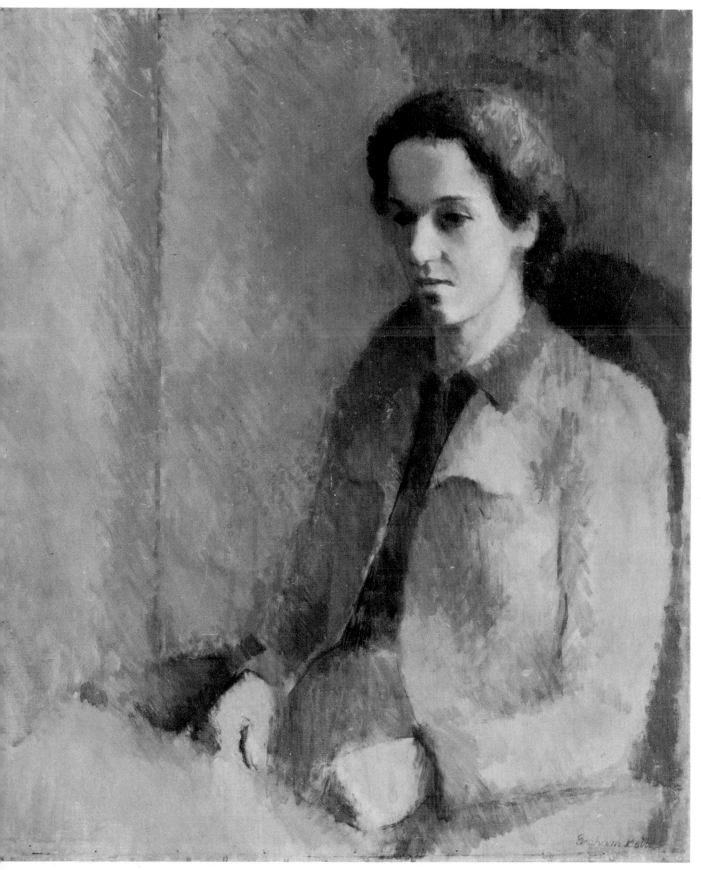

119 Graham Bell (1910–43): *Portrait of a lady*. 1937–8. Canvas, 30 × 25 in. London, Tate Gallery

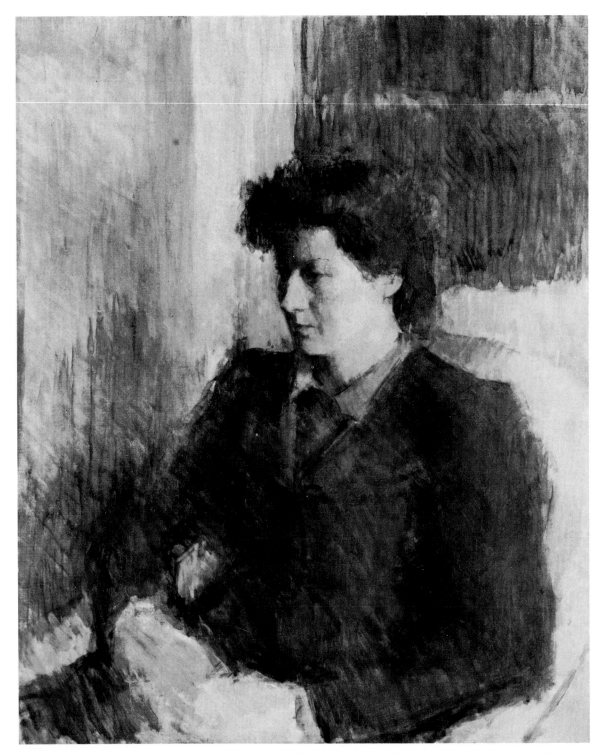

120 Lawrence Gowing (born 1918): *Julia Strachey*. 1940. Canvas, 30 × 25 in. Arts
Council Collection

Qualities characteristic of Euston Road painting are amply evident here in the
work of Coldstream and his student at the school Lawrence Gowing: a passionate
conviction as to the claims of realism, a restrained gesture in paint and the
emergence of sensuous and poetic qualities through sustained observation.

121 William Coldstream (born 1908): *Seated nude*. 1951–2. Canvas, 42 × 28 in. Private
Collection

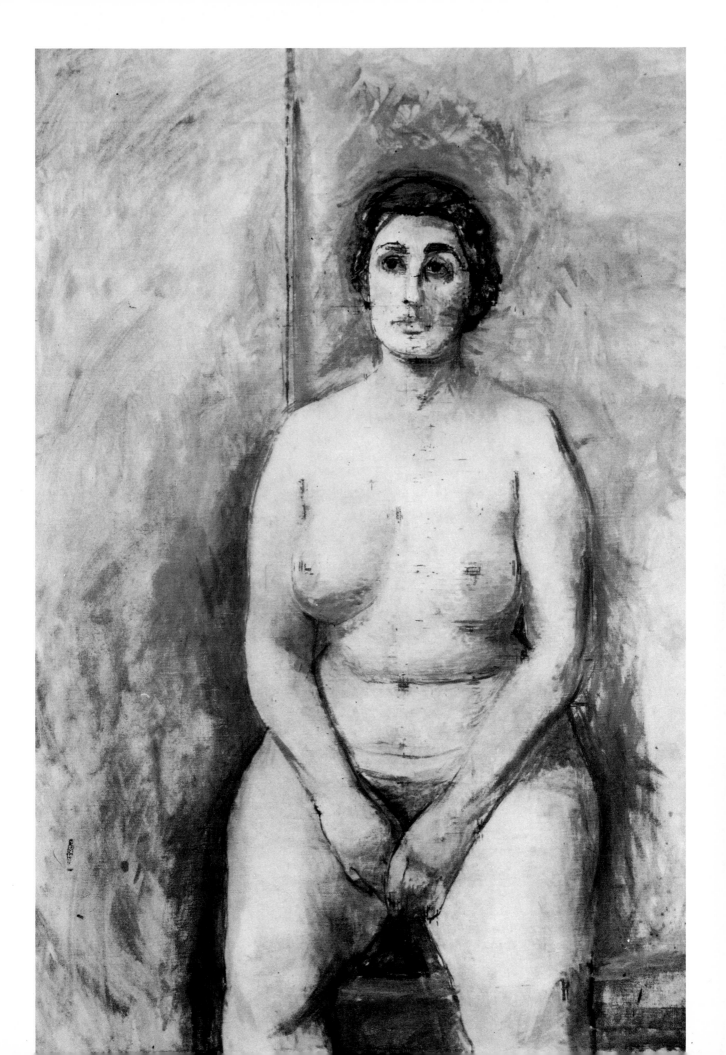

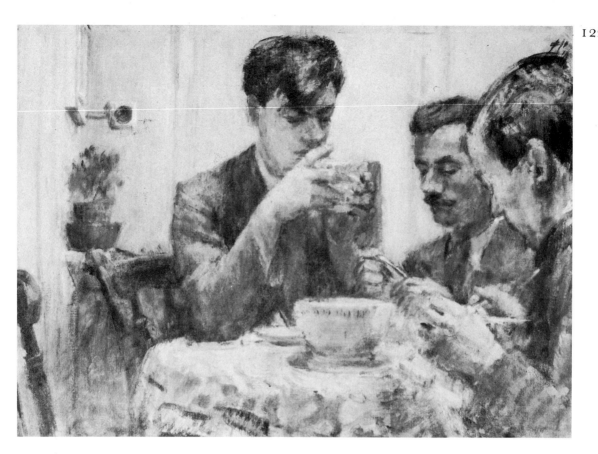

123 Claude Rogers (born 1907): *Miss Lynn*. 1950–1. Canvas, $42\frac{1}{2}$ × $69\frac{3}{4}$ in. Southampton Art Gallery

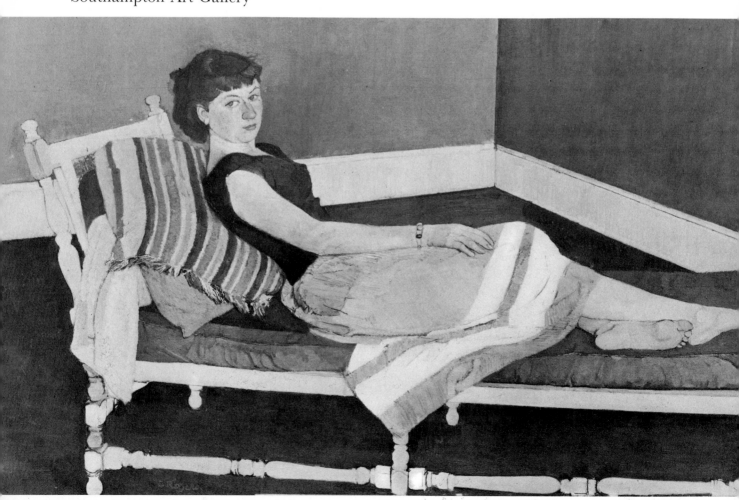

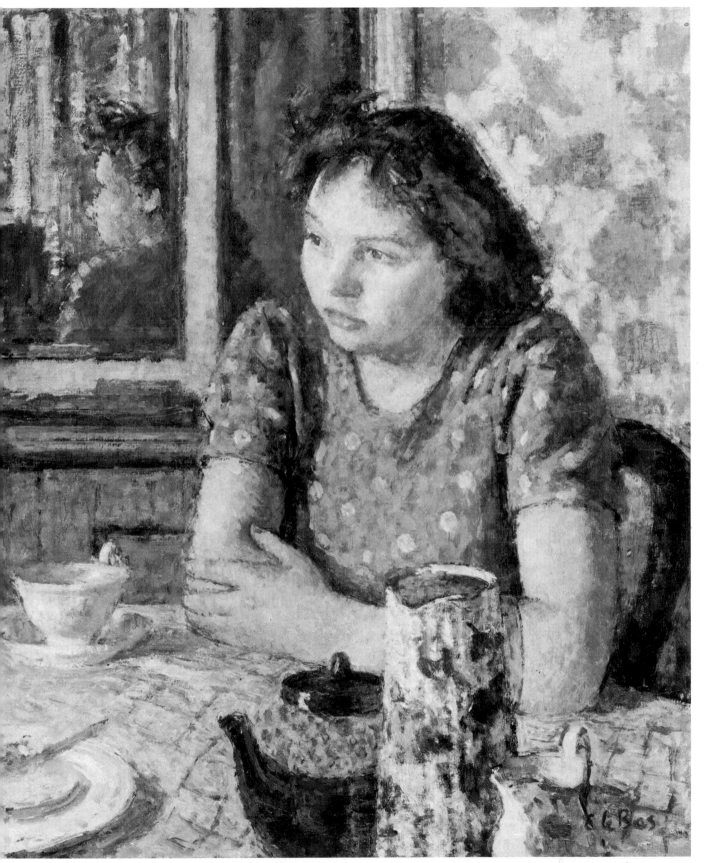

124 Edward Le Bas (1904–66): *The tea table*. 1947–8. Oil on board, 26¼ ×
22 in. London, Tate Gallery

French *intimisme* and something of Sickert's robust approach to
character are evident in Le Bas's work of this period. More exuberant
colour and an emphasis on contour characterize his later painting.

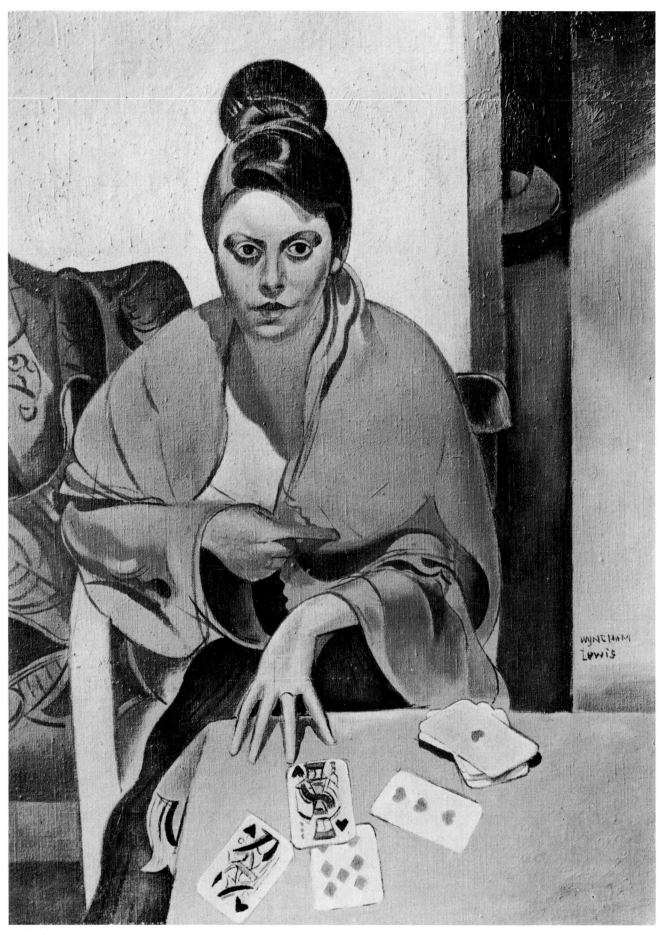

125 Wyndham Lewis (1882–1957): *La Suerte*. 1938. Canvas, 24 × 18 in. London, Tate Gallery

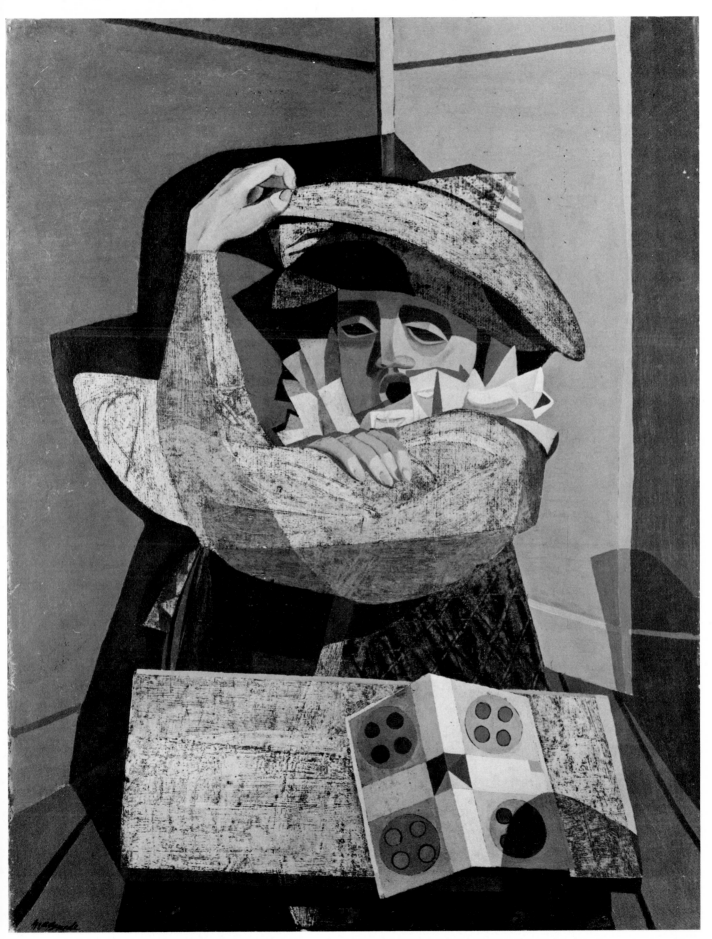

126 Robert MacBryde (1913–66): *Performing clown*. 1946. Canvas, 36 × 28 in. London, Tate Gallery

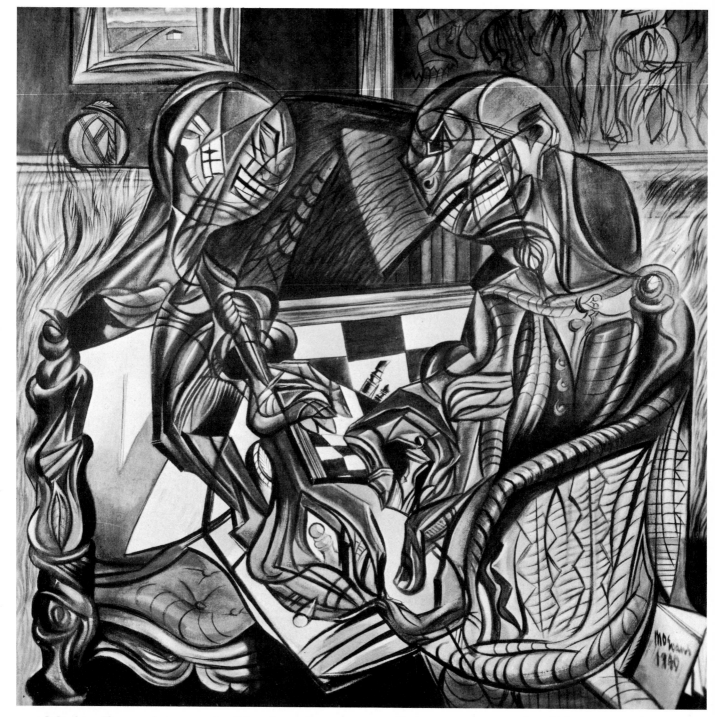

127 Merlyn Evans (1910–73): *The chess players*. 1940. Canvas, 39 × 40 in. Private Collection

Evans employed a variety of European styles in the thirties using sombre colour and a whipping line. He was more explicit and more successful than most of his contemporaries in his passionate condemnation of cruelty and war. Here perhaps dictators preside over the chessboard of Europe.

128 Roy de Maistre (1894–1968): *Marriage*. 1936. Canvas, 60 × 45 in. London, Tate Gallery

The figurative work of de Maistre embodies an austere linear sensibility and refined colour. His personal interpretation of aspects of Picasso's more expressionist works of the early thirties distinguish a whole series of Pietàs and Crucifixions.

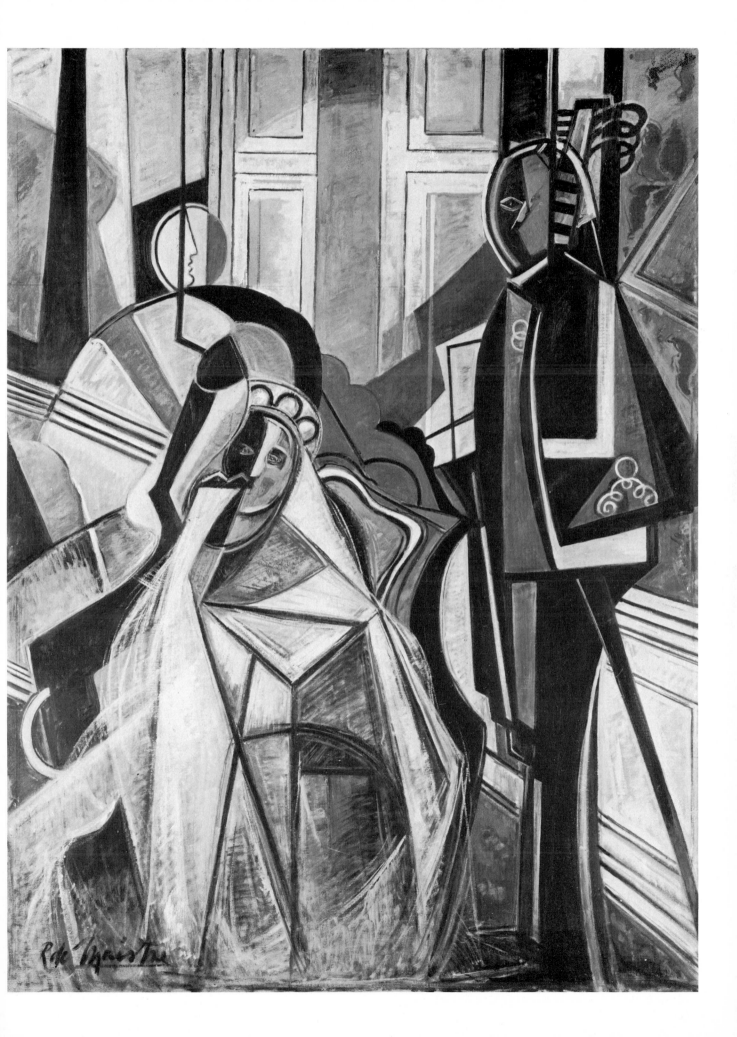

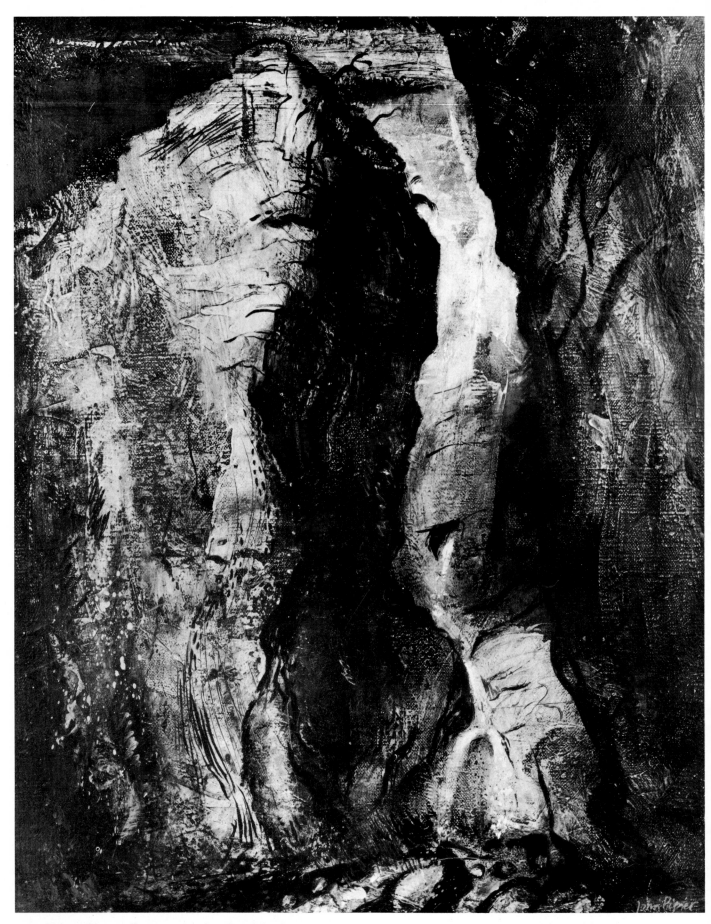

129 John Piper (born 1903): *Gordale Scar: 1943*. Canvas, 30 × 25 in. Lord Clark
Collection

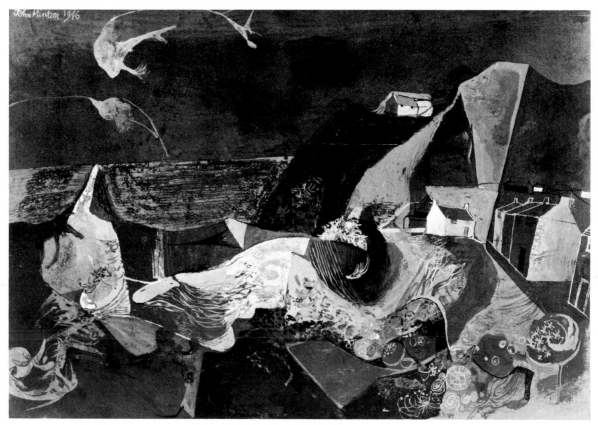

130 John Minton (1917–57): *Stormy day, Cornwall*. 1946. Gouache, $10\frac{1}{4} \times 14\frac{3}{4}$ in. British Council Collection

131 John Craxton (born 1922): *Four herdsmen in a mountain landscape*. 1950–1. Canvas, 63 × 48 in. Bristol, City Art Gallery

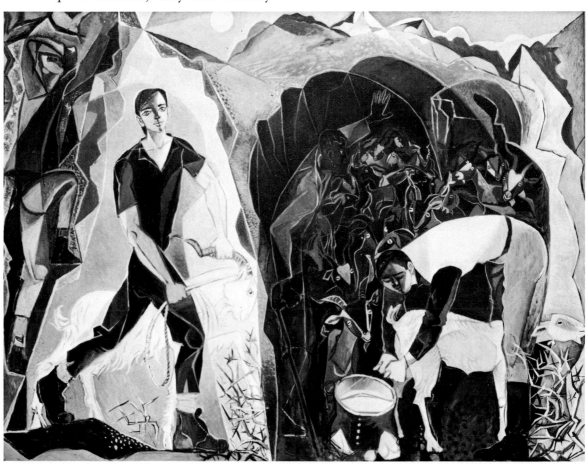

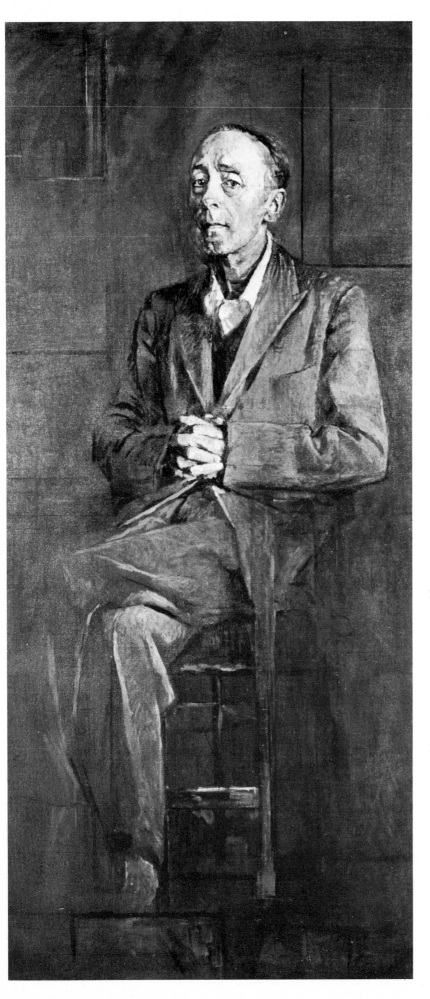

132 Graham Sutherland (born 1903): *Portrait of E. Sackville-West.* 1953. Canvas, 66 × 33 in. England, Private Collection

It was only after the Second World War that Sutherland became interested in portraiture, doubtless encouraged by his recent *Crucifixion* (1946). The series began with *Somerset Maugham* (1949) and later sitters have included Beaverbrook, Churchill and Helena Rubenstein. Edward Sackville-West (1901–65), who wrote a monograph on Sutherland, was a novelist, critic and biographer who later became 5th Lord Sackville. He wrote of Sutherland's portraits as 'among the most perspicacious of our time'.

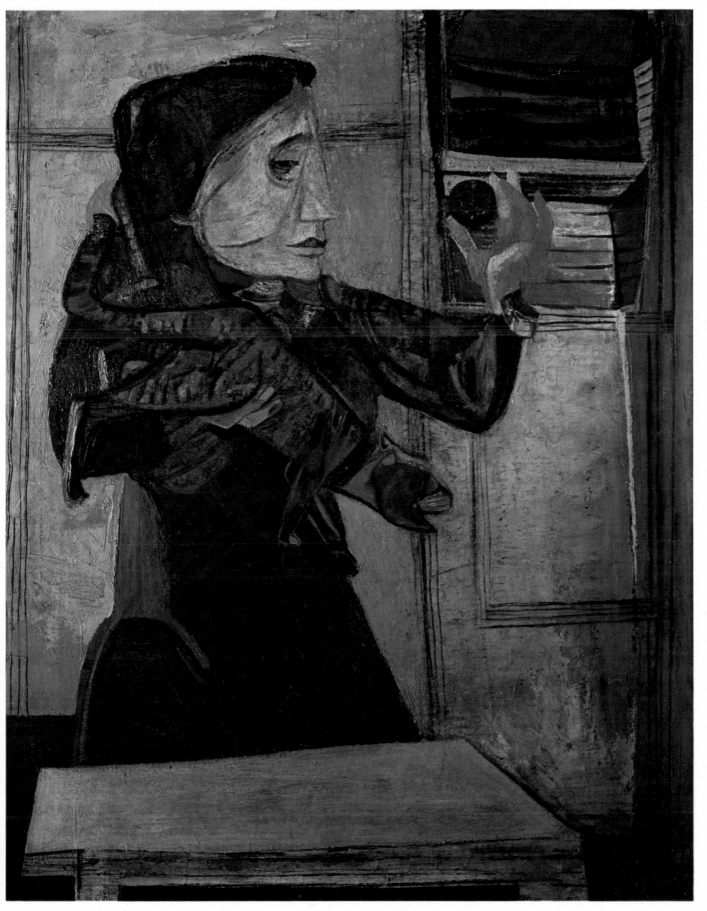

133 Robert Colquhoun (1914–62): *Woman with leaping cat.* 1945. Canvas, 30 × 24 in.
London, Tate Gallery

134 Cecil Collins (born 1908): *The promise*. 1936. Panel, 20 × 24 in. London, Tate Gallery

In the upper painting, Collins shows a moment in evolution, the promise of life from inside the earth at the very moment the chrysalises, seeds and shells become invested with power to emerge into the light. The lower picture shows the spiritual potentialities of transfiguration at the moment of death. With formidable invention, Collins has explored symbols and landscape as the 'theatre of the soul's' development.

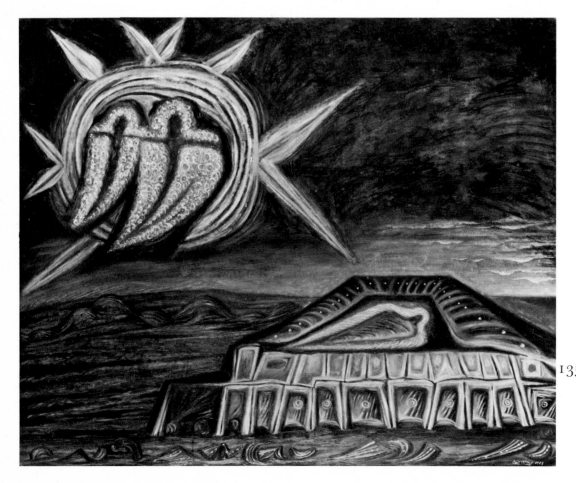

135 Cecil Collins (born 1908): *Hymn*. 1953. Oil on card, 48¼ × 60¼ in. London, Tate Gallery

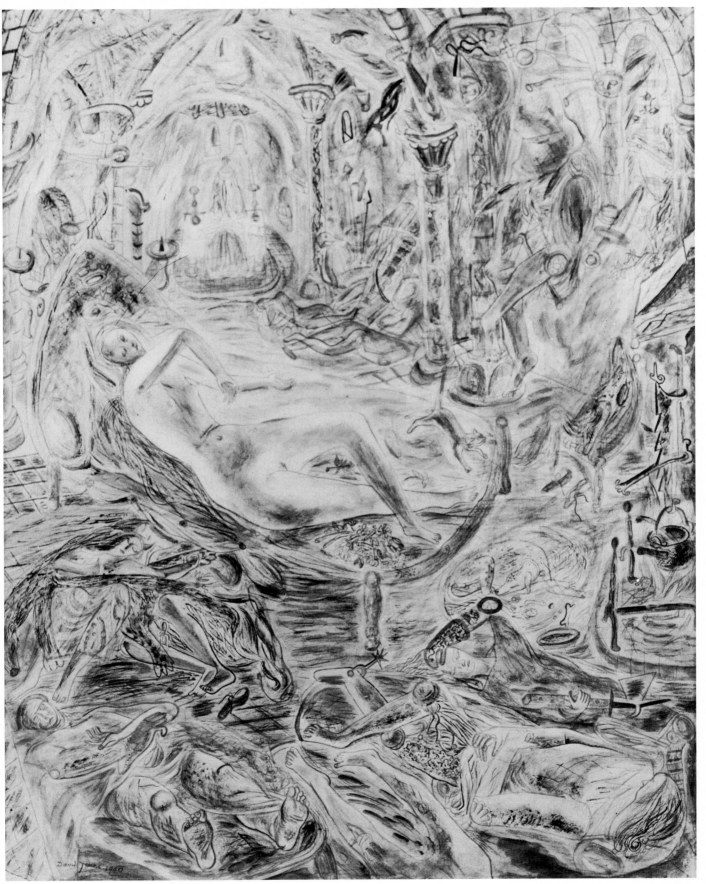

136 David Jones (1895–1974): *Illustration to the Arthurian Legend: Guenever.* Drawing and watercolour, 24½ × 19½ in. London, Tate Gallery

Through the symbols of Celtic and Arthurian legend, Jones, like Collins, invests his landscape with the potentials of wonder and transformation.

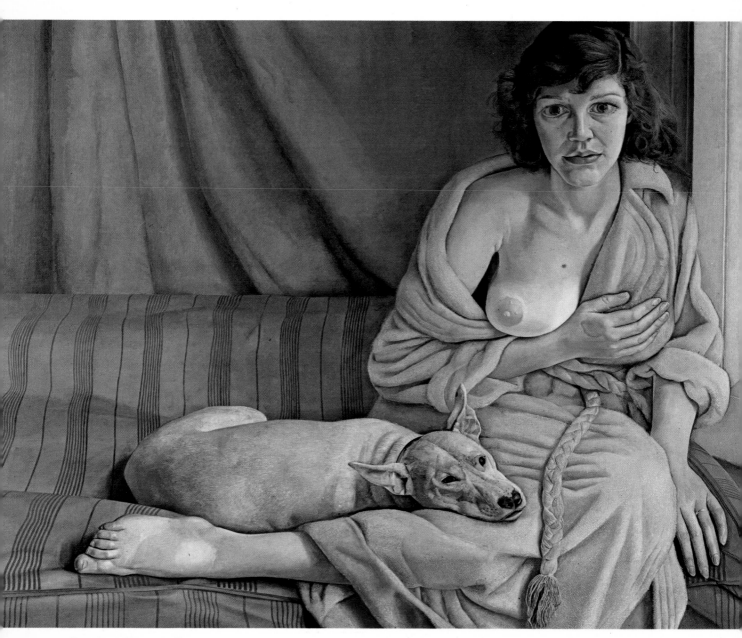

137 Lucian Freud (born 1922): *Girl with a white dog*. 1950–1. Canvas, 30 × 40 in.
London, Tate Gallery

In a series of intensely observed portraits and figure studies, Freud has charted a
territory of his own with his 'unblinking fascinated stare'. Sometimes reminiscent
of fifteenth-century Flemish portraits in their technical accomplishment, their
psychological force aligns them in this century with some of Gertler's Jewish heads
and with Spencer's portraits (*see Plates 24 and 60*).

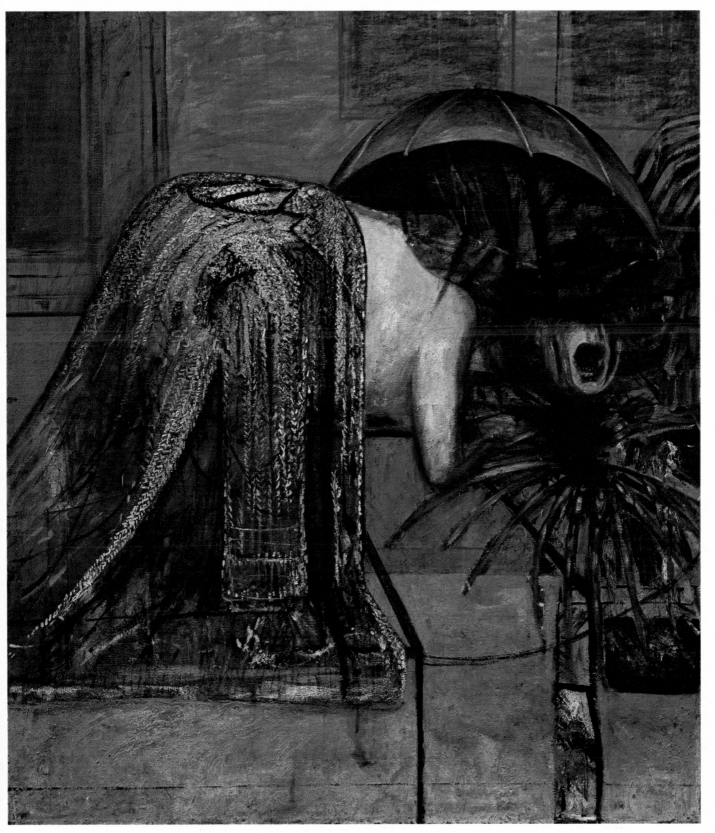

138 Francis Bacon (born 1909): *Figure study II*. 1945–6. Canvas, $57\frac{1}{4} \times 50\frac{3}{4}$ in. Batley, Bagshaw Art Gallery

The relatively isolated position of Bacon in recent years has sometimes made it possible to overlook his connections with the work of his contemporaries at the time of this painting, albeit out-distancing them in grandeur of conception and a human content which, through its very ambiguity—a kind of snarling privacy—offered a considerable extension to the 'tinted anxiety' of others.

139 Edward Bawden (born 1903): *Menelik's Palace, the Old Gebbo.* 1941. Chalk, ink and watercolour on paper, 18¼ × 45¾ in. London, Imperial War Museum

140 Albert Richards (1919–45): *The landing: H. Hour minus 6. In the distance glow of the Lancasters bombing battery to be attacked.* 1944. Watercolour, 21¼ × 29 in. London, Tate Gallery

141 Eric Ravilious (1903–42):
*Submarines in dry dock*. 1940.
Watercolour, 17 × 22½ in.
London, Tate Gallery

142 Edward Wadsworth (1889–
1949): *Bronze ballet*. 1940.
Tempera, 25 × 30 in. Lon-
don, Tate Gallery

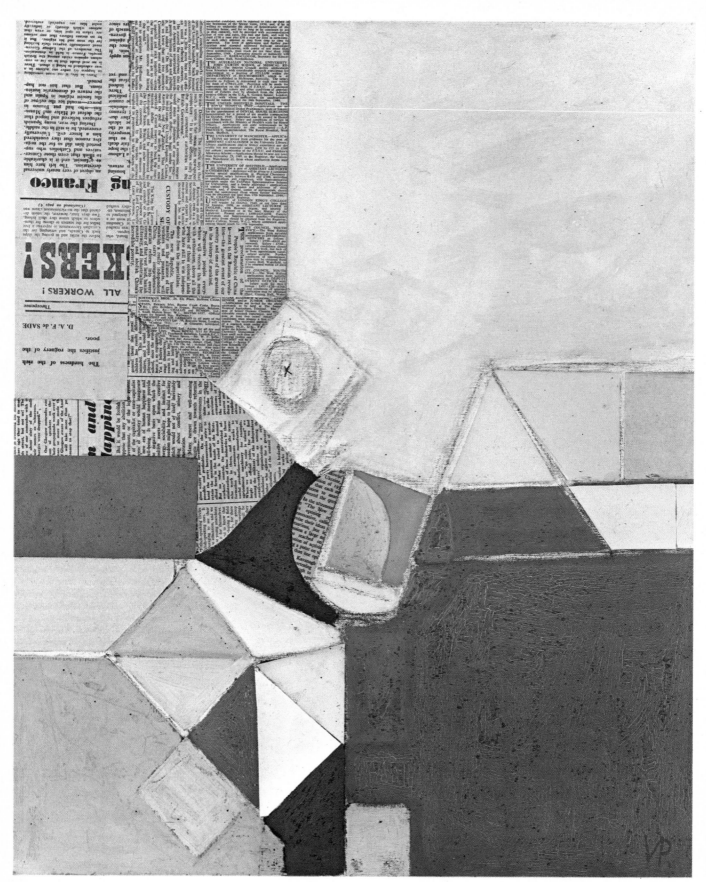

143 Victor Pasmore (born 1908): *Triangular motif in pink and yellow*. 1949. Oil, collage and newspaper on canvas, 24 × 20 in. Hull, Ferens Art Gallery

A gradual abandonment of his interest in evocative mood and changing light led Pasmore towards a concentration on spatial interval and related colour planes which was initially announced in a series of refined abstract collages such as this.

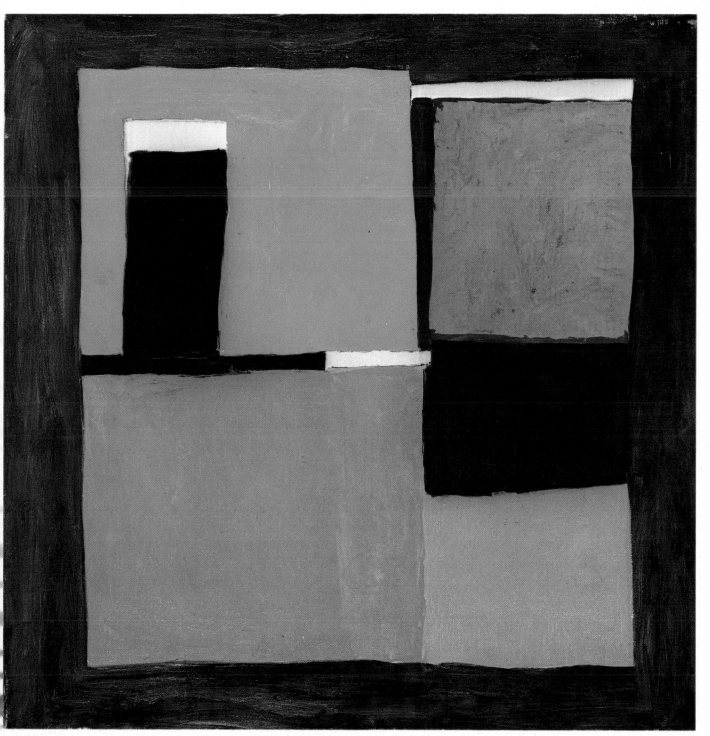

144 William Scott (born 1913): *Orange, black and white composition*. 1953. Canvas, 48 × 48 in. London, Tate Gallery

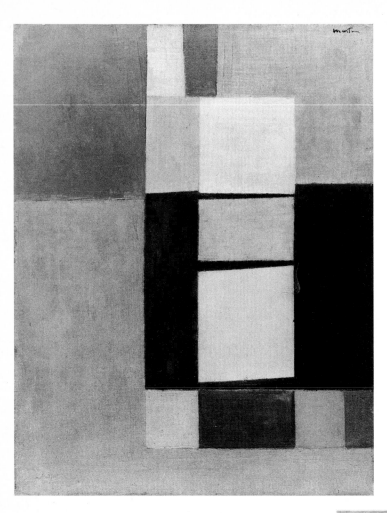

145 Kenneth Martin (born 1905): *Composition*. 1949. Canvas, 20 × 16⅛ in. London, Tate Gallery

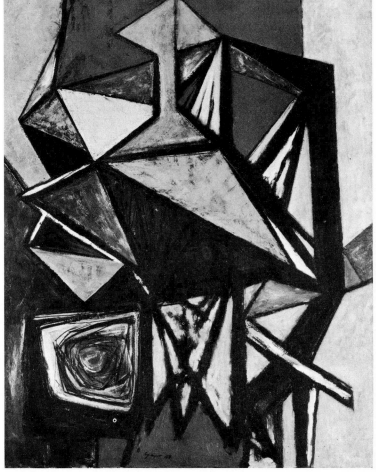

146 William Gear (born 1915): *Interior*. 1949. Canvas, 39½ × 32¼ in. London, Tate Gallery

Among the few practitioners of abstraction in Britain—a movement greeted with considerable hostility, particularly Pasmore's apparent *volte face*—Gear was close to post-war developments, especially the work of Soulages and Hartung, through his residence in Paris. His work was distinguished by its brilliant colour (his early masters were Gillies and McTaggart) and dramatic structure—something the artist characterized as 'a feature in a setting' when writing of this work. The year it was painted Gear exhibited alongside Jackson Pollock in New York.

After an earlier period of mainly landscape painting, Martin's reconsideration of his work's direction formed an interesting and close parallel with Pasmore's (both artists teaching in the late forties at Camberwell School of Art). They felt in varying degrees a dissatisfaction with the kind of abstraction resulting from a reduction and simplification of figurative imagery—landscape in particular—and began to pursue a more self-referential art of balance and architectonic harmony.

147 John Tunnard (1900–71): *Iconoclast*. 1944. Oil on hardboard, 22 × 29½ in. Manchester, City Art Gallery

149 Richard Hamilton (born 1922): *Just what is it that makes today's homes so different so appealing?* 1956. Collage on paper, 10¼ × 9⅞ in. Collection of Professor Dr Georg Zundel
Similarities with Paolozzi's imagery can be found in Hamilton's collage, a key work in the development of post-war British art.

48 Eduardo Paolozzi (born 1924): *I was a rich man's plaything.* 1947. Mixed media, 14 × 9¼ in. London, Tate Gallery
This uninhibited and prophetic collage comes from a whole series of such works originally bound together in a scrapbook entitled *Bunk* and made by Paolozzi between 1947 and 1952.

150 Ben Nicholson (born 1894): *November 1947 (Mousehole)*. 1947. Canvas, 18¼ × 23 in. British Council Collection

Nicholson's wartime residence in Cornwall produced a further development in his art which reflected the weather and physical textures of the area; landscape and still-life were often combined as in this picture and pointed a way towards the great carved reliefs of the fifties and early sixties of which *1964 (Sirius)* is a particularly taut and representative example (*Plate 152*).

151 Alfred Wallis (1855–1942): *St Ives, houses at water's edge*. Oil on card, 8 × 10½ in. University of Cambridge, Kettle's Yard

Discovered by Nicholson and Christopher Wood on a visit to St Ives in 1928, Alfred Wallis, untrained and elderly when he began painting, exerted an influence on Wood and helped confirm Nicholson's direction at the time, particularly his increasing awareness of the physical properties of a picture's support. Wallis's magical response to a scene, perfect placing and rhythmic vitality are well shown in this typical example of his work.

152 Ben Nicholson (born 1894): *1964 (Sirius)*. 1964. Oil on carved hardboard, 43 × 87 in. Stuyvesant Collection

153 Frank Auerbach (born 1931): *Mornington Crescent*. 1967. Canvas, 48 × 58 in.
Courtesy of Marlborough Fine Art, London

Although David Bomberg was consistently neglected between the wars, he
maintained a devoted following as a teacher. The dense textures and inseparable
identification of image and paint in which the original image comes close to being
lost in the recreation of its sensory impact can be seen in varying degrees of intensity
in the work of Auerbach and Kossoff, both of whom draw on urban subject-matter.

154 Leon Kossof (born 1926): *Children's swimming pool, autumn*. 1972. Oil on board, 84 × 72 in. London, Fischer Fine Art Limited

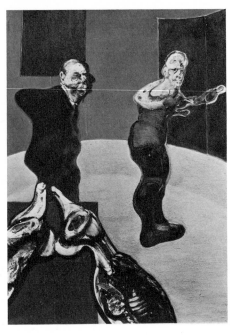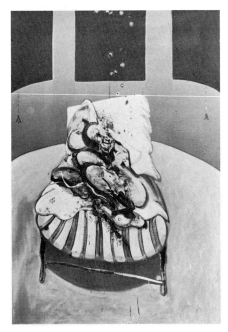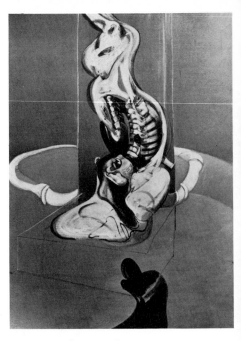

155 Francis Bacon (born 1909): *Three studies for a Crucifixion*. 1962. Canvas, each panel, 78 × 57 in. New York, Solomon R. Guggenheim Museum

Bacon's grand traditionalism has often been overlooked in favour of the impact of his subject-matter. As one critic wrote, 'over and above the disturbing aspect of a painting by Bacon, isn't it essentially elegant and imperturbable, and suitable for any really civilized woman's boudoir?'

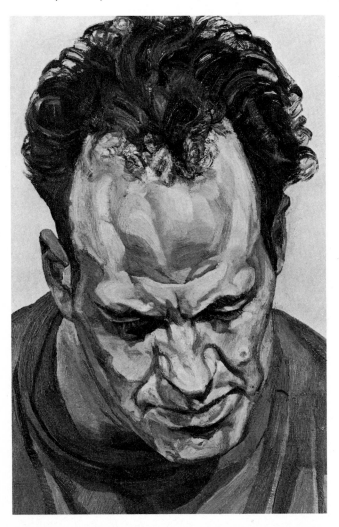

156 Lucian Freud (born 1922): *Portrait of Frank Auerbach*. 1975/6. Canvas, 15¾ × 10½ in. Private Collection

157 Francis Bacon (born 1909): *Portrait of George Dyer and Lucian Freud*. 1967. Canvas, 78 × 57 in. Hamburg, Klaus and Helga Hegewisch

A strong current of northern expressionism—never far below the surface in painters as different as Sickert, Matthew Smith and Burra, distinctly in evidence in Auerbach, Bacon and Freud—has been a consistent feature of much British painting of this century.

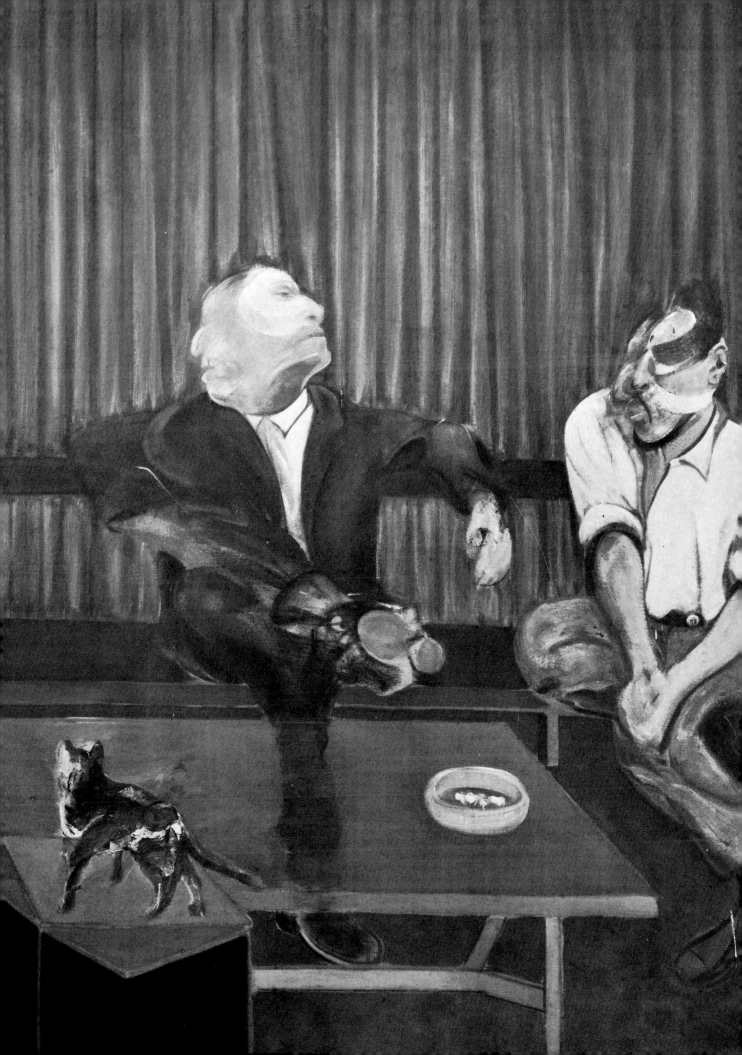

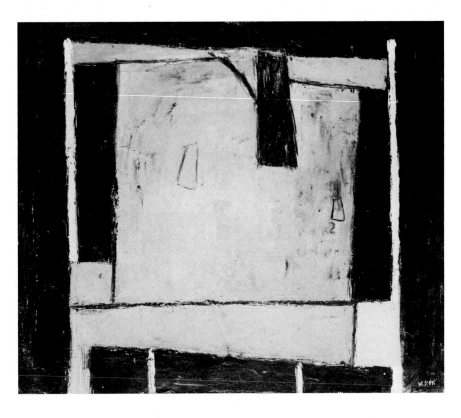

158 William Scott (born 1913):
*Still-life, coffee pot 1*. 1952–3.
Canvas, 26½ × 32 in. London,
Private Collection

The sensual apprehension of the
still-life objects which recur in
Scott's work of this period—
particularly the dark, somehow
uneasy presence of this coffee
pot—is conveyed in works not-
able for their almost ascetic
simplicity and vigorous re-
examination of formal con-
stituents.

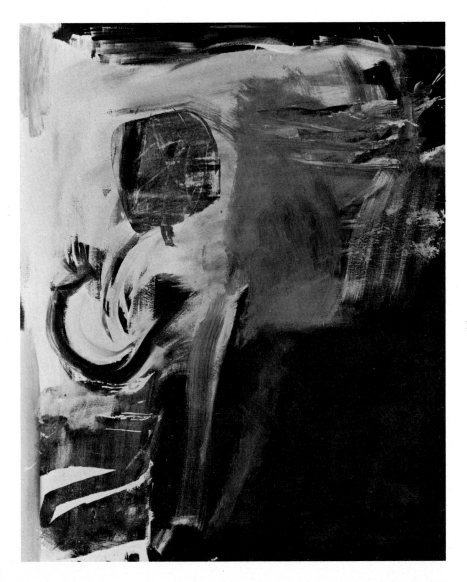

159 Peter Lanyon (1918–64): *Ther-
mal*. 1960. Canvas, 72 × 60 in.
London, Tate Gallery

Lanyon gradually abandoned
specific and allusive imagery in
his work for a more gesturally
composed and evocative paint-
ing. *Thermal* is one of a series
which came directly out of his
experience of gliding. 'The air'
he wrote, 'is a very definite
world of activity as complex
and demanding as the sea.'

160 Alan Davie (born 1920): *Entrance for a red temple, no. 1.* 1960. Canvas, 84 × 68 in. London, Tate Gallery

Employing vivid, heraldic colour and a joyous synthesis of signs, emblems and enigmatic personal imagery, Davie's work was in marked contrast to that of many of his contemporaries in the fifties.

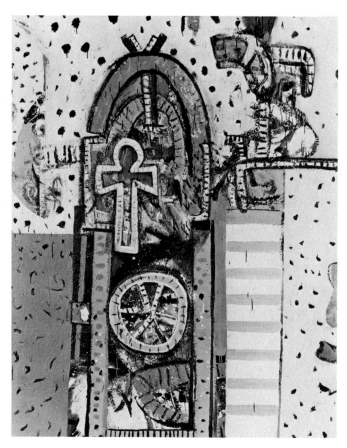

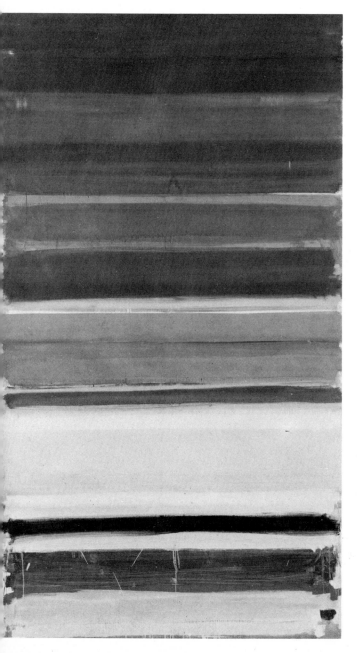

161 Patrick Heron (born 1920): *Horizontal stripe painting: November 1957—January 1958.* 1957–8. Canvas, 108 × 60 in. London, Tate Gallery

Writing specifically about his stripe paintings of 1957–8, Heron touched on a feature characteristic of his later development: 'I realised that the emptier the general format was, the more exclusive the concentration upon the experiences of colour itself.'

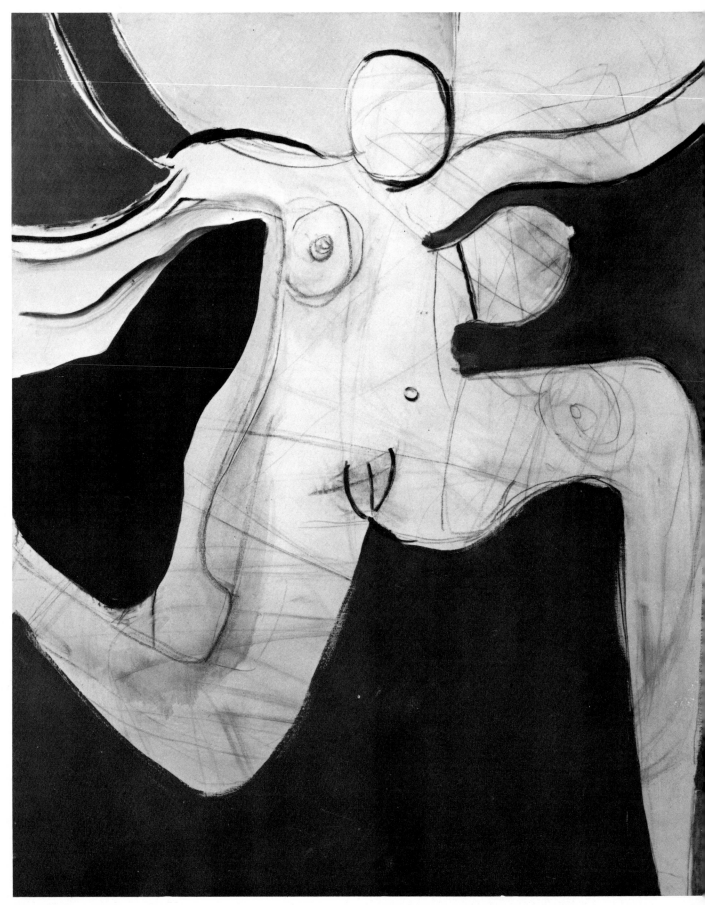

162 Roger Hilton (1911–75): *Dancing woman*. 1963. Canvas, 60 × 50 in. England,
Private Collection

163 Roger Hilton (1911–75): *February*. 1954.
Canvas, 50 × 40 in. London, Tate Gallery

The exuberance of Hilton's *Dancing woman*
(*opposite*) contrasts with this painting of a
decade earlier which belongs to Hilton's most
austerely non-figurative period. Common to
both—and to much of Hilton's work—is the
closeness of image to the picture plane with its
suggestion of continuing activity beyond the
confines of the canvas.

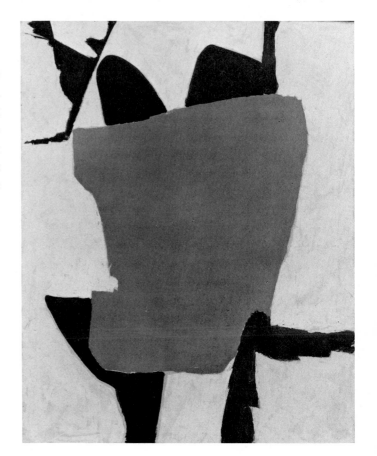

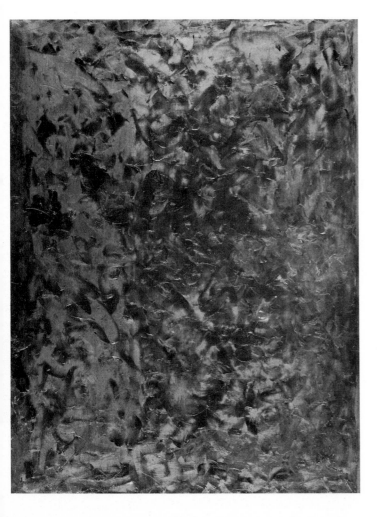

164 William Turnbull (born 1922): *No. 7*.
1959. Canvas, 78 × 58 in. London, Tate
Gallery

In the late fifties, Turnbull carried out
some of the most uncompromising abstract
works produced in Britain. Figurative
imagery and shape were eliminated; large
scale and monochromatic use of colour
enforced the direct physical appeal to the
spectator.

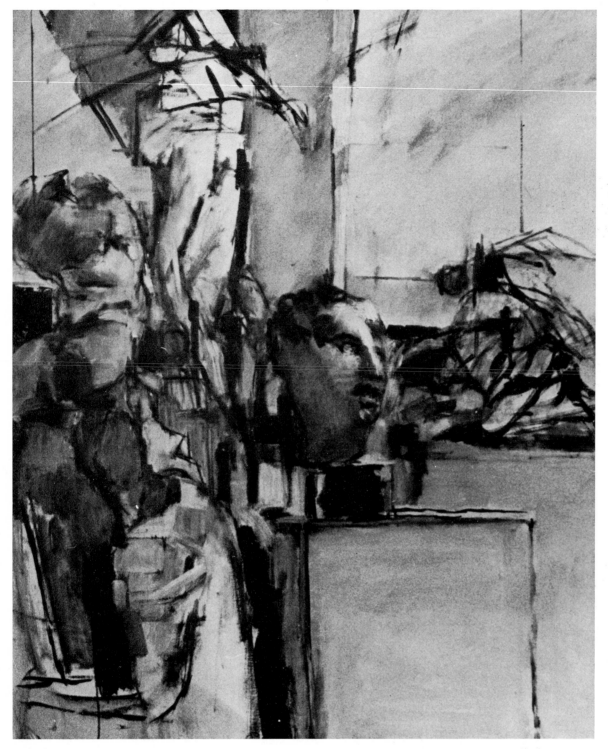

165 Robert Medley (born 1905): *The slave and the wrestlers, Antique Room*. 1953. Canvas, 49 × 42 in. Artist's Collection

166 Keith Vaughan (born 1912): *Leaping figure*. 1951. Canvas, 36 × 28 in. London, Tate Gallery

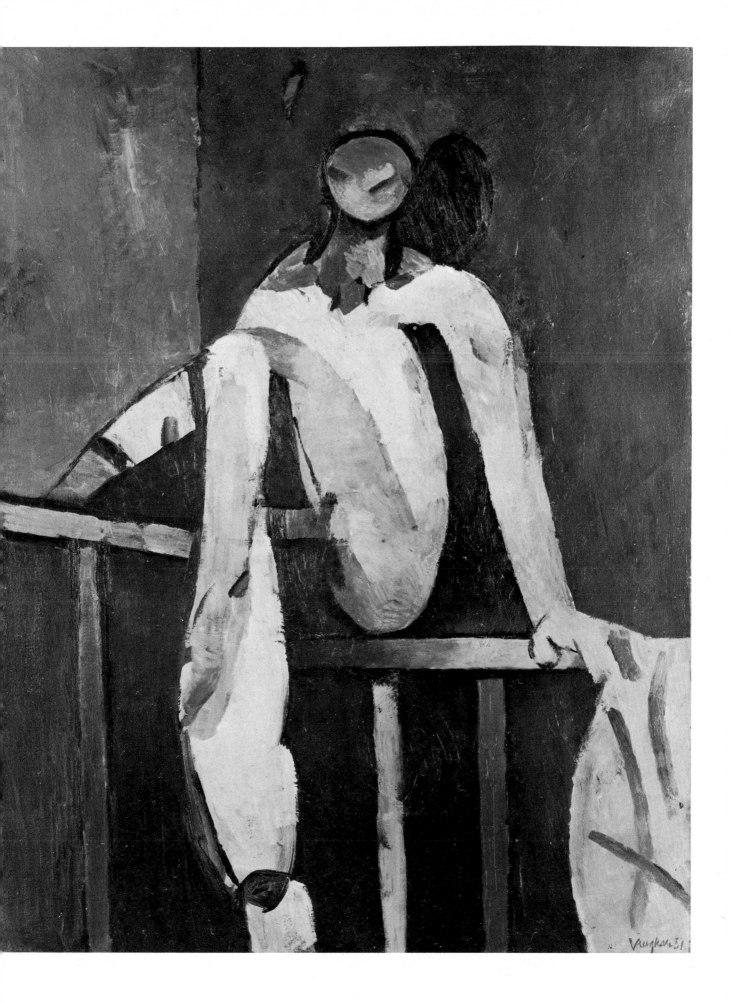

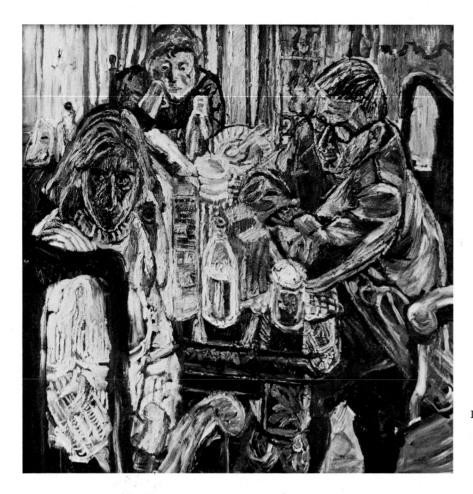

167 John Bratby (born 1928):
*Three people at a table.* 1955.
Canvas, $47\frac{1}{2} \times 47\frac{1}{2}$ in. British
Council Collection

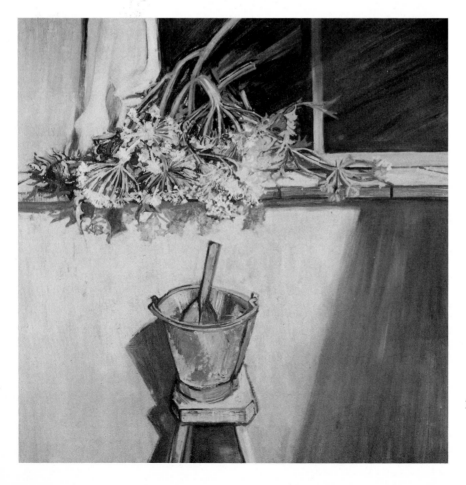

168 Edward Middleditch (born
1923): *Cow parsley.* 1956.
Canvas, 48 × 48 in. Liver-
pool, Walker Art Gallery

169 Jack Smith (born 1928): *After a Spanish feast*. 1955. Oil on hardboard, 96 × 48½ in. Sheffield City Art Gallery

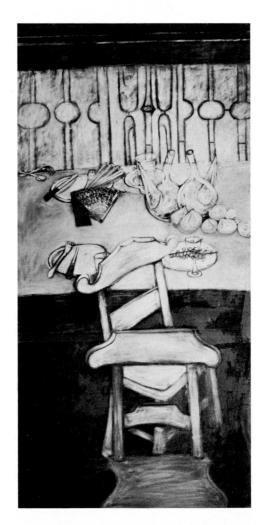

170 Josef Herman (born 1911): *Tired miner*. 1948. Canvas, 16 × 20 in. Henry Roland Collection

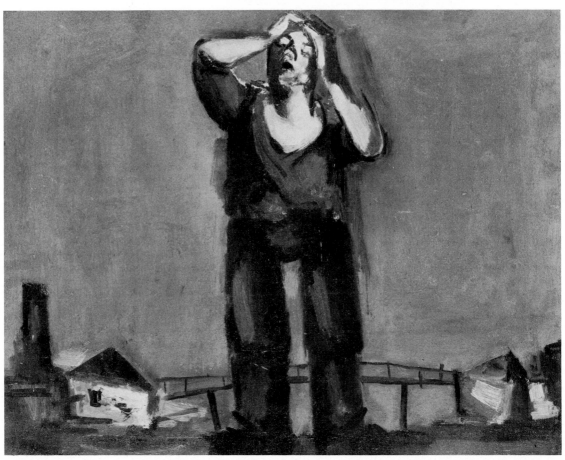

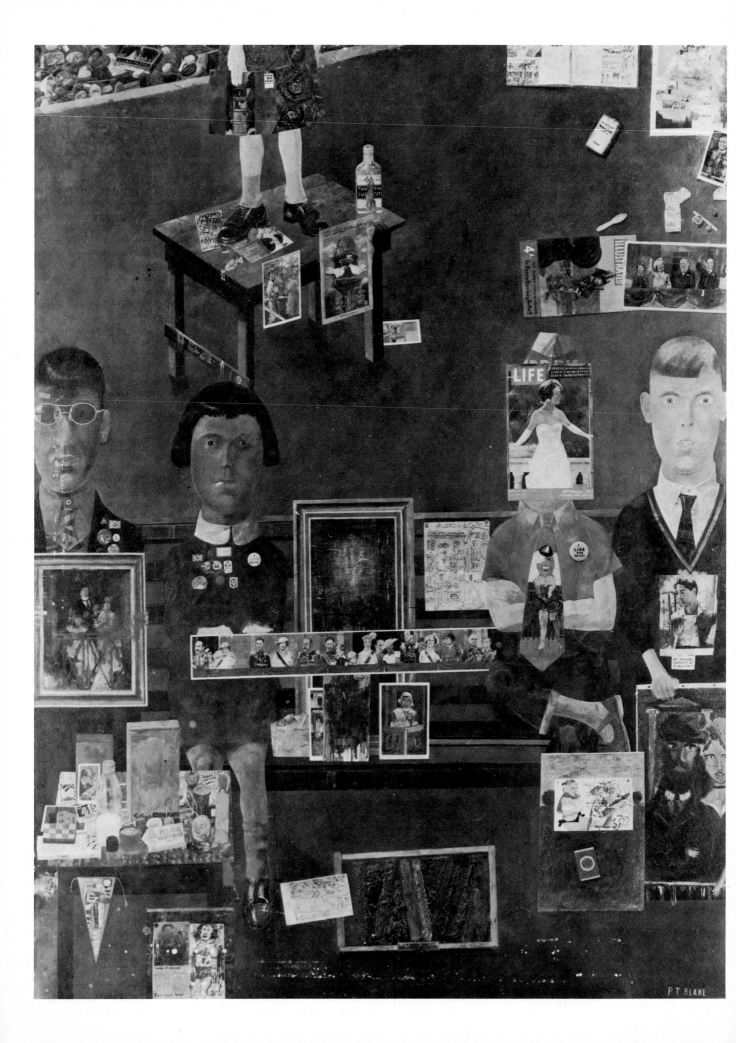

Peter Blake (born 1932): *On the balcony.* 1955–7. Canvas, 47¾ × 35¾ in. London, Tate Gallery

In contrast to the younger generation of Pop artists, Blake is altogether more homely, more unquestioningly figurative, less seduced by American admass imagery, ultimately more thoroughly English, as his subsequent development has shown. In this key painting in British art of the time, Blake introduces variations on the balcony motif elaborating a dialogue between producer and consumer, presenter and spectator, illusion and reality.

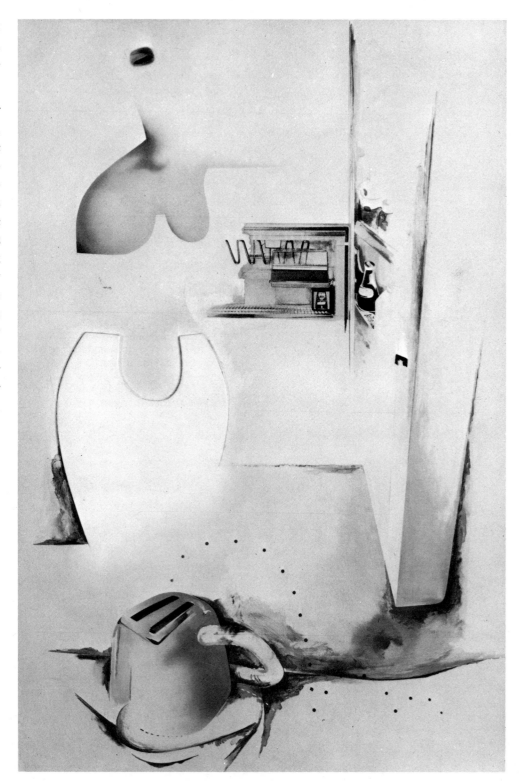

172 Richard Hamilton (born 1922): *$he.* 1958–61. Oil, mixed on board, 48 × 32 in. London, Tate Gallery

The presentation techniques of consumer goods, a constant theme of Hamilton's work, is at the heart of this painting in which such appliances—refrigerator, toaster, vacuum cleaner, all essentials to the 'home beautiful'—are offered by a pin-up/wife/mother figure calculated to de-frost the most reluctant consumer.

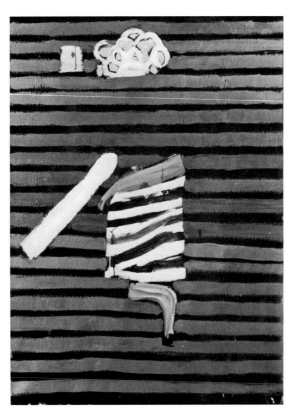

173 Howard Hodgkin (born 1932): *Dancing*. 1959. Canvas, 50 × 36 in. Private Collection

The increasing preoccupation of British artists with an inseparable presentation of form and content found vivid expression in Hodgkin's work at this time.

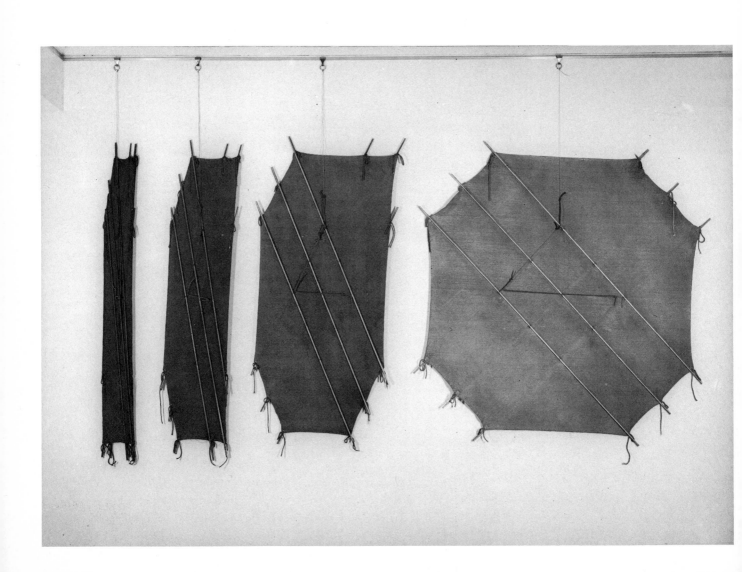

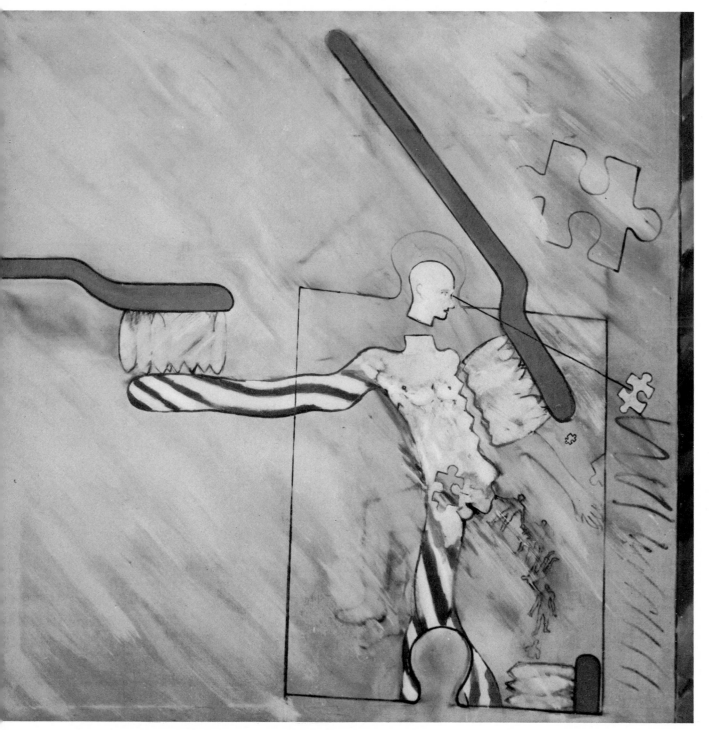

175 Derek Boshier (born 1937): *The Identi-kit Man*. 1962. Canvas, 72 × 72 in. London, Tate Gallery

The manipulation of present-day consumers by advertising is a theme of Blake's *On the balcony* (*Plate 171*) and Hamilton's *She* (*Plate 172*). A more grimly critical view was taken by Boshier in his identi-kit man series, a figure made up from jigsaw pieces and representing, in the artist's words 'the spectator, participant, player, or cog in the wheel.'

174 Richard Smith (born 1931): *The pod*. 1976. Acrylic on canvas, $63\frac{1}{3}$ × 129 in. Courtesy of Gimpel Fils, London

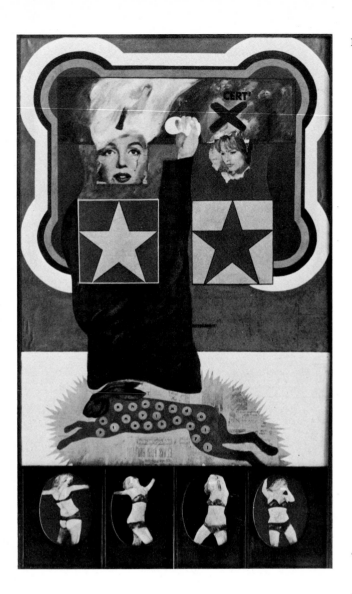

176 Peter Phillips (born 1939): *For men only starring MM & BB*. 1961. Oil and collage on canvas, 108 × 60 in. British Council Collection

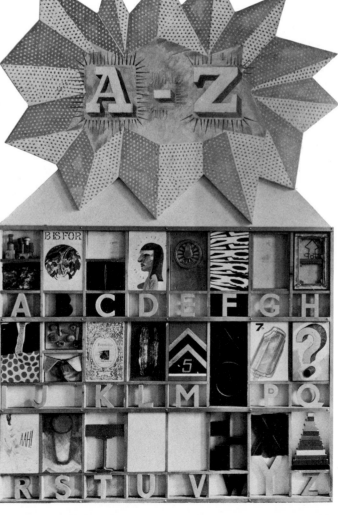

177 Joe Tilson (born 1928): *A-Z box of friends and family*. 1963. Mixed media, 92 × 60 in. Artist's Collection

The sources for some of Tilson's imagery and his inventive presentation—here friends have contributed objects and pictures closely identified with their own work and interests—connect him with some Pop and figurative art of the sixties, though he was concerned with a more symbolic language drawing much on various systems of communication.

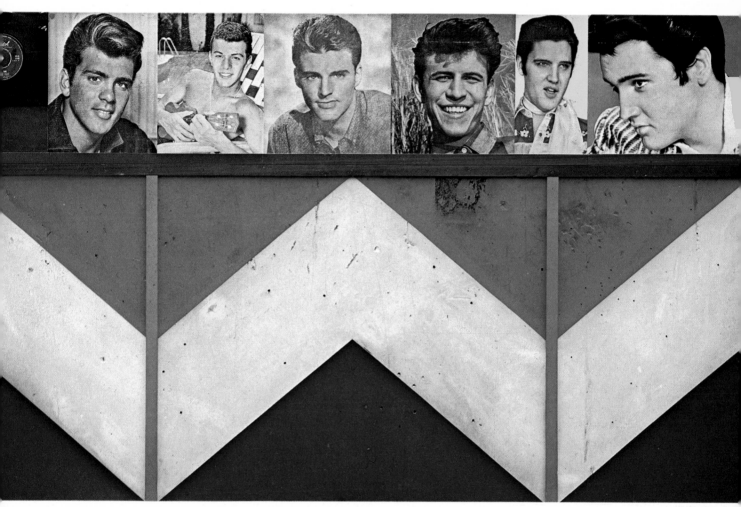

178 Peter Blake (born 1932): *Got a girl*. 1960–1. Oil on hardboard with additions of wood, photo-collage and gramophone record, 27 × 61 in. University of Manchester, The Whitworth Art Gallery

In the song which gives this picture its title, a boy complains that his girlfriend pays him no attention and can only think of her heroes in the pop charts—Fabian, Avalon, Presley, whose pictures are collaged above. Blake's winning, decorative simplicity contrasts with Phillips's colder, more complex presentation of imagery drawn from a similar world, if more 'adult' and sophisticated. Bardot and Monroe are exhibited as prizes in the mechanics of entertainment.

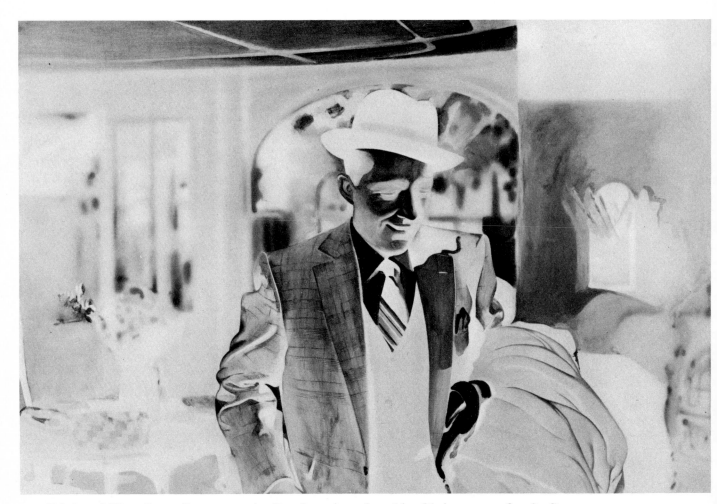

179 Richard Hamilton (born 1922): *I'm dreaming of a white Christmas*. 1967–8. Canvas, 52 × 63 in. London, Tate Gallery

Figures in interiors have been a constant source of inspiration for Hamilton (*Plates 149, 172*), sometimes composed from a variety of elements, sometimes taken straight, as in this still of Bing Crosby in the film *White Christmas*. Hamilton's technical virtuosity and choice of richly allusive imagery are both apparent in this presentation of the reversal of a colour negative. The nature of the still itself produces extremes of clarity and vagueness (*compare Sickert, Plate 83*), concealed and exposed application of paint, a treatment sharp and delicate, witty and strangely foreboding.

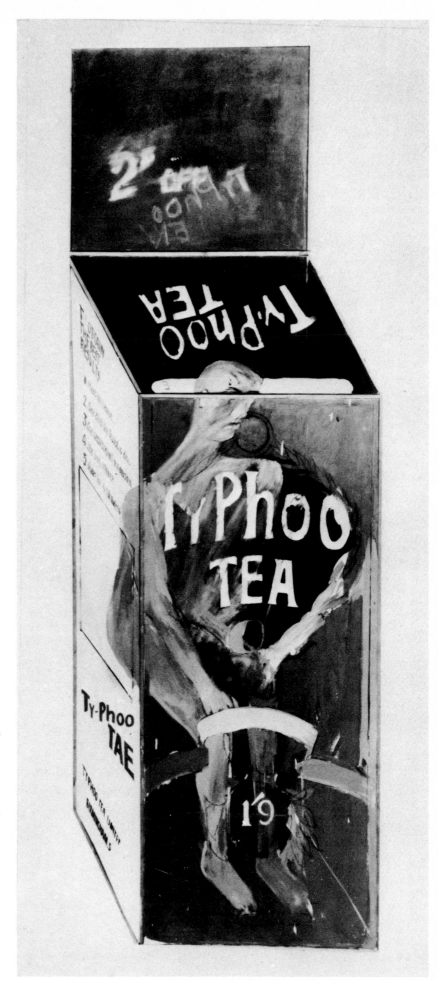

180 David Hockney (born 1937): *Tea painting in illusionistic style*. 1961. Canvas, 78 × 30 in. Courtesy of Kasmin Ltd.

The impulse behind Hockney's earlier work was considerably more personal (if not always self-revealing), more sensual and playful than that of some of his contemporaries—Phillips or Kitaj for example. The present picture, combining elements of advertising, graffiti, sex and art styles, is part of a series called 'Demonstrations of Versatility'.

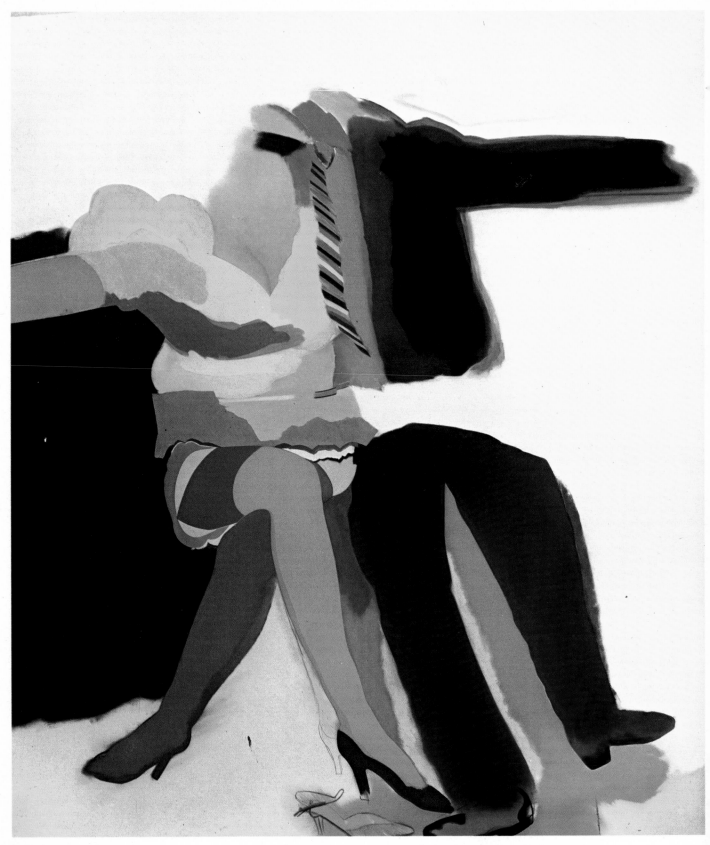

181 Allen Jones (born 1937): *Man/woman*. 1963. Canvas, $84\frac{1}{2} \times 74\frac{3}{8}$ in. London, Tate Gallery

182 David Hockney (born 1937): *Still-life with figure and curtain*. 1963. Canvas, 78 × 84 in. Stuyvesant Collection

Jones's painting in the early sixties, like Hockney's and to some extent Boshier's, was influenced by the example of Kitaj (*Plate 189*), if not by his actual imagery. He has disclaimed any particularly emotive feelings for the images he chooses and certainly much of his work, erotic and glamorous as it is, was consistently more painterly and decorative than someone like Phillips for example; such qualities should not disguise, however, his personal formal investigations, which rely, as in this painting, on ambiguity.

183 Bridget Riley (born 1931): *Crest*. 1964. Emulsion on board, $65\frac{1}{2} \times 65\frac{1}{2}$ in. Stuyvesant Collection

Simple procedures, apparent reduction of imagery and an emphasis on the non-illusionistic properties of a painting connect several artists working apart from the new Pop figuration. The limitations imposed by the label 'op art' have been considerably extended by Bridget Riley. Lancaster created works of allusive complexity of mood from predetermined yet flexible formal propositions. In his re-sighting of banal and familiar imagery, Caulfield retains some of its original compulsion and directness.

184 Mark Lancaster (born 1938): *Zapruder*. 1967. Liquitex on canvas, 68 × 84 in. Artist's Collection

Patrick Caulfield (born 1936): *Battle-ments*. 1967. Canvas, 60 × 108 in. London, Tate Gallery

186 Richard Smith (born 1931): *Staggerlee*. 1963. Canvas, 89 × 89 in. (irregular). Stuyvesant Collection

In the art of the late fifties and early sixties Richard Smith occupied an important position through his unique knowledge of recent American developments in art, particularly the colour-field painters. Using sensuous colour and a painterly handling, Smith approached contemporary imagery in a more oblique way than, for example, Hamilton or the younger Royal College generation of artists. His sources were found mainly in packaging, advertising photography and, more obtusely, contemporary culture—Staggerlee was the title of a current Jerry Lee Lewis song. Later preoccupations with three-dimensional forms and sequences of images have led to an examination of the tensions of activity itself, as in *The pod* (*Plate 174*).

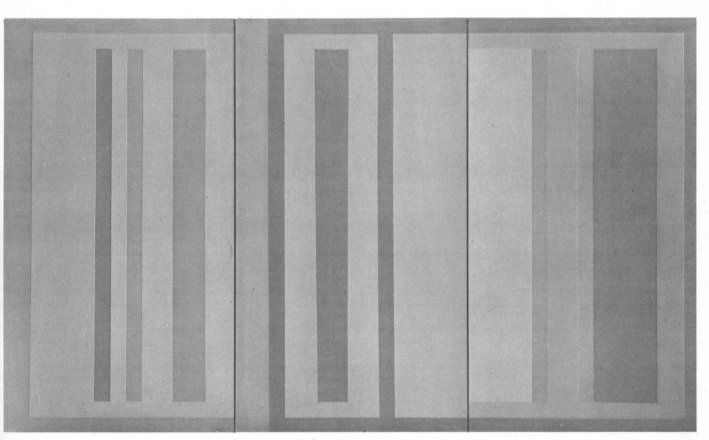

187 Robyn Denny (born 1930): *Baby is three*. 1960. Emulsion on canvas, 84 × 144 in. London, Tate Gallery

Smith and Denny were originally associated in the 'Place' exhibition at the Institute of Contemporary Arts in 1959 and in the following year in the 'Situation' group of artists at whose exhibition Denny exhibited *Baby is three*. 'At this time', he later wrote, 'I was experimenting with what new sensations of colour can be achieved with the most limited means—what great diversity of formal experience I could make with very limited forms.'

188 Tom Phillips (born 1937): *Benches*. 1970–1. Acrylic on canvas, 48 × 108¾ in. London, Tate Gallery

Like Kitaj (*below*) Tom Phillips's sources are diverse, synthesized however in a more deliberately accumulative way, each element chosen with extreme care to illustrate frank commentaries on aspects of life and death and creativity. *Benches*, one of his most complex and best known paintings, was inspired by his personal association of figures on park benches with a mood of mortality and separation; 'I had not thought death had undone so many,' Eliot's adaptation of Dante lies behind much of the imagery and mood of the painting.

189 R. B. Kitaj (born 1932): *Junta*. 1962. Oil on canvas with collage, 36 × 84 in. Courtesy of Marlborough Fine Art, London

The sources for Kitaj's paintings draw on a wide range of literature, history, music, films and photographs, reassembled by him at a moment of poetic fusion. Through association and actual image, they frequently evoke moods of violence, menace, corruption and conspiracy. The smell of old Europe hangs about *Junta* as it does in passages by Eliot and Pound, *emigrés* Americans like Kitaj himself.

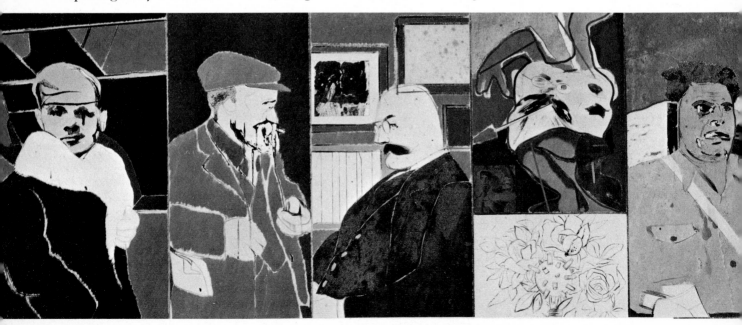

190 Bernard Cohen (born 1933): *Matter of Identity I.* 1963. Oil, enamel, tempera on canvas, 96 × 96 in. Private Collection

In the restless questioning of stylistic conventions, of the potential of image and form, the ways of making a picture, which accounts for the startling variety (and of course some of the similarities) of images in these last pages, Bernard Cohen has been one of the most acute intelligences at work in British painting of this period. One commentator has written of this and connected 'panel' paintings as being 'akin to the shufflable, flexible structure of some contemporary music and poetry, and instead of presenting the spectator with a clear-cut content they invite him to enter the systems of the painting and unravel or develop them himself.'

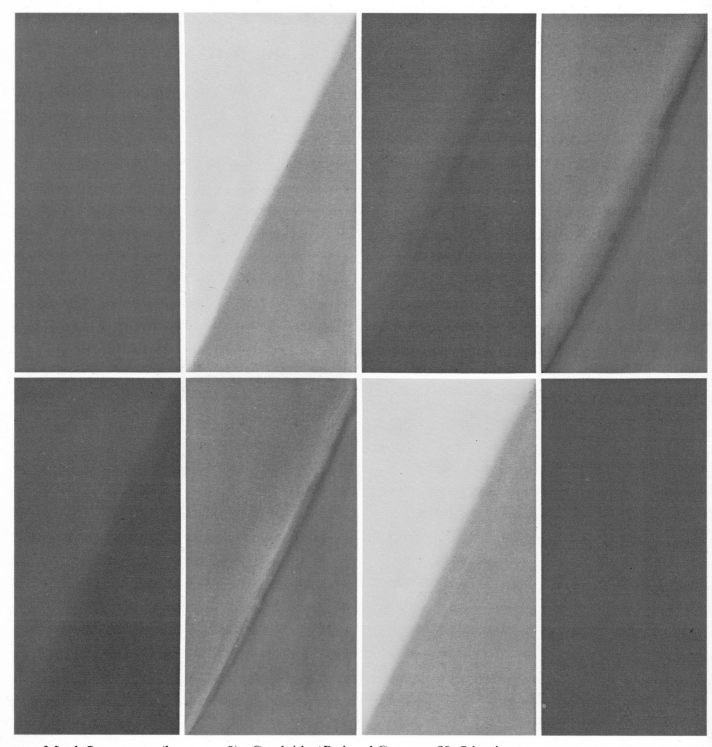

191 Mark Lancaster (born 1938): *Cambridge/Red and Green*. 1968. Liquitex on canvas, 68 × 68 in. Courtesy of the Rowan Gallery

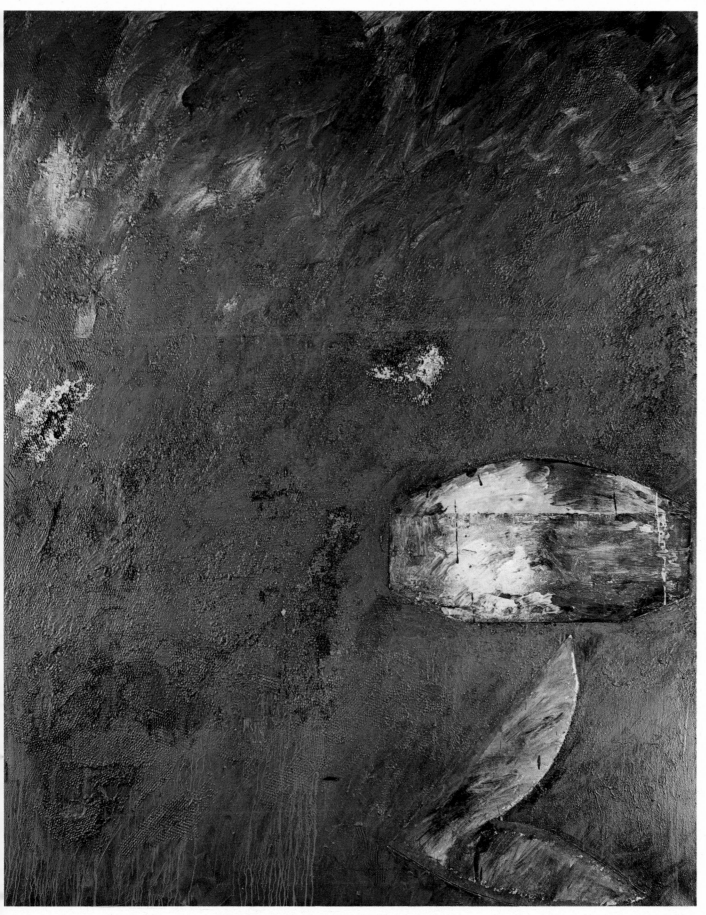

192 John Walker (born 1939): *Untitled*. 1972. Acrylic on canvas, 120 × 96 in. London, Nigel Greenwood Inc. Ltd.

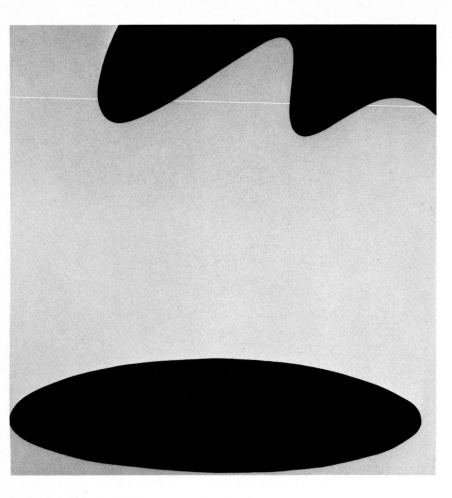

193 Paul Huxley (born 1938): *Untitled no. 21*. 1963. Acrylic on canvas, 80 × 80 in. Courtesy of the Rowan Gallery

195 Stephen Buckley (born 1944): *Red yellow diamond*. 1973. Oil, cryla, PVA and garden netting over cotton duck, 34 × 24 in. Eastern Arts Association Collection

Using a variety of media and methods, Buckley intimately involves the spectator in the physical activities by which each painting is made, a consideration of which reveals unusually dense layers of attitude, meaning and mood.

194 Keith Milow (born 1945): *123456 . . . B*. 1970. Relief, acrylic and drawing, 42 × 84 in. London, Tate Gallery

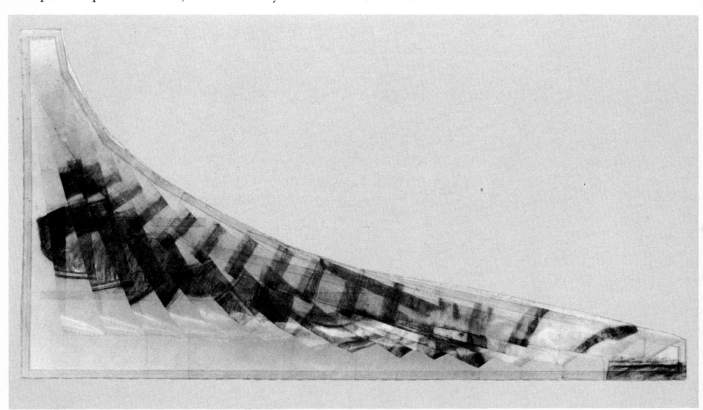

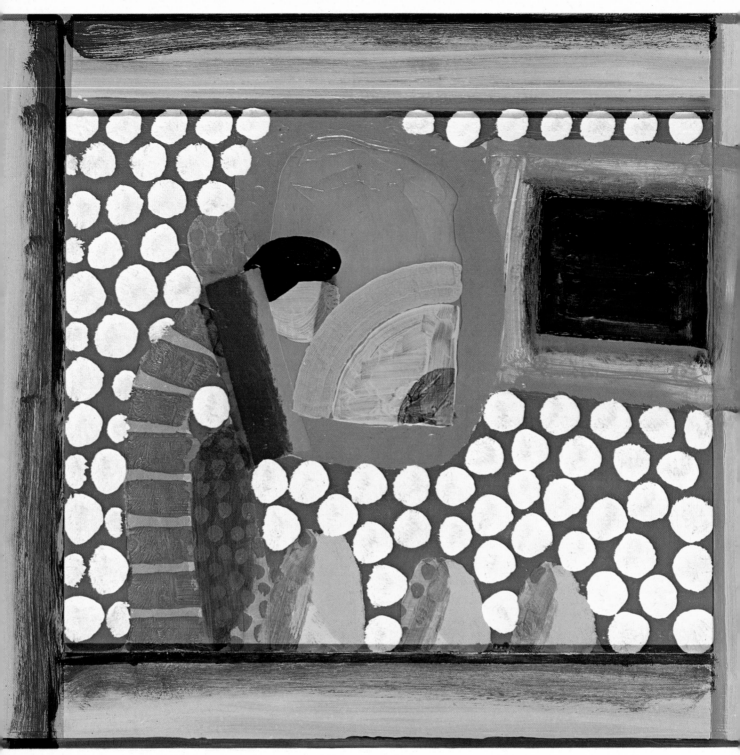

196 Howard Hodgkin (born 1932): *Small Durand Gardens*. 1974. Panel, $22\frac{1}{2} \times 26\frac{1}{4}$ in. Private Collection

The compilation of these notes would have been impossible without the two invaluable volumes *Modern British Paintings, Drawings and Sculpture* written by Mary Chamot, Dennis Farr and Martin Butlin and published by the Tate Gallery, 1964. Much information has also been used from the following catalogues: *Vorticism and its Allies*, Arts Council exhibition, Hayward Gallery, London, 1974, with introduction and notes by Richard Cork; *Camden Town Recalled*, Fine Art Society, London, 1976, with introduction and notes by Wendy Baron; *British Art and the Modern Movement 1930–40*, Welsh Arts Council, National Museum of Wales, Cardiff, 1962, with introduction and notes by Alan Bowness; *Pop Art in England 1947–63*, exhibition shown in Hamburg, Munich and York City Art Gallery, 1976, introduction and commentary by Uwe M. Schneede and Frank Whitford; *British Painting 1900–60*, Sheffield and Aberdeen, 1975–6, introduction and notes by Frank Constantine and Julian Spalding; and the catalogue to *British Painting '74*, Hayward Gallery, London, 1974.

## ARMFIELD, *Maxwell* (1881–1972)

Born in 1881 in Ringwood, Hampshire. Studied at Birmingham School of Art and in Paris from 1902. Exhibited at the Paris Salon, 1904–14, and the New English Art Club, 1906–60. First one-artist exhibition, Carfax Gallery, London, 1908. One of the foremost painters in tempera influenced by the Birmingham Quaker artist Joseph Southall. Poet and composer, author of *An Artist in America* (1925), *An Artist in Italy* (1926) and *A Manual of Tempera Painting* (1930); illustrated several books by his wife Constance Smedley. Exhibitions at the Fine Art Society, London, 1970, 1971, 1972 (memorial exhibition). Died January 1972.

## ARMSTRONG, *John* (1893–1973)

Born in 1893 in Hastings, Sussex. St Paul's School, London, 1907–12. St John's College, Oxford, 1912–13, and St John's Wood School of Art. Served in Royal Field Artillery, 1914–18. Contributed sets to the revue *Riverside Nights*, Lyric Theatre, Hammersmith, 1926. Decorations in the house of Mr and Mrs Samuel Courtauld, 20 Portman Square, London. First one-artist exhibition at the Leicester Galleries, London, 1928 (also 1929 and 1957). Wrote art criticism, designed film and theatre sets and the décor for the ballet *Façade*, 1931. Member of Unit One, 1933. Exhibited at the Lefevre Gallery, London, 1938, 1945, 1947, 1951. Worked on commissions from the War Artists' Advisory Committee, 1940–3. Painted a ceiling for the Council Chamber,

Bristol, 1955. Elected A.R.A., 1966. Lived in London from 1955 until his death in 1973. Retrospective at the Royal Academy, London (with tour), February to April, 1975. Exhibition at the New Art Centre, London, 1977, and at The Minories, Colchester, of work from 1935 to 1970, 1977.

## ATKINSON, *Lawrence* (1873–1931)

Born in 1873 at Chorlton-upon-Medlock, near Manchester. Educated in Chester and studied music in Berlin and Paris. Self-taught as an artist, he contributed to the 1913 Allied Artists' Association, joined the Rebel Art Centre, 1914, and exhibited, on invitation, with the Vorticists, 1915. Published a book of poems *Aura* (1915) and held an exhibition 'Abstract Sculpture and Painting' at the Eldar Gallery, London, May 1921. Devoted himself to sculpture in the last decade of his life and died in Paris in 1931. Like several Vorticist artists and their associates, much of his work has disappeared.

## AUERBACH, *Frank* (born 1931)

Born in 1931 in Berlin and came to England in 1939. Studied at St Martin's School of Art, 1948–52, and at the Royal College of Art, London, 1952–5; evening classes under David Bomberg, 1948–53. One-artist exhibitions at the Beaux Arts Gallery, London, 1956, 1959, 1961, 1962, 1963, and subsequently at the Marlborough Gallery, London and New York, 1969 and 1974.

## BACON, *Francis* (born 1909)

Born in Dublin in 1909, a collateral descendant of his Elizabethan namesake. Briefly attended school in Cheltenham and moved to London at the age of sixteen. Lived in Berlin and Paris. Began painting about 1928 with no formal training. Earned a living as an interior decorator holding an exhibition of his furniture and rugs in 1928. Much painting of the 1930s subsequently destroyed. Attracted wide attention with three paintings exhibited in a group show at the Lefevre Gallery, London, 1945; first one-artist exhibition, Hanover Gallery, London, 1949; Durlacher Bros., New York, 1953; Galerie Rive Droite, Paris, 1957. Lived mainly in Monte Carlo, 1946–50. Retrospective exhibitions at the Venice Biennale, 1954, the Institute of Contemporary Arts, London, 1955, and at the Tate Gallery, 1962 (with European and American tour, 1962–4). Since 1958 has exhibited at the Marlborough Galleries in London and New York. *Interviews with Francis Bacon* by David Sylvester published in 1975.

## BANTING, *John* (1902–72)

Born in 1902 in Chelsea, London. Studied under Bernard Meninsky and in Paris. Close contact with the Bloomsbury painters; designed book jackets for the Hogarth Press. Murals and interior decoration in several private houses. Member of the London Group; one-artist exhibition at the Wertheim Gallery, London, 1929. Studio in Paris in 1930, meeting the French Surrealists and Marcel Duchamp. Exhibited at the International Surrealist Exhibition, London, 1936. Worked on documentaries for Strand Films, 1939, and as art editor of *Our Time*, leftist magazine, 1941. In Ireland, 1947. Lived latterly in Sussex. Included in 'Britain's Contribution to Surrealism', Hamet Gallery, London, 1971. One-artist exhibition, Gallery Edward Harvane, London, 1972, the year of his death. Further exhibition at the same gallery, 1974.

## BAWDEN, *Edward* (born 1903)

Born in 1903 at Braintree, Essex. Studied at Cambridge School of Art and under Paul Nash at the Royal College of Art, London, 1922–5. Decorations for Morley College (with Ravilious and Mahoney) 1928–9; destroyed by bombing, 1941. Primarily a mural painter, designer and watercolourist, best known for his work as an official war artist in France and the Middle East, 1940–4. Elected R.A., 1956.

## BAYES, *Walter* (1869–1956)

Born in 1869 in London, son of a painter and brother of sculptor Gilbert Bayes. Studied painting part-time from 1886 to 1900 and at the Westminster School of Art, 1900–2. Art critic to *The Athenaeum*, 1906–16. Founder member of the Allied Artists' Association, 1908; Camden Town Group, 1911 (exhibiting at all three exhibitions), and London Group, 1913, the year of his first one-artist exhibition at Carfax Gallery, London (and in 1915). Became headmaster of Westminster School of Art, 1918-34, and influential teacher, especially of decorative and mural painting, about which he published a book in 1927. Died in London, 1956. Published *Turner, a Speculative Portrait* (1931).

## BELL, *Graham* (1910–43)

Born in 1910 in the Transvaal. Worked in a bank and at agriculture before studying painting at the Durban Art School. Arrived in England, 1931; influenced by Duncan Grant and came to know William Coldstream and Geoffrey Tibble, exhibiting at the show of 'Objective Abstractionists,' Zwemmer Gallery, London, 1934. Wrote art criticism for the *New Statesman*, 1934–7, and published a pamphlet *The Artist and His Public* (Hogarth Press, 1939). Associated with Coldstream, Pasmore and Rogers in the Euston Road School and joined the Artists' International Association. Enlisted with the R.A.F. and killed on a training flight in England, 1943. Best known for his portraits and landscapes and *The Café* (1937–8, Manchester, City Art Galleries).

## BELL, *Vanessa* (1879–1961)

Born in 1879 in London, daughter of Sir Leslie Stephen and sister of Virginia Woolf. Studied at Sir Arthur Cope's School, London, 1896–1900, and at the Royal Academy Schools under Sargent, 1901–4. Married the critic and writer Clive Bell, 1907. Founded and exhibited at the Friday Club exhibitions, London, 1905–12, at the Galerie Barbazanges, Paris, and in the Second Post-Impressionist Exhibition, Grafton Galleries, London, 1912. Member of the Grafton Group, 1913–14, and co-director of the Omega Workshops, 1913–19. First one-artist exhibition, Independent Gallery, 1922. Exhibited regularly with the London Group from 1919 until her death. Besides easel painting, worked as fabric and furniture designer, carried out murals in several private houses with Duncan Grant, designed ballets for the Camargo Ballet and Sadler's Wells Company. One-artist exhibitions in London at the Cooling Galleries, 1930, and Lefevre Galleries, 1934 and 1937. Murals for Berwick Church, Sussex (with Duncan Grant), 1940–3. Exhibition at the Adams Gallery, 1956, and memorial show there, 1961. Died in Sussex, 1961. Arts Council Memorial Exhibition, 1964, and 'Paintings and Drawings', Anthony d'Offay Gallery, London, 1973.

## BEVAN, *Robert Polhill* (1865–1925)

Born in 1865 at Hove, Sussex. Studied briefly at the Westminster School of Art under Frederick Brown and at the Académie Julian, Paris. Worked with Joseph Crawhall in Tangier, 1892. Met Gauguin and others in the Pont-Aven circle, Brittany, 1893–4. Married the Polish painter Stanislawa de Karlowska, 1897, and made frequent visits to Poland. Exhibited in 1908 with the Allied Artists' Association, joined the Fitzroy Street Group and was a founder member of the Camden Town Group, 1911, and the London Group, 1913. Closely associated with Ginner, Gilman and others of the Camden Town Group; best known for his landscapes and cab-yard scenes. One-artist exhibition at the Carfax Gallery, London, 1913. Died in 1925. Arts Council retrospective exhibition, 1956, and exhibition at Colnaghi's, London, 1965.

## BLAKE, *Peter* (born 1932)

Born in 1932 in Dartford, Kent. Attended Gravesend Technical College and Gravesend School of Art, 1946–51. Service in the Royal Air Force, 1951–3. Studied at the Royal College of Art, London, 1953–6. Scholarship for the study of folk art in various European countries, 1956–7. Exhibited in 'Five Painters', Institute of Contemporary Arts, 1958. First one-artist exhibition, Portal Gallery, London, 1962. Exhibited at Paris Biennale, 1963, and visited U.S.A. Included in the 1964 'Nieuwe Realisten' exhibition, The Hague, 1964, and in 'The English Eye', Marlborough-Gerson Gallery, New York, 1965. Retrospective at Bristol City Art Gallery, 1969, and further retrospective, 1973–4, in Amsterdam, Hamburg and Brussels. Exhibitions at

Waddington Gallery, London, 1972, 1977. Represented in 'Pop Art in England', Hamburg, Munich and York, 1976.

## BOMBERG, *David* (1890–1957)

Born in 1890 in Birmingham into Polish immigrant family. Lived in Whitechapel, London, 1895–1913. Apprenticed to a lithographer and studied under Walter Bayes at the City and Guilds evening classes, 1906–7. Slade School, 1911–13, where fellow students included Nevinson, Wadsworth, Roberts and Jacob Kramer. Exhibited in 1913 with the Friday Club and in the 'Camden Town Group and Others', Brighton Art Gallery. First one-artist exhibition at the Chenil Galleries, London, 1914. Included as an invited artist in the Vorticists' only exhibition, Doré Gallery, London, 1915. Active service, 1916–18; worked on a commission for the Canadian War Memorials Scheme while still in France, from where he returned to England, 1918. Published *Russian Ballet* (1919) with text and lithographs. Living and working mainly in Palestine, 1923–7, visiting Petra in 1924, Spain, 1929, Morocco and the Greek islands, 1930, Russia, 1933, Spain, 1934–5. Began teaching in the Second World War, forming the Borough Group with his students in 1947 and the Borough Bottega group, 1953. Considerable influence on such artists as Creffield, Holden, Auerbach and Kossoff. Mainly in Spain, 1954–7. Died in London in 1957, one of the most neglected of modern British painters. His reputation grew considerably with the 1967 Tate Gallery retrospective (with provincial tour). Exhibitions since then include 'Drawings, Watercolours and Prints 1912–1925', Anthony d'Offay Gallery, London, 1971, and 'Paintings, Drawings, Watercolours and Lithographs', Fischer Fine Art, London, 1973.

## BOSHIER, *Derek* (born 1937)

Born in 1937 in Portsmouth. Studied at Yeovil School of Art, 1953–7, and at the Royal College of Art, London, 1959–62. Exhibited from 1959 with the 'Young Contemporaries', R.B.A. Galleries, London. First one-artist exhibition, Grabowski Gallery, London, 1962. Visited India, 1962–3. Exhibited at the Paris Biennale, 1963, and included in the 'New Generation' exhibition Whitechapel Art Gallery, London, 1964, with Hockney, Jones, Tom Phillips, Caulfield, etc. Visited U.S.A., 1964. Retrospective at Ferens Art Gallery, Hull, 1973. Exhibition of works 1971–4 at the Whitworth Art Gallery, Manchester, 1975, and included in 'Pop Art in England' Hamburg, Munich and York, 1976. Published *16 Situations* (1971) and *Six Cities* (1972). One-artist exhibition, Angela Flowers Gallery, London, 1976.

## BRANGWYN, *Sir Frank* (1867–1956)

Born in 1867 in Bruges, the son of a Welsh architect. Worked briefly under William Morris, 1882, but was largely self-taught. Exhibited at the Royal Academy in 1885 (elected member, 1919). Best known for his etchings and large-scale mural decorations and as a designer of furniture, pottery and carpets. Exhibition of paintings and etchings at the Fine Art Society, London, 1908. Painted mural decorations for Skinners Hall, 1904–9, for the House of Lords (commissioned 1926, rejected 1930 and bought by Swansea City Centre, 1933), and for the Rockefeller Center, New York, 1932 (with Diego Rivera and José Maria Sert). Retrospective exhibition at the Royal Academy, 1952. Widely travelled, the recipient of many foreign honours and with an international reputation (a Brangwyn Museum was established in Bruges, 1936). Knighted in 1941. Died at Ditchling, Sussex, 1956. Memorial exhibition at the Fine Art Society, London, 1958; three centenary exhibitions, 1967 – at the William Morris Gallery, the National Museum of Wales and the Fine Art Society, London.

## BRATBY, *John* (born 1928)

Born in 1928 in London. Studied at the Kingston School of Art and the Royal College of Art, 1951–4. First one-artist exhibition at the Beaux Arts Gallery, 1954, the year in which he received an Italian Government Scholarship enabling him to visit Italy for six months. Represented at the International Exhibition of Modern Art, Carnegie Institute, Pittsburgh, U.S.A., 1955. Represented Britain at the Venice Biennale, 1956, with others of the so-called 'Kitchen Sink School' – Middleditch, Greaves and Jack Smith. Designed sets for the film *The Horse's Mouth* from the novel by Joyce Carey, 1957–8. He married the painter Jean Cooke in 1953. Author of *Breakdown* (1960); regular exhibitor at the Royal Academy.

## BUCKLEY, *Stephen* (born 1944)

Born in 1944 in Leicester. Studied under Richard Hamilton, University of Newcastle upon Tyne, 1962–7, and at University of Reading, 1967–9. One-artist exhibition at Durham University, 1966. Artist in Residence at King's College, Cambridge. Further exhibitions at Nigel Greenwood Inc., London, 1970, Galerie Neundorf, Hamburg and Cologne, and Kasmin Gallery, London (both 1970). Various group exhibitions, London, Newcastle and Paris. Included in 'Henry Moore to Gilbert and George', Palais des Beaux-Arts, Brussels, 1973. 'Cambridge Works', Kettle's Yard Gallery, Cambridge, 1974; new work at Garage Gallery, London, 1974, and recent work at Waddington, London, 1976. Represented in 'Five British Artists' (with Milow, R. Smith and others), Young Hoffman Gallery, Chicago, 1977. Lives in London.

## BURRA, *Edward John* (1905–76)

Born in 1905 in South Kensington, London. Spent most of his life in Rye, Sussex. Chelsea School of Art, 1921–2, Royal College of Art, 1923. Frequent visits to Paris, the South of France (with Paul Nash, 1930), to Mexico, New York and Boston, 1934. First one-artist exhibition at the Leicester Galleries, London, 1929; member of Unit One, 1933. Contributed

to 'International Surrealist Exhibition', London, and 'Fantastic Art, Dada, Surrealism', Museum of Modern Art, New York, 1936. Designed five ballets, including *Rio Grand* (Camargo Ballet, 1931); *Miracle in the Gorbals* (Sadler's Wells, 1944); *Don Juan* (Covent Garden, 1948), and sets and costumes for Bizet's *Carmen* (Covent Garden, 1947). One-artist exhibition at the Lefevre Gallery, London, 1952, and biennially at that gallery from 1955. Included in 'The English Eye', Marlborough-Gerson Gallery, New York, 1965. Retrospectives at the Hamet Gallery, London, 1970, and at the Tate Gallery, 1973. Worked almost entirely in watercolour, often on a large scale. Created C.B.E., 1970. Died at Rye, 1976. One-artist exhibition at Towner Art Gallery, Eastbourne, 1976.

# CAULFIELD, *Patrick* (born 1936)
Born in 1936 in London. Attended Chelsea School of Art, 1956–9, and the Royal College of Art, 1959–63. Attracted initial notice through the 'Young Contemporaries' exhibitions, R.B.A. Galleries, London, 1961, 1962 and 1963. Included in the 'New Generation' exhibition at the Whitechapel Gallery, London, 1964. First one-artist exhibition at the Robert Fraser Gallery, 1965 (again in 1967). Represented in 'Jeunes Peintres Anglais', Palais des Beaux-Arts, Brussels, 1967, and in the following year in the 'European Painters of Today' exhibition, Musée des Arts Décoratifs, Paris. One-artist exhibitions at the Robert Elkon Gallery, New York, 1966 and 1968, and at the Waddington Galleries, London, 1969, 1971, 1973 and 1975. Exhibition of screenprints, Atmosphere Gallery, London, 1974. Lives in London.

# CLAUSEN, *Sir George* (1852–1944)
Born in 1852 in London, of Danish descent. Worked as a youth in a drawing office and studied at the Royal College of Art, 1873–5. Exhibited at the Royal Academy from 1875. Assistant to Edwin Long, R.A., and in 1883 attended the Académie Julian, Paris, for a short time. Influenced by Bastien–Lepage and the French *plein-air* school. Founder member of the New English Art Club, 1886, where he exhibited until 1895, when he was elected A.R.A. (R.A., 1908). Lived in Essex and Berkshire, painting landscapes and scenes of country life and occasional portraits. Professor of Painting at the Royal Academy Schools, 1904–6. Author of *Lectures on Painting* (1904) and *Aims and Ideals in Art* (1906). Knighted, 1927. Retrospective exhibitions at Barbizon House, 1928 and 1932. Died at Cold Ash, near Newbury, Berkshire, in 1944.

# COHEN, *Bernard* (born 1933)
Born in 1933 in London of Polish-Russian parents. Evacuated from London, 1939–43, without family. Studied at South-West Essex Technical College and School of Art, 1949–50. Attended St Martin's School of Art, London, 1950–1, under Kenneth Martin and others, and at the Slade School of Fine Art, London, 1951–4. Exhibited in the 'Young Con-

temporaries', London, 1953, and in 'Six Young Contemporaries', Gimpel Fils, London, 1953. Between 1954 and 1956 lived partly in Paris and in Rome. Exhibited in 'Dimensions', O'Hana Gallery, London, 1957, and first one-artist exhibition held at Gimpel Fils, 1958. Took part in 'Situation' exhibition, R.B.A. Galleries, London, 1960, along with his brother Harold Cohen (born 1928), Robyn Denny, John Hoyland, Richard Smith, William Turnbull and others.'New London Situation', New London Gallery, 1961. One-artist exhibitions include Molton Gallery, London, 1962; Kasmin Gallery, London, 1963; Kasmin Gallery (drawings), 1964; Betty Parsons Gallery, New York; Arnolfini, Bristol, and Kasmin Gallery, all 1967. Teaching at the University of New Mexico, 1969–70. Exhibitions of drawings and prints, Arnolfini, Bristol, and Waddington Galleries, London, 1972. Retrospective exhibition 'Paintings and Drawings 1959–71', Hayward Gallery, 1972 (shown also in Newcastle and Leeds). Exhibitions in 1973 at the Galleria Annunciata, Milan, and represented in 'La peinture anglaise d'aujourd'hui,' Musée d'Art Moderne, Paris. One-artist exhibitions, Waddinton Galleries, London, 1974, 1977.

# COLDSTREAM, Sir William (born 1908)
Born in 1908 in Belford, Northumberland, the son of a doctor. Privately educated owing to illness. Began drawing and painting in 1925 and attended the Slade School of Fine Art, London, under Professor Henry Tonks, 1926–9. Exhibited with the New English Art Club and the London Group. First one-artist exhibition shared with Enslin de Plessis (born 1894) as members of the London Artists' Association, 1933. Worked for the G.P.O. film unit and collaborated with W.H. Auden on *Coal Face* (1935). Resumed full-time painting, 1937. In the following year he opened the Euston Road School of Drawing and Painting, with Victor Pasmore and Claude Rogers, at 12 Fitzroy Street, later moving to 316 Euston Road, London. His students included Lawrence Gowing. Joined the Royal Artillery, later commissioned as Camouflage Officer, 1940. Official war artist in Egypt and Italy, 1943–5. Appointed Slade Professor at University College, London (retired 1975). Arts Council retrospective exhibition with tour, 1962. Recent paintings at the Anthony d'Offay Gallery, London, 1976.

# COLLINS, *Cecil* (born 1908)
Born in 1908 at Plymouth. Won a scholarship to Plymouth School of Art, where he studied, 1923–7. Royal College of Art, London, 1927–31. Contributed to the 'International Surrealist Exhibition', London, 1936. Met the American painter Mark Tobey, 1938, who encouraged his interest in the art and philosophy of the Far East. Taught at Dartington Hall and in 1947 published *The Vision of the Fool*. Exhibited at the Lefevre Gallery, London, in 1944, 1945 and 1946; at the Ashmolean Museum, Oxford, 1953; Whitechapel Gallery retrospective,

1959, and in the Carnegie International Exhibition, Pittsburgh, U.S.A., 1964. Has executed tapestries and an altarpiece for Chichester Cathedral. Exhibition of recent drawings at the Anthony d'Offay Gallery, London, 1976. Lives in London.

## COLQUHOUN, *Robert* (1914–62)

Born in 1914 at Kilmarnock, Ayrshire, where he later attended the local Academy. Released from apprenticeship in an engineering concern and attended Glasgow School of Art, where he met Robert MacBryde, his lifelong friend, with whom he travelled to France and Italy, 1937–9. Joined the Royal Army Medical Corps, stationed in Edinburgh and Leeds. Invalided out of the army and settled in London, 1941. First one-artist exhibition at the Lefevre Gallery, London, 1943 (subsequently showed there singly in 1944, 1947 and 1951, and in several group exhibitions). Shared a house with John Minton and MacBryde, 1943. Began producing monotypes and lithographs for Miller's Press, Lewes, Sussex. Visited Italy, 1949. Sets and costumes for the ballet *Donald of the Burthens*, Covent Garden, 1951. Sets and costumes (with MacBryde) for *King Lear*, Stratford, 1953. Represented in '60 Paintings for 1951', Arts Council, London, 1951, and 'Figures in their Setting', Contemporary Art Society, 1953. Retrospective exhibition at the Whitechapel Gallery, 1958. Died in London in 1962. A Colquhoun Memorial Art Gallery opened in Kilmarnock, 1972. 'Paintings by Colquhoun and MacBryde', Mayor Gallery, London, 1977.

## CONDER, *Charles* (1868–1909)

Born in 1868 in London. Childhood in England and India and emigrated to Australia in 1884. Studied in Sydney and exhibited with Australian Impressionists, Melbourne, 1889. Returned to Europe, 1890, and studied in Paris, where he exhibited with William Rothenstein, 1891. Friends in Paris included Toulouse-Lautrec (who painted him) and Louis Anquetin. Member of the New English Art Club, 1892. Painting in Normandy and on the Seine, summers of 1892–4, the years of his first paintings on silk, which he continued for the rest of his life. First one-artist show in London at the Carfax Gallery, 1899. Married in 1901, suffering increasing ill-health. Died at Virginia Water in 1909. Memorial exhibition at the Leicester Galleries, London, 1913, and the Tate Gallery, 1927. 'Paintings, Watercolours and Drawings', the Piccadilly Gallery, London (with Fine Art Society), November, 1969.

## CRAXTON, *John* (born 1922)

Born in 1922 in London, son of the pianist Harold Craxton. Early impressed by the work of Picasso and Miró in Paris, 1936. Studied at La Grande Chaumière, Paris, 1939; at the Westminster and Central Schools of Art and at Goldsmiths' College of Art, 1941–2. Shared a studio with Lucian Freud, London, 1942–4. First one-artist show, Leicester Galleries, London, 1944. Since 1945, prolonged stays abroad, particularly in Greece (at Xania from

1960). Further one-artist shows at the Leicester Galleries, London, in 1951, 1954, 1956, 1961 and 1966. Exhibited in Athens through the British Council, 1946 and 1949. Designed the sets and costumes for Ravel's *Daphnis and Chloë* (Sadler's Wells Ballet, 1951). Designs for *Apollo* ballet (Covent Garden, 1966). Retrospective exhibition at Whitechapel Art Gallery, 1967. Included in many group exhibitions.

## DAVIE, *Alan* (born 1920)

Born in 1920 in Grangemouth, Scotland, son of a painter and etcher. Began serious painting in 1936 and studied at Edinburgh College of Art, 1937–40. Exhibited with the Royal Scottish Academy and the Society of Scottish Artists, 1940–2. Served in Royal Artillery, 1940–2. Made ceramics and jewellery and was a professional jazz musician, 1947, the year he married the potter Janet Gaul. Travelled abroad in Italy and Switzerland, 1948–9. Lived by making jewellery, 1949–53. Exhibited in several group exhibitions in London (mainly at Gimpel Fils) and abroad ('Abstract Artists', Riverside Gallery, New York, 1951). Visited New York in 1956 and gave first public lecture 'Self Portrait' at the Institute of Contemporary Arts, London, 1956. Gregory Fellowship, Leeds University, 1956–9. One-artist touring exhibition, 1962–3, in Amsterdam, Oslo, Baden-Baden, Berne and Pforzheim; Martha Jackson Gallery, New York, 1965, and shows at Gimpel Fils, London, Zurich and Milan. First public recital of his music at Gimpel Fils, London, and the Tate Gallery, 1971. Lives in Hertfordshire and Cornwall.

## DE MAISTRE, *Roy* (1894–1968)

Born in 1894 in New South Wales, Australia. Studied there at the Royal Art Society and later at the Sydney Art School. Early interest in the connections between the colour spectrum and the musical scale; lecture 'Colour in Art' delivered to Arts Club, Sydney, 1918. Awarded travelling scholarship, 1923; moved from London after six months to Paris. Returned to Australia, 1926, holding first one-artist exhibition at Macquarie Galleries, Sydney. Returned to Europe, 1930, dividing time between London, Paris and St Jean de Luz (1930–2). First London show at Beaux Arts Gallery, 1930. Friendship with Francis Bacon, with whom he held an exhibition in Bacon's London studio, winter 1930. Ran a school of painting in the thirties with Martin Bloch. Exhibited in 'Art Now', Mayor Gallery, London, 1933, and held one-artist show there in following year. Worked in Foreign Relations Branch of British Red Cross (French Section) from 1939 to 1943. Retrospective at Temple Newsam, Leeds, 1943, Birmingham, 1946; exhibitions at Adams Gallery, London, 1950, and Hanover Gallery, London, 1953; at Whitechapel Art Gallery, London, 1960. Represented in 'Art in Britain 1930–40', Marlborough Gallery, London, 1965. Lived and worked after the war in Eccleston Street studio, London, and died in 1968. Created C.B.E. in 1962. Exhibition of work at Dynveor Castle, Carmarthenshire, 1968.

## DENNY, *Robyn* (born 1930)

Born in 1930 in Abinger, Surrey. Attended Académie de la Grande Chaumière, Paris, 1950. St Martin's School of Art, 1951–4. Italian Government Scholarship, 1957. Included in 'Metavisual, Tachiste, Abstract', Redfern Gallery, London, 1957, and collaborated in 'Place' (with Richard Smith and Ralph Rumney) at the Institute of Contemporary Arts, 1959. Member of 'Situation' group, R.B.A. Galleries, London, 1960, and 'New London Situation', New London Gallery, 1961. Various teaching posts including visiting professor at Minneapolis Institute of Fine Art. One-artist shows at the Kasmin Gallery, London, 1964, 1967 and 1969. One of the 'Five Young British Artists' at the Venice Biennale British Pavilion, 1966. Tate Gallery retrospective, 1973. Delivered the first William Townsend Memorial Lecture, University College, London, 27 November 1974, 'Art and the State and the State of Art'.

## DISMORR, *Jessica* (1885–1939)

Born in 1885 at Gravesend, Kent. Educated in Hampstead, about 1897–1901. Attended Slade School of Fine Art, 1902–3. From about 1905 until 1914 painted in France and attended the Atelier de la Palette under Segonzac, Metzinger and Blanche. Illustrations published in *Rhythm* (1911) and in the following year exhibited at the Stafford Gallery, London, with Peploe, Fergusson, Anne Estelle Rice and others. Signed Vorticist manifesto in *Blast*, 1914, exhibited at the only Vorticist exhibition at the Doré Galleries, London, and contributed to the second issue of *Blast*, 1915. Exhibited with Group X, Heal's Mansard Gallery, London, 1920. One-artist show of European and English watercolours, Mayor Gallery, London, 1925. Exhibiting member of London Group and Seven and Five Society from 1926. Contributed poems in the thirties to the *London Mercury*. Died in Hampstead, 1939. Exhibition at Marjorie Parr Gallery, London, 1973. Retrospective of oils, watercolours and drawings at the Mercury Gallery, London, 1974.

## DRUMMOND, *Malcolm* (1880–1945)

Born in 1880 at Boyne Hill, Berkshire. Graduated from Oxford, 1903, and studied at the Slade School of Fine Art, 1903–7, and under Sickert at the Westminster School of Art. Founder student at Sickert's Rowlandson House School, 1910. Exhibited with the Allied Artists' Association, 1910, and was a member of the Camden Town Group showing work at its three exhibitions (June and December 1911, December 1912). Founder member of the London Group, 1913, and its treasurer, 1921. Moved to Berkshire in 1932 and after three years blindness died there in 1945. Arts Council retrospective, 1963–4, and exhibition of work at the Maltzahn Gallery, London, 1974.

## ETCHELLS, *Frederick* (1886–1973)

Born in 1886, Newcastle on Tyne, son of an engineer; educated at Macclesfield Grammar School. Studied at Royal College of Art, London, 1908–11, and later in Paris. Taught part-time at the Central School and executed a mural for the Borough Polytechnic, London, along with Fry, Grant and others. Became friendly with Bloomsbury Group and collaborated on a large mural *Street accident* with Grant at 38 Brunswick Square, London, in 1912. A member of the Friday Club (as was his sister Jessie Etchells) and was included in the English Section of the 'Second Post-Impressionist Exhibition', Grafton Galleries, London, 1912. Closely involved in the formation of the Omega Workshops, 1913, where he notably designed textiles. Left the Omega with Lewis, Wadsworth and Hamilton, October 1913, the month he was included in the Doré Galleries 'Post Impressionist and Futurist Exhibition' in London. Founder member of London Group and the Rebel Art Centre, 1914. Contributed illustrations to both issues of *Blast* and represented in both Vorticist exhibitions, London, 1915, and New York, 1917. Medically unfit for war service; member of Lewis's Group X showing at Mansard Gallery, Heal's, 1920. Thereafter devoted himself to architecture, becoming F.R.I.B.A. in 1931. Designed the Holborn Crawford Building. Translated Le Corbusier's *Towards a new Architecture* (1927) and *The City of Tomorrow* (1929) with G.W.O. Addleshaw. Wrote *The Architectural Setting of Anglican Worship* (1948). Later specialized in church architecture and restoration; adviser to the Berwick Church murals scheme, Sussex, 1941. Died at Folkestone in 1973. Represented in 'Vorticism and its Allies', Hayward Gallery, 1974.

## EVANS, *Merlyn* (1910–73)

Born in Cardiff, Wales, in 1910. Glasgow School of Art, 1927–30, and Royal College of Art, London, 1931–3. Studied carving and etching. Exhibited with the International Surrealist Exhibition, London, 1936, and held a one-artist exhibition in Durban, South Africa, 1939. Taught in South Africa, 1939–46. Held several one-artist shows at the Leicester Galleries, London, 1952, 1953, 1955 and 1958. 'Paintings, Drawings and Etchings', Whitechapel Art Gallery, 1956. One-artist exhibitions at Art Institute of Chicago, 1967, and New Art Centre, London, 1972. Died in London, 1973. Posthumous retrospective at the National Museum of Wales, Cardiff, and Glasgow Art Gallery, 1974. Exhibitions at the New Art Centre, London, 1975 and 1976.

## FERGUSSON, *John Duncan* (1874–1961)

Born in 1874 in Leith. Attended Royal High School, Edinburgh, 1886–9, and Blair Lodge, Linlithgo, 1889–91. Gave up study of medicine for painting; influenced by Arthur Melville of the Glasgow School. Visited Paris, about 1896, and again in 1898, when he was impressed by the Caillebotte

Collection of Impressionists in the Luxembourg. First one-artist exhibition at Baillie Gallery, London, 1905. Settled in France, 1907, where he taught at Atelier de la Palette, meeting Segonzac. Began making sculpture, 1908. Painted with Peploe at Royan, near Bordeaux, 1910. Art editor of *Rhythm* magazine (J. Middleton Murry and Katherine Mansfield as co-editors), 1911. Two one-artist exhibitions at Stafford Gallery, London, 1912, and showed at 'Post Impressionist and Futurist Exhibition', Doré Galleries, London, 1913. One-artist show at Doré Galleries, 1914. Returned to London on outbreak of war and remained there until 1929 with frequent visits to Scotland and France. Several group exhibitions in Britain and France, particularly with Scottish Colourists – Peploe, Cadell and Hunter. Exhibition in New York, Whitney Studios, 1926. Lived in Paris, 1929–39, with visits to South of France. Moved to Glasgow on outbreak of Second World War, where he lived until his death. Annual visits to South of France, 1950–60. First retrospective exhibition, McLellan Galleries, Glasgow, 1948; Scottish Arts Council touring exhibition, 1954; paintings from 1898–1954, Lefevre Gallery, London, 1954. Died in Glasgow, 1961. Leicester Galleries, London, retrospective, 1964; early work 1895–1910, Anthony d'Offay Gallery, London, 1967; centenary retrospective at Fine Art Society, London (and at Kelvingrove Art Gallery, Glasgow, and Fine Art Society, Edinburgh), 1974.

## FREUD, *Lucian* (born 1922)

Born in 1922 in Berlin, son of Ernst Freud and grandson of Sigmund Freud. Came to England at the age of ten and became British subject, 1939. Studied at the Central School, 1939, and under the painter Cedric Morris in Suffolk. Part-time student at Goldsmiths' College of Art, London, 1942. Served with Merchant Marine, 1941, from which he was invalided out. One-artist exhibitions at the Lefevre Gallery, London, 1944 and 1946. Won an Arts Council Prize, Festival of Britain Exhibition, 1951, and exhibited at the Venice Biennale, 1954. Further one-artist exhibitions at the Hanover Gallery, London, 1954, 1956, and with Marlborough Fine Art, London, 1958, 1963 and 1968; 'Recent Paintings' shown at the Anthony d'Offay Gallery, London, and at the Gray Art Gallery, Hartlepool, 1972. Retrospective exhibition, Hayward Gallery, 1974, and 'Pages from a Sketchbook of 1941', Anthony d'Offay Gallery, London, 1974.

## FRY, *Roger Eliot* (1866–1934)

Born in 1866 in Highgate, son of Sir Edward Fry, the judge. Studied science at King's College, Cambridge, 1885–8. Decided to become a painter, studying under Francis Bate at the Académie Julian, Paris, and under Sickert in 1893 on his return to London. Started writing art criticism, 1892; married the painter Helen Coombe, 1896. Published his first book *Giovanni Bellini* (1899) and became art critic to the *Athenaeum* in 1902. First one-artist exhibition, Carfax Gallery, London, 1903. Member of the New English Art Club, 1893 (resigned from jury, 1908). Curator of Paintings, Metropolitan Museum, New York, 1905–10. Editor of *Burlington Magazine*, 1910–19. Organized the first Post-Impressionist exhibition at the Grafton Galleries, 1910 – 'Manet and the Post-Impressionists', and, with the help of the Russian artist Boris Anrep and the critic Clive Bell, organized the 'Second Post-Impressionist Exhibition', Grafton Galleries, 1912–13. Exhibition at the Alpine Club Gallery, 1912, and founded the Omega Workshops, 1913 (to 1919); member of the Grafton Group, 1913 and 1914. Member of the London Group, 1918. 'Recent Paintings' at Independent Gallery, London, 1923, and at Lefevre Gallery, London, 1927 (with Frederick Porter and Bernard Meninsky). Retrospective, London Artists' Association, 1931. Appointed Slade Professor of Fine Art at Cambridge, 1933. Died in London in 1934. Published works include *Vision and Design* (1920), *Transformations* (1926), *Cézanne* (1927), *Matisse* (1930), *Characteristics of French Art* (1932), *Last Lectures* (1939), and *Letters* (1972). Further exhibitions include Bristol, 1935; Arts Council, 1952, and centenary exhibition, 1966; The Minories, Colchester, 1959; 'Portraits by Roger Fry', Courtauld Institute Galleries, London, and Mappin Art Gallery, Sheffield, 1976.

## GAUDIER-BRZESKA, *Henri* (1891–1915)

Born in 1891 as Henri Gaudier, son of a carpenter at St Jean de Braye, near Orléans. Visited England in 1906 and 1908. Worked in Paris as a sculptor from 1910, meeting Sophie-Brzeska, a Pole; thereafter they lived together and he added her name to his. Came to London in 1911 and was associated with *Rhythm* magazine; showed at the Allied Artists' Association Salon, 1913, and came to know Epstein, T. E. Hulme, Lewis, etc. Through the painter Nina Hamnett he designed briefly for the Omega Workshops, where he also exhibited small sculptures; showed with Fry, Grant, Bell etc., at second Grafton Group exhibition, January 1914. Joined the Rebel Art Centre, spring 1914, and signed the manifesto of the first issue of *Blast*. Contributed article to the *Egoist* on the 1914 Allied Artists' Association Salon. Joined French army and was killed soon afterwards in June 1915 at Neuville-St-Vaast. Contributions and obituary in *Blast* No. 2. Memorial exhibition at Leicester Galleries, London, 1918. Further retrospectives at Temple Newsam, Leeds, 1943; Beaux Arts Gallery, London, 1952 and 1954; Orléans, 1956; Arts Council, 1956–7; exhibitions at the Mercury Gallery, London, most recently in 1977.

## GEAR, *William* (born 1915)

Born in 1915 in Fife, Scotland. Studied at Edinburgh College of Art, 1932–7, and Edinburgh University Fine Art Class, 1936–7, under Gillies, Maxwell and McTaggart. Living abroad on a travelling scholarship, 1937–8, working in 1937 under Léger in Paris. War service in the Middle East and Italy, 1939–45, holding his first one-artist show in Siena

(and Florence), 1944. One-artist exhibitions in Celle and Hamburg, 1947, the year he moved to Paris (until 1950). Exhibited in Paris alongside Soulages, Hartung and others and held an exhibition at Gimpel Fils, 1948. One-artist exhibition at the Betty Parsons Gallery, New York, November 1949. Member of the London Group, 1953. Visited New York, 1957 and 1959. Head of the Fine Arts Department, Birmingham College of Art. Retrospective exhibition, Gimpel Fils, London, 1961; retrospective of work 1946–62, Towner Art Gallery, Eastbourne, 1962; exhibition with Alan Davie, Edinburgh, 1966; 'Paintings 1948–68', Belfast Art Gallery, 1968; exhibition of paintings 1948–68, Arts Council of Northern Ireland, 1969.

## GERTLER, *Mark* (1891–1939)

Born in 1891 in Spitalfields, East London, son of Austrian Jewish immigrants. In Austria, 1893–8. Began drawing and painting at the Regent Street Polytechnic. With the help of the Jewish Education Aid Society and the encouragement of William Rothenstein, he attended the Slade School of Fine Art from 1908 to 1910, where he won several prizes. Began exhibiting work at the Friday Club, 1910, and the New English Art Club, 1911. Member of the London Group, 1915. Early patrons included Sir Edward Marsh and Lady Ottoline Morrell. Exhibited at the Omega Workshops, 1917 and 1918. Paris, 1919; first one-artist exhibition at Goupil Gallery, London, 1921. Periods of ill-health enforced several stays in a sanatorium. Exhibitions at the Leicester Galleries, London, 1928 and 1934. Visited Spain, 1936, and moved to Highgate. Exhibition at Lefevre Gallery, London, 1939. Committed suicide, 1939. Posthumous exhibitions include Leicester Galleries, 1941, Ben Uri Gallery, London, 1944, Whitechapel Art Gallery, 1949, and retrospective at The Minories, Colchester, 1971, with showings at the Morley College Gallery, London, Ashmolean Museum, Oxford, and Graves Art Gallery, Sheffield. Publication of *Selected Letters* (1965).

## GILMAN, *Harold* (1876–1919)

Born in 1876 at Rode, Somerset. Hastings School of Art, 1896, and Slade School of Fine Art, London, 1897–1901. Visited Spain, about 1903–4, copying in the Prado. Founder member of the Allied Artists' Association, 1908, and the Camden Town Group, 1911. First president of the London Group, 1913. Exhibited with Camden Town Group and the Friday Club. In Paris in 1911 with Charles Ginner and in Sweden and Norway, 1912–13. Completed large painting of Halifax Harbour for the Canadian War Memorial, Ottawa, 1919, and died in the epidemic of Spanish influenza, London, 1919. Memorial exhibition, Leicester Galleries, London, 1919; Arts Council, 1954; 'Paintings and drawings', Reid Gallery, London, 1963, and retrospective at The Minories, Colchester (and at Oxford and Sheffield), 1969.

## GINNER, *Charles* (1878–1952)

Born in 1878 in Cannes, France, of Anglo-Scottish parents. Studied architecture and painting in Paris, 1899–1908, including a period at the École des Beaux-Arts. Exhibited in the Allied Artists' Association, London, 1908, and settled in London, 1910. Founder member of the Camden Town Group, 1911, and the London Group, 1913, and member of Cumberland Market Group, 1914, with Bevan and Gilman. Served in the Intelligence Corps, 1916–18. Member of the New English Art Club, 1922. Official war artist, 1939–45. Awarded C.B.E. in 1950 and died in London in 1952. Published 'Neo-Realism' manifesto in the *New Age,* 1 January 1914, and 'The Camden Town Group' in *Studio* magazine, November 1945. Arts Council memorial exhibition, 1953–4, and exhibition at the Piccadilly Gallery, London, 1969.

## GORE, *Spencer Frederick* (1878–1914)

Born in 1878 at Epsom, Surrey. Attended the Slade School of Fine Art, 1896–9. With Wyndham Lewis in Spain, 1902, and met Sickert in Dieppe, 1904, with whom he formed a close friendship. Painted at Hertingfordbury in the summers of 1907–9. Exhibited with Allied Artists' Association, 1908; founder member of Camden Town Group, 1911. Exhibited at the Chenil Galleries, London, 1911, and at the 'Second Post-Impressionist Exhibition', Grafton Galleries, 1912–13; with Gilman at the Carfax Gallery, London, 1913. Contributed mural decorations to 'The Cave of the Golden Calf', a night club, with Ginner, Epstein and Wyndham Lewis. Died from pneumonia in Richmond, Surrey, in 1914. Memorial exhibitions at the Carfax Gallery, 1916 and 1918; Arts Council retrospective, 1955; Redfern Gallery, London, (with son Frederick Gore), 1962; The Minories, Colchester (also Oxford and Sheffield), 1970; Anthony d'Offay Gallery, London, 1974.

## GOSSE, *Sylvia* (1881–1968)

Born in 1881 in London, daughter of Sir Edmund Gosse. Privately educated in London and France. Began painting and studied at the Royal Academy Schools, 1903–6. Important meeting with Sickert, 1908; taught at his Rowlandson House School, 1910–14. Exhibited at the New English Art Club, 1911 (to 1924), and London Group, 1914 (to 1919). 'Drawings and Etchings', Carfax Gallery, London, 1913; represented in 'Twentieth Century Art', Whitechapel Art Gallery, 1914; paintings and drawings at the Carfax Gallery, 1916. In France, 1920–2 (later in Camden Town and from 1952 at Ore, near Hastings, Sussex). Various one-artist exhibitions including Tooth's, London, 1927, and Lefevre, London, 1931. Died at Ore, 1968. Represented in 'The Sickert Women and The Sickert Girls', Parkin Gallery, London, 1974.

## GOWING, *Lawrence* (born 1918)

Born in 1918 at Stoke Newington, London. Studied under Coldstream at the Euston Road School.

Exhibited in various group exhibitions in London at the Storran Gallery and the Leicester Galleries; first one-artist show at the latter gallery, 1948. Professor of Fine Art, Durham University, 1948–58, and later at Leeds University. Slade Professor at University College, London, from 1974. One-artist exhibition, Marlborough Gallery, London, 1965. Author of *Renoir* (1947), *Vermeer* (1952) and *Constable* (1959) and numerous exhibition catalogues, e.g. *Cézanne*, exhibition, Tate Gallery and Edinburgh Festival, 1954; William Coldstream retrospective, Arts Council, 1962.

## GRANT, *Duncan James Corrowr* (born 1885)

Born in 1885 at Rothiemurchus, Inverness-shire, with childhood in India and England. Attended St Paul's School, London, 1899–1902; Westminster School of Art, 1902–5. In Florence copying Piero della Francesca, 1904–5. Studied under Blanche at the Atelier de la Palette, Paris, 1906–7. Visited Matisse in 1909 and Picasso on several occasions, 1911–14. Exhibited at the Friday Club, 1910–12, and carried out murals for the Borough Polytechnic, London, 1911 (with Fry, Etchells, Rutherston and others). Member of Camden Town Group, 1911. Included in exhibition of modern English art, Galerie Barbazanges, Paris, 1912, and in the 'Second Post-Impressionist Exhibition', Grafton Galleries, 1912–13. Co-director of the Omega Workshops with Fry and Vanessa Bell, 1913–19. Conscientious objector working on farms, 1915–18. First one-artist exhibition, Carfax Gallery, London, 1920, and exhibited in Paris, Galerie Vildrac, 1920. One-artist exhibitions in London at Independent Gallery, 1923; at London Artists' Association Gallery, 1931; at Agnew's, 1937; at Leicester Galleries, 1945 and 1957. Painted much in Paris and South of France between the wars; carried out numerous decorative schemes in private houses with Vanessa Bell; murals for *R.M.S. Queen Mary*, 1935; designs for textiles and pottery; décor and costumes for several ballets including *The Enchanted Grove* (Vic-Wells Ballet, 1932) and for Blow's opera *Venus and Adonis* (English Opera Group, 1956). Retrospectives include Tate Gallery, 1959 (with tour); The Minories, Colchester, 1963; 'Duncan Grant and His World', Wildenstein, London, 1964; 'Portraits', Arts Council, 1969 (Cambridge, Newcastle, Hull and Nottingham); 'Recent Paintings' and 'Early Paintings', Anthony d'Offay Gallery, London, 1975; 'Ninetieth Birthday Exhibition', Tate Gallery, 1975; retrospective, Scottish National Gallery of Modern Art (and at Oxford), 1975, and 'Drawings and Watercolours', Davis and Long, New York, 1975.

## GUEVARA, *Alvaro* (1894–1951)

Born in 1894 at Cerro Alegre, Chile, into an aristocratic family; began painting early. Arrived in England, 1910; attended Bradford Technical College, preparatory to entering the family wool business there. Encouraged by William Rothenstein; won scholarship to the Slade School of Fine Art, London,

1912, where he was a student, 1913–16. With the poet Roy Campbell, decorated Harlequin Restaurant, Soho, 1919; first one-artist exhibition at the Omega Workshops, Fitzroy Square, June 1916, and second at the Chenil Galleries, Chelsea, 1917. Exhibited portraits with the National Portrait Society, 1917–22. Returned to Chile, 1922–6, winning Gold Belt for boxing. One-artist show at the Leicester Galleries, London (with Edward Wadsworth), 1926. Moved to Paris and exhibited *Fleurs Imaginaires*, Galerie Van Leer, Paris, 1928. Married the painter Meraud Guinness, London, 1929. Lived in South of France and Paris. Arrested by the Nazis as Chilean hostage, 1941, and imprisoned; returned to Chile. Appointed Honorary Chilean Consul in London, 1945. Cultural attaché in Bern, Switzerland, 1946. Moved to Aix-en-Provence, 1948, where he died in 1951. Publications include *St George at Silene* (Hours Press, 1929) and *Dictionnaire Intuitif* (1954). Memorial exhibition, Mayor Gallery, London, 1952; exhibition of drawings, Mayor Gallery, 1954; retrospective exhibition at P. and D. Colnaghi, London, 1974–5.

## HAMILTON, *Richard* (born 1922)

Born in 1922 in London. Worked in advertising and attended Westminster Technical College, 1936, teachers including Gertler and Bernard Meninsky. Royal Academy Schools, 1938–40. Jig and tool draughtsman, 1941–5. Expelled from Royal Academy Schools, 1946. Military service, 1946–7, the year he married. Attended Slade School of Fine Art, 1948–51; exhibited at Gimpel Fils, London, 1950. Organized 'Growth and Form' exhibition, Institute of Contemporary Arts. Member of Independent Group, I.C.A., 1952–5. One-artist exhibition, Hanover Gallery, 1955; organized 'Man, Machine and Motion', Hatton Gallery, Newcastle, and I.C.A., London, 1955. Lecturer at King's College, Durham University, 1953–66, introducing influential Basic Design Course (with Victor Pasmore). Collaborated with John McHale and John Voelcker on 'This is Tomorrow' exhibition, Whitechapel Art Gallery, 1956. Organized 'an Exhibit' (with Pasmore and Alloway), Hatton Gallery, Newcastle and I.C.A., London, 1957. Visited United States, 1963; reconstruction of Duchamp's *Large glass*, 1965–6. Exhibition at Robert Fraser Gallery, London, 1966; at Galerie Ricke, Kassell, and Galerie A. Iolas, New York, 1967. Selected work, 1957–68, Studio Marconi, Milan, 1968. Exhibition at Robert Fraser Gallery, London, 1969, the year a film was made about his work for the Arts Council. Exhibition of *Cosmetic studies*, Galerie Block, Berlin, 1970. Tate Gallery retrospective, 1970, with subsequent showings at Eindhoven and Bern. Exhibition at Nigel Greenwood, Inc., London, 1972; touring exhibition in 1973, Solomon R. Guggenheim Museum, New York (Cincinnati, Munich, Tübingen, Berlin). Represented in 'British Painting '74', Hayward Gallery, 1974. Exhibition (with Mark Boyle), Serpentine Gallery, London, 1975. Collaborative exhibition with Dieter Roth, I.C.A. Gallery, 1977.

## HERMAN, *Josef* (born 1911)

Born in 1911 in Warsaw, where he attended the School of Art, 1930–2. Exhibited in Warsaw and worked in the Borinage area of Belgium. As a refugee, settled in Glasgow, 1940, and married a Scot; friendship with Jankel Adler. Arrived in London, 1943; first one-man exhibition at Lefevre Gallery (with L.S. Lowry). Worked in Welsh mining village, 1944–53. Exhibited with Martin Bloch (1883–1954) at Ben Uri Gallery, London, 1949, and held one-artist show at Geffrye Museum, London, in the same year. Exhibited in '60 Paintings for '51' exhibition and moved back to London, 1953. Member of the London Group, 1952. Retrospective at the Whitechapel Art Gallery, 1956, and numerous one-artist shows subsequently, in particular of drawings. Further retrospective at Glasgow Art Gallery, Scottish Arts Council Gallery, Edinburgh, and National Museum of Wales, Cardiff, 1975. One-artist exhibition at Roland, Browse and Delbanco, 1976.

## HERON, *Patrick* (born 1920)

Born in 1920 in Leeds and lived in St Ives, Cornwall, 1925–30. Part-time student at Slade School of Fine Art, 1937–9. Resumed painting, 1945, and held first one-artist exhibition at the Redfern Gallery, London, 1947 (and showed there, 1948, 1950, 1951, 1954, 1956 and 1958). Began to write about painting and became art critic to the *New Statesman and Nation*, 1947–50, and London correspondent to *Arts* (New York), 1955–8. No writing between 1958 and 1966. Retrospective exhibition, Wakefield Art Gallery (and tour), 1952; devised 'Space in Colour' exhibition, Hanover Gallery, London, 1953. Numerous one-artist exhibitions, Waddington Galleries, London, from 1959 and in New York at Bertha Schaefer Gallery, 1960, 1962 and 1965. Exhibited in Zurich, Montreal and Australia and at the Whitechapel Art Gallery, 1972. Lives in Cornwall. Publications include *The Changing Forms of Art* (1955); *Ivon Hitchens* (1955); *Braque* (1956); and articles in *Studio International* and the *Guardian*.

## HILLIER, *Tristram* (born 1905)

Born in 1905 in Peking. Studied at Downside and Christ's College, Cambridge, 1922–4, at the Slade School of Fine Art and the Westminster School of Art, 1926–8. Later in Paris studied under André Lhote and at the Atelier Colarossi. Lived in Cassis and travelled widely in Mediterranean countries. First one-artist exhibition at Lefevre Gallery, London, 1931; member of Unit One, 1933. Served in Royal Naval Volunteer Reserve, 1940–4. Settled in Somerset; painting abroad in Spain and Portugal. Further exhibitions at Lefevre Gallery before the war and at Tooth's after it. Retrospective at Worthing Art Gallery, 1960; elected to Royal Academy, 1967. Autobiography *Leda and the Goose* (1954).

## HILTON, *Roger* (1911–75)

Born in 1911 in Northwood, Middlesex, and studied at the Slade School of Fine Art, London, 1929–31.

From 1931 lived in Paris and studied under Bissière at the Académie Ranson. First one-artist exhibition at Bloomsbury Gallery, London, 1936, and included in Agnew's Coronation Exhibition, 1937. Served in H.M. Forces and taken prisoner of war, 1942–5. One-artist exhibitions at Gimpel Fils, London, 1952, 1954 and 1956; included in 'Metavisual, Tachiste, Abstract Painting in Britain', Redfern Gallery, London, 1957; numerous one-artist exhibitions at Waddington Galleries, London, between 1960 and 1971. Exhibited at the Venice Biennale, 1964, and was awarded UNESCO prize. Awarded C.B.E., 1968. Retrospective survey, Serpentine Gallery, London, 1974, and included in 'British Painting '74', Hayward Gallery, 1974. Died in St Just, Cornwall, 1975 (where he had lived since 1965).

## HITCHENS, *Ivon* (born 1893)

Born in 1893 in London, son of a painter. Studied at the St John's Wood and Royal Academy Schools. Member of the Seven and Five Society, 1920–35. First one-artist exhibition, Mayor Gallery, London, 1925; contributed to 'Objective Abstractionists' exhibition, Zwemmer Gallery, London, 1934. Member of the London Group and the London Artists' Association. Bombed out of Hampstead home, 1940, and moved permanently to Lavington Common, Sussex. Numerous group and one-artist exhibitions. Murals for Cecil Sharp House, London, 1954, Nuffield College, Oxford, 1959, and for Sussex University, 1963. Retrospective exhibitions at Temple Newsam, Leeds, 1945, Venice Biennale, 1956 (and in Vienna, Munich, Paris and Amsterdam), Tate Gallery (with tour) 1963; Poindexter Gallery, New York, 1965. Retrospective at Waddington Galleries, London, 1973. Represented in 'British Painting '74', Hayward Gallery, 1974.

## HOCKNEY, *David* (born 1937)

Born in 1937 in Bradford, Yorkshire. Studied at Bradford College of Art, 1953–7; worked in a hospital as conscientious objector, 1957–9. Studied at the Royal College of Art, London, 1959–62, winning gold medal, 1961. Fellow students included R.B. Kitaj, Boshier and Jones. Exhibited with 'Young Contemporaries', R.B.A. Galleries, London, from 1960. Visited Egypt and Los Angeles, 1963, the year he held his first one-artist exhibition at Kasmin Gallery, London; included in 'New Generation' exhibition, Whitechapel Art Gallery, 1964, and 'Young British Painters', Palais des Beaux-Arts, Brussels. Several teaching posts in U.S.A. Sets and costumes for Jarry's *Ubu Roi,* Royal Court Theatre, London, 1966, and for Stravinsky's *Rake's Progress,* Glyndebourne, 1975. Illustrated *Six Fairy Tales,* Grimm brothers, 1970. Retrospective 'Paintings, Prints and Drawings 1960–70', Whitechapel Art Gallery, London, 1970 (seen at Kestner Gesellschaft, Hanover, and Boymans Museum, Rotterdam); further exhibitions include Musée des Arts Décoratifs, Paris, 1974; 'Paintings, Drawings and Prints', Newcastle, 1976, and 'Early Paintings', Waddington Galleries, London, 1976. *David Hockney*

by David Hockney (ed. Nikos Stangos) published 1976.

## HODGKIN, *Howard* (born 1932)

Born in 1932 in London into well-known Quaker family. Evacuated to America, 1939–43. Attended Camberwell School of Art, London, 1949–50, and Bath Academy of Art, Corsham, 1950–4, where teachers included Clifford Ellis and William Scott. Assistant art master, Charterhouse School, 1955–7. Taught at Bath Academy, 1956–66. Exhibited with London Group, 1959, 1960 and 1961. First one-artist exhibition at Tooth's, London, 1962 (and 1964 and 1967); at Kasmin Gallery, London, 1969 and 1971. Numerous group exhibitions in Britain and abroad and first one-artist exhibition in New York at Kornblee Gallery, 1973. Represented in 'La Peinture Anglaise d'Aujourd'hui', Musée d'Art Moderne, Paris, 1973. One-artist exhibition at Arnolfini Gallery, Bristol, 1975. Arts Council exhibition 'Howard Hodgkin, Forty-Five Paintings 1949–1975', Museum of Modern Art, Oxford, 1976 (with subsequent showings at Serpentine Gallery, London, Leigh, Newcastle, Aberdeen and Sheffield). Exhibition at Waddington Galleries, London, 1976. Visits to India; lives in London and Wiltshire. Appointed artist-in-residence, Brasenose College, Oxford, 1976.

## HODGKINS, *Frances* (1869–1947)

Born in 1869 in Dunedin, New Zealand. Father an amateur artist. Dunedin Art School, 1895–8; teaching and working as illustrator. Arrived in Europe, 1901, travelling in France, Italy and North Africa. First one-artist exhibition Paterson's Gallery, London, 1907. Moved to Paris, 1908; visited New Zealand, 1904–6 and 1912–13. Mainly in Cornwall, 1914–19. France in 1920, much influenced by Matisse. Exhibition at Claridge Gallery, London, 1928. Member of the Seven and Five Society, 1929–34. Numerous group exhibitions and one-artist shows at Lefevre Gallery, London. Painted in Spain, Ibiza, France and in Cornwall, Suffolk and Dorset. Died in Dorchester in 1947, a year after Lefevre Gallery retrospective. Memorial exhibitions in Manchester, 1947, St George's Gallery, London, 1949, and at the Tate Gallery, London; Arts Council exhibition 'Ethel Walker, Frances Hodgkins, Gwen John', 1952 (with tour). Further retrospective Commonwealth Institute, London, 1970 (after Australian and New Zealand tour).

## HUXLEY, *Paul* (born 1938)

Born in 1938 in London and attended Harrow School of Art and Royal Academy Schools, 1953–60. Exhibited in 'Young Contemporaries', R.B.A. Galleries, London, 1959 and 1960; 'New Generation' exhibition, Whitechapel Art Gallery, London, 1964. Numerous one-artist exhibitions at the Rowan Gallery, London, from 1963. Prolonged visit to New York, 1965–7. One-artist exhibitions at Kornblee Gallery, New York, 1967 and 1970. Represented in 'Six Painters, Six Sculptors' exhibition of recent British art, circulated by Museum of Modern Art, New York, 1968. One-artist exhibition Galeria da Emenda, Lisbon, 1974, and included in 'British Painting '74', Hayward Gallery, 1974.

## INNES, *James Dickson* (1887–1914)

Born in 1887 at Llanelly, Carmarthenshire. Attended Slade School of Fine Art, London, 1905–8. Member of the New English Art Club and the Camden Town Group, 1911 (exhibiting with Group, December 1911 only). One-artist exhibition at Chenil Galleries, London, 1910–11. Painted in France and the Pyrenees. Worked with Augustus John in Wales, 1911 and 1912. In North Africa in 1913; died of consumption at Swanley, Kent, in 1914. Memorial exhibitions Tate Gallery, 1921–2, and Chenil Galleries, London, 1923. Retrospective exhibitions at Leicester Galleries, London, 1952, and at Sheffield, Swansea and Aberystwyth, 1961.

## JOHN, *Augustus* (1878–1961)

Born in 1878 in Tenby, South-West Wales; brother of Gwen John. Attended Slade School of Fine Art London, 1894–8. Exhibited at New English Art Club and one-artist exhibition, Carfax Gallery London, 1899. Visited Paris, 1900, and travelled in Europe. Professor of painting, University of Liverpool, 1901–4. Co-principal of 'The Chelsea Art School' with William Orpen, 1903–7. Met Picasso in Paris, 1907. Painted at Martigues, 1910, exhibiting work at Chenil Galleries, London, 1910. Member of Camden Town Group, 1911. Elected president of National Portrait Society, 1914. In Paris as official war artist, 1919. Elected to Royal Academy, 1928; resigned, 1938, and re-elected, 1940. Member of London Group, 1940–61. Awarded Order of Merit, 1942; retrospective at Temple Newsam, Leeds, 1946; at R.A. Diploma Gallery, 1954, and at Graves Art Gallery, Sheffield, 1956. Joined British Peace Committee, 1958. Died at Fryern Court, Hampshire, 1961. Sale of studio contents, 1962 and 1963. Exhibition of graphic work P. and D. Colnaghi, London, 1974; exhibition of life and work National Portrait Gallery, London, 1975. Published autobiography *Chiaroscuro* (1952) and *Finishing Touches* (1964).

## JOHN, *Gwen* (1876–1939)

Born in 1876 in Haverfordwest, Pembrokeshire, sister of Augustus John. Childhood in Tenby and attended Slade School of Fine Art, 1894–7, and studied under Whistler in Paris, where she lived from 1898. Exhibited with New English Art Club irregularly, 1900–11. Joint exhibition with brother, Carfax Gallery, London, 1903. Converted to Catholicism, 1913. Moved to Meudon, Paris, 1914, and lived there until her death. One painting in Armory Show, New York, 1913. Retrospective of paintings and drawings, New Chenil Galleries, London, 1926. Exhibited with various Paris Salons. Died in Dieppe, 1939. Numerous retrospective exhibitions: at Matthiesen Gallery, London, 1946, 1958 and 1961; Tate Gallery (with Ethel Walker and Frances

Hodgkins), 1952, and at Edinburgh College of Art, 1952; Faerber and Maison, London, 1964 and 1970; Arts Council retrospective, 1968; Davis and Long, New York, 1975; centenary exhibition at Anthony d'Offay Gallery, London, 1976.

## JONES, *Allen* (born 1937)

Born in 1937 in Southampton. Studied at Hornsey College of Art, London, 1958–9, and Royal College of Art, 1959–60. Exhibited in 'Young Contemporaries', R.B.A. Galleries, London, 1960 and 1961; included in 'Image in Progress', Grabowski Gallery, London, 1962, and 'New Generation' exhibition, Whitechapel Art Gallery, London, 1964. Lived in New York, 1964–5, where he held first one-artist show at Richard Feigen Gallery (and in 1965 and 1970). First British one-artist show at I.C.A. Gallery, London, 1962; shows at Tooth's, 1963 (and in 1964, 1967 and 1970). Guest teacher at University of South Florida, 1969; graphics retrospective at Boymans Museum, Rotterdam. Numerous group and one-artist exhibitions of painting, graphic work and sculpture in Europe, America and Japan. One-artist exhibitions at Marlborough Fine Art, London, 1971, 1972, and at Waddington's, 1975 and 1976. Designed set and costumes for part of *O Calcutta* revue, London, 1970. Published *Allen Jones Figures Book* (1969) and *Allen Jones Projects* (1971).

## JONES, *David* (1895–1974)

Born in 1895 in Brockley, Kent, of Welsh descent. Drew and painted from an early age, exhibiting at the Royal Drawing Society. Studied under A. S. Hartrick at the Camberwell School of Art, who introduced him to the work of Post-Impressionists, 1909–15. Enlisted in Royal Welch Fusiliers, 1915; demobilized, 1918. Studied at Westminster School of Art under Meninsky and Bayes, 1919–22. Converted to Catholicism, 1921; joined Eric Gill's Guild of St Joseph and St Dominic, Ditchling, Sussex, and learned engraving, working as illustrator for Ditchling and Golden Cockerel Presses. First one-artist exhibition at St George's Gallery, London, 1927. Engravings for *The Ancient Mariner* published, 1928; one-artist exhibition at Goupil Gallery, London, in same year. Member of Seven and Five Society, 1928–33. Work shown in Chicago, 1933; Venice Biennale, 1934; New York World Fair, 1939; Toledo Museum, Ohio, 'Contemporary British Art', 1944. Retrospective exhibitions included C.E.M.A. (later the Arts Council), 1944; Arts Council Welsh tour and at Tate Gallery, 1954–5. Awarded C.B.E., 1955. Died in 1974. Exhibition of work at Anthony d'Offay Gallery, London, 1975, and Stirling University, 1976. Published works include the poems *In Parenthesis* (1937) and *The Anathemata* (1952) and a collection of essays etc. *Epoch and Artist* (1959).

## KAUFFER, *Edward McKnight* (1890–1954)

Born in 1890 in Great Falls, Montana, and grew up in Indiana. Studied in San Francisco and at Art Institute of Chicago. Arrived in Paris, 1913, and moved to England on outbreak of war, 1914. Earned a living designing textiles and posters. Associated with Camden Town painters through the London Group. First poster commission in 1915. Secretary of London Group, 1917, and exhibited watercolours in 'New Movements in Art' (Birmingham and Heal's, London), 1917. Work exhibited at Omega Workshops. Member of Lewis's Group X, 1920, and abandoned easel painting in 1921, the year of a visit to New York. Returned to England working mainly for the London Underground as poster designer; illustrated *Don Quixote* (1930) among many books. Worked for the General Post Office, Shell-Mex and B.P., Great Western Railway; sets and costumes for ballet *Checkmate* (1938) and designed murals and textiles. Died in New York, 1954. Memorial exhibition, 1955, and travelling exhibition 'Poster Art 1915–40', 1973, both at Victoria and Albert Museum, London.

## KELLY, *Sir Gerald* (1879–1972)

Born in Paddington, London, in 1879, son of Irish parents. Educated at Eton and at Trinity Hall, Cambridge; studied in Paris from 1901; influenced by Whistler and the Impressionists; friends included Somerset Maugham, Clive Bell and Arnold Bennett and the painters Roderic O'Conor and James Wilson Morrice; brother-in-law of Alaister Crowley. Exhibited with the Salon d'Automne, 1904, and at the Royal Academy from 1909. Painted in Marseilles, 1908, and at Etretat, summer 1908; in Burma, 1909, and later in the Far East. Founder member of Modern Portrait Society, 1907, and of National Portrait Society, 1911. Married in 1920, 'Jane' Ryan, whom he painted on many occasions. Associate of Royal Academy, 1922; member, 1930; keeper, 1943–5, and president, 1949–54. Knighted in 1945. Retrospective exhibitions at Leicester Galleries, London, 1950, and at the Royal Academy, 1957; painted many official portraits and state portraits of George VI and Queen Elizabeth, 1945. Died in London in 1972. Retrospective exhibition held at the Fine Art Society, London, and later in Edinburgh, 1975–6.

## KITAJ, *Ronald B.* (born 1932)

Born in 1932 in Cleveland, Ohio. Studied at Cooper Union Institute, New York, 1950. Studied at the Akademie der Bildenden Künste, Vienna. Seaman on American ships, 1952–3, and served in U.S. army in Germany and France, 1955–7. Studied at the Ruskin School of Drawing, Oxford, 1958–61, on G.I. scholarship. Attended Royal College of Art, London, 1959–61. Exhibited with 'Young Contemporaries', R.B.A. Galleries, London, from 1960. Various teaching posts in England and first one-artist show at the Marlborough Gallery, London, 1963, and in New York at Marlborough, 1965 (and in 1974). Retrospective at County Museum of Art, Los Angeles, 1965; guest teacher at University of California, Berkeley; exhibitions in Cleveland, Ohio, and at Stedelijk Museum, Amsterdam, 1967.

Retrospective at the Kestner Gesellschaft, Hanover, and Boymans Museum, Rotterdam, 1970. Exhibited with Jim Dine, Cincinnati Museum of Art, 1970. Shows of graphics at Marlborough Gallery, London, and elsewhere. Contributed plates to *A Day Book* by Robert Creeley, 1972. Selected Arts Council exhibition 'The Human Clay', Hayward Gallery, 1976. One-artist exhibition, Marlborough, 1977.

## KNIGHT, *Dame Laura* (1877–1970)

Born in 1877 at Long Eaton, Derbyshire, daughter of Charles and Charlotte Johnson, the latter a painter and teacher of art. Moved to Nottingham, 1879. From 1892 attended Nottingham School of Art under Wilson Foster and met Harold Knight (1874–1961), whom she married in 1903, the year she first showed at the Royal Academy. Painted at Staithes, Yorkshire. The Knights held a joint exhibition in Nottingham, 1903, and first exhibited together in London at the Leicester Galleries, 1906. Studied old masters in Holland, 1905–6. Moved to Newlyn, Cornwall, 1908, where the Knights came to know some of the Newlyn School painters and met artists such as Dod and Ernest Proctor, Alfred Munnings and Augustus John. Exhibited with Harold Knight at Leicester Galleries, 1912. Lived in Cornwall, where Harold Knight did agricultural work as a conscientious objector in the war. Commissioned under the Canadian War Records scheme in 1916 to paint a boxing scene at Witley Camp, Surrey; completed, 1918. Moved to London, 1919, and began to establish herself as a painter of outdoor life, gypsies, dancers and the circus. Harold Knight became a well-known portrait painter elected to Royal Academy, 1937, a year after Laura Knight's election. Visited America, 1922, as European judge at the Carnegie International, Pittsburgh. Visited the Italian Tyrol, 1923, and European tour, 1924; America, 1926. Exhibition of circus pictures, Alpine Club Gallery, London, 1930; further one-artist exhibition at Leicester Galleries, 1939. Designed pottery for Foley China, 1934. Worked as war artist from 1939, attending the Nuremberg Trials in that capacity, 1946. Retrospective exhibition at Upper Grosvenor Galleries, 1963, at the Royal Academy, 1965, and at Nottingham Castle Museum, 1970. Died in London in 1970. Published two volumes of memoirs *Oil Paint and Grease Paint* (1936) and *The Magic of a Line* (1965).

## KOSSOFF, *Leon* (born 1926)

Born in 1926 in London of Russian-Jewish parentage. Served in the army, 1945–8, and attended St Martin's School of Art, 1948–53, and under David Bomberg at the Borough Polytechnic, evening classes, 1950–2; at the Royal College of Art, London, 1953–6. First one-artist exhibition at Beaux Arts Gallery, London, 1957 (and showed there on six occasions to 1964). Member of the London Group, 1962, and held various teaching posts including 1966–9 at St Martin's. One-artist exhibition at Marlborough Gallery, 1968; retrospectives at Whitechapel Art Gallery, London, 1972, and at Fischer Fine Art, London, 1974. Included in 'British Painting '74', Hayward Gallery, 1974. Lives in London.

## LAMB, *Henry* (1883–1960)

Born in 1883 in Adelaide, Australia. Youth in Manchester, where his father was Professor of Mathematics at the university. Studied medicine at the university until 1904; turned to painting and studied at Orpen and John's school, Chelsea. Closely involved in formation of Friday Club, 1905–6. Studied at Atelier de la Palette, Paris, under J.-E. Blanche, 1907–8. Worked in Brittany, 1908, 1910 and 1911, and in Ireland, 1912–13. Exhibited at New English Art Club, 1909–14. Member of the Camden Town Group, 1911, and London Group, 1913. Exhibited in 'Second Post-Impressionist Exhibition', Grafton Galleries, London, 1912–13. Returned to study of medicine, 1914–16, when he joined R.A.M.C. as medical officer in Macedonia and Palestine and was appointed official war artist. First one-artist exhibition at Alpine Club Gallery, London, 1922; first show at Leicester Galleries, London, 1927, and nine subsequent one-artist shows there to 1956. Official war artist, 1940–5; elected to Royal Academy, 1949. Numerous group exhibitions of modern British painting. Died in Salisbury, 1960. Memorial exhibition of paintings and drawings, Leicester Galleries, 1961, and retrospective at New Grafton Gallery, London, 1973.

## LANCASTER, *Mark* (born 1938)

Born in 1938 in Holmfirth, Yorkshire. Studied at Department of Fine Art, Newcastle University, 1961–5, under Richard Hamilton. First visited New York, 1964, and was briefly studio assistant to Andy Warhol. Exhibited in 'Young Contemporaries' exhibition, London, 1963 and 1965. First one-artist exhibition at Rowan Gallery, London, 1965 (and in 1967, 1968, 1970, 1973 and 1975). Taught at Bath Academy, Corsham, and University of Newcastle, 1965–6. Included in 'New Generation' exhibition, Whitechapel Art Gallery, 1966, and in 'British Drawing – The New Generation', Museum of Modern Art, New York. Appointed Artist in Residence, King's College, Cambridge, 1968 (to 1970); exhibition at Arts Council Gallery, Cambridge, 1968, and Magdalene Street Gallery, Cambridge, 1971. Included in 'British Painting and Sculpture 1960–70', National Gallery, Washington, 1970. Exhibition of paintings at Betty Parsons Gallery, New York, 1972. 'Paintings: Cambridge/New York', Walker Art Gallery, Liverpool, 1973. Lives and works in New York.

## LANYON, *Peter* (1918–1964)

Born in 1918 in St Ives, Cornwall, where he lived for much of his life. Studied painting in Penzance and briefly at Euston Road School, 1938. Instruction from Ben Nicholson, end of 1938, and greatly encouraged by Naum Gabo. Served in the R.A.F., 1940–6. Co-founder of Crypt Group, St Ives (with Wynter, Wells and others); exhibited with 'Salon

des Réalités Nouvelles', Paris, 1947 (and 1949). First one-artist exhibition Lefevre Gallery, London, 1949, and at Passedoit Gallery, New York, 1953. Visited Italy and saw the Peggy Guggenheim Collection, Venice, 1948. Founder member of Penwith Society, St Ives, 1949. Italian Government Scholarship, 1953. Taught with Terry Frost and William Redgrave at St Peter's Loft School, St Ives, 1957–60. Executed tiled mural for Liverpool University, 1960. Numerous one-artist and group exhibitions; Sao Paulo Bienal, 1961. Killed in a gliding accident, Cornwall, 1964. Arts Council retrospective exhibition, Tate Gallery, 1968.

## LASZLO, *Philip de* (1869–1937)

Born in 1869 in Budapest, Hungary, where he studied painting from 1884 to 1889; attended Royal Bavarian Academy, 1889–92, with intervening year, 1890–1, spent at the Académie Julian, Paris. Exhibited in several European capitals and showed his first royal portraits in 1894 of the Bulgarian royal family. Settled in England in 1907, the year he held his first one-artist exhibition at the Fine Art Society, London. Rapidly established great reputation as portrait painter; painted many members of the British royal family. Founder member of the National Portrait Society, 1911. Died in London in 1937.

## LAVERY, *Sir John* (1856–1941)

Born in 1856 in Belfast. Studied at Haldane Academy, Glasgow, and Heatherley's School, London. In Paris as student from 1881, where he exhibited at Paris Salon, 1883. Influence of Whistler, whom he met in 1887. Early member of the Glasgow School of painters, which included E. A. Hornel, Sir James Guthrie and Arthur Melville. One-artist exhibition at Goupil Gallery, London, 1891. Helped Whistler in the foundation of the International Society, 1898. Retrospective at Grosvenor Galleries, London, 1914. Painted numerous naval pictures, 1917–18. Knighted, 1918, and elected to Royal Academy, 1921. In North Africa, 1920. Reputation as portrait painter. Died at Kilmaganny, County Kilkenny, 1941. Memorial exhibition at Leicester Galleries, London, 1941. Published *The Life of a Painter* (1940). Exhibition at Belfast Art Gallery, 1951.

## LE BAS, *Edward* (1904–66)

Born in London in 1904 into a wealthy manufacturing family of Channel Islands descent. Studied architecture at Cambridge University, taking a degree in 1924; studied painting at the Royal College of Art, London, from 1924 and also in Paris. Influenced by Vuillard and Bonnard. First one-artist exhibition at the Lefevre Gallery, London, 1936; represented in group exhibitions and elected to London Group, 1943, the year he became an Associate

of the Royal Academy (elected R.A., 1953). Represented in 'Eleven British Artists', British Council touring exhibition, Australia, 1949. Frequently painted abroad, sometimes in the company of Duncan Grant and Vanessa Bell (in Dieppe, 1946, and in Asolo, 1956); worked in Majorca, Morocco, France and at Marbella, Spain. Lived in Bedford Square and later in Glebe Place, Chelsea. In 1963 his large collection of modern French and British art was shown at the Royal Academy, London, including representative groups of work by Gilman, Sickert, Ginner and Grant and paintings by Matisse, Braque, Utrillo, Vuillard and Bonnard; after his death in 1966, Le Bas's Bonnard, *Bol de Lait* (about 1934), entered the Tate Gallery. The Gilman (Plate 21) was also in his collection.

## LEWIS, *Percy Wyndham* (1882–1957)

Born in 1882 on his father's yacht off Nova Scotia. Attended Rugby School and Slade School of Fine Art, 1898–1901, under Professor Tonks. Travelled widely in Europe, 1902–8, writing and painting; with Gore in Madrid, about 1902, and in Paris, 1907. Member of Camden Town Group, 1911 (exhibiting in June and December exhibitions, 1911, and December, 1912). Contributed to 'Second Post-Impressionist Exhibition', Grafton Galleries, London, 1912–13, to first Grafton Group Exhibition, Alpine Club Gallery, London, 1913, and founder member of London Group, 1913. Worked at the Omega Workshops, 1913, and founded his own Rebel Art Centre, 1914. Decorations for Lady Drogheda, 1913–14, and for Restaurant de la Tour Eiffel, Percy Street, London, 1916. Edited and contributed to *Blast* (first number), 1914, and second number, 1915. Contributed to only Vorticist exhibition, Doré Galleries, London, 1915. Joined Royal Artillery, 1915–17, and worked as official war artist to Canadian Corps Headquarters. First one-artist exhibition at Goupil Gallery, 1919, and founded and exhibited in Group X, Heal's Mansard Gallery, London, 1920. Some painting and much writing in the 1920s; married in 1929. Portrait drawings exhibited at Lefevre Gallery, London, 1932. One-artist show, Leicester Galleries, 1937. Spent war years in America and Canada, 1939–45. Retrospective exhibition at Redfern Gallery, London, 1949. Art critic to *The Listener* to 1951, a position terminated by oncoming blindness. Retrospective at the Tate Gallery, 1956; died in London, 1957. Large body of pre-1920 work shown in 'Vorticism and its Allies', Hayward Gallery, 1974; paintings and drawings at Mayor Gallery, London, 1974. Many published works include novel *Tarr* (1918), *The Tyro* (magazines 1 and 2, 1921–2), *The Wild Body* (1927), novel *The Childermass* (1928), *The Apes of God* (1930), *Hitler* (1931), *Blasting and Bombardiering* (autobiography, 1937), *Rude Assignment* (autobiography, 1950) and other novels including *The Human Age* (two novels *Monstre Gai* and *Malign Fiesta*, 1955). *The Letters of Wyndham Lewis* published 1963.

## LOWRY, *Laurence Stephen* (1887–1976)

Born in 1887 at Old Trafford, Manchester. Studied at Manchester School of Art, 1905–15, and at Salford School of Art, 1915–25. Began painting industrial landscapes in Pendlebury and Oldham Road area, Manchester. Exhibited in Paris Salon, 1927, and held first one-artist exhibition at Lefevre Gallery, London, 1939. Member of the London Group, 1948. Retrospective exhibitions at Salford, 1951, at Sheffield, 1962 (the year of his election to Royal Academy), and Tate Gallery, 1966. Numerous group and one-artist exhibitions, particularly at Lefevre Gallery and Crane Calman Gallery, London. Died in 1976. Memorial exhibition at Royal Academy, 1976.

## MacBRYDE, *Robert* (1913–66)

Born in 1913 at Maybole, Ayrshire, and worked in a factory for five years before going to Glasgow School of Art, 1932, where he met Robert Colquhoun. Left Glasgow, 1937, and travelled abroad with Colquhoun until 1939. Returned to Scotland and moved to London, 1941, with Colquhoun. First one-artist exhibition at Lefevre Gallery, 1943. Shared house with Colquhoun and John Minton, 1943–6. Friendship with Polish painter Jankel Adler. Monotypes and lithographs for Miller's Press, Lewes, 1947. Visited Italy in 1949 with Colquhoun and collaborated with him on sets and costumes for *Donald of the Burthens* ballet, Covent Garden, 1951. Lived in Essex, 1950–4. Various group exhibitions. After the death of Colquhoun, 1962, visited Spain. Moved to Dublin, where he was run over by a car and killed, 1966. Retrospective exhibition in Edinburgh, 1972. Exhibition with Colquhoun, Mayor Gallery, London, 1977.

## McEVOY, *Arthur Ambrose* (1878–1927)

Born in 1878 at Crudwell, Wiltshire. Attended Slade School of Fine Art, 1893–6, on encouragement from Whistler. Intense study of Old Masters, working in National Gallery. Friendship with Sickert and Augustus John. Exhibited with the New English Art Club from 1900, member 1902; founder member of National Portrait Society, 1911. From about 1915 became successful as a portrait painter, but continued to paint landscapes etc. Taught briefly at Slade School of Fine Art. War artist in Royal Naval Division, 1916–18. Visited New York, 1920, exhibiting at Duveen Galleries. Elected Associate of Royal Academy, 1924, and died in London of pneumonia, 1927. Memorial exhibition (with William Orpen and Charles Ricketts) at Manchester, 1933. Retrospective at Leicester Galleries, London, 1953, and at Ulster Museum, Belfast, 1968.

## MADDOX, *Conroy* (born 1912)

Born in 1912 in Ledbury, Herefordshire. In Birmingham in the early 1930s; worked with French Surrealists in Paris, 1937, and joined the English Surrealist group, 1940. Exhibited at the London and Zwemmer Galleries and contributed to the *London Bulletin*, journal of the English Surrealists. Lecturer in modern art, Birmingham University; contributed to *Le Savoir Vivre*, published by Belgian Surrealists, 1946. Included in the 'International Surrealist Exhibition', Galerie Maeght, Paris, 1947. Painting and lecturing on Surrealism in London from 1955. Retrospective at the Grabowski Gallery, London, 1963, and included in 'The Enchanted Domain' exhibition at Exeter and Zwemmer Gallery, 1967. Represented in 'Britain's Contribution to Surrealism', Hamet Gallery, 1971, with exhibitions at the Hamet Gallery in 1972 and 1973. 'Gouaches of the 1940s', Fischer Fine Art, London, 1976.

## MARTIN, *Kenneth* (born 1905)

Born in 1905 in Sheffield, where he attended part-time the School of Art, 1927–9. Royal College of Art, 1929–32. Taught at St John's Wood School of Art, London; exhibited with London Group from 1936; member, 1949. First one-artist exhibition, Leicester Galleries, 1943. With his wife Mary Martin (1906–69) and John Weeks contributed to 'This is Tomorrow' exhibition, Whitechapel Art Gallery, 1956, and exhibited with his wife, I.C.A., London, 'Essays in Movement', 1960. Lords Gallery retrospective, 1962; Arts Council touring exhibition (with Mary Martin), 1970–1; one-artist exhibitions at Waddington Galleries, London, 1970 and 1974. Included in 'Art as Thought Process', Arts Council touring exhibition, 1974. Retrospective exhibition, Tate Gallery, 1975. Numerous group exhibitions in England and abroad including 'Kinetics', Hayward Gallery, 1970. Published *Chance and Order*, book of drawings (1973).

## MEDLEY, *Robert* (born 1905)

Born in 1905 in London and educated at Gresham's School, Norfolk, 1919–21, where W. H. Auden was friend and fellow-pupil. Byam Shaw School of Art, 1921, and briefly at Royal Academy Schools. Slade School of Fine Art, 1923. Friendship wih Fry and Bloomsbury Group. To Paris, 1926, working under Jean Marchand, Académie Moderne, to 1927, and in Paris, 1929; met Tzara and Picabia. Member of London Group and London Artists' Association, 1930; held first one-artist exhibition (with Morland Lewis, 1903–43), Cooling Galleries, 1930. Taught with Moore and Sutherland, Chelsea School of Art, 1932. Designer of sets and costumes for Group Theatre, London, including costumes for *Dance of Death* (Auden, 1933), Eliot's *Sweeney Agonistes, The Dog Beneath the Skin* (Auden and Isherwood) and *Timon of Athens* (all 1935–6, Group Theatre Season). Contributed to 'International Surrealist Exhibition,' London, 1936. *Ascent of F6* produced at Mercury Theatre designed by Medley (Auden and Isherwood, 1937). Served in the army, 1940–5, in the Middle East and in America, 1943–4. One-artist exhibition, Lefevre Gallery, 1948, (and one-artist exhibitions at Leicester Galleries, 1960 and 1966, and Lisson Gallery, 1971). Appointed head of Fine

Arts Department, Camberwell School of Art, 1958; exhibition at Royal West of England Academy, Bristol, 1958 (with Keith Vaughan and Ruskin Spear). Retrospective exhibition, Whitechapel Art Gallery, London, 1963. Represented in 'British Painting '74', Hayward Gallery, 1974. Lives in London.

## MIDDLEDITCH, *Edward* (born 1923)

Born in 1923 at Chelmsford, Essex. Studied at Regent Street Polytechnic and Royal College of Art, 1948–52. Associated with Kitchen Sink School – Bratby, Smith and Greaves – exhibiting with them at 1956 Venice Biennale. One-artist exhibitions at Beaux Arts Gallery, 1954 and 1956, and included in Arts Council 'Six Young Painters' exhibition, 1957. Various one-artist (at New Art Centre, London) and group exhibitions. Lives in Suffolk.

## MILOW, *Keith* (born 1945)

Born in 1945 in London and attended Camberwell School of Art, 1962–8; postgraduate student Royal College of Art, 1967–8; experimental work at Royal Court Theatre, London, 1968. Exhibited in 'Young Contemporaries' exhibition, 1967, and group exhibitions at Axiom Gallery, 1968 and 1969, London, and Richard Feigen Gallery, New York, 1969. Awarded Gregory Fellowship, University of Leeds, 1970, and held first one-artist exhibition that year at Nigel Greenwood Inc., London (also in 1972, 1973, 1974 and 1976). Exhibited at I.C.A., London, 1971 and 1976, and King's College, Cambridge, 1971. Awarded Harkness Fellowship, 1972, and lived and worked in New York (with subsequent visits). Represented in 'The New Art', Hayward Gallery, 1972, and in 'Art as Thought Process', Arts Council touring exhibition, 1974. One-artist exhibition at Arnolfini Gallery Bristol, 1975, and numerous group exhibitions in England and abroad; first one-artist exhibition in New York at J. Duffy and Sons, 1973. One-artist exhibition at Galerie Albert Baronian, Brussels, 1977, and represented in 'Five British Artists' (with Buckley, R. Smith and others), Young Hoffman Gallery, Chicago, 1977.

## MINTON, *John* (1917–57)

Born in 1917 near Cambridge. Studied under Millard and Kenneth Martin at St John's Wood School of Art, London, 1935–8. Eight months in France, 1938–9, with Michael Ayrton. Registered as conscientious objector, 1940–1; served in Pioneer Corps, 1941–3. With Ayrton designed production of *Macbeth*, 1941, Piccadilly Theatre, London. Taught illustration at Camberwell School of Art, 1943–6. Tutor in Painting at Royal College of Art, London, 1948–56. Shared London studio with Colquhoun and MacBryde, 1943–6, and with Keith Vaughan, 1946–52. First one-artist show at Roland, Browse and Delbanco, 1945, and one-artist shows (six altogether) at Lefevre Gallery, London, 1945–56. Member of London Group, 1949. Extensive visits abroad to Spain, Corsica, West Indies etc. Committed suicide in London in 1957. Illustrated many books including Fournier's *The Wanderer*, Stevenson's *Treasure Island*, Elizabeth David's cookery books and the Folio Society edition of *Macbeth*. Arts Council memorial exhibition, 1958–9; commemorative exhibition, Leicester, 1967; Hamet Gallery, London, 1970, and retrospective exhibition 'Paintings, Drawings, Illustrations and Stage Designs', Reading, 1974, and Graves Art Gallery, Sheffield, 1974–5.

## MOYNIHAN, *Rodrigo* (born 1910)

Born in 1910 at Santa Cruz, Tenerife, of Irish-Spanish descent. Came to England, 1918; in New Jersey, 1925; studied in Rome, 1928, and attended Slade School of Fine Art, London, 1928. Exhibited at Bloomsbury Gallery, London, 1931. Member of London Group, 1933, and exhibited in 'Objective Abstractionists' exhibition, Zwemmer Gallery, London, 1934. Associated with Rogers, Pasmore, Coldstream in Euston Road School and taught at Royal College of Art, 1948–57. One-artist exhibition at Redfern Gallery, 1940 (and 1958 and 1961); exhibitions at Leicester Galleries, London, 1945 and 1954. Included in Arts Council touring exhibition 'British Painters 1939–45', 1946. Exhibitions at Hanover Gallery, London, 1963 and 1967, and at Fischer Fine Art, London, 1973. Married to the painter Anne Dunn and works in South of France and England.

## NASH, *John* (born 1893)

Born in 1893 in Kensington, London, younger brother of Paul Nash. Educated at Wellington College; no formal art training. Exhibited landscape watercolours with Paul Nash at Dorien Leigh Gallery, South Kensington, 1913. Member of Friday Club, 1913, and London Group, 1914. With Ginner and Gilman in Cumberland Market Group, 1915. Began painting in oils, 1914. Served in Artists' Rifles, 1916–18; taught at Ruskin School of Drawing, Oxford, 1922–7, and Royal College of Art, 1934–40 (and 1945–57). Many group exhibitions. Joined Observer Corps, 1939, and was official war artist to Admiralty, 1940, working in Plymouth. Acting major in Royal Marines and demobilized, 1944. A.R.A., 1940, and R.A., 1951. Retrospective exhibitions at Leicester Galleries, 1954, and at the Royal Academy, 1967. Exhibition of early drawings at Anthony d'Offay Gallery, London, 1973, and of flower and plant drawings, 1976. Illustrated numerous books from 1919, particularly on gardening and natural history, and has published *English Garden Flowers* (1948) and essay *The Artist Plantsman* (1976).

## NASH, *Paul* (1889–1946)

Born in 1889 in Kensington, London, brother of John Nash. Educated at St Paul's School, London, to 1906. Chelsea Polytechnic, 1906–8; L.C.C. School, Bolt Court, 1908–10; Slade School of Fine Art, 1910–11, making friends with Ben Nicholson, a fellow-student. First one-artist exhibition, Carfax

Gallery, London, 1912. Exhibited with John Nash, Dorien Leigh Gallery, South Kensington, 1913, and with Friday Club, 1914. Briefly associated with Omega Workshops, 1914. Served in Hampshire Regiment in France, 1917, and appointed official war artist later that year. 'Ypres Salient' drawings at Goupil Gallery, 1917, and 'Void of War: an exhibition of pictures by Lieut. Paul Nash' at Leicester Galleries, London, 1917. Lived at Dymchurch, Kent, 1921–5. One-artist exhibition, Leicester Galleries, 1924, and several subsequent shows of watercolours and drawings at Mayor Gallery, 1925, Leicester Galleries, etc. Member of the London Artists' Association, 1927. With Edward Burra in South of France, 1930, and appointed art critic for *Weekend Review* (to 1933), and working also as critic on *The Listener* with Herbert Read. Judge on jury of Carnegie International Award, Pittsburgh, U.S.A., 1931, and first retrospective, Oxford Arts Club, 1931. From 1933 suffered chronic bronchitis. Founded Unit One, 1933, and contributed to its travelling exhibition, 1934–5. Moved to Hampstead, 1936, after living in Dorset; contributed to 'International Surrealist Exhibition', London. Exhibition at the Redfern Gallery, London, 1937, and of surrealist objects and poems at London Gallery, 1937; exhibition at Leicester Galleries and Venice Biennale retrospective, 1938. New paintings exhibition, Tooth's London, 1939. Appointed official war artist, 1940–5. Retrospective at Temple Newsam, Leeds, 1943, and at Cheltenham Art Gallery, 1945; watercolours exhibited at Buchholz Gallery, New York, 1945. Died at Boscombe, Hampshire, 1946. Paul Nash's published works include *Places* (1922), *Room and Book* (1932), and *Dorset Shell Guide* (1936). *Outline. An Autobiography and Other Writings* was issued posthumously (1949). His illustrated edition of Browne's *Urne Buriall and The Garden of Cyrus* appeared in 1932 and an exhibition of his photographs, published in *Fertile Image*, was held in 1951. Correspondence with the poet Gordon Bottomley, *Poet and Painter*, published in 1955. The numerous posthumous exhibitions devoted to Paul Nash's work as painter and photographer are detailed in the catalogue to the most comprehensive retrospective of his work held at the Tate Gallery, 1975 (with tour to Plymouth; The Minories, Colchester; Bradford and Manchester).

## NEVINSON, *Christopher Richard Wynne* (1889–1946)

Born in 1889 in London, son of writer and war correspondent H. W. Nevinson. Attended Slade School of Fine Art, 1908–12. Exhibited with Allied Artists' Association and Friday Club, 1912–22. Studied in Paris, 1912–13, meeting Modigliani, Severini and others. Founder member of London Group, 1913. Host to Marinetti in London, 1913, and published with him 'Futurist Manifesto: Vital English Art', 1914. Represented in 1915 Vorticist exhibition, Doré Galleries, London. Served in France, 1914–16. First one-artist exhibition (war paintings) at Leicester Galleries, London, 1916.

Appointed official war artist, 1917, and showed war paintings again at Leicester Galleries, 1918, with similar success. Visited New York, 1919 and 1920, holding shows there. Renounced Futurism and worked on more traditional lines with exhibitions at Leicester Galleries. A.R.A., 1939. Died in London, 1946. Memorial exhibition, Leicester Galleries, 1947. Represented in 'Wyndham Lewis and Vorticism', Tate Gallery, 1956, and in 'Vorticism and its Allies', Hayward Gallery, 1974. Published autobiography *Paint and Prejudice* (1937).

## NEWTON, *Algernon* (1880–1968)

Born in 1880 in Hampstead, London. Attended Clare College, Cambridge, and afterwards Frank Calderon's School of Animal Painting and the London School of Art, Kensington. Invalided from the army, 1916. Exhibited regularly at the Royal Academy from 1903; elected R.A., 1943. First one-artist exhibition at Leicester Galleries, London, 1931. Represented at Carnegie International, Pittsburgh, U.S.A., 1936. One-artist exhibition at Leicester Galleries (with Frank Dobson and Vanessa Bell), 1943. Worked mainly in London but also in Yorkshire and Cornwall. Died in 1968.

## NICHOLSON, *Ben* (born 1894)

Born in 1894 in Denham, Buckinghamshire, eldest son of Sir William Nicholson and Mabel Nicholson (*née* Pryde, sister of James Pryde). Educated in London and at Gresham's School, Holt. Several summers spent in Dieppe. Briefly attended Slade School of Fine Art, London, 1911, becoming friends with Paul Nash. In Italy, France and Madeira, 1911–14; London and North Wales, 1914–17; Pasadena, California, 1917–18. Married the painter Winifred Dacre; painting in Castagnola, Cumberland and Wales. Held first one-artist show, Adelphi Gallery, London, 1922, and represented in 'Modern British Art', Whitechapel Art Gallery, 1923, exhibited with Winifred Dacre, Paterson Gallery, London, 1923. Member of Seven and Five Society, 1924–35. With Christopher Wood met Alfred Wallis in St Ives, Cornwall, 1928. Exhibition at Bernheim, Paris, and Lefevre Gallery, London, 1930 (and exhibited with Lefevre on ten occasions to 1954). Lived mainly in London, 1931–9, with frequent visits to Paris. Exhibition at Tooth's with Barbara Hepworth, his second wife. Member of Unit One and of 'Abstraction-Création', Paris, 1933. Visited Mondrian in Paris, 1934; represented in Unit One exhibition, London, and at the Venice Biennale. Various contributions to exhibitions of abstract art, Europe and New York. Co-editor (with Naum Gabo and Leslie Martin) of *Circle – An International Survey of Constructive Art*, 1937. Represented at New York's World Fair, British Section, 1939. Lived in Cornwall, 1940–58; retrospective at Temple Newsam, Leeds, 1944; one-artist exhibition at Durlacher Gallery, New York, 1949 (and in 1951, 1952, 1955 and 1956). Retrospective in Detroit, Dallas and Minneapolis, 1952–3; in Europe (including Tate Gallery), 1955. Exhibitions at Gimpel Fils, London,

1955 and 1957; exhibited with Marlborough and Waddington Galleries. Married Dr Felicitas Vogler, 1957, and moved to Switzerland, 1958, where he lived until 1971; since then in London and Cambridge. Numerous one-artist and group exhibitions in Europe and America. Order of Merit, 1968; retrospective exhibition, Tate Gallery, 1969. A special number of *Studio International*, devoted to Ben Nicholson (see bibliography: Sausmarez) contains most of his published writings. Exhibition at Gimpel Fils, London, 1973; 'The Graphic Work', Victoria and Albert Museum travelling exhibition, 1975.

## NICHOLSON, *Sir William* (1872–1949)

Born in 1872 at Newark-on-Trent, Notts; attended local school and Herkomer's Art School, Bushey, 1888–9. Attended Académie Julian, 1889–90. In 1893 married Mabel Pryde, painter and sister of James Pryde (1866–1941). With Pryde he formed 'J. and W. Beggarstaff', designing posters under that name, 1893–9. Illustrated several books with woodcuts for Heinemann, the publishers, including *London Types* and *An Alphabet;* awarded gold medal, Exposition Universelle, Paris, for woodcuts, 1900. Exhibited at the International Society and founder member of National Portrait Society, 1911. First one-artist exhibition at Paterson Gallery, London, 1906; exhibitions in London at the Chenil Galleries, 1910; Goupil Gallery, 1911 and 1918; Beaux Arts Gallery, 1927, 1929 and 1930; Leicester Galleries, 1934, 1936 and 1938. Lived in Rottingdean, Sussex, and after the First War at Sutton Veny, Wiltshire. In Spain, 1933, and frequently in Europe; knighted 1936. Retrospective exhibition at National Gallery, London (with Jack B. Yeats), 1942; Arts Council, London, 1947; Roland, Browse and Delbanco exhibition, 1945. Died at Blewbury, Berkshire, 1949. Exhibitions at Marlborough Gallery, 1967, and centenary exhibition at Roland, Browse and Delbanco and Aldeburgh, Suffolk, 1972.

## NICHOLSON, *Winifred* (born 1893)

Born in 1893 in Oxford; also known as Winifred Dacre (her mother's surname). Attended the Byam Shaw School of Art, London, and studied in Paris. Represented at 'Modern British Art', Whitechapel Art Gallery, 1923; joint exhibition with husband Ben Nicholson at Paterson Gallery, London, 1923. Member of the Seven and Five Society, 1925–35, and of the New English Art Club, 1937–43. Represented at Venice Biennale, 1928. Represented in 'The Englishness of English Painting', 1964, and held one-artist exhibition, 1974, both at Crane Kalman Gallery, London.

## O'CONOR, *Roderic* (1860–1940)

Born in 1860 in Roscommon, Ireland. Studied in London and Antwerp, 1881–3, and under Carolus-Duran in Paris from 1883. Spent most of the rest of his life in France. Worked at Grez-sur-Loing, 1889–90, and went to Pont-Aven, Brittany, 1892, meeting Bernard, Serusier and in the following year

Gauguin; painted under Gauguin and Van Gogh's influence. Exhibited with 'Les XX', Brussels, 1908, and at the Salon d'Automne, Paris. One-artist exhibition at the Galerie Bonaparte, Paris, 1937. Worked in the South of France and died at Neuil-sur-Layon, Maine-et-Loire, 1940. Studio contents sold at Hôtel Drouot, Paris, 1956, the year in which Roland, Browse and Delbanco, London, presented the first of several exhibitions devoted to his work. Aspects of his character were used by Somerset Maugham in his novel *The Moon and Sixpence.*

## ORPEN, *Sir William* (1878–1931)

Born in 1878 at Stillorgan, County Dublin. Attended Metropolitan School of Art, Dublin, 1890–7, and Slade School of Fine Art, London, 1897–9; teaching studio with Augustus John, Chelsea, 1899. Member of the New English Art Club, 1900; exhibited at Royal Academy from 1908 (R.A. 1921). Founder member of the National Portrait Society, 1911; great reputation as portrait painter. Official war artist, 1917–19; knighted, 1918. Died in London in 1931. Memorial exhibition at the Royal Academy and with McEvoy and Ricketts at Manchester, 1933. Published *An Onlooker in France 1917–1919* (1921), edited *An Outline of Art* (1923) and published *Tales of Old Ireland and Myself* (1924). Retrospective of paintings, watercolours and drawings, Rye Art Gallery, Sussex, 1968.

## PAOLOZZI, *Eduardo* (born 1924)

Born in 1924 in Edinburgh, son of Italian parents; educated in Catholic and Protestant schools, Scotland. Internment was followed by six months at Edinburgh School of Art, 1943. Served in Pioneer Corps, 1943–4. Attended Slade School of Fine Art, London, 1944–7; first one-artist exhibition of sculpture while still a student, Mayor Gallery, London, 1947. Moved to Paris, late 1947, living there until 1950; friendship with William Turnbull; visits to Giacometti, Tzara and Brancusi; exhibited at Galerie Maeght, Paris, 1948. Exhibition with Turnbull, Hanover Gallery, London, 1950. Taught textile design, Central School, 1950–5, sculpture at St Martin's School of Art, 1955–8. Exhibited at Venice Biennale, 1952; one-artist exhibition, Hanover Gallery, 1958. Member of the Independent Group, I.C.A., 1952–5; with Nigel Henderson and Peter and Alison Smithson collaborated on exhibit for 'This is Tomorrow', Whitechapel Art Gallery, 1956. First American one-artist exhibition, Betty Parsons Gallery, New York, 1960. Represented by sculpture and graphics in numerous exhibitions in England and abroad. Completed film *The History of Nothing* in 1962 after two years teaching in Hamburg. Retrospective (with Victor Pasmore) Venice Biennale, 1960 (and European tour 1960–1). Teaching at Royal College of Art from 1968. Exhibitions with Marlborough Gallery, London. Tate Gallery retrospective, 1971, and retrospective at Kestner Gesellschaft, Hanover, 1974, and at Nationalgalerie, Berlin, 1975. Early 'Bunk' collages etc. exhibited at Anthony d'Offay Gallery, London, 1977.

## PASMORE, *Victor* (born 1908)

Born in 1908 in Chelsham, Surrey. Educated at Harrow and worked from 1927 for London County Council, County Hall. Attended evening classes, Central School under A. S. Hartrick. Exhibited with London Group and made member of London Artists' Association, 1932; first one-artist exhibition with L.A.A., 1933. Friendship with Rogers, Coldstream, Graham Bell and others forming Euston Road School, 1937, soon after release from County Hall. Various group exhibitions and one-artist exhibition Wildenstein's, London, 1940. Exhibited abstract paintings at London Group, 1947, and held one-artist exhibition, Redfern Gallery, London, 1947 (and 1949, 1950–1, 1952 and 1955). Exhibited in 'Space and Colour' exhibition, Hanover Gallery, London, 1952. Head of Painting Department, Durham University, 1954–61. Collaborated with Erno Goldfinger and Helen Phillips on exhibit for 'This is Tomorrow', Whitechapel Art Gallery, 1956; and with Richard Hamilton and Lawrence Alloway on 'an Exhibit', Newcastle and I.C.A., London, 1957. Appointed consultant for planning of Peterlee New Town, 1955, the year of first retrospective exhibition, Arts Council Gallery, Cambridge. Venice Biennale retrospective (with Paolozzi), 1960 (and European tour 1960–1). First exhibition with Marlborough Gallery, London, 'Recent Paintings and Sculptures', 1961, and subsequent shows there; represented in 'The English Eye', Marlborough-Gerson Gallery, New York, 1965. Trustee of Tate Gallery, 1963–6; Tate Gallery retrospective, 1965.

## PENROSE, *Sir Roland* (born 1900)

Born in 1900 in London and educated at Queen's College, Cambridge; later studied painting in Paris and became friendly with Picasso, Ernst and Eluard among others. Lived mainly in France. Married Lee Miller, who appeared in Cocteau and Man Ray's film *Le Sang du Poète*. Founder of the British Surrealist group and organizer of the International Surrealist Exhibition, London, 1936, to which he contributed. Trustee of the Tate Gallery, 1959–66, and until recently chairman of the I.C.A. Publications include *Picasso: His Life and Work* (1958).

## PEPLOE, *Samuel John* (1871–1935)

Born in 1871 in Edinburgh. Gave up law studies and attended the Trustees' School and the Royal Scottish Academy Life Class, 1892–6, and again in 1902. Exhibited at R.S.A. from 1901 (elected 1927). First one-artist exhibition at Aitken Dott Gallery, Edinburgh, 1903; also studied in Paris. Exhibited with Allied Artists' Association, London, 1908, and shared exhibition with J. D. Fergusson, Stafford Gallery, London, 1912. Lived in Paris, 1910–13, painting with Fergusson at Royan in 1910 and 1911 and at Cassis, 1913. Associated with the Scottish colourists Hunter and Cadell, and with Fergusson, in various exhibitions including *Les peintres de l'Ecosse moderne*, Galerie Barbazanges, Paris, 1924, and

Leicester Galleries, London, 1925; in *Les peintres écossais*, Galerie Georges Petit, Paris, 1931. Taught at Edinburgh College of Art from 1933; painted in the Isle of Iona in the 1920s and in South of France, 1928. Died in Edinburgh, 1935. Memorial exhibitions at Aitken Dott Gallery, Edinburgh, 1936, and at the McLellan Galleries, Glasgow, 1937. Included in 'Four Scottish Colourists', Saltire Society, Edinburgh, 1952, and in Peploe, Cadell, Hunter exhibition at Edinburgh and London Fine Art Society, 1977.

## PHILLIPS, *Peter* (born 1939)

Born in 1939 in Birmingham. Attended Moseley Road Secondary School of Art, Birmingham, 1953–5; Birmingham College of Art, 1955–9; Royal College of Art, London, 1959–62. Exhibited with 'Young Contemporaries', R.B.A. Galleries, London, 1959–62; London Group, 1961; 'Four Young Artists', I.C.A. Gallery, and 'Image in Progress', Grabowski Gallery, London, 1962. Taught at Coventry and Birmingham Colleges of Art, 1962–3. Exhibited Paris Biennale, 1963. Lived in New York, 1964–6, holding first one-artist exhibition at Kornblee Gallery, New York, 1965 (and 1966 and 1967). Guest professorship at Hochschule für Bildende Künste, Hamburg, 1968–9, and one-artist exhibitions in Zurich, Cologne, Venice, Rome, Milan, Munich. Retrospective in the Westfälischer Kunstverein, Munster, 1972. One-artist exhibition, Waddington Gallery, London, 1976.

## PHILLIPS, *Tom* (born 1937)

Born in 1937 in London; educated, St Catherine's College, Oxford, and Camberwell School of Art, London, under Frank Auerbach; exhibited with 'Young Contemporaries', 1964, and held first one-artist exhibition, A.I.A. Galleries, London, 1965. Since 1966 has worked on 'A Humument', volumes issued by the Tetrad Press, exhibited at I.C.A. Gallery, 1973, containing visual material, scores, stories, poems, etc. Exhibited at Bear Lane Gallery, Oxford, 1971 and 1972; performances of his music given in Bordeaux Festival, 1968, and at York University, 1973, performance of opera *Irma*. Graphics retrospective at Marlborough Gallery, London, 1973; represented in *La peinture anglaise d'aujourd'hui*, Musée d'Art Moderne, Paris, 1973, and numerous exhibitions in England and abroad including Marlborough Gallery, New York, 1974.

## PHILPOT, *Glyn* (1884–1937)

Born in 1884 in London and studied under T. McKeggie and Philip Connard (1875–1958) at Lambeth School of Art. Initially an illustrator, much influenced by Charles Ricketts; exhibited at the R.A., 1904, elected, 1923; founder member of National Portrait Society, 1911. Studied under Laurens at Académie Julian, Paris, 1905. First one-artist exhibition Baillie Gallery, London, 1910. Enlisted, 1914; painted portraits for Imperial War Museum, 1918. Mural for St Stephen's Hall, Westminster, 1927. Moved to Paris, 1932, and influenced

by contemporary painting, particularly Surrealism. Died in London in 1937. Memorial exhibition at the Tate Gallery, 1938; retrospective exhibitions at Leighton House, London, 1959, Worthing, 1962, and Oxford, 1976.

## PIPER, *John* (born 1903)

Born at Epsom, Surrey, in 1903 and worked in father's solicitor's office to 1926. Studied at Kingston and Richmond Schools of Art and at the Royal College of Art, 1928–9, at Richmond under Raymond Coxon. Exhibited wood engravings, 1927, Arlington Gallery, London, and in 1928 became regular contributor to the *Nation* (later *New Statesman and Nation*) as art reviewer. Visited Paris and elected to London Group, 1933; member of Seven and Five Society, 1934–5. With his second wife, Myfanwy Evans, helped produce *Axis – a Quarterly Review of Contemporary 'Abstract' Painting and Sculpture* 1935–7. About 1938, returned to more representational painting and did stage designs for Spender's *Trial of a Judge*; other theatre designs include ballet *The Quest* and six operas by Benjamin Britten, including *Death in Venice*, Covent Garden, 1973. Official war artist, 1940–2. First New York exhibition at Curt Valentin Gallery, 1948; decorations for British Embassy, Rio de Janeiro, 1948; with Osbert Lancaster supervised design of Battersea Pleasure Gardens, 1951; designed stained-glass windows for Oundle School Chapel, 1954–6, for the baptistery of Coventry Cathedral, 1958, and for Nuffield College Chapel, 1961. Of many one-artist exhibitions, the Marlborough Gallery's London exhibition, 1975, included paintings, stage designs and ceramics. John Piper has published a book of poems *Wind in the Trees* (1927), *English Romantic Artists* (1942) and a collection of articles *Buildings and Prospects* (1948). Has illustrated several books including a series of drawings of Renishaw Hall, Derbyshire, and Montegufoni, Florence, for the autobiography of Sir Osbert Sitwell.

## PISSARRO, *Lucien* (1863–1944)

Born in 1863 in Paris, the eldest son of Camille Pissarro. Lived in London, 1870–1. Employed by textile firm, Paris, 1878–82. Influenced by his father and by friendship and contact with Signac, Seurat, Guillaumin, etc. Exhibited at eighth and last Impressionist Exhibition, Paris, 1886. Living and working in London and Paris; book illustrations. Served on hanging committee of 'Salon des Indépendants', Paris, 1888. Settled in London, 1890 (naturalized, 1916). Exhibited wood engravings, Ricketts's and Hacon's shop, London, 1896. Ran the Eragny Press from 1894 to 1914. Began frequenting Sickert's afternoons at 19 Fitzroy Street, London, and was founder member of Camden Town Group, 1911 (exhibiting in all three shows, 1911–12). First one-artist exhibition, Carfax Gallery, London, 1913. Visited Monet at Giverny with J. B. Manson, 1921; first exhibition with Leicester Galleries, London, 1922. Painted in England, Wales and France

between the wars. Retrospective exhibition, Manchester City Art Gallery, 1934; exhibition 'Three Generations of Pissarro', Leicester Galleries, London, and Miller's, Lewes, 1943. Lucien's daughter was the painter Orovida Pissarro (1893–1968). Died at Hewood, Somerset, 1944. Memorial exhibition of paintings and watercolours, Leicester Galleries, 1946, and Arts Council retrospective (with tour) 1963. *Notes on the Eragny Press, and a Letter to J. B. Manson* was published posthumously (1957).

## RATCLIFFE, *William* (1870–1955)

Born in 1870 near King's Lynn, Norfolk. Studied at Manchester School of Art and worked for nearly twenty years as a wallpaper designer. He met Harold Gilman in 1908, who encouraged him to take up painting. Briefly attended Slade School of Fine Art, 1910, and visited Sickert's Fitzroy Street afternoons. Founder member of Camden Town Group, 1911 (exhibiting at all three exhibitions, 1911–12). First exhibited at Allied Artists' Association Salon, 1911. Member of London Group, 1913, when he also visited Sweden, probably with Gilman. After 1921 he painted little in oils but continued in watercolours and wood engravings. First one-artist exhibition at Roland, Browse and Delbanco, London, 1946, and exhibition at Letchworth Art Gallery, 1954. Lived for much of his life in Letchworth, Hertfordshire. Died in London in 1955.

## RAVILIOUS, *Eric* (1903–42)

Born in 1903 in London. Attended Eastbourne School of Art and Design School of Royal College of Art, London, 1922–5; encouraged and influenced by teacher Paul Nash. Visited Italy, 1925. With Bawden and Charles Mahoney carried out decorations for Morley College, 1928–9 (destroyed by bombing 1941). Made wood engravings for Golden Cockerel Press, including those for *Twelfth Night* (1932); and for Nonesuch Press for *The Writings of Gilbert White of Selborne* (1938). First one-artist exhibition at Zwemmer Gallery, London, 1933. Instructor in design, Royal College, 1929–38. Worked as applied designer and poster artist. Joined Royal Observer Corps, 1939; appointed official war artist attached to Royal Marines, 1940; later worked on R.A.F. subjects in England. Sent to Iceland, 1942, and reported missing, September 1942. Memorial exhibitions at Eastbourne and Brighton, 1948, Arts Council, 1948–9, and at Sheffield, 1958. Represented as designer in 'Artists at Curwen', Tate Gallery, 1977.

## RICHARDS, *Albert* (1919–45)

Born in 1919 in Liverpool. Studied at Wallasey School of Art, 1934–9; briefly attended Royal College of Art, 1940, before being called up in 1940. Served with Royal Engineers. Numerous submissions to the War Artists' Advisory Committee. Appointed official war artist, 1943. Took part in Invasion of Normandy, 1944. Killed by enemy mine,

France, 1945. Memorial exhibition at the National Gallery, London, 1945.

## RICHARDS, *Ceri* (1903–71)

Born in 1903 at Dunvant, Swansea. Apprentice electrician; Swansea School of Art, 1921–4, and Royal College of Art, London, 1924–7; also attended life-drawing classes under Bernard Meninsky, Westminster School of Art. Worked for London Press Exchange, 1928; married fellow-student Frances Clayton, 1929, and held first one-man show, Glynn Vivian Art Gallery, Swansea, 1930. Began making relief constructions, 1933, and contributed to 'Objective Abstractionists' exhibition, Zwemmer Gallery, London, 1934; member of London Group, 1937, and exhibited with English Surrealists, London Gallery, 1938 and 1939. Taught design at Cardiff Technical College, 1940–4, and at Chelsea School of Art, 1945–55. First one-artist London exhibition, Leger Gallery, 1942; show at Redfern Gallery, 1944 (and on nine subsequent occasions). Produced décor for 'Homage to Dylan Thomas' (Globe Theatre reading), 1953, and décor and costumes for Berkeley's opera *Ruth* (English Opera Group), 1956, and for Britten's *Noye's Fludde*, 1958. Retrospective exhibitions include King's College, Newcastle (and northern tour), 1954; Whitechapel Art Gallery, London, 1960; Venice Biennale (and European tour), 1960–2. Illustrated books and designed tabernacle, windows and reredos in Cathedral of Christ the King, Liverpool, 1968. Recent work shown at Marlborough Gallery, London, 1970. Died in London, 1971. 'Homage to Ceri Richards', exhibition, Fischer Fine Art, London, 1971.

## RILEY, *Bridget* (born 1931)

Born in 1931 in South London. Childhood partly in Lincolnshire and Cheltenham Ladies' College. Studied at Goldsmiths' College of Art, 1949–52, and at Royal College of Art, 1952–5. Various teaching posts and work for J. Walter Thompson advertising group. Encouraged by Maurice de Sausmarez, 1959, and began about 1959–60 to develop her distinctive style. Visited Italy, 1960; taught at Hornsey College of Art, 1960–1, and at Croydon College of Art, 1963–6. First one-artist exhibition at Gallery One, London, 1962 (and in 1963), and in New York at Richard Feigen Gallery, 1965 (and in 1966 and 1967). Represented in Op Art exhibition 'The Responsive Eye', Museum of Modern Art, New York, 1964, and in 'The English Eye', Marlborough-Gerson Gallery, New York, 1965. Exhibitions with Rowan Gallery, London, since 1969 and many one-artist and group exhibitions abroad. Retrospective at Hayward Gallery, 1971, and Arts Council touring exhibition, 1973. A film made for B.B.C. television, directed by David Thompson, produced by Ann Turner, about the artist's work was shown in 1969.

## ROBERTS, *William* (born 1895)

Born in 1895 in Hackney, London. Early apprenticed to advertising and design firm of Sir Joseph Causton Ltd., and attended St Martin's School of Art. Won a scholarship to Slade School of Fine Art, where he studied, 1910–13; travelled in Europe in 1913 and at the end of the year was briefly employed at Fry's Omega Workshops, London. Exhibited in second Grafton Group exhibition, Alpine Club Gallery, London, 1914, and soon after joined Wyndham Lewis and his circle, exhibiting at Rebel Art Centre. Signatory of Vorticist Manifesto, *Blast* (first number), 1914; represented in only Vorticist exhibition, Doré Galleries, London, 1915, and contributed illustrations to *Blast* (second number). In France with Royal Field Artillery, 1916. Official war artist, 1918; demobilized, 1919. Took part in Group X exhibition, Mansard Gallery, Heal's London, 1920, and held first one-artist show at Chenil Galleries, Chelsea, 1923. Visiting teacher at Central School, 1925 to 1960 (except 1939–45 when he lived in Oxford). Member of the London Artists' Association, 1927–32, holding one-artist exhibitions at its Cooling Galleries premises in 1929 and 1931; one-artist exhibition at Lefevre Gallery, London, 1935 (and 1938); London exhibitions since then at Redfern and Leicester Galleries. First exhibited at Royal Academy, 1948, and elected R.A., 1966. Arts Council retrospective exhibition, 1965, shown at Tate Gallery, and at Newcastle and Manchester, 1966. 'Drawings and Watercolours', Anthony d'Offay Gallery, 1969; Hamet Gallery exhibitions, London, 1971 and 1973; exhibition at Exeter, 1971; represented in 'Vorticism and its Allies', Hayward Gallery, 1974; 'Paintings and Drawings', Parkin Gallery, London, 1976–7. Has published a series of pamphlets on his early work and connections with Lewis and Vorticism, including *Vortex Pamphlets* (1956–8) and *A Reply to My Biographer Sir John Rothenstein* (Favil Press, 1957).

## ROGERS, *Claude* (born 1907)

Born in 1907 in London and spent childhood years in London and Buenos Aires; attended St Paul's School, London, 1920–5. Studied at Slade School of Fine Art, London, 1925–8, where he was a contemporary of Coldstream, Moynihan, Tibble, Townsend and others associated with the Euston Road School. Member of the London Artists' Association, 1931–4, holding first one-artist exhibition with it, 1933. Married the painter Elsie Few, 1937. Member of the London Group, 1938 (president 1952–65). Founder member of Euston Road School of Drawing and Painting, 1937–40. One-artist exhibition at Leicester Galleries, London, 1940 (and 1947, 1954 and 1960). Served in Royal Engineers, 1941–3. Visiting lecturer at Slade School of Fine Art, 1948–63. Retrospective exhibition at Newcastle, Manchester, Bristol and Leicester, 1955. Professor of Fine Art, Reading University, 1963–72. Lives in London and has painted frequently in East Anglia and latterly in Greece, Denmark and Brussels (1974). Retrospective with tour at Whitechapel Art Gallery, 1973; represented in 'British Painting '74', Hayward Gallery, 1974. One-artist exhibition at Fischer Fine Art, London, 1975.

## ROTHENSTEIN, *Sir William* (1872–1945)

Born in 1872 in Bradford, Yorkshire. Studied at the Slade School of Fine Art, London, under Alphonse Legros, 1888–9, and at the Académie Julian, Paris, 1889–93. Came to know Whistler, Degas and Pissarro; friendship with Toulouse-Lautrec and Charles Conder, holding with the latter his first show at the Galerie Tomas, Paris, 1891. Travelled in Spain and North Africa. Returned to England and began making reputation as portrait draughtsman; member of New English Art Club, 1894. One-artist exhibition Art Institute of Chicago, 1912; several previous one-artist exhibitions in London and in 1910 in Bradford. Official war artist, 1917–18. Principal of Royal College of Art, London, 1920–35; encouraged many prominent English painters, including in early years John, Spencer, Grant, Paul Nash and Gertler. Knighted, 1931, and published three volumes of memoirs, 1931–9 (see bibliography); also posthumous publication of correspondence with Max Beerbohm and Tagore. Attached to R.A.F. as war artist, 1939–41. Died in Gloucestershire, 1945. His brother was the painter and illustrator Albert Rutherston (*né* Rothenstein, 1881–1953) and his son is Sir John Rothenstein, author and past director of the Tate Gallery, London. A retrospective exhibition was held in 1950 at the Tate Gallery, at Gloucester Art Gallery, 1966, and at Bradford City Art Gallery, 1972.

## SARGENT, *John Singer* (1856–1925)

Born in 1856 in Florence of American parents. Cosmopolitan childhood followed by study of art in Rome, 1868–9, and in Florence, 1870–1. Attended École des Beaux-Arts, Paris, and worked under Carolus-Duran, 1874; was influenced by Monet (whom he met in 1876) in the late eighties. Settled in London in 1885; exhibited at Royal Academy; elected, 1897. Decorations for Boston Public Library, U.S.A., 1890–1916. After world-wide reputation as portraitist, gradually abandoned commissions, concentrating on landscape about 1910 and spending much time in Switzerland and Italy. Painted *Gassed*, 1919, among other war pictures. Decoration for Rotunda, Boston Museum of Fine Arts, completed 1921. Died in Chelsea, 1925. Memorial exhibition in Boston, 1925, and at Royal Academy, London, 1926. Centennial exhibition, Boston, 1956; exhibitions in Paris, 1963, Birmingham, 1964, and 'The Private World of John Singer Sargent', Corcoran Gallery, Washington, and elsewhere, 1964–5.

## SCOTT, *William* (born 1913)

Born in 1913 at Greenock, Scotland, of Irish and Scottish parents; moved to Northern Ireland in 1924 and attended Belfast School of Art, 1928–31. Studied at Royal Academy Schools, London, 1931–5. Awarded Leverhulme Scholarship, 1936, and worked at Mousehole, Cornwall. With his wife and the painter Geoffrey Nelson ran a summer painting school at Pont-Aven, Brittany, in 1938 and 1939; lived in South of France until outbreak of war; returned to London in 1940. Part-time teaching at Bath Academy of Art, 1941, and first one-artist exhibition, Leger Gallery, London, 1942. Served as volunteer in Royal Engineers, 1942–6. Senior teacher, Bath Academy, Corsham, 1946–56. Member of London Group, 1949. Various one-artist and group exhibitions at Leicester and Hanover Galleries, London, and at Martha Jackson Gallery, New York (from 1956). Teaching in America, 1953; greatly impressed by the New York abstract expressionists. Exhibited at Venice Biennale, 1958 (with tour), and at Sao Paulo Bienal, 1961, winning International Critics' prize. Ford Foundation artist in residence, Berlin, 1963–5. Retrospective at Scottish National Gallery of Modern Art, 1971, and at Tate Gallery, 1972. Exhibited at Gimpel Fils, London, 1974. Lithographic illustrations to anthology of '*Soldier's Verse*', edited by Patrick Dickinson, 1945.

## SEABROOKE, *Elliott* (1886–1950)

Born in 1886 at Upton Park, Essex. Studied at the Slade School, 1906–11; much influenced by Cézanne. Exhibited occasionally at the Friday Club until its demise, 1922. First one-artist exhibition at the Carfax Gallery, London, 1912. Edward Marsh was an early patron. Served in the British Red Cross and as an official war artist on the Italian front. Member of the London Group, 1920. Worked in Paris, 1922, with Edward Wolfe. Various mixed exhibitions and shows at Leicester Galleries, London, and elsewhere; worked abroad, particularly in Holland and France. President of the London Group, 1943–8. Died in Nice in 1950. Memorial exhibitions at Leicester Galleries, 1951, and at Matthiesen Gallery, London, 1955.

## SICKERT, *Walter Richard* (1860–1942)

Born in 1860 in Munich of Danish father Oswald Sickert, painter, and an Anglo-Irish mother; brother of painter and writer Bernard Sickert. Settled in London, 1868. Worked as an actor from 1877 to 1881 appearing in London and provincial repertory companies. Studied at the Slade School, 1881–2, and under Whistler as pupil and assistant. Met Degas in Paris, 1883, and in Dieppe, 1885, the year of Sickert's first marriage (divorced 1899). Exhibited jointly with Bernard Sickert, Dutch Gallery, London, 1895, and in Paris, one-artist exhibition at Durand-Ruel, 1900 (subsequent shows at Bernheim-Jeune), and on occasions at the 'Salon des Indépendants' and the 'Salon d'Automne'. From 1885 to 1922 Sickert spent some part of the year in Dieppe (save the 1914–18 war), living there permanently 1898–1905, but making several stays in Venice. After 1922 lived in England. Sickert organized the 'London Impressionists' exhibition, 1889, and exhibited with the New English Art Club, 1888–1917. More permanently in London after 1905; founder member of Fitzroy Street group, 1907; the Allied Artists' Association, 1908, and the

Camden Town Group, 1911 (exhibiting at all three exhibitions, 1911–12). Member of the London Group, 1916; lived in Fitzroy Street and in Bath (1917) during the war. Sickert's second wife (from 1911) Christine Angus died in 1920 and he married the painter Thérèse Lessore in 1926. Elected to Royal Academy, 1934 (resigned 1935). National Gallery retrospective, 1941. Lived in Broadstairs, Kent, from 1934 (previously in Islington, London), in Bath from 1938 and died in Bathampton, Somerset, 1942. Sickert was a dedicated teacher (founding Rowlandson House School, 1910–14) and a prolific writer on art, contributing to the *Yellow Book*, the *New Age* and the *Burlington Magazine* among other journals; also several catalogue prefaces to shows by Steer, Francis James, Nina Hamnett, the Scottish Colourists, etc. A selection of his writings was edited by Sir Osbert Sitwell in *A Free House!* (1947). Numerous exhibitions since his death including retrospective shows at Roland, Browse and Delbanco, 1951 (and 1960); Arts Council, Edinburgh, 1953; Le Musée de Dieppe, 1954; Sheffield, 1957; centenary exhibition at Tate Gallery, 1960 (also Southampton and Bradford); Agnew's, London, 1964; Arts Council touring exhibition, 1964; Hull, 1968; Fine Art Society, 1973; 'Sickert in Dieppe', Eastbourne and Guildford, 1975; major representation in 'Camden Town Recalled', Fine Art Society, London, 1976.

## SMITH, *Jack* (born 1928)

Born in 1928 in Sheffield. Attended Sheffield College of Art, 1944–6; national service in R.A.F.; attended St Martin's School of Art, 1948–50, Royal College of Art, 1950–3, under Minton, Weight and Spear. First one-artist exhibition at Beaux Arts Gallery, 1953 (and subsequently there to 1958). Showed at Venice Biennale, 1956, with Greaves, Middleditch, Bratby, but moved away from 'Kitchen Sink' style soon after. First exhibition in New York at Catherine Viviano Gallery, 1958 (and in 1962 and 1963); Whitechapel Art Gallery retrospective, 1959; several teaching posts since 1957. One-artist exhibitions at Bear Lane Gallery, Oxford, 1970, and Redfern Gallery, London, 1974 and 1976. Retrospective of paintings and drawings, 1949–75, Sunderland Arts Centre, 1977.

## SMITH, *Sir Matthew* (1879–1959)

Born in 1879 in Halifax, Yorkshire, of a prosperous manufacturing family. Worked in the family business from 1896 to 1900. Attended Manchester School of Art, 1900–4, and the Slade School of Fine Art under Professor Tonks, 1905–7, with little encouragement. In 1908–9 he spent nine months in Pont-Aven, Brittany; moved to Paris in 1910, where he briefly attended Matisse's school and exhibited at the 'Salon des Indépendants' in 1911 and 1912. Returned to England, 1912, and married Slade student Gwendolen Salmond; living in France, mainly at Grez-sur-Loing. Returned to England, 1914; took a studio at 2 Fitzroy Street. Exhibited with London Group, 1916, and was called up,

commissioned in the Labour Corps, Artists' Rifles. Painted in Cornwall, 1920; travelled in France and Switzerland, 1920–2. Lived mainly in Paris, 1923–6, with the painter Vera Cuningham as model. First one-artist exhibition at the Mayor Gallery, London, 1926. Visited Dieppe for six months, 1926; studio in Fitzroy Street and in St John's Wood, 1927–9. Exhibition at Lefevre Gallery, London, 1927, and retrospective of work 1913–29 at Tooth's, London, 1929. From 1930 to 1940 based mainly in France (with visits to England), first in Paris, Cagnes near Nice and Arles, 1932, Cagnes again, 1932–3, and thereafter in Aix-en-Provence. In Paris at the outbreak of war; returned to London, 1940. Both sons killed; little painting between 1941 and 1943. Retrospective exhibition at Temple Newsam, Leeds, 1942; awarded C.B.E., 1949; one-artist exhibition at Venice Biennale, 1950. Lived mainly in London until his death, with visits to Aix, Mentone and Tenerife. Tate Gallery retrospective, 1953; knighted, 1954. Died in 1959. Memorial exhibition, Royal Academy, 1960. Large loan exhibition at Tooth's (pre-1926 work) and Roland, Browse and Delbanco (post-1926 work), London, 1976.

## SMITH, *Richard* (born 1931)

Born in 1931 in Letchworth, Hertfordshire; studied at Luton School of Art, 1948–50, and St Albans School of Art, 1950–4. Exhibited with 'Young Contemporaries' and later with London Group. Studied at Royal College of Art, 1954–7; travelled on scholarship in Italy and contributed articles to R.C.A. journal *Ark*. Participated in 'Situation' exhibition, R.B.A. Galleries, London, 1960, and in 'New London Situation', 1961. Harkness Fellowship, 1959, enabling him to live in New York to 1961; first one-artist exhibition at Green Gallery, New York, 1961; works shown at Paris Biennale. Taught at St Martin's School of Art, 1961–3; exhibitions at I.C.A. Gallery, 1962, and at Kasmin Gallery, 1963 (and in 1969 and 1971). Lived in New York, 1963–5, with teaching posts at Universities of Virginia and California (1967 and 1968 respectively). Exhibition at Whitechapel Art Gallery, London, 1966, and awarded Robert C. Scull Prize, 1966, Venice Biennale; one-artist shows at Richard Feigen Gallery, New York, 1967 and 1971; represented Britain at 1970 Venice Biennale; retrospective of graphics and multiples at Arnolfini Gallery, Bristol, 1970. Exhibited with Waddington, at Garage Gallery, London, and recently at Gimpel Fils, London, 1976. Numerous group exhibitions in Britain and abroad and one-artist exhibitions in Los Angeles and Milan. Frequent visits to U.S.A. and visit to India, 1976. Represented in 'Five British Artists' (with Buckley, Milow and others), Young Hoffman Gallery, Chicago, 1977. Lives in Wiltshire and London.

## SPENCER, *Gilbert* (born 1892)

Born in 1892 at Cookham-on-Thames, Berkshire, brother of Stanley Spencer. Attended Camberwell School, the Royal College of Art and the Slade

School of Fine Art, 1913–15 and 1919–20, initially under Frederick Brown and Professor Tonks. Served with Royal Army Medical Corps, 1915–19; exhibited with New English Art Club and held first one-artist exhibition, Goupil Gallery, London, 1923. Lived and worked at Garsington, Oxford, in Berkshire, Dorset and Lake District. Professor of painting, Royal College, 1932–48. Executed murals at Holywell Manor, annexe to Balliol College, Oxford, 1935. Official war artist, 1940–3. One-artist exhibitions at the Leicester Galleries, London, 1939, 1943 and 1949. Various teaching posts; elected to Royal Academy, 1960; retrospectives at Reading Art Gallery, 1964, and at Fine Art Society, 1974. Author of *Stanley Spencer* (1961) and *Memoirs of a Painter* (1974). Lives in Suffolk.

# SPENCER, *Sir Stanley* (1891–1959)

Born in 1891 at Cookham-on-Thames, Berkshire, brother of Gilbert Spencer. Briefly at Maidenhead Technical College, 1907, and then at the Slade School of Fine Art, 1908–12, under Professor Tonks but continuing to live in Cookham. Exhibited with the English Section of the 'Second Post-Impressionist Exhibition', Grafton Galleries, London, 1912–13. Enlisted in Royal Army Medical Corps, 1915; served with Field Ambulance in Macedonia, 1916–17; then in 7th battalion Royal Berkshires to end of 1918. Completed war artist commission at Cookham, 1919; member of the New English Art Club, 1919–27. Visited Yugoslavia, 1922; briefly returned to Slade School, spring 1923. Lived in Hampstead. Met patrons Mr and Mrs J. L. Behrend, who decided to build a memorial chapel at Burghclere to contain murals by Spencer (completed in 1932). Married Hilda Carline, 1925, sister of the painter and writer Richard Carline. First one-artist exhibition, *The Resurrection* and other works, Goupil Gallery, London, 1927; exhibited at Venice Biennale, 1932; resigned from Royal Academy, 1935 (elected A.R.A., 1932); visited Switzerland, 1936. Exhibited with Tooth's, London (from 1932, his sole agent). Married Patricia Preece, painter, 1937; large showing of work at Venice Biennale, 1938. Official war artist, 1940–4, painting shipyards at Port Glasgow on the Clyde. One-artist exhibition, Leicester Galleries, London, 1942, and at Temple Newsam, Leeds, 1947. Burghclere Chapel presented by Behrends to National Trust. Returned permanently to Cookham, 1945. Created C.B.E., 1950; Arts Council 'Drawings' exhibition (with tour), 1954–5; Tate Gallery retrospective, 1955 with catalogue introduction by artist. Knighted, 1958; died at Cliveden Canadian War Memorial Hospital, 1959. Spencer Gallery, Cookham, opened, 1962; Plymouth, retrospective, 1963; Scottish Arts Council, Glasgow, exhibition of Clydeside work, 1975; touring Arts Council exhibition, 1976–7.

# STEER, *Philip Wilson* (1860–1942)

Born in 1860 in Birkenhead, son of a farmer and amateur painter. Attended Hereford Cathedral School, 1875; abandoned studies for Civil Service examinations and entered Gloucester School of Art, 1878–81. Worked under Bouguereau, Académie Julian, Paris, 1882–3; later at Ecole des Beaux-Arts, under Cabanel, 1883–4, when he returned to England. Lived in London with annual summer visits to France and in England particularly at Walberswick, in Yorkshire, Shropshire and Hampshire; and at Etaples, Boulogne, Montreuil-sur-Mer. Founder member of New English Art Club, 1886; exhibited with 'Les XX', Brussels, 1889 and 1891. First one-artist exhibition, Goupil Gallery, London, 1894. Moved to 109 Cheyne Walk, Chelsea, where he remained until his death. Painted in Chepstow, 1905, and Gloucestershire, 1909, the year of one-artist exhibition, Goupil Gallery, London. Official war artist at Dover, painting shipping, 1918. One-artist exhibition, Barbizon House, London, 1927. Retrospective at Tate Gallery, 1929, the first accorded to a living painter. Retired from teaching at the Slade School, 1930 (since 1899). First symptoms of blindness occured, 1934; he was forced to give up painting in the following year; Barbizon House exhibition, 1935. Died at Cheyne Walk, 1942. Memorial exhibition at National Gallery, 1943; Arts Council centenary exhibition at Tate Gallery, 1960, and elsewhere, 1961.

# STEPHENSON, *John Cecil* (1889–1965)

Born in 1889 at Bishop Auckland, Durham. Studied at Leeds School of Art, 1908–14, at the Royal College of Art, 1914–18, and the Slade School of Fine Art, 1918; worked also as toolmaker in First World War. Taught drawing at Northern Polytechnic, 1922–55; committed to abstraction, 1932, and lived in Hampstead, friend of Moore, Nicholson, Hepworth, Read and Paul Nash. Exhibited at 'Seven and Five Society', 1934; in 'Living Art in England' at E.L.T. Mesens's London Gallery, 1939, and at the London Group, 1953–9. Designed mural for Festival of Britain, 1951; also designed furniture and glass. Represented in 'British Art and the Modern Movement 1930–40', Cardiff, 1962. Exhibited at Marlborough Gallery, London; retrospective, 1932–55, at Fischer Fine Art, London, 1976.

# STRANG, *William* (1859–1921)

Born in 1859 at Dumbarton in the Scottish Lowlands. Entered the Slade School of Fine Art, 1875, and studied under Alphonse Legros. Originally concentrated on etching and engraving portraits and illustrations. Exhibited at the Royal Academy from 1883 (elected, 1921). Awarded silver medal at the Paris International Exhibition, 1889; 1st class gold medal at the Dresden International Exhibition, 1897. A member of the original executive of the International Society, London, and president in 1918. Showed work at the Carfax Gallery, London, and the Royal Academy. In later life turned to oil paint for portraits, landscapes and genre scenes. Lived in Hamilton Terrace, London, and died in Bournemouth in 1921. With H. W. Singer he pub-

lished *Etching, Engraving, and Methods of Printing Pictures* (1897). His son Ian Strang (1886–1952) was also a draughtsman and etcher.

## SUTHERLAND, *Graham* (born 1903)

Born in 1903 in South London; childhood in Surrey and Sussex; went to Epsom College, 1914. Apprenticed to engineering branch, Midland Railway, Derby, 1919. Studied at Goldsmiths' College of Art, 1921–6, specializing in etching and engraving; published first etching, 1923, and exhibited at Royal Academy. First one-artist exhibition, XXI Gallery, 1925. Converted to Catholicism, 1926; married 1927. Taught engraving at Chelsea School of Art, 1926–35. Designed fabrics, posters and china in the early 1930s and began painting, 1934–5. Exhibited at 'International Surrealist Exhibition', London, 1936. Pembrokeshire landscapes shown at Rosenberg and Helft, London, 1938; second show of paintings at Leicester Galleries, London, 1940, the year he was made an official war artist, painting foundries, mines and bomb devastation to 1944. Visited Paris for first time, 1944. *Crucifixion* for St Matthew's, Northampton, 1944–6. One-artist exhibitions at Hanover Gallery, London, and Curt Valentin, New York, 1946. Substantial showing of work Venice Biennale, 1952, winning Sao Paulo prize (exhibition shown at Tate Gallery, 1953). First of annual visits to South of France, 1947; bought a house near Menton, 1956. Lives there with holidays in Kent, Wales, etc. Designed '*Christ in Glory*' tapestry for the new Coventry Cathedral, completed, 1962; *Crucifixion* for St Aidan's, Acton, 1962–3. Numerous exhibitions in England and abroad including retrospectives at the Musée d'Art Moderne, Paris, 1952, Galleria Civica d'Arte Moderna, Turin, 1965, and Kunsthalle, Basle, 1966. Exhibitions in London with Marlborough Gallery and Fischer Fine Art. Awarded Order of Merit, 1960; D.Litt. Oxford, 1962; Hon. member American Academy of Arts and Letters, 1972.

## TIBBLE, *Geoffrey* (1909–52)

Born in 1909 in Reading, Berkshire, into prosperous family of bakers. Attended Reading Grammar School and Reading School of Art, 1925–7; early influences included Stanley Spencer and later Derain. Studied at the Slade School of Fine Art, London, where he was one of a group which included Rodrigo Moynihan, William Townsend and William Coldstream. Exhibited in the exhibition of 'Objective Abstractionists' at the Zwemmer Gallery, London, 1934; first exhibited with the London Group, 1935 (elected 1944); held a one-artist exhibition at his own studio at 13 Fitzroy Street, London, 1936. Abandoned interest in abstraction and Surrealism, 1936–7, and became associated with the Euston Road painters, particularly Graham Bell, who included him in his *The Café* (1937–8). With his wife and child left London, 1939, and continued to live in the country until his death. Showed at the Lefevre Gallery, London, 1942, and held two one-

artist exhibitions at Arthur Tooth, London, 1946 and 1949, mainly of women dressing, bathing, etc., and other genre scenes, often with an expressionist emphasis. Suffered from consumption; died in 1952.

## TILSON, *Joe* (born 1928)

Born in 1928 in London. Worked as cabinet-maker and carpenter, 1944–6, and served with Royal Air Force, 1946–9. Studied at St Martin's School of Art, London, 1949–52; from 1950 exhibited with 'Young Contemporaries', R.B.A. Galleries and also with London Group. Royal College of Art, 1952–5; in Italy and Spain, 1955–7 (Knapping and Rome prizewinner). Taught at St Martin's School of Art, 1958–63; exhibited at Paris Biennale, 1961, and first one-artist exhibition, Marlborough Gallery, London, 1962. Guest lecturer at Slade School and Durham University, Newcastle upon Tyne, 1962–3; lecturer at New York School of Visual Arts, 1966; represented in 'Young British Painters', Palais des Beaux-Arts, Brussels, 1967. Guest teacher at the Hochschule für Bildende Künste, Hamburg, 1971–2; retrospective at Boymans Museum, Rotterdam, 1973–4, and in Parma, 1975. Recent one-artist exhibition at Marlborough Gallery, London, 1976. Lives in Italy and Wiltshire.

## TREVELYAN, *Julian* (born 1910)

Born in 1910 in Dorking, Surrey, son of the poet and translator Robert C. Trevelyan and nephew of historian Sir George Trevelyan. Educated at Trinity College, Cambridge, and received lessons briefly from Frederick J. Porter (1883–1944). Went to Paris in 1930, studying initially at Léger and Ozenfant's School, at the Grande Chaumière and under S. W. Hayter. Travelled extensively in Europe and settled at Hammersmith, London, 1935. Member of English Surrealist Group, 1936, and participated in several exhibitions and events; contributed to 'International Surrealist Exhibition', London, 1936. First one-artist exhibition, Lefevre Gallery, London, 1937. Camouflage Officer, Royal Engineers, 1940–3, visiting Africa and Palestine. Member of London Group, 1948, and vice-president, 1956. Taught at Chelsea School of Art, 1949–60; senior tutor in etching Royal College of Art, 1955–63. Numerous exhibitions in London at Redfern, Gimpel Fils and Zwemmer Gallery. Represented in 'Britain's Contribution to Surrealism', Hamet Gallery, 1971. Published an autobiography *Indigo Days* (1957) and *The Artist and His World* (1960). Lives in London.

## TUKE, *Henry Scott* (1858–1929)

Born in 1858 in York and studied at Slade School of Fine Art, London, 1875–80; later in Italy and in Paris under J.-P. Laurens, 1881–3, where he was influenced by Bastien-Lepage. Settled near Newlyn, Cornwall, and was associated with the Newlyn School. Exhibited at the Royal Academy from 1879 (elected R.A., 1914), member of New English Art Club, 1886, and active in both organizations. Paint-

ed portraits, seascapes, Venice, marine genre subjects and particularly youths bathing and boating, sometimes barely disguised under mythological and poetic titles. Died near Falmouth in 1929. Represented in 'Late Members', Royal Academy, 1933.

## TUNNARD, *John* (1900–71)

Born in 1900 at Sandy, Bedfordshire; summers spent in Lincolnshire and educated at Charterhouse School. Attended Royal College of Art, London, 1919–23, studying design. From 1923 to 1929 worked as a textile designer for Tootal Broadhurst Lee, Manchester, H. and M. Southwell, carpet manufacturers, Bridgenorth, and advisor to John Lewis; also played jazz professionally. Taught design at Central School, 1929; member of London Group, 1934. Settled with his wife in Cornwall, 1930, and established hand-blocked printed silk business. One-artist exhibition, Redfern Gallery, London, 1933, and represented in 'Living Art in England', London Gallery, 1939, and 'Surrealism Today', Zwemmer Gallery, London, 1940. One-artist exhibitions at Redfern Gallery and exhibited in New York, 1944. Served as coastguard, Cornwall, 1940–5. Taught design at Penzance School of Art, 1948–64. Included in British Council 'Eleven British Artists' exhibition, Australian tour, 1949. Designed mural for Festival of Britain, 1951. Exhibition of paintings and gouaches, 1944–59, McRoberts and Tunnard, London, 1959. Represented in 'Britain's Contribution to Surrealism', Hamet Gallery, London, 1971. Retrospective exhibition held at the Royal Academy, 1977.

## TURNBULL, *William* (born 1922)

Born in 1922 in Dundee, Scotland, son of a shipyard engineer. Left school at fifteen and worked as illustrator for D. C. Thompson publishing house and attended art school evening classes. Served in R.A.F. during the war and then studied at the Slade School of Fine Art, London, 1946–8. Lived in Paris, 1948–50, seeing much of fellow Slade student Paolozzi, and visiting Brancusi, Giacometti, Léger, etc. First exhibited sculpture at Hanover Gallery, London, 1950 (joint show with Paolozzi), and showed sculpture and paintings there in 1952; in the same year he was represented in 'New Aspects of British Sculpture', Venice Biennale. Founder member of Independent Group at the I.C.A. and contributed to 'This is Tomorrow' exhibition, Whitechapel Art Gallery, 1956. On executive committee of 'Situation' exhibition, R.B.A. Galleries, London, 1960; exhibition of sculpture, 1960, and of paintings, 1961, at Molton Gallery, London. First American exhibition of sculpture at Marlborough Gallery, New York, and of paintings at Bennington College, Vermont. Taught design as visiting artist at the Central School, London, 1952–61; taught sculpture there, 1964–72. Paintings exhibited at Hayward Gallery, 1968, and retrospective exhibition at Tate Gallery, 1973. Recent one-artist exhibitions at Waddington Galleries, London. Married to the artist Kim Lim and lives in London.

## VAUGHAN, *Keith* (born 1912)

Born in 1912 at Selsea Bill, Sussex; educated Christ's Hospital, Horsham, 1921–30. Employed as trainee in Unilever advertising agency art department, 1930–9, and painted in spare time. Joined St John's Ambulance on outbreak of war, 1939; Pioneer Corps and as German interpreter in P.O.W. camp, 1941–6, in Yorkshire. Contributed autobiographical and critical articles to *Penguin New Writing*, where his early drawings were first published; exhibition of drawings at Lefevre Gallery, London, 1942. Contact during war with Sutherland, Minton etc. and shared studio with Minton in Hampstead, 1946–52. First one-artist exhibition of paintings at Lefevre Gallery, 1946 (and 1948 and 1951), and in America at George Dix Gallery, New York, 1948. Taught part-time at Camberwell School of Art and at Central School, 1948–57. Travelled extensively abroad: Avignon, 1951, France, 1955, Spain, 1958, America, 1959 (where he was resident painter, State University, Iowa), Italy and North Africa. Exhibitions at the Redfern, Leicester and Hanover Galleries, London, and at Durlacher Bros., New York. Mural decoration *Theseus* for Dome of Discovery, Festival of Britain, 1951; mural for Aboyne Road Estate, London, 1963. Has designed textiles and book-jackets. Retrospective exhibition with tour, Whitechapel Art Gallery, 1962; Mappin Art Gallery, Sheffield, 1969, and University of York, 1970, both retrospectives. Recent one-artist exhibitions at Waddington, London, 1973 and 1976. In 1966 Vaughan published *Journal and Drawings*, extracts from a diary begun in 1939.

## WADSWORTH, *Edward* (1889–1949)

1930.

Born in 1889 at Cleckheaton, Yorkshire, into manufacturing family. Attended Fettes College, Edinburgh, about 1902–6. Studied engineering in Munich, 1906–7. Bradford School of Art, 1906, winning scholarship to Slade School of Fine Art, where he studied 1908–12; won first prize for landscape painting, 1910, and for figure painting, 1911. Exhibited with the Friday Club, 1912 and 1913; included in the 'Second Post-Impressionist Exhibition', Grafton Galleries, London, 1912–13. Married in 1912 and honeymooned in Canary Islands. Worked at the Omega Workshops, 1913, designing carpets, textiles, etc; left the Omega with Lewis, Etchells and Cuthbert Hamilton, October 1913. Contributed to first London Group exhibition, Goupil Gallery, 1914 (founder member in previous year). Illustrations and translation of Kandinsky in *Blast* (first number) and signed Vorticist manifesto, 1914. Served with RNVR as intelligence officer in Mediterranean, 1914–17; represented in 'Vorticist Exhibition', Doré Galleries, London, 1915, and contributed illustrations to *Blast* (second number). Represented in New York Vorticist exhibition, Penguin Club, 1917; worked on ship camouflage, 1917–18; painted picture for Canadian War Mem-

orials Fund. First one-artist exhibition (woodcuts and drawings), Adelphi Gallery, London, 1919. One-artist exhibition, Leicester Galleries, London, 'The Black Country', 1920; exhibited with Group X, Heal's Mansard Gallery, London, and published 'Black Country' drawings, Ovid Press, 1920. Exhibition at Leicester Galleries (with Alvaro Guevara), 1926; one-artist show Galerie Barbazanges, Paris, 1927. Moved to Sussex from London. One-artist show Tooth's, London, 1929. Member of Unit One and exhibition at Mayor Gallery, London, 1933; contributed to *Unit One* publication, 1934. Commission for murals for *Queen Mary* liner and mural for de la Warr Pavilion, Bexhill, 1936. Various group exhibitions and one-artist show at Tooth's, London, 1938. Consignment of work intended for Venice Biennale shown at Wallace Collection, London, 1940. Served with Home Guard, 1940–5, in Derbyshire. Decorative paintings for I.C.I. Limited, 1941. Associate of Royal Academy, 1944. Died in London in 1949. Tate Gallery memorial exhibition, 1950; Venice Biennale retrospective, 1952; represented in 'Wyndham Lewis and Vorticism', Tate Gallery, 1956; 'Abstract Art in England 1913–15', Anthony d'Offay, 1969, and 'Vorticism and its Allies', Hayward Gallery, 1974. Early woodcuts exhibited at C. Drake Ltd, London, 1973. Full retrospective of paintings, drawings and prints, P. and D. Colnaghi, London, 1974.

# WALKER, *Dame Ethel* (1861–1951)

Born in 1861 in Edinburgh; childhood in Wimbledon. In the early eighties she attended Putney School of Art. Studied under Fred Brown at the Westminster School of Art and under him again at the Slade School of Fine Art, 1892–4. Early admiration for Velasquez; in Paris saw Manet exhibition, 1884. Friendship with the writer George Moore, who included a written portrait of her in *Hail and Farewell*. Attended evening classes under Sickert and returned to study at the Slade School intermittently until 1922. Exhibited at the Royal Academy from 1898 and at Dudley Gallery, London, 1899; member of New English Art Club, 1900. First one-artist show at the Redfern Gallery, London, 1927; exhibitions at the Lefevre Gallery, London, 1935 and 1939. Numerous group exhibitions and also represented at Venice Biennale, 1930 and 1932. Elected Associate of Royal Academy, 1940, and made D.B.E., 1943. Lived most of her working life at 127 Cheyne Walk, Chelsea, and also painted at Robin Hood's Bay, Yorkshire. Died in London, 1951. Memorial exhibition (with Gwen John and Frances Hodgkins), Tate Gallery, 1952.

# WALKER, *John* (born 1939)

Born in 1939 in Birmingham; studied at Birmingham College of Art, 1955–60. Attended Académie de la Grande Chaumière, Paris, 1960–1; exhibited with 'Young Contemporaries', 1960. Taught at Stourbridge College of Art, 1962–3; at Birmingham College of Art, 1963–8. First one-artist show at

Axiom Gallery, London, 1967, and appointed in same year Gregory Fellow, University of Leeds (to 1969). Exhibition of paintings at Hayward Gallery, 1968, and showed in various group exhibitions in America, Düsseldorf and Florence; represented in British section, Paris Biennale, 1969. Awarded Harkness Fellowship to U.S.A., 1969–70. First exhibition at Nigel Greenwood Inc., London, 1970, and in subsequent years. Exhibition at Ikon Gallery, Birmingham, 1972; prints at Concourse Gallery (Polytechnic of Central London), 1975; represented in 'New Art 1', Hayward Gallery, 1975. Recent one-artist exhibitions at Nigel Greenwood Inc., London, 1975, and at Galerie Marguerite Lamy, Paris, 1976. Winner of first prize at the 10th John Moores Liverpool exhibition 1976.

# WALLIS, *Alfred* (1855–1942)

Born in 1855 in Devonport, the son of a master paver from Devon; mother died when he was a child. At the age of nine he went to sea as cabin boy on Atlantic steamer sailing between Penzance and Newfoundland; later on fishing trawlers in North Sea. In 1890 he moved to St Ives with a wife twenty-one years his senior, a widow with five children; started a Marine Rag and Bone Stores in St Ives. After the death of his wife in 1922 he began to paint, usually using cardboard or plywood and ship's oil paint. In 1928, Ben Nicholson and Christopher Wood discovered his work and introduced it to various painters and collectors. Some was shown in London at Tooth's in the 'Seven and Five Society' exhibition, 1929, and at the Wertheim Gallery. Wallis died in Madron Workhouse in 1942. Work included in many group exhibitions; 'Paintings by Alfred Wallis', Bournemouth Arts Club, 1950; Nicholson, Wood, Wallis exhibition, Crane Kalman Gallery, London, 1966; exhibition at Bluecoat Gallery, Liverpool, 1974.

# WHITE, *Ethelbert* (1891–1972)

Born in 1891 at Isleworth, Middlesex, of Hampshire family. St George's College, Weybridge, 1902–7. Attended St John's Wood School of Art, 1911–12. Member of the London Group, 1916, and New English Art Club, 1921. Numerous group exhibitions; first one-artist show, Paterson and Carfax Gallery, London, 1921; St George's Gallery, London, 1922, 1924 and 1926; many one-artist exhibitions at the Leicester Galleries, London, from 1929, and at the Fine Art Society, London, 1936. Travelled through Europe on many occasions in a gipsy caravan, particularly in Spain, France and also in North Africa. Collector of folk-songs and musician, poster designer and engraver. Illustrated many books including collections of poems by Herbert Read, W. W. Gibson and Robert Nichols; also C. W. Beaumont's *Impressions of the Russian Ballet* (1919) and Jeffries's *The Story of My Heart* (1923). Retrospective of paintings and watercolours, Leicester Galleries, 1971. Died in London in 1972.

## WOLFE, *Edward* (born 1897)

Born in 1897 in Johannesburg, where he was educated, 1905–7; in England, 1907–9; returned to South Africa, acting child parts in repertory companies on tour; attended night-school while working in a jeweller's shop in Johannesburg and later received lessons from British painter George Smithard. Arrived in England, 1916, and attended Regent Street Polytechnic School of Art as well as Drama School. Admitted to the Slade School of Fine Art, 1917; worked for the Omega Workshops, 1917–19, exhibiting there in group exhibitions and also with the London Group from 1918 (member 1923). In South Africa, 1919–21, holding one-artist show at Leon Levson Gallery, Johannesburg. In Paris with Elliott Seabrooke, 1922. In Italy, 1923–5, mainly painting in Florence. First one-artist London exhibition Mayor Gallery, 1925 (watercolours and drawings). Member of Seven and Five Society, 1926–31. Member of London Artists' Association, with whom he exhibited, 1930 and 1934 (Cooling Galleries, London). Designed sets for Cochran revues, 1931 and 1933. In Mexico and New York, 1934–6. One-artist show Lefevre Gallery, London, 1936. One-artist show at Mayor Gallery, 1938, in the same year designed set for *The Heart was not Burned* by James Laver. Worked for the B.B.C., 1940–5. Painted at Portmeirion after the war; one-artist exhibition at Lefevre Gallery, 1948; exhibition (with Grant, Baynes and du Plessis), Bristol City Art Gallery, 1948; various one-artist exhibitions in England, Paris (1953), Johannesburg and Cape Town. Painted much abroad; also in Wales and by the river at Rotherhithe. Elected A.R.A., 1967 (R.A., 1972). Retrospective exhibition, Arts Council (London and tour), 1967. Paintings, 1923–62, exhibition at Mayor Gallery, 1973. Lives in London.

## WOOD, *Christopher* (1901–30)

Born in 1901 at Knowsley, Lancashire. Educated at Marlborough and Malvern. In London, 1920, decided to become a painter. Studied at Académie Julian and at La Grande Chaumière, Paris, 1921, and travelled extensively in Europe and North Africa until his death; returned to Paris and London annually. Friendship with Picasso, Cocteau and Diaghilev. Member of the Seven and Five Society, 1926–30; held his first one-artist exhibition with Ben Nicholson at Beaux Arts Gallery, London, 1927. With Nicholson in St Ives, 1928, where they met the Cornish painter Alfred Wallis. Further one-artist show at Tooth's, London, 1929, and again with Nicholson at Bernheim-Jeune, Paris, 1930. Painted at Tréboul, Brittany, 1929 and 1930. Returned from Paris to London, summer 1930, and was killed by a train at Salisbury, August 1930. Posthumous London exhibitions at Wertheim Gallery, 1931, Lefevre Gallery, 1932 and 1934, at the Redfern Gallery, 1936, 1937, 1959 and 1965. Collected works shown at New Burlington Galleries, London, 1938, organized by Rex Nan Kivell of the Redfern. Wood, Nicholson, Wallis exhibition at Crane Kalman Gallery, London, 1966.

## YEATS, *Jack Butler* (1871–1957)

Born in 1871 in London, son of the Irish painter John Butler Yeats and brother of the poet William Butler Yeats. Childhood spent in Sligo, 1879–87 (described in his autobiographical *Sligo*, 1930). Attended Westminster School of Art, 1888, under Fred Brown. Visited Venice, 1898, and held his first one-artist exhibition in Dublin, 1899. Illustrated books by J. M. Synge and worked for the Cuala Press. Exhibited at Royal Hibernian Academy from 1899 (member, 1915). Five paintings in Armory Show, New York, 1913. Exhibitions in London and Dublin; at Tooth's, London, 1926. Lived mostly in Dublin until his death, visiting Paris, 1923. Joined Dublin branch of Waddington Galleries, 1940, with whom his work has been consistently shown since. Retrospective exhibition at National Gallery, London (with Sir William Nicholson), 1940; further retrospectives in Dublin, 1945, at Temple Newsam, Leeds, 1948 (with tour including Tate Gallery). Officier de la Légion d'Honneur, 1950; touring retrospective in America and Canada, 1951–2. Died in Dublin in 1957. Retrospective exhibition at York City Art Gallery, 1960. Oil-paintings and early work at Waddington's, London, 1967. Author of several books and plays including *The Careless Flower* (1947) and *In Sand* (1949).

# Photographic acknowledgements

*The author and publishers are grateful to all artists, owners and copyright holders who have given permission for works to be reproduced. Unless listed below photographs were kindly supplied by the owners of the works as named in the captions. Other sources of photographs are as follows:*

A. C. Cooper Ltd (for Phaidon Press): 27, 40, 52, 62, 70, 72, 80, 93, 96, 110, 111, 113, 115, 121, 129, 133, 137, 158, 162, 168, 169, 171
Courtauld Institute, London: 53
The Fine Art Society, London: 3, 9, 10, 14, 37, 57, 66, 75, 76
Kasmin Ltd., London: 173, 180, 196
Kirklees Libraries and Museums Service: 33, 138
Marlborough Fine Art, London: 153, 157, 177, 189
New Art Centre, London, 127
Anthony d'Offay Gallery, London: 23, 28, 39, 43, 47, 55, 84, 87, 112, 156
Michael Parkin Fine Art: 41
Phaidon archives: 25, 26, 50, 102
Mrs Ceri Richards: 116
Dr H. Roland: 170
Rowan Gallery, London: 184, 191, 193
Peter Stuyvesant Foundation Ltd: 178
Sotheby Parke Bernet, London: 2, 4, 105, 122
Southampton Art Gallery: 158
Waddington and Tooth Galleries Ltd., London: 176, 190
Wildenstein & Co. Ltd., London: 85

Plate 69 is reproduced by courtesy of the Medici Society Ltd., London
Plate 1 is reproduced by permission of the Trustees of the Devonshire Settlement
Plates 113 and 132 are © ADAGP, Paris, 1977

# Index of persons and places

238